# MY

# ART

天 行

之 路

林天行

著

LAM TIAN XING

# JOURNEY

# 目錄

# Contents

# 現代中國水墨畫
# 一個有意味的藝術形式——
## 論林天行的繪畫美學

一

　　因集古齋趙東曉博士之介，認識了林天行其人其畫。四年來多次到林天行先生作畫的「大也堂」，大也堂不止大，而且大氣典雅。一進門，最引人眼目的是大畫桌上彩墨未乾的新畫和三面牆上掛的堂主人不同時期的畫作，牆邊高桌上擺滿的是天行歷年出版的畫冊，如《景象香港》《閃亮的西藏》《天行之荷》《菖蒲集》。

　　大也堂畫室的前後方是書房，南北兩壁的書架，自頂至腳，盡是古今中西的書和畫集，可以想見主人是愛知好學之人。房內精緻的茶具和三五座椅，當是天行獨飲冥思或與友好品茶論藝的生活常態。林天行畫畫是如癡如醉，而對生活美學的追求，也是專情傾注。他愛美食（不分中外），亦會做美食（福建家鄉菜）；他愛美酒（最愛紅酒，亦愛白酒），更懂得品酒。我們共飲，常止於微醺或半醉，但天行卻不無放馬平川，一醉方休的時候。天行亦文亦武亦溫柔，他好習草書，勤練武術瑜珈，平時默然不多語，談藝興起時充滿激情，笑聲可裂石震瓦。

　　走出大也堂，室外是二層逾千呎的天台，有松、有竹、有荷、有菖蒲，有多種的花花草草，每日施水，親力親為。他對荷花，對菖蒲，總是輕言軟語，一片溫柔。樹也，花也，草也，都是人化的朋友。

林天行 1963 年出生於福建福州鄉間，十二歲已喜歡繪畫，十五歲師從林光、陳挺，學中國畫、西洋畫。1981 年，十八歲，作品參加福建繪畫聯展，初露畫才。1984 年移民香港，次年，二十二歲，天行成為專業畫家，以畫畫安身立命。1989 年，到北京中央美術學院國畫系的山水畫室進修，插班三年級，受業於張憑、賈又福、周思聰、王鏞等教授，並常騎自行車到中國畫研究院（現為國家畫院）問學求教，拜劉牧為師。系統性的學院訓練，為天行奠定了廣闊多元的美學基礎。名師的點撥，更令他對畫學三味增多了體會。1990 年中央美術學院畢業，同年，在陝北寫生。陝北的特殊結構、色彩令他手舞足蹈，首次以墨與色彩的塊面構成圖像，在中國畫院作《陝北系列》之個人畫展。這應該是他第一次以新的繪畫語言面世。

1990 年返港，此時香港在天行心中已是他的「第二故鄉」，從此展開了持續三十年的繪畫美學的創新之路。自 1991 年迄今，天行已創作多個繪畫系列，以香港、西藏、荷花、菖蒲為主題，每個系列都展示了林天行深具個性的繪畫美學，也展示現代中國水墨畫的「可能的」藝術形式。

林天行曾在北京、紐約、柏林、荷蘭、新加坡、台灣、首爾等地舉辦過五十個以上的個展，其作品為中國美術館、國家畫院、西藏美術館、香港藝術館、香港的四季酒店、北京的香格里拉酒店、香港國泰航空公司、聯合航空公司以及許多私人收藏。2005 年及 2008 年，天行兩度獲國家文化部邀請，以香港景象為主題的畫作《晨曲》《維港兩岸》隨神州六號及七號飛船升入太空。

林天行今年五十八歲，在我眼中還是中年，但他的畫齡已經超過四十年，是畫壇一位資深的畫家了。今天林天行是香港美協主席，也是中國美術家協會香港會員分會的主席。林天行是現代中國畫極少數具有代表性的畫家之一，毫無疑義地，林天行是香港一個矚目的藝術存在。

三

對中國近現代（包括當代）的繪畫，我有一個基本的觀點，自清末迄今一百五十年中，中國繪畫遇到了一個三千年未有的新局面。一方面，中國從一農業文明時快時慢地向工業文明轉型。二十世紀末期，中國已經是初具現代性的

文明體，也因此，中國的畫家們不能不感到古今之異；另一方面，西方文化排闥中土，因中西二個繪畫體系的接觸與碰撞，更不能不感到中西之別。近現代的中國畫家所面對的是一個錯綜複雜的古今中西四維的挑戰。當然，這是挑戰，也是機遇。

　　此是清末之前歷代畫家所未曾有的，面對這個四維的挑戰，畫界自然產生了群體性與個體性的回應。於是，出現了眾聲喧嘩的種種畫學主張。鶩新而主西化者有之，保守而維護傳統者有之；有的主張國畫革命，有的主張返本開新。對於中西兩維挑戰的回應，最具影響力的有兩種對立的主張：國畫大師潘天壽有「中西繪畫要拉開距離」之論，潘氏不是「反西派」，亦非國粹保守派，他最在意的是保有中國繪畫「中國獨特的民族風格」；而中西繪畫兼修的徐悲鴻則有「中西合璧」之說。誠然，國畫與西畫是兩個不同的藝術範式，這猶如中醫與西醫屬於兩個不同的醫學範式。

　　簡單說，二個不同的藝術範式，最好是同立並峙，各自精彩，這是潘天壽所持的立場；但二個藝術範式之間也大有可以交流、互融，而產生的藝術的新姿。徐悲鴻顯然有這樣的宏圖願景，觀之近現代笑傲當世的中國大畫家，不入於潘天壽一路，便歸於徐悲鴻一路。而不論在潘天壽或徐悲鴻之路中展現卓爾不群的藝術才華者，都有一共通點，那就是創新之力度特高特強，而有一家之面目。

　　在這裏，特別要說說古今兩維的問題，尤其是畫家對中國繪畫傳統所持的態度。毋可諱言，五四新文化運動倡導並引發了幾代的文化（包括藝術）的激進主義者。文化的激進主義視傳統為一切落後、腐朽的代名詞，傳統全被看做現代化的障礙。因此，反（文化）傳統是五四前後數十年中的一個時代強音。毫無疑問，八股文、包小腳、宦官制、做官發財、愚忠愚孝等傳統的習俗、事物的思想、制度應然剷除。揚棄，這是三尺童子都會明白的，但不分青紅黑白、不分糟粕與精粹，凡是古的、舊的，中國原有的傳統要一概打倒、鏟棄，那就淪為文化的虛無主義了。這不但無助於中國的現代化，並且不期而然地使現代化走上歪路，斷巷絕港。必須知道，像中國這樣一個有千年歷史的文明古國，傳統是無數代前人的智慧所創造積聚而成的。

　　若以繪畫來說，傳統是極具豐厚多樣性的。它的內涵涉及到形而上形而下的美學思想和筆墨形式等元素。中國繪畫傳統元素不是一元而是多元的。有的傳統元素在現代已顯得蒼白、僵固而失去了生命力，但有的傳統元素則仍然充滿

生機與再生的活力，他們完全可以轉化為中國畫現代化的創新靈源。但在五四以來反傳統的氣候下，幾乎已看不到「傳統」了。所以，後五四的有所作為的畫家，必須有再發現「傳統」的努力與修為。中國近現代的真正一流的畫家，沒有一個是完全無中生有的創新，沒有一個不是從傳統中得到靈感和啟發的。

1979 年我為當年年方不惑的畫家何懷碩新作《藝術・文學・人生》寫了一篇〈沒有「沒有傳統的現代化」〉的序文，深得他的認同。最近我看到一篇報導已故旅法畫家趙無極之文，在法國享有盛譽的趙無極生前曾表示，他的抽象畫受到中國道家空無思想的影響。他說：「誠然，巴黎對我藝術風格的形成有着不可否認的影響，但我仍然要說，隨着我個人風格的形成，我逐漸發現了中國。」（見〈恣意浩渺，無極無盡 —— 畫家趙無極的藝術心跡〉，《愛尚美術》2018 年第三期）

# 四

林天行是以繪畫為志業的，他沒有什麼口號式的美學主張，但他是一位思想型畫家。天行，像所有近現代的中國畫家一樣，面對的是一個古今中西四維的挑戰，他對此是有深刻體會和思考的。在中西兩維的關係上，他明白地贊同徐悲鴻的中西融合。秦嶺雪是一位深知天行畫藝的詩人作家。他說天行的「西藏繪畫」，鋪天蓋地的論題是「中西結合」的主張。而在古今兩維的考量上，他卻與潘天壽所言「個人風格要有獨特性」是十分契合的。天行認為，今日的畫家不可依傍前人筆墨，必須創新以回應時代需要。天行是有強烈時代感的。他青年時期，看到老師陳挺的山水畫感動落淚，正因為陳畫充滿「時代感」。天行生活在今日的工業文明中，他有一種衝動，要畫出所處時代的「現代性」。

香港維多利亞港的兩岸，繽紛絢麗的色彩、船鳴車號、高樓大廈森立的景觀，使天行驚覺到數百年一統中國的「中國畫」所出現的美學落差，他說：

「難以理解，『世外桃源』式不食人間煙火的超然之境，悠然、自在、坐忘、閒適早已成為逝去的白日夢的今天，如何體味清涼、淡泊。」

天行感到文人畫傳統已面臨危機，他說：

「在這文化多元的時代，任何事物都已失去它原有的意義與純度，一切盡在

混合中成長，固守『山水文化』載體，以傳統規範的準則，來作為統剎不夠『傳統』的武器，無疑對傳統誤解而導向淪落成『文物』的險境。」

在這裏，天行發出心底的心聲：

「置身大時代縫隙中求存的藝術家，又該如何把握住自身的藝術生命，並走出狹窄，重塑一個屬於今天的『真理』；抑或隨波逐流繼續掠奪和炫耀前人的成就而沾沾自喜。」（林天行，〈景象種種〉，1998 年）

在 1996 年所寫的〈繪畫筆記〉中，天行明白地表達了他的「現代繪畫」的審美立場，他說：

「現代藝術觀念的轉變是不受傳統審美定義的制約」，他心中的現代中國畫，根本上是解除中西的界綫，他說：

「沒有必要去劃清『中國畫』和『西洋畫』的界綫，也沒有必要抱着中國畫的態度來畫中國畫，井水不犯河水的結果只能是永遠也領會不到兩水相溶的美妙。」

顯然，天行把中、西兩維的挑戰看成了最難有的機遇。他直面中、西兩維，又有超越二維的創新企圖。他心中藝術家的創新之路是：「站在更高的地方去看過去和未來，從遙遠的古代智慧到科學昌明的現代文化，不分中西、不分時空，全擔在一起，靠自我的想像和直覺的力量，一種自發原創的藝術，正如羅丹所說，『一個真正的藝術家永遠表現他所想的東西，不怕踐踏現存的規範。』」

他又說：「作爲一個現代中國畫家必須具備全面的知識結構和廣泛的審美能力，不再滯留於『小橋流水』『雲霧山中』以及『筆墨效應』獨沽一味的陳規舊套裏，面對任何不同表現方式和媒介的藝術，都應該有着『看』進去的能力和判斷力。」

讀到林天行這番文字，天行顯然是一位傳統的「叛逆者」了，他也的確是立志於創立現代的中國畫的。但是，天行對傳統只是單面向的叛逆關係嗎？顯然不是。我看他明白反對的是明之後風行數百年的文人畫傳統；從他的一些訪問中的講話（包括我與他之間的聊天），他對北宋、南宋的立體山水畫大師如李

成、郭熙、巨然等都衷心欽仰，明代的徐渭、八大更使他「震撼」，徐渭奔放不羈的大家韻格讓天行覺得他是「用靈魂來畫畫的畫家」，他的畫已達到「天人合一」「物我兩忘」的境地。八大的理性沉着，則進入到一種神聖的精神王國。不止於此，天行對現當代的傳統畫家齊白石、李可染、石魯、吳冠中等都讚美有加，所以我覺得天行所叛逆的「傳統」主要是指一個特定時空中成爲主流的「文人山水畫」，那是一種已遠離文人畫家的精神，成爲格式化、抱殘守缺、沒有靈魂、沒有生命力的中國畫，也即他所叛逆的只是傳統中的一元；反之，天行對中國繪畫大傳統更多的是讚美、見賢思齊、心向往之，即使是他最認同主張「筆墨當隨時代」的石濤也是大傳統中的一個「傳統」組成。實際上，天行繪畫思想的實踐中，也即天行的繪畫語言中更多展現了他對傳統的承繼。邵大箴先生在評論天行的「繪畫藝術」中，精確地指出：「他的藝術一直顯示出獨特的個性的面貌：反叛傳統的樣式和承繼傳統的精神。」

<h2 style="text-align:center">五</h2>

　　林天行是一位思想型的畫家。我前面已介紹了他對繪畫的藝術觀點，天行的基本思想是：今日畫家必須有「時代感」，也即必須表現出「現代性」。他對古、今、中、西四維的挑戰的回應是：「不分中西、不分時空，全捏在一起」，一切「靠自己的想像和直覺的力量」作「自我原創的藝術」，探索「未知」。當然，這是天行的藝術思想，而要認識天行之爲一畫家，就必須看他的藝術實踐，也即是他的繪畫語言。

　　第一次看到天行的畫作時，我真有「驚艷」之感，「美」是我第一反應（今日仍是我的反應）。我覺得他的畫與傳統的中國畫是很不一樣的視覺藝術，中西繪畫的元素在天行的畫中水乳交融，時隱時現，產生強烈的時代意念與詩意的遐思，而整體的藝術表現則洋溢着中國美學的精神和意象。以下，我對天行的《景象香港》《閃亮的西藏》《天行之荷》的繪畫語言試作解讀。

### （一）景象香港

　　天行有意識地走上中國水墨畫現代化之路，很顯著地表現於他的《景象香港》系列（1997-1999）。1963 年出生於福建農村的林天行移居到亞洲國際都會的香港，天行面對維多利亞港兩岸的高樓巨廈的城市森林，「滿眼直綫」，他感到傳統的山水畫法已「無可措手」。這促成林天行有意識地創立了他自己的繪

畫語言。在此，我要指出，天行發現香港這個現代都會時，他也發現了香港新界的傳統鄉村。新界的寧靜、屋村、天橋、道路都使天行找到了家鄉的原趣。天行見到的香港是現代與傳統的混合，這也可以理解天行畫筆下展示的「現代性」中總帶有揮之不去的傳統情調。香港系列的畫作，在一定程度上是對明清以來文人山水畫的一個顛覆，其中真有幾幅畫，為：《秋林》《窗景》《碼頭》《海月下的房子》《樹梢行船》《青山公路》《傾聽》《黃耀的海港》，在視覺感受上，更像是西方現代抽象畫，幾乎看不到中國水墨畫的蹤跡。僅就這些畫來說，林天行應該可以說是傳統的「叛逆者」，但《景象香港》整個系列，則強有力地顯示林天行同時也確是傳統的「承繼者」。我們試看天行的《家在五彩秋風裏》《開滿葵花的家園》《秋天的話》《紅色的村莊》《晨舞》等，從畫的結構、造型，到點、綫、面的寫意筆墨與彩色的肆恣渲染，展露了中、西繪畫元素交光互彩的耀眼形象。

我注意到，新界身邊周圍日常可見的景物：公園裏的長椅，一根根的燈柱；月色朦朧下的屋村；風雨中掠過的巴士；蔚藍的大海，彩色繽紛的船隻；水天交映的霓虹燈，在天行的「心眼」中，無一不具有「攝人的魅力」和特具的「情趣」；在他的畫筆下，都一一變成了造型奇崛、浪漫（看看那些在雲邊、花叢中童話式的房屋）、彩色斑斕絢麗，實境與虛境相互滲透的視覺美學。天行的畫並非純客觀的存在，更多是畫家主觀意念的創造。我特別要指出，天行的畫有強烈的現代感，但他不是一個平面的「現代主義」者。事實上，他有一個濃烈的抗拒機械理性的詩意衝動。他的畫是他的詩語。他所企圖的是要用他的畫來詩化鋪天蓋地的機械文明。

## （二）西藏

林天行畫山水，離不開寫生。他喜歡直師自然，學之於造化。家鄉的蓮花峰是他永恆之愛，也是他藝術想像的源泉。天行讀小學時，路上看到一朵形狀奇特的白雲，為了看個究竟，翻過一座座山頭，從早上七八點，一直追到天色入薔。

改革開放後，天行隨陳挺老師到全國十一個省做了三個月的寫生之旅。1979 年，到黃山訪友寫生，當他離開黃山時，「回頭望去，竟然熱淚盈眶」。1983 年登頂泰山，從此岱宗「一覽天下小」的巍巍山勢，常念不忘。1999 年陝北寫生，奇特的結構、色彩，令他興奮難眠，不知不覺間他開始探索山水的繪畫語言。

無說，林天行的畫作高潮是西藏之行。1999年，他頂着感冒到達世界屋脊，那是地球最接近大天的地方，也是最突顯出天地精神的地方。西藏的吸引力使他無法抗拒，三次西藏之行，幾乎要了他的性命，天行說：「西藏是讓你不要命的地方。」2005年他去了西藏的「阿里」與「土林」，都在 5,000 米以上，土林奇觀、山石紋理「像在月球上的景色」。天行說「在中國畫美術史上沒有人畫西藏山水的。」畫西藏山水，「找不到借鑒」。2006年展出的《天行西藏》的百幅畫作，可說是天行空無依傍，自我探索與創新的成果。正如古人所說「外師造化，中得心源」，他直接師法自然，一切又經由心靈想像的喚醒，這便形成了天行獨特的山水繪畫美學。

林天行的西藏畫，其中一幅是在阿里當地千年古寺托林寺門前畫的2,000厘米土林寫生長卷。一次，天行在「大也堂」的地板上展示給朋友欣賞。這樣長的長卷，三小時畫就，不能不說是極速快筆了，展現在我眼前的是佛國雪域，千里風光。天行表示，長卷畫成後，他去了三百年前的古格王朝，第二天就把古格王朝加進去，他說這是「超越時空的取捨」。是的，土林長卷六七分寫實，三四分抽象。但寫實也好，抽象也好，天行畫的終究是他「心眼」的所見、所感與所思。

《阿里行》是西藏系列中很能代表天行重彩山水風格的一幅。這幅畫中，看不到中國傳統青綠山水的影跡，也看不到傳統的綫條寫意，佈滿整個畫面的是大小冰火相接相離的色塊：冰是冷寂的雪嶽雪湖；火勢熊熊如燒的陽光。所形成斑斕炫麗的是西藏的天與地，西藏的山與水。

詩人秦嶺雪說：「天行的繪畫，有強烈的印象主義色彩和崇高的象徵意義。」他又說，「天行有雙積法的運用，既積墨又積色，既空靈又渾厚。」顯然的，天行的雙積法充分展現了他的「塊面思維」。天行說：「我喜歡把大自然中的物象都看成各不同形狀的平面，同時帶有色彩的對比，就像我凝視一棵樹時，它引起我什麼樣的色塊的聯想，而不是樹本身。用塊面思維方式觀察事物更加簡練，更加整體，去掉一切繁縟的細節，簡化元素的物性及其含意，凸現明確而有力的繪畫語言。」（林天行，〈繪畫筆記〉，1996）

「塊面思維」，在一定意義上，決定了天行的山水繪畫的風格，也成爲天行繪畫美學的一個特性。

天行用墨色重彩的塊面畫出了西藏種種自然之美與神祕，如《美麗的日子》

《五彩的神山》《紅色的早晨》《陽光裏的寺院》《藍天下的僧人》《陽光裏的雪山》《掉落聖湖的彩霞》；但天行表現得最深刻的是西藏的「神聖性之美」，如《潔淨的地方》《神聖的家園》，當我看到八長幅的《神聖的地方》時，我被他的畫帶進一個璀璨聖潔、佛光閃耀的天國境界。這裏，我覺得天行的色塊似乎加入了我在敦煌壁畫中看到的那種光色！

從最具「俗世化」性格的香港這個繁華熱鬧，變動不居的城市到達西藏這個寂天寞地，歲月被凝固的佛國聖地，對一個有佛性的畫家林天行來說，更是心靈的一次昇華與飛躍。「俗世化」是「現代性」的一個標誌，但現代人內心深處始終有「神聖性」（永恆、聖潔、神祕）的追求。天行有志於繪畫「現代性」的建構，但他似乎相信，現代性中應該是且必須有「神聖性」的位置。事實上，天行對「神聖性」的探求在他的《天行之荷》《菖蒲集》的系列中，都體現在一朵朵荷花，一根根菖蒲中。

## （三）荷花系列

生長在蓮花峰腳下的林天行，幼小時從祖母的言說中，對荷蓮就有了佛性的聯想。西藏的佛國之旅，天行更體悟了荷蓮的「神聖性」，在他的《金荷》《祥光》《淨植》《悅來》《佛光》等大畫中，無不強烈地表現了荷蓮的莊嚴、聖潔、歡愉、永恆的精神特質。誠然，這是千年的國畫中從未之見的荷蓮。

天行自志於繪畫後，就有畫荷之思。他畫荷醞釀有聲，在思想上有長期準備；他愛讀歷代吟荷詩文，通覽宋之後畫荷傑作；他更靜賞、默識莫奈絢爛的蓮塘、周思聰淒美的荷雨。天行還走遍大江南北，尋荷不倦：拙政園的翠蓋，西湖曲園的風荷，北海的荷香，湘西紅白相間的十里煙荷，佛山五彩繽紛的盛荷，台灣南投的那「風流全在半開時的新荷」；2002 年在故鄉閩江畔與一片「聽雨」的枯荷不期相遇，終於認得了荷的剛毅、頑強、無畏、樂天的一面；在第二故鄉的香港新界的荷塘，更常見「天然不飾」「野趣盎然」的荷蓮，令天行喊出「是你，把這冷漠繁囂而又無奈的都市，變得寧靜、安詳和充滿生機；是你的愛，浸潤着我的心田。多美！人世間，因爲有你！」

天行愛荷尋荷的癡情，就像他少年時追雲的那份鍥而不捨的執着。1999 年第一次登上西藏高原而病，「面臨死亡邊緣的時候，根本無法入睡。閉上眼睛，腦海裏就有荷花滿天飛」。天行說，「荷花與西藏是分不開的，荷花是佛教之

花」。顯然，在西藏他的潛意識間回到了幼時蓮花峰下祖母的荷花叮嚀。2003年，他覺得「找到了屬於自己之荷」。天行所說「找到了屬於自己之荷」，實表示他已有了如何畫荷的畫法。天行心中，他對荷蓮的本質以及化身千億的樣貌，都已胸有成「荷」（竹）了。2004年，天行發表了〈寫給荷花〉的文章，這是繼宋代周敦頤的《愛蓮說》千年後對荷蓮頌讚的一首散文詩。同年，一百幅《天行之荷》在香港隆重展出。一百幅《天行之荷》展現了林天行畫荷的大能淋漓、豐沛真情、多彩多法的繪畫語言，代表性的展示了林天行的繪畫美學。「天行之荷」的問世，正如鄭培凱教授所說，它「開啟了香港藝壇的畫荷傳奇」。

　　林天行的荷花系列，與之前的《景象香港》《天行西藏》及之後的《楚頌新聲：菖蒲集》所展現的繪畫美學，有強烈的一貫性。這也因此形成了獨有的林天行的繪畫風格。但是，不同系列之間的畫作也有不盡一樣的表現形式。當然，這與所畫的「對象」之不同有關。天行的畫荷語言，不似《天行西藏》以彩色塊面為主調，而是通過潑墨潑彩，營造了「面」的彩色「大寫意」，產生「滃然而雲，瀅然而雨，泛泛然而露也」（徐渭評陳鶴畫）的畫面氣息。值得注意的是，荷畫中，綫條大量地出現了。綫條的濃淡、粗細、長短，或彎或直，或顯或隱，助長了畫的氣韻與靈動。在我看，天行的畫以彩色之美名世。事實上，天行畫面所展顯的彩色之美有幾乎使人「無法抗拒」的魅力。的確，「墨分五色」，在他的《荷塘煙雨》中得到極緻的發揮；至於他的「彩色」究竟可分幾色，則實非我所能辨識。天行對彩色可謂情有獨鍾。有一次，他被問到「你怎能把彩色表現得那麼美麗？」天行笑着說：「因為我是好色之人。」這個幽默的答案也是說明了為何林天行是一位彩色繪畫的妙手。

　　儘管彩色在天行畫中佔有最高的比重，但我還是要說說天行的筆墨修養與功夫。天行的筆墨，特別是他綫條的表現，實際上是他的畫之所以定性為現代「中國的」水墨畫的重要原因。我相信，認真看過天行的《荷塘煙雨》這幅傑出的長卷的人，讚畫之餘，當不能不同意我的看法。

　　天行的荷蓮，無疑是中、西繪畫的一個高度融合。在此，我必須強調，主張中、西融合是一種藝術態度，這與能不能畫出一流的畫，毫無關係，如何結合中、西的繪畫元素，如何選擇中西的元素而融合之，並且能創出一個獨特的藝術形式，那才是「中西合璧」這個命題的真正挑戰所在。從天行四十年的繪畫實踐來看，天行顯然成功地回應了這個挑戰。他已創立了一個有「中國性」的現代水墨畫的「有意味的」藝術形式。

（英國評論家 Clive Bell 提出「美」是一種「significant form」的著名觀點，李澤厚將之譯為「有意味的形式」，特借用之。在此我要對這位剛去世，對中國美學有重大貢獻的哲學家李澤厚先生表達個人的敬意與哀思。）

在這裏，我想對天行畫的「中國性」再說幾句。上面我提到中、西的繪畫元素。繪畫元素包括結構、造型、筆墨、彩色以至畫的整體的意識與氣象；它涉及到形而下與形而上的器與道的二個層次。天行的畫（特別是荷花以及菖蒲兩個系列）心手營造最美妙的是畫的整體的「意象」，這關乎到形而上的道，也即美學的思想。天行之荷（以及菖蒲）的畫題，常只一個字，如逸、思、歸、凝、遇、綺、淨等，或二個字，如荷唱、荷歌、荷悅、荷祝、蓮開、蓮樂、蓮影、蓮雨等。一字也好，二字也好，都是一種美學的「意象」，意象的表達千狀萬態：或雲絮飄逸，或剛健婀娜，時則莊嚴肅穆，時則輕快愉悅，有時濃妝艷麗，有時淡雅清素，不論表現的是哪一種意象，無不透顯了氣、韻、神的中國畫特色。天行繪畫中展顯的是中國的美之象。

## 六

林天行四十年的繪畫之路，攀峰越嶺，無日不在探索現代中國水墨畫的藝術形式與美學精神。如前所言，作為一個近現（當）代的中國畫家，天行面對古、今、中、西四維的挑戰，他採取的是完全開放的態度，只要有助於畫出他要畫的畫，他都「一把抓」；他徹底打掉中、西繪畫之間的「對立性」。明代以後格式化的文人畫是他揚棄的，但畫壇「異類」徐渭的水墨大寫意卻是他傾心嚮往的。傳統與現代之間在他筆下有了「有意味的」結合，大多數標「現代主義」的畫家與他是不可同日而語的。著名的藝術評論家范迪安對林天行的繪畫有如下的評論：

「在新文化、新信息、新元素的激發下，林天行不斷突破舊有藩籬，勇創新圖。尋找最適合於這個時代的藝術圖式，這是十分難能可貴的。在藝術語言的創新與拓展上，林天行打通了『中』與『西』兩種異質文化間的認知差異與意識界限，將西畫中適宜於表達自身思想情感的元素巧妙融合在傳統畫學當中。在當代中國水墨畫藝術中，對傳統的反叛總是一些畫家藉以出新的手段，但林天行所不同的是，他在看似對傳統筆墨的『反叛』的同時，實際上是通過現代生活感受對傳統精髓的繼承和弘揚。」（〈淋漓華彩歲月歌——論林天行的藝術〉，《美術家》，香港，2019 年）。

范迪安先生的論點是我完全認同的。無疑地，林天行為現代中國水墨畫開創了一個「有意味的」藝術形式（當然，現代中國水墨畫還有其他「可能有的」藝術形式）。林天行的繪畫美學是「現代的」，也是「中國的」，當然，也是林天行個人的。

金耀基

香港中文大學榮休社會學講座教授
台北中央研究院院士
2021 年 12 月 16 日清晨

# A Significant Art Form of Modern Chinese Ink Painting—

## On Lam Tian Xing's Painting Aesthetics

### One

Through the introduction of Dr. Zhao Dongxiao from Tsi Ku Chai, I got to know Lam Tian Xing and his paintings. In the past four years, I have visited Mr. Lam Tian Xing's studio "Da Ye Tang" – meaning "The Hall of Boundlessness", many times. The "Da Ye Tang" is not only large, almost huge, but also gracefully elegant. As soon as entering the double doors, I was caught by the new paintings with wet paints laying on the large painting table and the paintings hanging on the three walls done at different periods by Tian Xing. There are high tables standing by the wall, displaying many painting albums published by Tian Xing over the years, such as *Scenes – Hong Kong*, *Shining Tibet*, *The Lotus of My Heart* and *Anthem of Calamus*.

There are two huge study rooms in the front and at the rear of the "Da Ye Tang" studio. The bookshelves standing on the north and south walls are very tall, nearly reaching the ceiling, full of ancient and modern books, both in Chinese and foreign languages, and a good collection of paintings books. It clearly reflects that the owner is a person who loves to learn. In the middle of the studio, there is an exquisite tea set with a few seats; this is the place where Tian Xing spends most of his time alone or with friends, either drinking tea or meditating, or studying the arts. Lam Tian Xing is feverishly addicted to painting. He is also dedicated and devoted to the pursuit of life aesthetics. He loves food (regardless of Chinese and international) and cooks well (Fujian hometown cuisine); he loves fine wine (both western red wine and Chinese white wine). He has acquired good knowledge of wine tasting. Those few times we drank together, we often had good control and knew when to stop; however, there were also times when Tian Xing was so happy that we could have drunk a bit too much. Nevertheless, we all had fun. Tian Xing is gentle in nature. He enjoys his life in many ways. In addition to his passion for paintings, he also is fond of cursive calligraphy and practices martial arts and yoga. He is usually silent and does not speak much. However, he can get very excited when talking about art and sometimes his voice becomes so loud that it can pierce through the walls.

Walking out of the "Da Ye Tang", there is the rooftop garden with more than 1,000 square feet of space. There are pines, bamboos, lotus, calamus, and a variety of flowers and grasses; he waters them every day himself. The lotus and the calamus are the love of his heart. When he looks at them, there is an obvious tenderness in his handling. These trees, flowers and grasses are his humanized friends.

## Two

Lam Tian Xing was born in 1963 in the countryside of Fuzhou, Fujian. At age 12, he developed an interest in painting. At age 15, he studied Chinese painting and Western painting under the tutelage of Lin Guang and Chen Ting. In 1981, age 18, he participated in some painting group exhibitions in Fujian where his talent in painting was demonstrated for the first time. He immigrated to Hong Kong in 1984. The following year, at age 22, Tian Xing became a professional painter and made a living by it. In 1989, he studied at the Landscape Painting Studio of the Chinese Painting Department at the Central Academy of Fine Arts (CAFA) in Beijing. He was accepted as a third-year student, attending courses given by Professors Zhang Ping, Jia Youfu, Zhou Sicong, Wang Yong and other professors. At the same time, he often bicycled to Research Institute of Traditional Chinese Painting (now the China National Academy of Painting) to study and seek advice, and followed Liu Mu as his teacher. The systematic academic training has laid a broad and diverse aesthetic foundation for him. The guidance and inspiration of those well-established teachers, has brought him a more perceptive understanding of painting. Upon his graduation from the CAFA in 1990, he went to sketch in Northern Shaanxi. The spectacular and unique geographic structure and colourfulness of Northern Shaanxi made him thrilled with joy. For the first time, he composed images with blocks of ink and colour, and then held a solo exhibition of "Northern Shaanxi Series" at the Research Institute of Traditional Chinese Painting. This was his first appearance in a new painting language.

Returning to Hong Kong in 1990, by then, Hong Kong was already his "second hometown". Ever since, he has embarked on a road of innovation in painting aesthetics which has lasted for over 30 years. Up to date, Tian Xing has created several series of paintings, themed on Hong Kong, Tibet, lotus and calamus. Each series showcased Lam Tian Xing's unique painting aesthetics, and projected the "possible" way of expressing modern Chinese ink painting.

Lam Tian Xing has held more than 50 solo exhibitions in Beijing, New York, Berlin, the Netherlands, Singapore, Taiwan, Seoul, etc. His works are widely collected by the National Art Museum of China, China National Academy of Painting, Tibet Art Museum, Hong Kong Museum of Art, Four Seasons Hotel in Hong Kong, Shangri-La Hotel in Beijing, Cathay Pacific Airways in Hong Kong, United Airlines and many private

collections. In 2005 and 2008, Tian Xing was respectively invited by the Ministry of Culture to launch his paintings, "Morning Song" and "Sideview in Victoria Harbour" with the theme of Hong Kong scenes, into space with the Shenzhou 6 and 7 spacecraft.

Lam Tian Xing is 58 years old this year. In my eyes, he is still middle-aged, though he has been painting for more than 40 years and is a renowned painter in the art world. Tian Xing is the chairman of The Hong Kong Artists Association and at the same time chairs the China Artists Association Hong Kong Chapter. As one of the very few significant representatives in modern Chinese painting, Tian Xing is without doubt an attention-seeking artist in Hong Kong.

## Three

I always believe that Chinese paintings, both modern and contemporary, in the last 150 years since the late Qing, have encountered an unprecedented situation. On the one hand, China has gradually been transforming from an agricultural civilisation to an industrial civilisation. At the end of the 20th century, China had already developed a civilisation with early modernity. Therefore, Chinese painters could feel the difference between ancient and modern. On the other hand, the Western culture was dominant in China. The inevitable contact and collision between the two painting systems have strongly influenced the feelings of Chinese painters. Modern Chinese painters are facing a complex four-dimensional challenge of ancient versus modern and Chinese versus Western. Of course, this is a challenge as well as an opportunity.

This is something that Chinese painters did not need to face until the end of the Qing Dynasty. Facing this four-dimensional challenge, the group and individual responses of the painting world naturally emerged. As a result, all kinds of painting ideas were making noises. There were those who were new and focus on Westernisation, and there were those who were conservative and uphold tradition; some advocated a revolution in traditional Chinese painting, while others advocated sticking to the original. The most influential responses to the two-dimensional challenge between Chinese and the Western were two opposing propositions. Pan Tianshou, a master of traditional Chinese painting, opined that "Chinese and Western painting should be separated from each other". Pan is neither an "anti-Westerner" nor a quintessential conservative. What he cared most was to maintain the "unique Chinese national style" of Chinese painting. Xu Beihong, who was trained in both Chinese and Western painting, believed that "Chinese and Western painting skills should be combined". Obviously, Chinese painting and Western painting are two different artistic paradigms, just as that Chinese medicine and Western medicine belong to two different medical paradigms.

To simply put, Pan Tianshou believed that two different artistic paradigms could stand side by side with each keeping their uniqueness. However, there also can be a lot of communication and integration between the two art paradigms, resulting in new artistic styles. Xu Beihong obviously had such a grand vision. Looking at these prominent Chinese painters in contemporary China, they took sides with either Pan Tianshou or Xu Beihong, but either way, they all displayed outstanding artistic talents, and high-level and powerful innovative capacities.

Here, I want to talk about the two-dimensional dispute of ancient and modern art, especially the painters' attitude towards the Chinese painting tradition. Needless to say, the May 4th New Culture Movement advocated and inspired generations of cultural (including artistic) activists. There is no doubt that some traditional customs, ideas and norms such as Baguwen, bounding feet, the eunuch system, the association of being an official and making a fortune, unquestioning loyalty and filial piety, should be eradicated. Abandonment is something easily understood even by a kid, but if we do not distinguish black from white, or dross from essence, and overthrow all ancient and old original Chinese traditions, it will become cultural nihilism. This is not helpful to China's modernisation, but unintentionally makes modernisation go down the wrong path. We must understand that, in such an ancient civilisation as China, with a history of thousands of years, traditions are created and accumulated by the wisdom of countless generations of predecessors.

For traditional painting, it is very rich with diversities. Its connotation involves metaphysical and physical aesthetic elements and forms of brush and ink. The traditional elements of Chinese painting are not unitary but plural, though some traditional elements have become pale, rigid and have lost their vitality in modern times. However, some traditional elements are still full of vitality and can be easily regenerated into new forms, and they can be the source of innovation in the modernisation of Chinese painting. Unfortunately, in the anti-traditional climate since the May 4th Movement, "tradition" has been almost invisible. Therefore, the painters, in the post-May 4th period, must have the determination as well as the capability to unearth the "traditional" and cultivate the new painting styles. None of the first-class painters in modern China is completely innovative from nowhere, and all of them are inspired by tradition.

In 1979, I wrote a preface titled "No 'Modernisation Without Tradition'" for painter He Huaishuo's new work of *Art-Literature-Life*. Mr. He agrees with my viewpoints in that preface very much. Recently I read an article reporting on the late famous painter Zao Wou Ki, living in France for many years. He said that his abstract paintings were influenced by Chinese Taoism emptiness (Wu) philosophy. He said, "It is true that Paris had an undeniable influence on the formation of my artistic style, but I still have to say that with the formation of my personal style, I gradually discovered China." (See "Wildly vast, infinite and endless – Artist Zao Wou-Ki's artistic aspirations", *iFine Art*, 2018 Issue 3)

# Four

Lam Tian Xing takes painting as his career. He has no slogan-style aesthetics, but he is an ideological painter. Tian Xing, like all modern Chinese painters, is facing a four-dimensional challenge. he has deep understanding of it and thinks about it always. In terms of the two-dimensional relationship between Chinese and the Western, he clearly agrees with Xu Beihong's integration of Chinese and the Western. Qin Lingxue, a poet and writer, says that Tian Xing's "Tibetan painting" made the proposition of "the combination of Chinese and the Western". Considering the ancient – modern dimension, Tian Xing is very consistent with Pan Tianshou's statement that "personal style must be unique". Tian Xing believes that painters of nowadays could not completely rely on their predecessors, but have to innovate to respond to the needs of the times. Tian Xing has a strong sense of the times. At his younger age, he was moved to tears when he saw his teacher Chen Ting's landscape paintings, because Chen's paintings were full of "a sense of the times". Tian Xing lives in today's industrial civilisation, and he feels the urge to paint the "modernity" of the contemporary era.

In viewing the scenery of Hong Kong Victoria Harbour, the vivid glowing colours, the chirping boats and the landscape of high-rises, Tian Xing is shocked to realise that the so-called "Chinese painting" of the past hundreds of years has fallen into a huge aesthetic gap. He says:

"The Shangri-La transcendent realm is incomprehensible; the lifestyle of laying back, sitting and thinking of nothing, has long become a passing dream today."

Tian Xing feels that the tradition of literati painting is facing a crisis. He says:

"In this era of cultural diversity, everything has lost its original meaning and purity. Everything mixed and developed together. Conservatism may become an obstacle for the development of contemporary art."

Tian Xing expresses his innermost voice:

"Artists who seek survival within the compressed space of this great era, how could they lead their own artistic life to make a breakthrough? How to reshape a truth that belongs to today? Or should they simply go with the flow, continue to plunder and show off the achievements of their predecessors, and be complacent about that?" (Lam Tian Xing, "Different Images", 1998)

In "Painting Notes" written in 1996, Tian Xing clearly expresses his aesthetic stance on "modern painting":

"The pre-prompt for the transformation of modern art concepts is not restricted

by the definition of traditional aesthetics." In his mind, modern Chinese painting fundamentally removes the boundary between Chinese and the Western. He says:

"There is no need to draw a clear line between 'Chinese painting' and 'Western painting'; there is no need to paint Chinese painting with the attitude of Chinese painting. The idea of 'do not interfere with one another' stops people from admiring the beauty of the fusion of two artistic styles."

Obviously, Tian Xing regards the challenge of Chinese versus Western dimension as the rarest opportunity. He chooses to face such challenge and tries to go beyond two dimensions by innovation. An ideal innovative path for an artist is: "Standing at a higher level to see the past and the future, to experience the ancient wisdom and the modern culture with scientific prosperity. Regardless of Chinese and the Western, time and space, all are compressed together; painters must rely on the power of self-imagination and intuition to create spontaneous and original art. As Rodin said, 'A true artist always expresses what he thinks and is not afraid to deviate from existing norms.'"

He adds: "As a modern Chinese painter, one must have a comprehensive knowledge of painting structure and a wide range of aesthetic abilities. He can no longer linger in the stereotypes such as 'Little Bridge and Flowing Water', 'In the Clouds and Misty Mountains' and 'Brush and Ink Effect'. For any art with different expression methods and media, one should be able to 'see' the art itself."

Reading his words, we may label Tian Xing a traditional "rebel". Indeed, he is determined to create modern Chinese painting. Is Tian Xing just a one-sided rebellion to tradition? Obviously not. I think he clearly is only opposed to the literati painting tradition that was popular for hundreds of years after the Ming Dynasty. From some of his interviews (including my chat with him), he sincerely admires the three-dimensional landscape painting masters of the Northern and Southern Song dynasties, such as Li Cheng, Guo Xi and Ju Ran. He is "shocked" by Xu Wei and Bada Shanren of the Ming Dynasty. Xu Wei's unrestrained personality and painting rhyme makes Tian Xing feel that he is "a painter who paints with soul", and his paintings have reached the state of "harmony between man and nature" and "forgetting both things and oneself". The rational composure of Bada reaches a sacred spiritual realm. Moreover, Tian Xing praises the modern and contemporary traditional painters Qi Baishi, Li Keran, Shi Lu and Wu Guanzhong. Therefore, I think the "tradition" that Tian Xing rebels mainly refers to the "literati landscape painting" which was the mainstream in a certain time and space, being formatted, preserving the outworn without soul and vitality. It had been far away from the spirits of literati painters and was only the monism in the tradition which Tian Xing rebels. On the contrary, Tian Xing praises the great tradition of Chinese painting, sees the good and wishes to be alike, yearning for the great. Even the one he most agrees with, Shi Tao,

who advocated that "brush and ink should be in line with the times", is also a "traditional" component of the great tradition. In fact, in the practice of Tian Xing's painting thoughts, Tian Xing's painting language reflects more of his inheritance of tradition. In Mr. Shao Dazhen's comments on Tian Xing's "Art of Painting", he points out precisely: "His art has always shown a unique personality: a form that rebels against tradition and a spirit that inherits tradition."

## Five

Lam Tian Xing is an ideological painter. I have already introduced his artistic views on painting. Tian Xing's basic idea is that today's painters must have a "sense of the times", that is, they must show "modernity". His response to the challenge of the four dimensions of ancient–modern and Chinese–Western is: "regardless of Chinese and the Western, regardless of time and space, all are merged together." Everything "relies on the power of one's own imagination and intuition" to make "self-original art" and explore the "unknown". Of course, this is Tian Xing's artistic thoughts. To know Tian Xing as a painter, one must look at his artistic practice, that is, his painting language.

When I saw Tian Xing's paintings for the first time, I really felt "amazing", and "beauty" was my first reaction (it is still my reaction today). I think his painting is a very different kind of visual art from traditional Chinese paintings. The elements of Chinese and Western paintings are blended in Tian Xing's paintings, these elements appearing here and then disappearing there. It produces strong ideas of the times and poetic reverie, and the overall artistic expression is filled with the spirit and imagery of Chinese aesthetics. Below, I will try to interpret the painting language of Tian Xing's "Scenes – Hong Kong", "Shining Tibet" and "The Lotus of My Heart".

### I. Scenes – Hong Kong

Tian Xing has consciously embarked on the path of modernisation of Chinese ink painting, which is evident in his "Scenes – Hong Kong" series (1997-1999). Born in rural Fujian in 1963, Tian Xing moved to Hong Kong, the world city of Asia. He faced the urban forest of high-rise buildings on both sides of Victoria Harbour. All he saw was "straight lines everywhere he laid his eyes". He felt that the traditional landscape painting method had not been "applicable". Thus, he decided to consciously create his own painting language. Here, I would like to point out that when Tian Xing discovered the modern metropolis of Hong Kong, he also discovered the traditional villages of Hong Kong's New Territories. The tranquility of the New Territories, villages, flyovers, and roads have all enabled Tian Xing to find the original taste of his hometown. The Hong Kong that Tian Xing sees is a mixture of modernity and tradition. It is also understandable that the "modernity" displayed under Tian Xing's brush has a lingering traditional sentiment. The

paintings in the Hong Kong series are, to a certain extent, the subversion of the literati landscape paintings since the Ming and Qing dynasties. To name a few among them, there are "Live in Autumn", "By the Window", "The Pier", "House by the Moon-shining Seaside", "Boat Floating on the Top of the Trees", "Castle Peak Road", "Affending" and "Glittering Harbour". In terms of visual perception, these paintings are more like modern Western abstract paintings, and there is almost no trace of Chinese ink painting. As far as these paintings are concerned, Lam Tian Xing can be said to be a traditional "rebel". However, when examining closely the entire series of "Scenes – Hong Kong", it strongly shows that Lam Tian Xing is indeed the "successor" of tradition. Let's look at Tian Xing's "Home in Colourful Winds", "Home Full of Blooming Sunflowers", "Word of Autumn", "Red Village", "Dancing in Morning", etc. From the structure and shape of these paintings, to the freehand brushwork and colour rendering of points, lines and surfaces, it shows a dazzling image of Chinese and Western painting elements interacting with each other.

I notice that the ordinary surroundings around the New Territories, such as the benches in the park, the roll of lamp posts; the housing estate under the hazy moonlight; the passing by bus in the wind and rain; the blue sea, the colourful boats; the neon lights in the sky, all of them present "charming scene" and special "interest" in Tian Xing's eyes. Under his brush, all of them have become strange and romantic (look at those fairy-tale houses beside the clouds and among the flowers), and colourful and gorgeous visual aesthetics with mutual penetration between reality and virtual environment. Tian Xing's paintings are not purely objective existences, but rather the creations of the painter's subjective ideas. I would like to point out that though Tian Xing's paintings have a strong sense of modernity, he is not a strictly "modernist". In fact, he has a strong poetic impulse to resist mechanical rationality. His paintings are his poetry. What he attempted is to use (painting) to poetise the overwhelming mechanical civilisation.

## II. Tibet

Lam Tian Xing's landscape painting cannot be separated from his sketching. He likes to learn from nature. "Being in nature and believing nature" is the best teacher, he always talks about. The Lotus Peak in his hometown is his eternal love and the source of his artistic imagination. When Tian Xing was in elementary school, one day, he saw a strangely shaped white cloud on his way. To see what happened, he climbed over the hills, followed the cloud, from seven or eight in the morning, until the sky turned into an evening rosy colour.

After the launch of the reform and opening-up of China, Tian Xing accompanied Mr. Chen Ting on a three-month sketch trip to eleven provinces across the country. In 1979, they sketched in Mount Huangshan. As they were leaving, Tian Xing recalled when he was "looking back, tears filled his eyes". In 1983, he climbed to the top of Mount Tai,

and since then, Daizong's majestic mountains, "glancing the world's small", have never been forgotten. In 1999, he sketched in Northern Shaanxi. The peculiar structure and colour made him excited and sleepless. Before he knew it, he began to explore the painting language of landscape.

Needless to say, the climax of Lam Tian Xing's painting was his trip to Tibet. In 1999, with a cold, he arrived at the roof of the world, which is the place where the earth is closest to the sky and where the spirit of heaven and earth is most prominent. The attraction of Tibet was irresistible, but three trips to Tibet almost cost him his life. Tian Xing says: "Tibet is a place where you are willing to die for without any regret."

In 2005, he went to "Ali" and "Tulin" in Tibet, both above 5,000 meters. In Tulin, the soil forest and rock texture were "like the scenery on the moon". Tian Xing says, "No one has ever painted Tibetan landscapes in the history of Chinese painting art." He also says, "Painting Tibetan landscapes, I can't find predecessors."

In 2006, about a hundred paintings of "Tibet – A Cosmovital Vision" were exhibited, which can be considered the result of self-exploration and innovation. As it is said "artistic creation comes from learning from nature, but the beauty of nature cannot automatically become the beauty of art. For this transformation process, the artist's inner feelings and constructions are indispensable." He directly imitated nature, and everything was awakened by spiritual imagination, which has become Tian Xing's unique landscape painting aesthetics.

Among Lam Tian Xing's Tibetan paintings is a 2,000-centimetre sketching scroll painted in front of the Toling Monastery, a thousand-year-old ancient temple in Ali. Once, Tian Xing showed it to friends on the floor of "Da Ye Tang". Such a long scroll was painted in three hours. It must be said that the drawing was extremely fast. What unfolded in front of my eyes was the snowy area of the Buddhist land, with thousands of miles of scenery. Tian Xing said that after the long scroll was completed, he went to the Guge Dynasty old site, built three hundred years ago. He added the Guge Dynasty old site to the scroll the next day. He said that this was "a choice beyond time and space". Yes, Tulin Long Scroll is 60%-70% realistic, and 30%-40% abstract. Whether it is realistic or abstract, Tian Xing's paintings are ultimately what he sees, feels and thinks with his "eyes of heart".

"Travelling in Ali"– a painting which well represents a style of Tian Xing's ink-colour landscape in the Tibet series. In this painting, there is no trace of the traditional Chinese green landscape, nor the traditional freehand lines. The whole painting is filled with colour blocks of ice and fire with different sizes: The ice is the cold and quiet Snow Mountain and Snow Lake; the sun is blazing with fire. It forms the gorgeous and dazzling heaven and earth of Tibet, and the mountains and waters of Tibet.

The poet Qin Lingxue says: "Tian Xing's paintings have strong impressionistic colours and sublimely symbolic meanings." He also says, "Tian Xing has applied double accumulation method, which accumulates ink and colour, and is both ethereal and rich. Obviously, Tian Xing's double accumulation method fully demonstrates his 'block thinking'." Tian Xing says: "I like to see the objects in nature as pieces of different shapes with contrasting colours. It is like when I find a tree, it reminds me of what colour patches it brings to me, not the tree itself. It is more concise and more holistic to observe things with block thinking. Removing all the tedious details, the physical properties and meanings of the elements are simplified, and the clear and powerful painting language is highlighted." (Lam Tian Xing, "Painting Notes", 1996)

In a certain sense, "block thinking" determines the style of Tian Xing's landscape painting, and it has also become a feature of Tian Xing's painting aesthetics.

Tian Xing painted the various natural beauties and godly mysteries of Tibet, such as "Beautiful Days", "Colourful Mountains", "Morning in Red", "Monastery in Sunshine", "Monasteries in Sunshine", "Snow Mountains in Sunshine" and "Colourful Clouds". The most profound manifestation of Tian Xing is the "beauty of holiness" in Tibet, such as "Place of Purity" and "Holy Homeland". When I saw the "Holy Place", I was taken into a splendid, holy and radiant heavenly realm by his paintings. Here, I feel that the colour blocks of Tian Xing echoed the light and colour I saw in the Dunhuang murals!

From the bustling and ever-changing city of Hong Kong, a place the most secularized, to the lonely land of Tibet, the sacred Buddhist place where the years have been frozen, for a painter with Buddha nature, it is a spiritual sublimation and leap. "Secularization" is a sign of "modernity", but in the heart of modern people there is always the pursuit of "sacredness" (eternity, holiness, gods). Tian Xing is interested in the construction of "modernity" in painting, but he seems to believe that modernity should and must have a "sacred" position. In fact, Tian Xing's quest for "sacredness" is reflected in the lotus flowers and calamus in his series of "Lotus of My Heart" and "Anthem of Calamus".

### III. Lotus Series

Lam Tian Xing, who grew up at the foot of Lotus Peak, had associated the Buddha-nature with Lotus from the words of his grandmother when he was young. During the trip to the Buddhist land in Tibet, Tian Xing realised the "sacredness" of lotus. In his large paintings such as "Golden Lotus", "Aurora of Blessings", "Purely Planted", "A Happy Visit" and "Buddha Glory", all of them strongly express the solemn, holy, joyful and eternal spiritual characteristics of lotus. It is true to say that this is a lotus that has never been seen in Chinese painting for thousands of years.

As soon as Tian Xing set his mind on painting, he thought of painting lotus. He draws the lotus with his life, and has long-term preparation in thoughts. He reads poetry and prose in the past dynasties; he studies masterpieces of Lotus done after the Song Dynasty. He admires and studies Monet's splendid lotus pond and Zhou Sicong's poignant lotus in the rain. Tian Xing also travelled all over the country, looking for the lotus tirelessly. He has been to the Humble Administrator's Garden, the "Qu Yuan" of West Lake, the North Sea of Beijing, Xiangxi to see the ten miles of lotus in the mists, Foshan in Guangdong, and Nantou in Taiwan; and the lotus at each place has its unique romantic charm. In 2002, he was on the bank of the Minjiang River in his hometown where he saw the withered dry lotus standing in the rain, seemingly they were "listening to the sound of falling rain". Until then, he recognized lotus' fortitude, tenacity, fearlessness and optimism. It is very common in the New Territories of Hong Kong, the second home of Tian Xing, the lotus in the ponds are more "Natural Unadorned" and "wild". Lam Tian Xing shouted, "It's you, make this indifferent, bustling and helpless city, to become serene, serene and full of life. It's your love that fills my heart. The world, because of you, lotus, has become so beautiful."

The obsession with lotus is just like Tian Xing's perseverance in chasing clouds when he was a teenager. In 1999, when he first climbed the Tibetan plateau, he was ill, "When I was on the verge of death, I couldn't sleep at all. When I closed my eyes, there were lotus flowers in my mind." Tian Xing says, "The lotus is inseparable from Tibet, and the lotus is the flower of Buddhism." Apparently, in Tibet, he subconsciously returned to the lotus warning of his grandmother under the Lotus Peak when he was a child. In 2003, he felt that he "found" his own lotus. When Tian Xing said "found his own lotus", it really means that he has already found a way of painting lotus. In Tian Xing's heart, he has already understood the essence of Lotus and the appearance of hundreds of billions of lotus incarnations. He has "lotus" in his mind. In 2004, Tian Xing published an article "To Lotus", which is, after the Song Dynasty, a thousand years later, after Zhou Dunyi's "Ode to the Lotus", a prose poem about lotus. In the same year, 100 works of "The Lotus of My Heart" were grandly exhibited in Hong Kong. The rich, sincere and colourful painting language represented Lam Tian Xing's painting aesthetics. The advent of "The Lotus of My Heart", as Professor Cheng Pei Kai said, it "opened up the legend of painting lotus in the Hong Kong art circle".

Lam Tian Xing's lotus series has a strong consistency with the painting aesthetics shown in the previous "Scenes – Hong Kong", "Tibet – A Cosmovital Vision" and the later "Anthem of Calamus". This has also formed the unique painting style of Lam Tian Xing. However, his paintings in different series also have different expressions. Of course, this has to do with the difference in the "object" being drawn. Tian Xing's lotus painting language, unlike "Tibet – A Cosmovital Vision", which is mainly composed of coloured blocks, instead, by splashing ink and colour, it creates a colourful "freehand" of "plane". It produces a picture of clear atmosphere of "clouds, rain, and dew" (Xu Wei's comments on

Chen He's paintings). It is worth noting that in the lotus paintings, lines appear in large numbers. The lines are either dark or pale, thick or thin, long or short, curved or straight, explicit or hidden, contributing to the charm and agility of the painting. In my opinion, Tian Xing's paintings are famous for the beauty of colour. In fact, the beauty of colour displayed in Tian Xing's painting is almost an "irresistible" charm to people. Indeed, "ink is divided into five shades of colours", in his "Lotus Pond in Mist Rain", he has gotten the ultimate play. As for his "colour", how many shades can it be divided into? It is beyond my ability to identify. Tian Xing has a soft spot for colours. One time, he was asked, "how can you make colours so beautiful?" Tian Xing smiled and said, "Because I love colour (in Chinese, colour can also mean beautiful woman)." This humorous answer also explains why Lam Tian Xing is a master of colour painting.

Although colour occupies the highest proportion in Tian Xing's paintings, I still want to talk about Tian Xing's brush and ink cultivation and "kung fu"- meaning his great effort in practice. Tian Xing's brush and ink, especially the expression of his lines, is an important reason why his paintings are characterized as modern "Chinese" ink paintings. I believe that anyone who has seen the outstanding long scroll of Tian Xing's "Lotus Pond in Mist Rain", in addition to complimenting the painting, would not disagree with my opinion.

Tian Xing's Lotus, undoubtedly, has a high degree of blending Chinese and Western painting. Here, I must stress that advocating the fusion of the Chinese and the Western is an artistic attitude. It has nothing to do with being able to draw first-class paintings or not. How to combine and choose Chinese and Western painting elements, and integrate them, to create an unique art form, is the real challenge to the proposition of "combining Chinese and the Western". Judging from Tian Xing's 40 years of painting practice, he has clearly and successfully responded to this challenge. He has created a "significant" art form of modern ink painting with a "Chinese character".

(British art critic Clive Bell's famous theory of "significant form" is translated by philosopher Li Zehou as " 有意味的形式 " which I quoted. Here I would like to express my personal respect and condolences to Mr. Li Zehou who has just passed away and who has made great contributions to Chinese aesthetics.)

I would like to say a few words about the "Chineseness" of Tian Xing's painting. Earlier, I mentioned Chinese and Western painting elements. Painting elements include structure, shape, brush and ink, colour and the overall consciousness and breath of the painting. It involves tangible things and metaphysical philosophy at two different levels. The most wonderful thing about Tian Xing's paintings (especially the two series of lotus and calamus) is the overall "imagery" of the painting. This is related to the metaphysical philosophy (Tao), that is, the idea of aesthetics. The title of the lotus in Tian

Xing's paintings (and the calamus) is often only one word (in Chinese), such as Carefree, Meditation, Homeward Journey, Gazing, Rendezvous, Charming and Purity, or two words, such as Singing of Lotus, Song of Lotus, Delighted Lotus, Blossom, Joyfulness, Gorgeous Shadow and In the Rain. Either one word or two words, all are an aesthetic "imagery". The imagery can be given in all kinds of states or forms. It could be cloudy, ethereal, robust or graceful. Sometimes it is solemn and dignified, sometimes relaxing and happy, sometimes with heavy makeup and gorgeous, sometimes elegant and pure. No matter what kind of imagery these paintings express, they all reveal the characteristics of Chinese painting of *qi*, rhyme and spirit. Tian Xing's paintings show the Chinese image of beauty.

## Six

In Lam Tian Xing's 40-year painting journey, he explores the artistic form and aesthetic spirit of modern Chinese ink painting every day. As mentioned above, being a Chinese painter of the recent (contemporary) era, Tian Xing faces the challenges of the four dimensions of ancient, modern, Chinese and Western. He keeps a completely open mind. As long as it helps him to paint what he wants to paint, he will "grab" it; he will completely destroy the "antagonism" between Chinese and Western paintings. The literati paintings formatted after the Ming Dynasty are sublated by him. However, Xu Wei's freehand ink painting, the "heterogeneous" in the painting circle, is what he yearns for. There is a "significant" blending between tradition and modernity under his brushes. Most of the painters who are labeled "modernism" are distinctively different from Tian Xing. Well-known art critic Fan Di'an comments Lam Tian Xing's paintings as follows:

"Inspired by new culture, new information and new elements, Lam Tian Xing continues to break through the old barriers and dares to innovate. It is very precious that he has always been looking for the best artistic schema for this era. In the innovation and expansion of artistic language, Lam Tian Xing has painted beyond the cognitive differences and conscious boundaries between the two heterogeneous cultures of 'Chinese' and 'Western'. He skilfully blends the elements of Western paintings suitable for expressing his own thoughts and feelings in traditional paintings. In contemporary Chinese ink painting art, the rebellion against tradition has always been used by some artists to create new methods. But Lam Tian Xing is different. While he seems to be 'rebellious' against traditional brush and ink, he actually inherits and promotes the essence of tradition through modern life. " ("A Song of Years Drenched with Gorgeous Colours — On Lam Tian Xing's Art", *Artist*, Hong Kong, 2019)

I fully agree with Mr. Fan Di'an's comments. Undoubtedly, Lam Tian Xing has created a "significant" art form for modern Chinese ink painting (of course, there are other "possible" art forms in modern Chinese ink painting). Lam Tian Xing's painting aesthetics is "modern" and "Chinese", and of course, it belongs to Lam Tian Xing personally.

**Ambrose King Yeo Chi**

**Emeritus Professor of Sociology at The Chinese University of Hong Kong**
**Academician of Academia Sinica, Taipei**
**Dawn, December 16th, 2021**

# 淋漓華彩歲月歌——
## 論林天行的藝術

　　我們處在一個多元且高度信息化的時代，亟待在傳承傳統的藝術規範與法則基礎上拓展創新，中國傳統水墨尤其面臨着對新現實和新圖景的表達需求。文變今情、具古以化成為每一位畫家必須思考的課題。

　　在當代中國水墨藝術的發展歷程中，林天行無疑是一位積澱了豐富經驗並取得豐碩成果的畫家。改革開放以來，他始終以探索中國畫的現代變革為志向，從中國傳統繪畫中進行自我筆墨個性與語言形式的衍變提煉，同時借鑒吸收西方現代繪畫的抽象表現風格，形成了色塊結構與水墨揮灑相結合的視覺美感，也形成了他華彩淋漓、充滿蓬勃生機的藝術氣象，在當代中國畫壇具有獨特的個性風格。從學術理路的角度看，他在中國傳統畫學與西方現代藝術之間找到了當代融合的基點，也通過感受時代、社會和自然找到了準確而真切的表達路徑，在繼承傳統與創新求變之間構築成濃彩重墨的抒情表現之境。

　　林天行出生於福州北郊一座名叫蓮花峰的山麓下，作為一位生長於閩中的畫家，他不僅從山林草木間獲得了對自然的美好感觸，還沉養於福建豐厚靈秀的文化氛圍與傳統底蘊，沉鬱的人文氣息熏染造就了他沉穩雅靜的性情志趣，也使他始終葆有對自然和生活的熱情。在移居香港之後，他一方面感受香港這

個國際文化薈萃之地多元的藝術生態，一方面頻繁地穿行於內地與香港之間，對每一座經過的城市、踏訪過的每一寸土地都有着故土般的親切感，他也將這種熱愛與激情貫注在他的創作中：無論是太行山脈、陝北高原渾樸的大山大水，還是西藏雪域充滿靈性的原始風景，抑或是香港繁華繽紛的現代景觀，都成為他創作的主題，從他的大量寫生作品中可以看到他對自然山川與城市圖景的嚮往，他也在不斷變化的時代大潮下探求新觀念、新語言和新筆墨的藝術新境。

正是由於寬闊的藝術視野和廣博的藝術感受，林天行形成了寬闊的繪畫理路與表達視域。他嚮往充滿蓬勃生機的生命意態，追求在藝術表現上的淋漓盡致，無論面對都市的建築叢林，還是近觀鄉村的荷塘柳岸，他都能敏銳地捕捉到物象的意態，在作品中形成生命的形態和語言的張力。從他的幾大系列作品——「香港」「西藏」「荷花」「鄉村」中可以看到他風格語言的逐漸成熟，也愈發堅定了自我創作的信仰與理想。尤其是他的荷花系列，從《天行之荷》開始，便形成了傳達荷花精神意蘊的繪荷之路。荷在中國傳統繪畫中古已有之，甚至是「經典」題材。與傳統荷花大多表現清雅意境不同，林天行用濃郁鮮明的色彩進行大膽創新，在設色上汲取了敦煌壁畫的斑駁色澤和西方抽象繪畫中的潑彩塗繪，突破傳統花鳥畫表現體系中荷花寂靜、冷峻的形象，而賦予荷花以新的生命內涵，充滿了強烈的視覺張力與神祕氣息。可以很明顯地感受到，林天行的荷花並不是完全寫實性的枝蔓花朵的再現，而是充滿了主觀意識的意匠安排，對畫面結構的大膽經營、色彩關係的冷暖鋪陳和筆墨意境的追求營造，都與傳統水墨中對荷花的表達有着很大不同，讓觀者在繁複密緻的荷、葉、莖的交錯中感受獨具韻致的節奏感，更從斑斕熱烈的色彩中感受生命的光采。

多年在香港生活工作使得林天行的作品帶有明顯的香港文化印記。香港這座城市所特有開放包容的氛圍影響了他兼容並蓄的接受態度；與此同時，林天行與內地藝術家保持着長期密切的交流，這使得他始終與中國當代水墨的發展同步前行。在新文化、新信息、新元素的激發下，林天行不斷突破舊有藩籬，勇創新圖，尋找最適合於這個時代的藝術圖式，這是十分難能可貴的。在藝術語言的創新與拓展上，林天行打通了「中」與「西」兩種異質文化間的認知差異與意識界限，將西畫中適宜於表達自身思想情感的元素巧妙融合在傳統畫學中。在當代中國水墨藝術中，對傳統的反叛總是一些畫家藉以出新的手段，但林天行所不同的是，他在看似對傳統筆墨「反叛」的同時，實際上是通過現代生活感受對傳統精髓的繼承和發揚，例如他對繪畫「書寫性」就有自己的獨到理解，

他極為推崇草書也深入研究潑彩、潑墨等技巧，在墨與彩的「書寫」過程中完成了自我胸臆的自由書寫，這不僅是畫家個人心與手的舒展，更是中國傳統大寫意精神的當代拓展，墨與彩通過這樣的創作語言，林天行筆下的景象充滿了與時代精神相合拍的氣韻與律動。

　　林天行的彩墨藝術是一種涵括田園與都市、祕境與家園、實像與意象的求索創造。他於不同維度間往返，在傳統與抽象間遊走，將中西繪畫中不同的結構、抽象的形以及色調融合起來，形成以水墨為骨、以色韻為神的藝術面貌。他畫中充滿抒情意味的荷花圖景，帶有奇崛形式感的城市建築和充溢着無窮想像的高原印象都是他構建出的自我心象，光影交錯，彩墨相映，大氣渾然。在中與西、傳統與現代雙重轉述的時代語境中，林天行堅持自己的探索和努力，在彰物於神，彰物於心的追求中構建起寬廣豐厚的筆墨格局，也在淋漓的華彩暈染中到達了一方充滿精神追求的世界。

<div style="text-align: right">

范迪安

中國美術家協會主席

中央美術學院院長

2019 年 6 月

</div>

# A Song of Years Drenched with Gorgeous Colours —

## On Lam Tian Xing's Art

We are living in a pluralistic and highly informative era, and need to urgently develop and innovate our art forms based on traditional art norms and rules. Chinese traditional ink paintings are especially faced with the need to express new realities and new visions. Every artist must think about how to respond to aesthetic demands in changing era and how to bring contemporary resonances to classics by innovation based on tradition.

During the development of contemporary Chinese ink art, Lam Tian Xing is undoubtedly an artist with rich experience and fruitful achievements. Since the reform and opening-up of the Chinese Mainland, he has always taken the modernisation of Chinese painting as his utmost goal. From Chinese traditional painting, he moves on to develop his own personalised ink-colour painting techniques and skills, and refines his art language style. At the same time, he studies the abstract expression of Western modern paintings and learnt from it. Thus, he develops a new form of colour block structure combined with ink swing style to form a new sense of visual aesthetic. This new approach brings about his gorgeous ink-colour paintings full of vitality and establishes his unique style in contemporary Chinese painting. From academic perspective, he has found the basis of contemporary integration between Chinese traditional painting and Western modern art. Through his sensitivity pertaining to the changing times, society and nature, he has found an accurate and sincere path of expression. Between inheriting tradition and innovation, Lam constructs thick brilliant colours with layers of different shades of ink to bring forth a new lyric-like realm.

Lam Tian Xing was born in the northern countryside of Fuzhou, at the foot of Lotus Peak. Growing up in the mountain forest, he has not only developed a strong admiration towards the beauty of nature and also has been nourished by the cultural atmosphere and traditional heritage in Fujian. The placid and profound humanistic atmosphere in his hometown has contributed to his calm and elegant temperament. It also makes him always passionate about nature and life. After moving to Hong Kong, on one hand, he senses the diverse artistic ecology of Hong Kong, an international city of cultural confluence. On the other, as he frequently travels between the Chinese Mainland and Hong Kong, every city he passed through and every inch of land he visited has also given him a homely intimacy.

Inevitably, he devoted this love and passion to his creation. Taihang Mountains, the vast mountainous waters of the Northern Shaanxi Plateau, the pristine landscapes of Tibet's snowy fields and the bustling modern landscape of Hong Kong, all have become the themes of his creations. From his large number of sketches, it is easy to see his longing for natural mountains and city landscape. He continues to explore the new world and form new ideas, new languages and new strokes in the ever-changing times.

Tian Xing's wide artistic vision and extensive artistic experience has brought about his broad painting theory and expressive approaches. He yearns for a lifestyle full of vitality and pursues expressive arts. Whether facing the urban jungle or close-up of lotus pond by the willow shore, he can sharply capture the images of the object; in his works, they are seen as the life's manifestation and the expansion of his art language. From his several series of works – "Hong Kong", "Tibet", "Lotus", "Country", we can see the gradual maturity of his art language style and how he has strengthened his beliefs and ideals of self-creation. Especially in his lotus series, since the birth of "The Lotus of My Heart", Lam has found his own way to convey the spirit of the lotus. Lotus painting has been the "classic" theme in traditional Chinese painting for many generations. Unlike the traditional lotus paintings which usually present the elegance of the flowers, Lam has developed bold innovation with rich and vivid colours. In the tinting, he draws the mottled colour of Dunhuang murals and uses the tectonics of the splashing of colours from the Western abstract paintings. He has broken lotus image of being "silent and cold" in the traditional flower and bird painting system. He has endowed the lotus with a new life connotation, full of strong visual tension and mystery. It can be clearly felt that Lam's lotus is not a reproduction of completely realistic branches and flowers, but full of subjective consciousness of the artisan arrangement. What significantly distinguishes Lam's lotus from the expression of lotus in traditional ink paintings is his bold management of the picture structure, the pursuit of colour relationship and the artistic conception of brush and ink. Lam's paintings impress viewers with the unique sense of rhythm in the intertwined lotus, leaf and stem, and lead them to experience the radiance of life manifestation of the warm colours.

The many years Tian Xing lived and worked in Hong Kong has marked his works with a clear Hong Kong culture. The unique openness and tolerance of Hong Kong has had a significant impact on him. At the same time, Lam maintains close liaison with mainland artists, which allows him to continue to move forward with the development of contemporary Chinese ink painting.

Inspired by new culture, new information and new elements, Lam Tian Xing continues to break through the old barriers and dares to innovate. It is very precious that he has always been looking for the best artistic schema of this era. In the innovation and expansion of artistic language, Lam Tian Xing has broken through the cognitive differences

and boundaries between the two heterogeneous cultures of "Chinese" and "Western". He skilfully blends the elements of Western paintings suitable for expressing his own thoughts and feelings in traditional paintings. In contemporary Chinese ink painting art, the rebellion against tradition has always been used by some artists to create new methods. But Lam Tian Xing is different. While he seems to be "rebellious" against traditional brush and ink, he actually inherits and promotes the essence of tradition through modern life. For example, he has his very own unique understanding of the characteristics of "writing" a painting. He highly praises the cursive writing and has made in-depth studies of the techniques of splashing ink and colours. In the process of "writing" in ink and colour, Lam completes his free writing of his heart-felt feelings. This is not only the expression of the artist's personal heart-felt-feelings through his hands, but also the contemporary expansion of the spirit of traditional Chinese freehand style. Through ink and colour painting in such a creative art language, Lam's paintings are full of the "Zeitgeist", so to speak.

The colourful ink art of Lam Tian Xing is a search for creation between the rural pastoral and urban, mysterious holy land and countryside homeland, and real image and imagery. He strolls between different dimensions and moves between tradition and abstraction. He combines different structures, abstract shapes and tones in Chinese and Western paintings together. He transforms them into a new art look, in which the ink is the skeleton and the colour rhyme the spirits in his works. His lyrical lotus, wonderful city building, and infinite imaginary plateau impression are all indigenous images from his heart. These images reflect interweaving and interlacing lights and shadows in his paintings. The colour and the ink shine onto each other. It airs greatness and magnificence. In the context of the dual transmission between Chinese and the Western, tradition and modernity, Lam Tian Xing insists on his own exploration and hard work. In the pursuit of manifesting objects in the spirit and the mind, he has built a broad and rich pattern of brushstrokes and ink. He has also reached a spiritual world whilst in pursuit of his drenched dripping brilliant colours.

**Fan Di'an**
**President of the China Artists Association**
**Dean of the Central Academy of Fine Arts**
**June 2019**

# 天行藝道——
## 林天行的彩墨天地

　　「重彩」是中國畫中的一種施彩設色技法，一般聯同「工筆」使用，意指以精細纖巧的筆觸勾描物象輪廓肌理，再敷濃重鮮麗的色彩染畫，早在兩晉時期已經出現，至唐宋達至高峰，見諸山水、人物、花鳥、樓閣各畫科。著名畫家包括擅畫宮廷妃嬪的晉代顧愷之，唐代精擅描繪宮廷妃嬪婦女的張萱、周昉，描寫帝王將相的閻立本，擅畫駿馬的韓幹，開青綠山水的宗師李思訓、李昭道父子。兩宋期間更見興盛，宋徽宗趙佶以妍雅設色、細膩筆法勾畫花鳥，李公麟精於白描人物，多不具名的院體畫家擅長繪畫花鳥、人物、界畫，清雅堂皇各具面目，風俗畫家張擇端的《清明上河圖》更成為曠世名跡。嗣後以水墨淺絳筆墨風格的文人士大夫畫成為主流，工筆重彩畫漸居次席，多屬宮廷院畫或被視為畫匠之作，但亦有名家相繼湧現，傳承流佈工筆重彩畫風，如明中晚期唐寅、仇英擅畫仕女，晚明丁雲鵬擅長白描道釋人物，陳洪綬開復古主義先河，清代宮廷畫院名師董誥、唐岱、焦秉貞各自領表山水、仕女、界畫畫科等均為例證。

　　降及二十世紀，傳統繪畫難以應對現代要求，畫家們開始求索西方東洋、革新國畫。西方繪畫的現實寫生風格，油畫、水彩的色彩運用成為畫家借鏡對象，並糅合國畫的筆墨、設色技法，另闢谿徑。劉海粟以強烈色彩描畫黃山勝景；丁衍庸先攻油畫，亦受野獸派的色彩影響，貫通中西；林風眠以印象派淡雅而具透明感的畫境蛻變中國畫山水、仕女、禽鳥的畫法，陳之佛借日本畫風演繹工筆重彩。此外，不少名家巨擘植根傳統，蛻變新風，如張大千精研歷代各家

精萃,更將敦煌壁畫的中亞的色彩情韻、金碧山水的精緻明麗畫法、恣放縱橫的潑墨、潑彩共冶一爐,繪寫山水、荷花、仕女高士,開創獨特面目。近大半個世紀以來,強調色彩、水墨效果變化已成主流,尤其在表現當代語境方面更見勝籌,「彩墨畫」一詞遂應運而生,成為風尚。

在彩墨畫範疇中,香港畫家林天行(原名林仚)是極具代表性之一。他的藝術耕耘歷程與其他名家並沒有太大分別。1963 年他於中國福州出生,雙親是中文教師,幼年在家鄉蓮花山鄉郊溜躂嬉戲。十四歲時開始對繪畫產生興趣,並獲舅父送贈一本《黃賓虹畫語錄》,誘發他對國畫的求索。其後他隨多位老師習畫,包括教授素描的吳國光老師,授他中國畫的前輩畫家林光、陳挺老師,並得到機會隨他們旅遊各地名山大川,體會風土人情,奠下穩固的繪畫基礎。1981 至 1983 年間,林氏開始嶄露頭角,山水畫作在福建省美術館、福州市美術館展出,益發加強他對水墨畫創作的決心和憧憬。

對林天行而言,1984 是他生命中的一個轉捩點。1976 年中國內地擺脫了文化大革命的包袱,開展改革開放路向,藝術家也比較容易出國發展。八十年代不少書畫家來港定居,包括日後在香港藝壇卓越有成的書畫家如區大為、葉民任、黃孝逵、天池、王守清、朱達誠、許恩琦等,也包括於 1984 年來港的林天行。這些藝術家初來乍到,對香港社會環境並不熟悉,生活條件也不優裕,但靠着自己辛勤努力和因緣際會,終在本地藝壇佔一席位。林天行來港後,曾當工人及倉務員一段時期,但其秉持向藝之心矢志不渝。1985 年他開始職業畫家生涯,其時香港藝術氛圍逐漸蓬勃,兼且是開放自由的現代都市,既背靠祖國,又面向國際,中西文化融會,各種藝術潮流匯集,有利藝術家發展。林天行也加入多個藝術團體如香港美術研究會、香港美術會、香港華人現代藝術研究會等,有機會與本地畫家接觸交流,亦參加展覽。在香港,他得以觀摩多位「新水墨運動」先鋒如呂壽琨、王無邪、梁巨廷、周綠雲等創新風格的畫作,領會到水墨畫是可以脫略傳統、也無需墨守學院派的成規,而嘗試不同技巧、注入創意觀念而開展新境界,由此他踏進了新的藝術語境。1989 年林天行赴北京中央美術學院中國畫系山水工作室進修。導師包括李行簡、賈又福、周思聰、王鏞、劉金貴等,並拜劉牧先生為師。期間經常往北京畫院、中國畫研究院(現為中國國家畫院)、中央工藝美術學院拜訪學習,從不少名家創作中獲益良多。

然而作為一位中國水墨畫家,從傳統中求法是不二法門。歷代名家輩出,流派湧現,各種筆墨技巧、皴染變化、色墨轉使是藝術創作靈感泉源的無盡藏。

林天行以彩墨鳴世，但絕不能忽略他在傳統國畫上孜孜求索的認真態度。其二十至三十歲出頭（1977-1990 年代初）的畫作呈示傳統對他的影響。1977 年《仿明朝吳偉〈溪山漁艇〉》描畫山巒疊嶂，層層深入，由近而遠，層次井然；皴染墨染深淺得度，筆觸厚重，漁舟泛棹江上，意境曠逸，反映由明代吳偉上溯北宗山水及元代吳鎮、黃公望的文人畫意趣。《武夷秋色》(1980) 章法採用傳統構圖，近景樹木引向中景層峰茂木，遠景淡墨渲染山巒，全圖「三遠」俱備，結構嚴謹，較近北宗山水佈局。1982 年所作《仿宋朝趙黻〈江山萬里圖〉》以橫幅形式處理畫面，由左邊山徑通向小橋，進入中央群巖樹林，再以山徑通貫遠山及以石橋通往左方樹叢，遠山迷濛，氣脈相連，正是中國山水「胸懷丘壑，臥遊山水」微妙之處。林天行亦以傳統皴法創作寫生，其《太行山寫生》(1989) 以交錯縱橫描畫太行山的險奇峭峻的巖壁風貌，加以濃墨渲染，益加強崇山峻嶺的渾厚雄偉。1990 年所作的《仿清代任熊〈海闊天空〉》是他少見的青綠山水摹作，以細緻綫條勾勒巖石輪廓，石綠花青渲染，色彩鮮明，畫樹造型古拙，雖說是仿晚清上海畫家任熊之作，實是遠溯唐宋青綠山水古拙的風格。這幾幀早期山水畫作，充分反映畫家探究傳統筆墨的努力和掌握。

1990 年林天行於中央美術學院修畢一年進修課程後，與同學赴陝北寫生，到榆林、米脂、綏德、神木、府谷、保德、大同等地，歷時一個月。這次旅程令他的創作踏入新階段。陝西北部是荒瘠山區，村落、窰洞遍佈，居住環境與城市落差極大，人民多以農耕畜牧為生；然而民情淳樸，景色開揚，陽光充沛，雲彩滿天，莊稼處處。這些風光為畫家帶來啟發，他以綿密曲折的鉛筆綫條創作和大量寫生畫稿以作記錄，如《陝北寫生》(1990) 以流暢俐落細綫勾勒石塊、窰洞，注重空間組織；另一幀《陝北寫生》(1990) 則幾乎全用點綫勾描平原地貌，變化層次處理。這些寫生稿反映了林氏的觀察力和速寫技巧。在此基礎上，他開始建立強烈的個人繪畫風格，以重彩濃墨表現山水，並傾向較抽象的幾何結構，營造了《陝北系列》之作，其中一幀以水墨渲染橫向山巒，由深入淺，前方描畫窰洞，殊有陝西雄奇山勢，拙樸窰洞山居的風土特色。另一幀《陝北系列》繪畫風格又有所變化，以墨綠渲畫團團樹叢，紅土、窰洞、山路掩映穿插其中，填滿畫面之餘，又具空間層次透溢之妙而不會擠塞臃腫。《天光雲影》(1991) 構圖疏朗，以金黃設色鋪染黃土地，片片青蔥代表新綠草叢，濃墨塊面象徵巖石高山，遠方藍天白雲；林天行以其彩墨設色技巧，重現陝北明媚的風光氣氛。此系列「陝北寫生」四十五幀新作更成為由國家級的北京中國畫研究院（現為中國國家畫院）主辦、1990 年僅二十七歲的林天行首次個展的主角，備受注目，其中兩幀更入藏該院庋藏。

1987 年林氏作品入選香港政府香港藝術館所舉辦，為香港藝術主要平台的「當代香港藝術雙年展」。其後數年間，他積極參與本港及國內展覽和交流活動，作品並入藏多所藝術館、博物館，奠定其藝壇地位。1999 年是他開展另一系列畫作的時刻。他與友人王守清、楊百友赴西藏、敦煌、蘭州寫生，因感冒到拉薩遇高山症頭痛欲裂，返港後與病魔搏鬥三年。然而這次旅程，在其藝海耕耘中留下深刻印象，令他開始創作「西藏系列」的新作。其後他於 2005 年再偕畫友往西藏拉薩、羊八井、當雄、納木錯、林芝、巴松錯、八一鎮、米松、朗縣、加查縣、澤當、桑耶寺，返拉薩往日喀則、薩迦、拉孜、薩嘎、神山、札達、古格王朝、土林托林寺、新疆葉城、喀什、庫爾勒、羅布泊、吐魯番、烏魯木齊各地寫畫。西藏是與中原文化大相逕庭的異域，充滿異國風情。人民以遊牧狩獵為生，藏民多篤信喇嘛教，寺廟林立，靈山聖湖，僧侶穿着紅、黃僧袍禮拜修行。當地或陽光熾烈，青天白雲；或冰雪漫天，封天蓋地。種種強烈色彩、異域生活習慣、獨特風景建築為畫家帶來嶄新靈感。他沿途寫生，如《西藏寫生（十一）》(1999) 以濃墨染畫群山山道、白雲蓋頂，呈現雄奇景色。《西藏寫生（八）》(1999) 以鮮明色彩寫一片青天白雲，其下為寺廟及喇嘛塔，寫實意味強烈。源於當地熾烈色彩影響，林天行「西藏系列」畫作多以紅、黃、藍、綠等亮麗設色為主；更多以神山、聖湖、廟宇、藏僧為題材。《夕陽裏的佛塔》(2001)、《寺院景象》(2008) 等均以鮮紅、黃設色，幾乎填滿畫面，描畫寺院院落、艷陽西下的景象。《遙遠的祝福（二）》(2007) 則以藍色渲染畫面，深淺互現，有如油畫用色，均反映「西藏系列」色彩與主題相輔相成的風格。

　　林天行「西藏系列」亦多有變化，包括以水墨為主的畫作，尤其是畫聖湖、雪山的作品，強調黑白、虛實的變化，以配合景象情韻。《聖湖靜月》(2006) 明月映照，畫面大量留白，表現光映雲霞，其下為平靜湖面，四週淡墨渲染，聖湖寧靜平和氣氛溢然紙上。《靜夜》(2006) 亦以淡水墨染畫山川湖面、雲煙飄渺，明月高掛天際，也在湖中倒影，這兩幀畫作均着重以水墨暈染表現西藏雪山冰峭而靜謐的意境。他亦以強調綫條筆勢、淡彩和變形結構組織畫面，如《聽水圖一、二》《論經一、二》(2008) 以彎曲穿插綫條勾畫山巒寺院輪廓，敷施赭石、淡紅設色，意境清新，頗具抽象意趣。在《憶》系列 (2006) 中，黃、綠、赭紅淡雅設色遍染畫面，房舍、樹木、僧人簡化掩映於彩墨意境中，迷濛浮現，呼應他在腦海中對西藏憶記的朦朧印象。林氏「西藏系列」畫作中，也傳遞了他對宗教聖地、異域風光、文化、僧侶修行的虔誠敬意和景仰禮拜。2012 年他以重彩設色描畫多幀西藏聖山層巖峭壁飛灑而下的飛瀑和水氣泛映的彩虹，氣勢磅礡，以示聖山彩虹為天地間的生命泉源，成為藏疆勝景。《吉祥的日

子》(2008) 中西藏村落房舍林立，密不透風，填滿畫面，全圖敷施赤紅設色，紅衣僧侶隱現巷陌樓房之間，設色互為輝映，反映藏族生活場景的熾熱氣氛，寄意吉祥安樂。《神聖的地方》(2006) 組畫八幀是他「西藏系列」的力作，以俯瞰角度繪畫西藏山川大地，雲霧跨越河山，色彩斑斕豐富，氣魄雄奇，為畫家對藏地山河的謳歌。在 2005 年西藏阿里行前，林天行做了大量對景點風土景象的研究，編排旅行路綫，一絲不苟。他在托林寺門前寫生二十米手卷，僅三小時完成。此幀《西藏寫生圖卷》，筆墨恣縱奔放，墨韻變化多端，筆隨心至，山川、房舍、樹木渾然天成，為他「西藏系列」經典之作。這系列西藏繪畫，既是永恆的回憶，也成為畫家最具代表性系列畫跡之一。

除在內地旅行寫生作畫而創製系列性山水畫作外，鄉郊與都市景觀也是林天行擅長的畫科。鄉野和城市的景觀地貌、生活環境嶄然不同，畫家自然也要因景應物採用不同構圖、技法和色彩作處理，以求「應物象形」而臻「氣韻生動」之境。鄉村充滿純樸天趣、林木青蔥、色彩明麗，體現大自然的清新氣息。林天行的「鄉村系列」之作品多以正方形畫面作構圖，將山野、村屋、樹木加以幾何化，變化塊面章法；又以點彩和簡略及簇集綫條描畫物象，彩墨較傾向鮮明設色，表現自然美感。《山頭悄悄飄過了紅雲》(1994) 是較早年之作，近景及遠景樹石、山峰施以金黃；中景樹叢予以幾何形態化。藍天湖泊彩雲互為襯托，意象清新。2005 年所作《開滿葵花的家園》在平面構圖上鋪陳點點明黃葵花，四週圍繞抽象化的草木，房舍穿插其中，色墨交融一體，繁而不亂，足見林氏的巧妙構思意念。《島上花開》(2002–2015) 背景施以靛藍，再以嫩綠點染盛開花朵，橙色小路迂迴穿插其中，導引觀者走入島上繁花世界；全圖以點彩技巧處理，色彩對比斑駁強烈，卻又具自然界的雅麗情韻。

城市生活，紛亂繁囂，高樓林立，空間困迫，車水馬龍，熙熙攘攘。林天行移居香港後，受到本地景觀和生活環境影響，創作心態和風格也有所改易。其「景象香港」系列呈現另一種畫風，色墨較為濃重，行筆趨向野逸奔放，更注重光影明暗變化，這與香港潮濕天氣形成的雲煙霧靄，維港水影變化和擁擠的城市空間有密切關係。此系列早年畫作《海島黃昏》(1996) 前景描畫抽象化的巨巖亂石，中景繪寫波濤洶湧，遠景夕陽雲動，全圖用筆荒率，色墨渾厚，動感強烈，彷有風雨欲來的張力。香港夏秋之際，常有颱風吹襲，此圖或從中獲取靈感。他亦以香港獨特的城市景觀入畫。香港貨櫃碼頭日夕作業，忙亂紛擾，其在 1998 年所繪《碼頭》，描畫香港葵涌貨櫃，吊機日夜運作，工人作業辛勞。圖中以濃重水墨、紅藍設色染畫碼頭情景，可見畫家對生活觀察入微。

2008 年作品《維港兩岸》更趨抽象，畫面以鮮紅染畫，綫條橫豎交織，中景為魚遊浪中，全圖行筆率放，隨手揮就，並不描寫具象景致細部，只以筆墨設色想像兩岸風光。2020 至 2022 年，林天行更以別具創意的構圖和技法處理畫面。他繪畫重要基建港珠澳大橋多幀作品，如《海上生輝》(2020)、《港珠澳大橋的雲朵（二）》(2022) 等。畫中以高空俯瞰角度望向橫跨大海，聯繫三地的大橋。四週圈圍以綫條勾描的片片藍、紅、黃雲朵，變化色調，手法抽象而具設計意味，意念獨特，為畫家風格的新嘗試。

在花卉畫方面，林天行對荷（蓮）花情有獨鍾。北宋周敦頤《愛蓮說》有云：「蓮，花之君子者也。」「予獨愛蓮之出淤泥而不染，濯清漣而不妖；中通外直，不蔓不枝；香遠益清，亭亭淨植，可遠觀而不可褻玩焉。」自古以來，是清逸高雅的象徵。荷蓮亦是佛教的表徵，佛坐蓮花座上，觀音手持蓮花，俱有普渡眾生的慈念，成為中國歷代陶瓷、工藝、繪畫的主要題材之一。古代宋院工筆重彩畫中描畫綫條纖麗，設色妍雅的荷花；繪畫大師徐渭、八大山人、石濤等均擅畫墨荷，筆墨酣暢淋漓。近代名家張大千以潑墨潑彩、金碧勾描的荷畫，林風眠清逸淡雅的荷花畫作，黃永玉畫荷色籠墨染，富麗堂皇，各擅勝場。林天行畫荷本源自少年時家鄉蓮花峰的思憶想念，也與西藏之行有密切關像。他於西藏染病時，腦海常浮現佛教神聖的荷花。他在八十年代始專注畫荷，亦受到內地畫家周思聰、黃永玉的啟發。來港後不時探訪荷花，如在元朗荷塘、雲泉仙館、公園廟宇等遊覽蹓躂觀荷，至今已創作不下數百幀荷畫，風格多變，面目各異。2003 年沙士疫情在港肆虐，林氏亦以荷畫寄意人民生活安靜平和，回歸自然。他的荷畫，一種是主要以水墨渲染及綫條繪寫，如早年 1996 年的《魚在月中游》，以濃淡潤濕水墨渲染荷葉、蓮蓬。魚兒悠然游於水波之間。《若雪》(2004) 純以水墨暈染畫，墨韻流淌自然變化，荷花形體已予抽象化，畫面空間虛實相生。2010 所作《雪霏霏》橫幅則着重綫條與墨點的表現，莖蔓綫條縱橫穿插，積點渲染成葉，繁而不亂，筆墨空間疏密有度，形成荷塘景致。近年來《淨》《悠》《新放》(2021) 等以潑墨技巧渲染荷葉，濃淡色墨淋漓紙上，荷花以淡設色染畫，濛朧隱現其中，以配合畫作命題，亦見巧思。

林天行畫荷的另一取向是注重表現荷花的清純素雅，脫俗出塵。這些畫作或施素淡設色，或用色鮮明而不落俗艷，荷花描畫重其柔軟質感神韻而輕其形。1994 年所作《潔淨世界》繪寫白荷數枝，亭亭玉立於青嫩荷葉之間，花瓣柔柔，有「濯清漣而不妖」「亭亭淨植」的情韻。《綠霧》(2007) 以明亮嫩綠渲染畫面，枝莖描畫呈現西方寫生技法，具立體感，而荷花穿插其間，反映初夏

清新氣息。《清境》《心遠》(2021) 以極淡水墨染畫畫面，如同水影雲光，淡設色紅荷浮現其間，迷濛幽清，意境空遠，所表達不是現實中的荷花，而是心中荷境，超然物外。《澄》(2021) 以明黃為地，施以點彩表現荷葉肌理，荷花荷蕊分置畫中上、中、下部分，互為呼應，全圖章法獨特，極具創意，傳遞「澄明」意趣。

除此兩種風格外，林天行亦採用繁密構圖和重彩技法畫荷，別樹一幟，有別古人。1991 年他繪畫《荷花心經》，畫面書寫佛教心經語句，用筆厚重，得隸法古拙精萃；白荷跨越畫面，雅逸清幽，與書法形成輕重對比，以荷花況喻佛教精神，別出心裁。《祥光》（一至八）(2007) 八屏為其力作，畫中枝蔓交纏穿插，有如行草，行筆率放流暢，紛而不亂；紅白荷花鋪陳其中，位置得法，象徵祥光遍照，萬物繁昌。《荷蟹蓮魚》(2012) 畫面繁密，各色荷花散佈，幾密不透風，但色墨運使之間卻留有呼息餘地，表現荷花盛開，競相爭艷，生機蓬勃的氣象。《歡唱》(2021) 是近年新作，彩墨充溢畫面，色彩交織襯托，花卉搖曳生姿，代表自然界的歡暢謳歌。類似風格亦見於 2022 年新作《明光》，畫面金光亮麗，花卉叢生，互相輝映。這幾種水墨、淡彩、重彩配合筆墨綫條，兼具西方意味的獨特風格，締造了「天行畫荷」的代表性系列畫作。

2019 至 2022 年，香港社會事件爆發，滿目瘡痍；接踵而來是新冠疫情襲港，一浪接一浪。人民處於困擾、惶恐、不安之中，每一個人都受到影響，心境灰暗，期待黎明。林天行也不例外，他創作「菖蒲」系列作品，以畫寄意，冀盼未來。菖蒲是水生植物，古人相信其有辟邪的作用，端午期間掛菖蒲及艾於門上，相沿成習，遂成端午風俗。江南人家每逢端午時節，懸菖蒲、艾葉於門窗，飲菖蒲酒，以祛避邪疫。菖蒲製作的盆景，因其枝葉梃秀，既富詩意，又有抗污染作用，多用於文人雅桌上裝飾之用。林氏這系列作品與其彩墨畫風大相逕庭，筆墨趨於荒率沉重，有如鬱結在心，難以抒懷。2019 年所作之畫如《麗》《歌》《幽》《覺》等雖以彩墨繪寫，但菖蒲葉綫條勾描荒率放恣，設色施彩亦有蒼涼意味，彷彿要藉筆墨轉使打破心中困境，宣洩感情。2020 年《幽思》及《幽思》(二) 氣韻沉重黝黑，在濃墨勾描菖蒲葉圍繞中，中央留空，恍如在心靈困局中打開一扇天窗，憧憬未來光明重臨。同年所作《瀑響》《如歌》《霧起》等描畫菖蒲野生溪流之間，我自為我，有如空谷幽蘭，萬事紛擾，於我何干？然而《晨曦》(2020) 以水墨亮綠抽象化繪畫山川新綠，遠方漸露晨光，況喻黑暗將逝，重現光明。

林天行亦致力於書法，尤其唐顏真卿、柳公權平正渾厚的書風和漢、魏碑拙樸奇崛的體勢。近年又嘗試「漢字系列」新作品。他所追求的不是漢字的結體，而是觀念性表達和創作過程的體驗，將漢字結構綫條重新組合，色墨渲染累疊，書法筆觸若有若現，營造抽象化的畫面效果。2020 年所作的《漢字系列──石》，粗黑拙樸綫條形成「石」字，在畫面上並列鋪排交疊，意象獨特。《漢字起源》(2020) 以濃淡水墨渲染畫面，紫色綫條筆觸縱橫交錯，加蓋鈐印，令作品既是漢字書法，也是繪畫，別開生面。

　　林天行傾向多用方度幅面作畫，因其形式有別於空間具有引導性的立軸、橫幅、扇面，更具現代感，繪畫元素縱橫欹斜鋪陳，更可自由發揮。他精擅塊面結構和行筆走勢，加上彩墨渲染揮灑，成為其山水風景、陝北、西藏、荷花畫作的共同風格，也締造了強烈的個人面目，在香港畫壇獨樹彩墨旗幟。

　　林天行除了創作繪畫外，也將畫意圖像注入陶瓷藝術，曾於 2000、2007 年與多位畫家合作提供畫圖作燒製青花、釉上彩瓷。他亦將繪畫意象鑲刻在宜興紫砂壺上，結合陶瓷繪畫藝術。林天行齋名「大也堂」，意指無邊界的規限。他的多元化藝術耕耘，獨特風格及創意精神，代表着八十年代來港的一批內地藝術家的個人風貌，於香港藝壇異彩紛呈。

<div align="right">

鄧海超

**香港浸會大學視覺藝術院客席教授**

</div>

# The Art Journey of Tian Xing —

## The World of Lam Tian Xing's Ink Colour

"Zhongcai" is a technique of applying and setting colours in Chinese painting, using strong colour and presenting strong picture effects. Generally, it is used in conjunction with "Gongbi", a category of Chinese painting techniques also called "Fine Brushwork", which belongs to a class of neat and meticulous painting methods. "Zhongcai" means delineating the outline and texture of objects with fine and delicate brushstrokes, and then applying strong and bright colours to dye the painting. It appeared as early as in the Jin Dynasty and reached its peak in the Tang and Song dynasties. It can be seen in various paintings of landscapes, figures, flowers and birds, and pavilions. Famous painters include Gu Kaizhi of the Jin Dynasty, who was good at painting court concubines; in the Tang Dynasty, Zhang Xuan and Zhou Fang who were good at painting court concubines, Yan Liben known for depicting emperors and generals, the leading horse painter Han Gan, and Li Sixun and Li Zhaodao, the masters who created Blue-green shan shui. During the Song Dynasty, it was even more prosperous. Zhao Ji, Emperor Huizong, used elegant colouring and delicate brushwork to outline flowers and birds. Li Gonglin was good at drawing figures, and many anonymous academic style painters were good at painting flowers and birds, figures or "*jie-hua*" – meaning drawing with a ruler. Those paintings are considered either elegant or grand and each one is unique. Genre painter painted with themes of daily life such as social customs and folk customs. Amongst them, the most famous one is Zhang Zeduan, whose "Along the River During Qingming Festival" has become a world-famous monument. Later, literati and scholar-officials' paintings in the style of ink with light colours had become the mainstream. Fine brushwork and strong colour painting gradually took the second place. And most of these paintings belonged to the court or were regarded as the works of painters who imitated the powder copy of the predecessors, or repeated the techniques of the predecessors, lack of their own unique artistic style. Nevertheless, there were also famous artists emerging one after another, who inherited the flowing style of fine brushwork and strong colour painting. For example, Tang Yin and Qiu Ying were good at painting ladies in the middle and late Ming Dynasty. In the late Ming Dynasty, Ding Yunpeng was good at line drawing (drawing the image with ink-coloured lines without colouring) Daoist and Buddhist figures. Chen Hongshou pioneered retroism. Dong Gao, Tang Dai and Jiao Bingzhen, the famous painters of the Palace Painting Academy in the Qing Dynasty, had each led the landscape, ladies and the "*jie-hua*" painting departments.

In the 20th century, Chinese painters found it difficult to meet modern requirements, therefore began to search ideas from Western and Japanese paintings to reform traditional Chinese painting. The realistic sketch style of Western painting and the use of colour in oil painting and watercolour became useful reference for many painters. They combined the brushwork, ink and colouring techniques of traditional Chinese painting with the borrowed techniques and created a new path. Liu Haisu painted the scenery of Mount Huangshan with strong colours. Ding Yanyong first worked at oil painting, influenced by Fauvism colour, and then bridged Chinese and Western painting techniques. Lin Fengmian adapted impressionism's elegance and transparent painting artistic conception to change the traditional way of painting landscapes, ladies and birds in Chinese painting. Chen Zhifo borrowed Japanese painting style to interpret meticulous brushwork. In addition, many famous painting masters were rooted in tradition but transformed into new styles. For example, Zhang Daqian studied the essence of various dynasties. He blended them with the colour sensibility of Central Asia in Dunhuang wall paintings, the exquisite and bright painting method of *Jinbi* (Green and gold) landscape, and unbridled splashes of ink and colours, thus creating a unique new look in his painting of landscapes, lotus flowers, ladies and nobles. For nearly half a century, emphasis on colour and changes in ink effects have become the mainstream, especially in expressing contemporary contexts. The term "ink colour painting" came into being and became a fashion.

In the field of ink colour painting, Hong Kong painter Lam Tian Xing (formerly known as Lam Sin) is one of the most representative. His artistic cultivation process is not much different from other famous artists. He was born in Fuzhou, China in 1963. His parents are Chinese language teachers. As a child, he roamed and played in the countryside of Lotus Peak, his hometown. At age 14, he became interested in painting, and received from his uncle a copy of *Quotations of Huang Binhong*, which inspired him to pursue Chinese painting. After that, he learnt painting from several teachers, including Wu Guoguang who taught sketching, Lin Guang and Chen Ting, the senior painters who taught him Chinese painting. During those years, he got the opportunities to travel with his teachers around famous mountains and rivers, experienced local customs, and laid a solid foundation for painting. From 1981 to 1983, Lam started to show great promises in exhibitions in Fujian Provincial Art Museum and Fuzhou Art Museum, which further strengthened his interest in the art of painting. He had longed for and was determined to create ink colour painting.

1984 was a turning point for Lam Tian Xing. After the end of the Cultural Revolution in 1976, the Chinese mainland transformed to the reform and opening-up, which made easier for artists to go abroad. In the 1980s, many calligraphers and painters came to settle in Hong Kong, including those who are outstanding and successful in the Hong Kong art circle later, such as Ou Dawei, Yip Man Yum, Wong Hau Kwei, Tien Chi, Wong Sau Ching, Chu Tat Shing and Hui Yan Ki. Amongst them is Lam Tian Xing who moved to

Hong Kong in 1984. These artists were new to Hong Kong, not familiar with the social environment, and their living conditions were not favourable. However, they were diligent and capable of seizing opportunities. They finally got a foothold in the local art scene. After Lam Tian Xing came to Hong Kong, he worked as a labourer and warehouse clerk for a period, but he was determined to pursue his passion for art. He started his career as a professional painter in 1985. At that time, the atmosphere for Hong Kong artists was gradually flourishing. Hong Kong has been an open and free modern city, not only backing by the motherland, but also facing the world. The fusion of Chinese and Western cultures and pluralistic artistic trends have been beneficial to the artists in this city. Lam Tian Xing joined several art groups such as the Hong Kong Art Researching Association, the Hong Kong Art Club and the Chinese Contemporary Artists' Guild. Therefore, he had the opportunity to constantly exchange with local painters and participate in exhibitions. In Hong Kong, he was able to observe the innovative paintings of many pioneers of the "New Ink Painting Movement" such as Lui Shou Kwan, Wucius Wong, Leung Kui Ting and Irene Chou. He started to understand that ink painting could steer clear of tradition and academic conventions. By trying different techniques and bringing in creative ideas to develop a new realm, he stepped into a new artistic context. In 1989, Lam Tian Xing went to the Landscape Painting Studio of the Chinese Painting Department of the Central Academy of Fine Arts (CAFA) in Beijing for further study. Teachers included Li Xingjian, Jia Youfu, Zhou Sicong, Wang Yong, Liu Jingui, etc., and Mr. Liu Mu was his mentor. During this period, he often visited and studied at the Beijing Fine Art Academy, Research Institute of Traditional Chinese Painting (now the China National Academy of Painting), and the Central Academy of Arts and Design (CAAD), and benefited a lot from the creations of many famous artists.

However, as a Chinese ink painter, seeking the methodological reference from tradition is the only way. Masters and painting schools came forth in various dynasties. Their brushwork and ink techniques, and the inter-changing use of colour and ink have been an endless source of inspiration for artistic creation. Lam Tian Xing has presented himself to the world with colour and ink, but we should not ignore his earnest attitude in pursuing traditional Chinese painting. His paintings in his twenties and early thirties (1977- early 1990s) have demonstrated the influence of tradition on him. In 1977, Lam precisely duplicated Wu Wei's "Fishing Boats on Rivers and Mountains" of the Ming Dynasty. The painting depicts the mountains and hills with explicit layers from near to far. Lam's brushstrokes are thick and heavy, with fishing boats floating on the River, and the artistic conception is spacious, reflecting the literati painting style of Wu Wei in the Ming Dynasty, which can be traced back to the "*Beizong*" (a school of systems theory) landscape, and Wu Zhen and Huang Gongwang in the Yuan Dynasty. "Autumn Colours in Wuyi" (1980) adopts traditional composition: trees in the close view, layered mountains of various heights full of lush forest in the middle scene, and the cluster of peaks in light ink in the distant view. The whole picture was prepared with "three distances", and the

structure is rigorous, which is closer to the layout of Beizong's landscape. In 1982, Lam duplicated "Landscape of Ten Thousand Miles of Rivers and Mountains" by Zhao Fu in the Song Dynasty. He arranged the picture in a horizontal scroll. On the left is the mountain path leading to a small bridge; to the central are a group of rocky forests connecting to the distant mountains through the mountain path and leading to the left woods by a stone bridge. The mountains in the distance are misty and the vein of nervous energy continues through the whole picture so uninterruptedly. It is exactly why the Chinese landscape is so exquisite, that "bringing the hills and valleys in the heart, and being able to travel the landscape while lying down". Lam Tian Xing also created sketches in the traditional way. His "Sketch of Taihang Mountains" (1989) depicts the dangerous and steep rocky look of Taihang Mountains in a crisscross pattern. He used thick ink to render, thus to make alpine more majestic amongst the mountains. In 1990, Lam imitated Ren Xiong's (the Qing Dynasty) "Boundless as the Sea and the Sky" which is a piece of rare Blue-green shan shui artwork by Lam. The outline of the rock is sketched with meticulous lines, the stone green and cyanine blue are rendered, the colours are bright, and the tree shape is aged and simple. Though it is an imitation of Shanghai painter Ren Xiong's works in the late Qing Dynasty, it can really be traced back to Blue-green shan shui style in Tang and Song dynasties. These early landscape paintings fully reflect Lam's efforts and mastery in exploring traditional brush and ink.

In 1990, after Lam Tian Xing completed a one-year refresher course at CAFA, he and his classmates went to Northern Shaanxi to sketch. They traveled to Yulin, Mizhi, Suide, Shenmu, Fugu, Baode and Datong for one month. This journey took him to a new phase of creation. The northern part of Shaanxi is a barren mountainous area with many villages and cave dwellings. The living environment is very different from that of the city. Most of the people live on farming and animal husbandry. However, people's life and expectations for life are simple, the scenery is broad, the sun is abundant, the sky is full of cloud iridescence, and the crops are everywhere. The beautiful sceneries inspired the painter, who used dense and zig zag pencil lines and sketched a large number of drawings to record what he saw. For example, in "Sketch in Northern Shaanxi" (1990), he outlined stones and cave dwellings with smooth and thin lines, focusing on spatial organisation. In another "Sketch in Northern Shaanxi" (1990), he almost entirely outlined the plain landform with dots and lines, and presented changes in layers. These sketches reflect Lam's observations and sketching skills. Against this background, he began to establish a strong personal painting style, expressing landscapes with strong colours and thick ink, leaning towards more abstract geometric structures, and finally creating the 'Northern Shaanxi Series". Amongst them is a painting that he started with ink rendering horizontal mountains, from the strong ink-coloured to the light ink-coloured; the cave dwellings were depicted in the front, which is unique only to the majestic mountains of Shaanxi. The terroir characteristics of the humble cave dwellings are well shown in this painting. In another painting in this Series, Lam applied a different painting style, with

dark green renderings of dense trees, and with red clay, cave dwellings, and mountain roads interspersed. While filling the picture, it still has the beauty of spatial layers and is not crowded and bloated. "Daylight with the Reflection of Cloud" (1991) has a sparse composition, with golden yellow colour paving and dyeing the yellow earth, patches of green-onion colour representing fresh green grass, thick ink blocks symbolizing rocks and mountains, and blue sky and white clouds in the distance. Lam Tian Xing reproduced the beautiful scenery and atmosphere of northern Shaanxi with his colour and ink-colouring skills. The forty-five new works in this series "Sketch in Northern Shaanxi" became the focus of the 27-year-old Lam Tian Xing's first solo exhibition in 1990 which was held by Research Institute of Traditional Chinese Painting (now the China National Academy of Painting). The exhibition attracted much attention and two paintings were even collected by Research Institute of Traditional Chinese Painting.

In 1987, Lam's works were selected for the "Contemporary Hong Kong Art Biennial Exhibition" held by the Hong Kong Museum of Art of the Hong Kong Government, which is the main platform for Hong Kong art. In the following years, he actively participated in exhibitions and exchange activities in Hong Kong and the Chinese Mainland, and his works were collected by many art galleries and museums, thus establishing his major presence in the art world. 1999 saw another significant moment when he developed another important series of paintings.

He went to Tibet, Dunhuang and Lanzhou to sketch with his friends Wong Sau Ching and Yeung Pak Yau. He arrived at Lhasa with a cold and suffered from a splitting headache. After returning to Hong Kong, he fought the headache for three years. This journey left a deep impression on his artistic cultivation, and he began to create new works along the "Tibet Series". Subsequently, in 2005, again, together with his painting friends, he went to Lhasa, Yangbajing, Dangxiong, Namtso, Nyingchi, Basongco, Bayi Town, Misong, Lang County, Jiacha County, Zedang and Samye Monastery in Tibet, and then, returned to Lhasa; from there he traveled to Shigatse, Sakya, Lazi, Sa'an, Shenshan, Zada, Guge Dynasty, Toling Monastery, and Yecheng, Kashgar, Korla, Lop Nor, Turpan and Urumqi in Xinjiang, sketching wherever he went. Tibet is an exotic land, very different from the Central Plains culture and full of exotic customs. The people in Tibet live on nomadic hunting and most Tibetans believe in Lamaism. There are many temples, "*Lingshan*" (spiritual mountains) and holy lakes, and monks wear red and yellow robes to worship and practice cultivation of virtue. The Tibetan area is either blazing sunshine with blue sky and white clouds, or snowy and icy, covering the sky and earth. A variety of strong colours, exotic living habits, unique landscapes and architecture bring new inspiration to the painter. He sketched along the way, such as "Tibetan Sketch (11)" (1999), in which the mountains and mountain roads are painted with thick ink, with white clouds covering the top, presenting a magnificent scenery. "Tibetan Sketch (8)" (1999) presents the blue sky and white clouds in bright colours, and temples and lama pagodas beneath it, which has

a strong realistic meaning. Influenced by the fiery burning local colours, Lam Tian Xing's "Tibet Series" paintings are mostly red, yellow, blue, green and other bright colours; more often the themes are sacred mountains, holy lakes, temples, and Tibetan monks. "Stupa at Sunset" (2001), "Monastery Scene" (2008) and some other paintings are all painted in bright red and yellow, almost filling the whole picture, depicting the scene of the temple compound and the sun setting in the west. "Faraway Blessing (2)" (2007) uses blue to render the picture, and the shades appear, just like the colours used in oil paintings, which reflect the style of the "Tibet Series" where colours and themes complement with each other.

Lam Tian Xing's "Tibet Series" is diversified, including ink-based paintings, especially the paintings of holy lakes and snow-capped mountains, emphasizing the changes of black and white, virtual and real, to match the emotional rhythm of the scene. In "Quiet Night at Sacred Lake" (2006), the bright moon illuminates the picture, leaving a lot of blank space, showing the light reflecting the clouds, the calm lake below it, and the surrounding light ink rendering the tranquil and peaceful atmosphere of the holy lake overflowing on the paper. "Quiet Night" (2006) also paints mountains, rivers and lakes with light ink, with misty and murky clouds, the bright moon hanging high in the sky, and reflecting in the lake. Both paintings focus on using ink smudges to express the icy nature of the snow-capped mountains in artistic conception of Tibet. He also organised his pictures by emphasizing line strokes, light colours, and changing morphological structures, such as "Sound of Water 1 and 2" and "Discussing Scriptures 1 and 2" (2008), where he used curved and interspersed lines to draw the outlines of mountains and temples, and applied ochre and pale red colouring, presenting fresh and abstract artistic conception. In the "Memories" series (2006), yellow, green, and ochre red are elegantly painted all over the screen, and the houses, trees, and monks are simplified and hidden in the colour and ink artistic notion, emerging in misty, echoing his hazy memories about Tibet. Lam's "Tibet Series" paintings also convey his sincere, genuine respect and admiration for religious holy places, fascinating scenery, culture, and monks' practice. In 2012, he used heavy colour to paint multiple pictures of waterfalls and cliffs of the holy mountains in Tibet. The rainbow reflected by the water vapour is majestic, showing that the rainbow on the holy mountain is the source of life between heaven and earth, and it has become a scenic spot in Tibet. In "Auspicious Days" (2008), houses in the Tibetan villages fill the picture so that it seems impossible for the wind to pass through. The whole picture is painted with crimson colour. The monks in red loom between the alleys and buildings, and the colours are radiant, reflecting the life of the Tibetan people. The fiery burning atmosphere of the scene means good luck and happiness. The group of eight paintings in "Holy Place" (2006) is a masterpiece of his "Tibet series". He painted the mountains and rivers of Tibet from a bird's eye view. The clouds and mists cross the rivers and mountains. It is the painter's view of the mountains and rivers in Tibet and he praised all in his paintings. Before the trip to Ali in Tibet in 2005, Lam Tian Xing did a lot of research on the scenery and landscape,

and planned the itineraries meticulously. He sketched a 20-meter hand scroll in front of the Toling Monastery and completed it in just three hours. In this framework of "Tibetan Sketching Scroll", the brushstrokes are free and unrestrained, the ink tempo varies, the brush follows his heart freely, and the mountains, houses and trees are naturally formed. It is an exemplary work of his "Tibet Series". The "Tibet Series" has not only been the most precious memories, but also the representative masterpiece of Lam Tian Xing.

In addition to the creation of a series of landscape paintings originating from the sketches in the Chinese Mainland, Lam Tian Xing is also good at painting rural and urban landscapes. As the landscape, landform and living environment of the countryside and the city are completely different, the painter needs to use different compositions, techniques and colours to deal with the scene and the object, so as to achieve a "lively charm" and "according to the pictograph of the object". The countryside is full of simple and natural fun, lush forests and bright colours, reflecting the fresh breath of nature. Most of Lam Tian Xing's "Country Series" works are composed of block images. He deals with the shapes of mountains, village houses and trees geometrically, and changes the block constitutions. He also uses stippling, and abbreviated and clustered lines to draw objects, while colour and ink tends to be more vivid to express natural beauty. "Red Clouds Floated Past Hilltop" (1994) is a work from an earlier period. The trees, rocks and mountain peaks in the close and distant views are painted with golden colour; the trees in the middle ground are morphologically changed; the blue sky, lake and colourful clouds are the backdrop, and the image is fresh. The "Home Full of Blooming Sunflowers" made in 2005, lays out a little sunflower on the plane composition, surrounded by abstract plants and trees, and interspersed with houses. Colour and ink blend together, sophisticated but not chaotic, which shows Lam's ingenious ideas. In "Flowers on the Island" (2002-2015), the background is indigo blue, and the blooming flowers are dyed with bright green dots; the orange paths are interspersed in a circuitous way, leading the viewers into the world of flowers on the island. The whole picture is handled with stippling technique, though mottled with strong colour contrast, presenting the elegance of nature.

City life is chaotic, hustle and bustle, with high-rise buildings, space constraints and traffic jams. After Lam Tian Xing moved to Hong Kong, influenced by the local landscape and living environment, his creative mentality and style has also changed. His "Scenes – Hong Kong" series presents a different style of painting, with thicker colours and ink, and his brushwork tends to be wild and unrestrained. He pays more attention to the change of light and shadow, which is closely related to the haze of clouds and smog formed by the humid weather in Hong Kong, the change of water shadow in Victoria Harbour and the crowded urban space. The early painting in this series, "Sunset on an Island" (1996), depicts abstract giant rocks at the foreground, turbulent waves in the middle scene, and sun and clouds at a distance. The use of brush in the whole picture is sparse, with rich ink and colour forming dynamics and tensions. In summer and autumn, Hong Kong is often hit by

typhoons. This picture may draw inspiration from it. He also painted the unique cityscape of Hong Kong. The Hong Kong Container Terminal busily operates day and night. In 1998, he painted "The Pier", which depicts containers in Kwai Chung, Hong Kong. The cranes operate day and night, and the workers work hard. In the picture, the scene of the wharf is painted with heavy ink, red and blue, projecting his subtle observations in life.

The 2008 work "Sideview in Victoria Harbour" is more abstract. The picture is painted with bright red, with lines intertwined horizontally and vertically. The middle scene is fish swimming in waves. The painter uses his brush freely and unrestrainedly, not depicting the details but imagining the scenery on both sides of the harbour by the brush and ink colour. From 2020 to 2022, Lam Tian Xing has used even more creative composition and techniques when dealing with the picture. He painted several works of the important infrastructure, Hong Kong-Zhuhai-Macao Bridge, such as "The Hong Kong-Zhuhai-Macao Bridge" (2020) and "Clouds Over the Hong Kong-Zhuhai-Macao Bridge (2)" (2022). In these paintings, the painter overlooks the bridge connecting the three places across the sea. The bridge is surrounded by blue, red and yellow clouds outlined by lines, with the changing shades of colours. The technique is abstract with design implications; the idea is unique and creative in nature. This is apparently a new attempt to develop a new artistic style by the painter.

In terms of flower painting, Lam Tian Xing has a soft spot for lotus (*Lian*) flowers. Zhou Dunyi of Northern Song Dynasty said: "Lotus is the gentleman of flowers." In his "Ode to the Lotus", he further said, "I only prefer lotus because it is unadulterated despite coming from mud; it is not alluring although having been rinsed with limpid water; it is hollow inside yet upright outside uninterrupted by tendrils or branches; its fragrance gets more refreshing as it travels further away; its stem is straight and unsoiled; it could be admired from distance but not be tampered with up close and personal." [01] Since ancient times, lotus has been a symbol of elegance and charm.

The lotus is also a symbol of Buddhism. The Buddha sits on the lotus seat, and Guanyin holds the lotus, all of which have the compassion of purifying all living beings. It has become one of the main themes of Chinese ceramics, crafts and paintings in the past dynasties. In the meticulous and strong-colour paintings of the Song academic style, lotus flowers with delicate lines and elegant colours are depicted. Painting masters Xu Wei, Bada Shanren, Shi Tao and some other masters are all good at painting ink lotus, and their brush and ink works are pleasant and delightful. The famous modern master Zhang Daqian splashed ink and colour, outlining the lotus in gold and blue; Lin Fengmian's lotus

---

**01** Translation of "Ode to the Lotus" refers to adamlam99, ZZ61 翻譯：愛蓮說（周敦頤）, available at: https://zhuanlan.zhihu.com/p/57985844.

paintings are elegant and sophisticated, while Huang Yongyu's lotus paintings are splendid and magnificent with his infinite palette. They all have their own style and characteristics. Lam Tian Xing's paintings of lotus originate from the perception and impression of his hometown Lotus Peak when he was young, and it is also closely related to his trip to Tibet. When he fell ill in Tibet, the sacred lotus flower in Buddhism often came to his mind. He began to focus on painting lotus in the 1980s, and was also inspired by mainland painters Zhou Sicong and Huang Yongyu. After coming to Hong Kong, he went out to the outskirts field to observe the lotus from time to time, such as the lotus pond in Yuen Long, Wun Chuen Sin Kwoon, parks and temples, and has created more than hundreds of lotus paintings so far, with various styles and different looks. In 2003, when the SARS epidemic raged in Hong Kong, Lam used the lotus painting to express the hope that people would live a quiet and peaceful life and return to nature. One of his lotus painting styles is mainly rendered with ink and line drawing. For example, in his early 1996 "Fish in Moonlight", lotus leaves and lotus pods are rendered with shades of wet ink. The fish swim leisurely among the waves. "Snow-White" (2004) is a pure ink smudge painting. The rhythm of ink flows and changes naturally and the shape of the lotus is abstracted, thus the reality and the abstraction coexist in the same space. The horizontal scroll "In the Snow" in 2010 focuses on the performance of lines and ink dots. The lines of stems and vines are interspersed vertically and horizontally. The brush and ink space is sparse and moderate, forming a view of the lotus pond. In recent works "Purity", "Leisure" and "New Bloom" (2021), he uses the ink splash technique to render lotus leaves. The dark and light ink is dripping on the paper. The lotus flowers are painted with light colours, which are faintly looming, to match the proposition of the painting. This shows his creativity.

Another orientation of Lam Tian Xing's lotus paintings is to focus on expressing the purity and elegance of lotus flowers. These paintings use either plain colours, or bright colours without being gaudy. His lotus painting emphasizes its soft texture and charm, and ignores its shape. "A World of Purity" (1994) paints several branches of white lotus standing slim among the green lotus leaves with soft petals, with the emotional charm of being "unadulterated despite coming from mud" and "straight and unsoiled". "Verdant Haze" (2007) uses bright green to render the picture, the branches and stems are drawn to show Western sketching techniques, with a three-dimensional effect, and the lotus flowers are interspersed in the middle, reflecting the fresh air of early summer. "Tranquility" and "Wisdom" (2021) are painted with very light ink and water rendering like clouds shadows in the water. Pale red lotus appears in the misty and quiet scene. The mood of paintings is clear and distant, presenting the lotus in the heart detached from the outside world, not the lotus in reality. "Clarity" (2021) uses bright yellow as the ground, and stippling is applied to express the texture of the lotus leaf. The lotus and lotus stamens are divided into the upper, middle and lower parts of the painting, which echo each other. The whole composition is unique and very creative, conveying the meaning of "clarity".

In addition to the two styles above, Lam Tian Xing also uses dense composition and strong-colour techniques to paint lotus, which is unique and different from his predecessors. In 1991, he painted "Lotus Heart Sutra", in which he wrote Buddhist Heart Sutra sentences. The strokes are thick and heavy, apparently inspired by the unsophisticated characteristics of "*Lishu*" (official script) calligraphy. The white lotus crosses the painting, elegant and discreet, forming a light and heavy contrast with calligraphy. The painter is so ingenious at using the lotus as a metaphor for the spirit of Buddhism. "Aurora of Blessings (1-8)" (2007) is a masterpiece of eight panel screens. The branches and vines are intertwined and interspersed in the painting, which is like cursive script, and the writing is smooth and tidy. The red and white lotus flowers are laid out in the right position, symbolizing the auspicious light and prosperity of all things. The picture of "Livelihoods in the Pond" (2012) is complex and the lotus flowers of various colours are scattered, almost impermeable to the wind. But there is space among the colour and ink, showing that the lotus flowers are in full bloom and competing for beauty. The atmosphere of the painting is vibrant with livelihoods. "Carol" (2021) is a new work in recent years. The colour ink fills the picture, the colours are intertwined, and the flowers are swaying, celebrating the joyful nature. A similar style can also be seen in the new work "Luminosity" in 2022. The picture is golden and bright, and the flowers are sprightly grown, which complement each other. These types of ink colour, light colour and heavy colour accompanied with brush ink lines, along with a unique style of Western connotation, have created a representative series of paintings of "Tian Xing Lotus".

In 2019, the social events in Hong Kong made the whole place full of desolation. In 2020, the COVID-19 pandemic hit Hong Kong, wave after wave. People are disgruntled, frightened and worried. Everyone is longing for the dawn. Lam Tian Xing is no exception. He created the series of works "Calamus" to express his hope for the future. Calamus is an aquatic plant, which has been believed in the ancient times to has the power of warding off evil spirits. Thus, hanging calamus and wormwood on the door became a custom of the Dragon Boat Festival. People in the south of the Yangtze River, during the Dragon Boat Festival, hang calamus and wormwood leaves on doors and windows, and drink calamus wine to ward off evil and epidemics. The bonsai made of calamus, with its beautiful branches and leaves, is both poetic and anti-pollution, and is mostly used for decorating tables of literati. This series of works by Lam is very different from his colour and ink painting style. The brush and ink tend to be direct and heavy, like a stagnation in the heart, which is difficult to express. The paintings made in 2019, such as "Beauty", "Chanting", "Quiet" and "Awaking", are painted in colour and ink, but the lines of the calamus leaves are unrestrained and unbridled. The choices of colour and the shades of colour also have a desolate connotation, as if the painter wants to use the brush strokes and ink to break the predicament in the heart and vent his feelings. In 2020 works "Mystic Thought" and "Mystic Thought (2)", the ambience is heavy and dark, surrounded by thick ink outlines of calamus leaves, and the center is left empty, as if there is a skylight opened

in a mental predicament and the bright future is expected. In the same year, he created "Sound of Waterfall ", "As if a Song", "Mist", etc. Each sketches wild calamus growing by the streams. It seems that the calamus is telling people that I am myself, like orchid in an uninhabited valley; though everything outside is disturbed, it has nothing to do with me. However, "Dawn" (2020) showcases the new green mountains and rivers with ink and bright green, and the morning light gradually appears at a distance, which implies every cloud has a silver lining.

Lam Tian Xing also devotes himself to calligraphy, especially the neat and tidy style of Yan Zhenqing and Liu Gongquan of the Tang Dynasty, and the humble and rather unsophisticated style of "Lishu" of Han and Wei Bei monuments. In recent years, he has tried new works of "Chinese Characters Series". What he pursues is not the structure of Chinese characters, but the conceptual expression and the experience of the creative process. He recombines the structural lines of Chinese characters, renders the colours and inks in layers, and creates an abstract effect with the presence of calligraphy strokes. In 2020 works "Chinese Characters Series – Stone", thick black and simple lines, juxtaposed and overlapped on the paper, form the word "stone" and present an idiosyncratic image. "The Origin of Chinese Characters" (2020) uses different shades of ink to render the picture. The purple lines and ink strokes are crisscrossed, with red stamps making the work both the Chinese calligraphy and a painting, which is a new approach and unique.

Lam Tian Xing likes to use block format for painting. Unlike the space-oriented vertical or horizontal scroll and fan, the block format is more modern so that the painting elements could be freely used vertically or horizontally. He is good at steering block surface and creating stroke momentum, and is also a master in colour and ink manifestations. The unique characteristics, seen in his series of landscapes, Northern Shaanxi, Tibet and lotus paintings, have showed his strong personal styles and have established himself as a master in ink colour in the Hong Kong painting circles.

In addition to painting, Lam Tian Xing also puts pictorial images into ceramic art. In 2000 and 2007, he cooperated with a few painters to provide paintings for firing blue-and-white and overglazed coloured porcelain. He also engraved painting images on Yixing purple clay pots, integrating with the art of ceramic painting. Lam Tian Xing named his studio "Da Ye Tang" which means The Hall of Boundlessness. His endeavours in various artistic areas, his unique style and the spirit of creativity have become representations of the mainland artists who moved to Hong Kong in the 1980s. Their artistic achievements have enchanted Hong Kong art scene with splendidness and magnificence.

<div align="right">

**Tang Hoi Chiu**

**Adjunct Professor, Academy of Visual Arts, Hong Kong Baptist University**

</div>

# 自序

　　歷史從來沒有像今天這樣瞬息萬變、多元開放，各種各樣的藝術，隨着互聯網發展應運而生，目不暇給。「苟日新，日日新，又日新」，兩千多年前的智慧，已經告訴我們「新」是發展的必然趨勢，今天的文明就是靠不斷地推陳出新。王羲之有句話：「適我無非新。」能夠留傳到今天的藝術，無可否認都是當時最「新」的藝術。當然，「新」還需要蘊含美的規律以及具有啟迪後來者的作用。

　　優秀的傳統文化藝術必定啟迪後來者！我十四歲學畫至今近五十年，荊棘滿途，藝途並不平坦。二十一歲移居香港，人生地不熟，加上語言不通，可謂一無所有，唯一的心靈慰藉就是藝術。我在艱難困苦中寫下「沒有藝術就沒有我的生命」。彼時的香港，從事藝術是難以維生的。一九八六年，我又寫下「只要有一口飯吃，我就要畫畫」。藝術是我的精神支柱，也是我的人生目標。雖然她讓我在痛苦中掙扎，但我堅定信念，一次又一次見到希望。正如泰戈爾所說：「天空中沒有翅膀的痕跡，但我已經飛過。」

　　對於藝術家來講，更大的痛苦是在藝術追求路上的困惑，愛得愈深也就陷得愈深。「沒有困境就沒有新境，把自己投進困境中去，陷得越深，創造才會越精彩。」李可染在《困而知之》裏這麼說。但我的痛苦比較頻繁，從傳統到陝北之變，然後到鄉村系列、景象系列、西藏系列、荷蓮系列、菖蒲系列以及漢字系列。每一次「求變」，都經過「蠟炬成灰淚始乾」「望盡天涯路」的艱辛；每一次的「新」都是在「山重水複疑無路，柳暗花明又一村」中出現的。無論如何，「新」是我畢生的追求。

　　董其昌是這樣談創新的：「先師古人，後師造化，集其大成，自出機杼。」這是一條漫長的道路。傳統藝術被不斷顛覆的今天，有多少人願意「以最大的力量打進去，以最大的勇氣打出來」（李可染）？早已進入後後現代的今天，其實任何藝術都有着它存在的意義。因心造境，多大的心就有多遼闊的視野，「畫之道，所謂宇宙在乎手者，眼前無非生機」（董其昌）。境由心生，每個時代都有它自身的「時境」，不同的生命情景又產生不同的藝術情境。藝術就是執着於自身生活情景的一種生動的體驗方式，坦坦蕩蕩，率性而為，手舞足蹈，如泣如訴，感動自己，感動別人，創造當下生活的情境。

「充實為美，充實而有光輝之為大」（孟子），是我追求的視覺方式。我一直在充實而光輝之中尋找靈感的來源，追尋一種充實光輝中而又帶有空靈的情境。我喜歡接近自然的一切，飽滿的構圖，果斷蒼勁的直綫，縱橫交錯、豪邁奔放的筆觸；時而墨色交溶，時而墨不礙色、色不礙墨，積墨與積色相間，厚重清新，意境空靈而蘊含時間張力。這些因素形成我建構的畫面空間，遊離在抽象與意象、夢幻與現實之間。其想像中的語境，不僅是藝術的對象，也是直覺的力量，而且還是我心靈通過觀照自然與人生的體現，而轉化成為自己的藝術語言。

美學家宗白華說：「所謂藝術，就是人生忘我的一刹那。」比如王羲之的《蘭亭序》，顏真卿的《祭姪文稿》、蘇東坡的《寒食帖》，比如八大、徐渭、吳昌碩……以及黃賓虹晚年的作品，那些動人心肺的畫，都是在忘我一刹那間完成。鄭板橋說得好，「愛看古廟破苔痕，慣寫荒崖亂樹根，畫到情神飄沒處，更無真相有真魂。」西方大師們也一樣不遑多讓，梵高、馬諦斯、畢加索、康定斯基、波洛克、德庫寧、勞生柏……其實，所有感人的畫面都是在忘我中完成的，如佛家「無我」，道家「天人合一」之境。我是一個容易激動，容易感動，容易衝動，情商較低的人，尤其創作時，經常抑制不住情緒。幸好走的是藝術這條路，它需要發洩，甚至狂熱的發洩。羅丹說：「藝術就是崇高的發洩！」當然，我也經常會有忘我的一刹那，每個時期都有在無我狀態下完成的作品，今天看到還激動不已！我想，當你以生命換取它時，同樣會展出「新」的生命。

難以想像，在追求藝術的道路上，如果沒有家人不斷包容，如果沒有師友們無私教誨、鼓勵與支持，如何走到今日！

泰戈爾說：「除了通過黑夜的道路，無以達到光明。」在藝術的道路上，我始終在努力攀行！在即將呈現給讀者的這本書裏，我投入了我對藝術的瘋狂與忠誠；在筆墨交織的光影中，我思、我行。

希望這本充滿探索的《天行之路》可以為新時代的香港故事增添異彩！

2022 年 6 月 19 日於大也堂

# Author's Preface

The society has never been so fast-changing, diverse and open. All forms of arts have emerged, facilitated by the light speed development of the Internet. As it is said that "if it can be new every day, it should be kept new every day, and if it is new, it should be updated", the wisdom of more than 2,000 years ago has told us that "new" is the inevitable trend of development. The evolution of civilisation relies on constant innovation. Wang Xizhi has a saying: "For me there is nothing but new." Art that has survived to this day is undeniably the "newest" at that time. Of course, "new" also needs to contain the laws of beauty and is able to inspire latecomers.

Great traditional culture and art will surely inspire latecomers and followers. It has been nearly 50 years since I first learnt painting at age 14. My journey has been full of thorns and my artistic career has not been smooth. I immigrated to Hong Kong at age 21. I didn't know anyone, nor the place; moreover, I couldn't speak Cantonese. I had nothing in Hong Kong but art as my only spiritual comfort. In the midst of hardship, I wrote, "I would not have my life without art." In Hong Kong at that time, it was difficult to make a living as an artist. In 1986, I wrote again, "As long as I have a bite to eat, I will paint." Art is my spiritual pillar and my life goal. Although life has made me struggle with pain, I have strong faith and see hope again and again. As Tagore said, "I leave no trace of wings in the air, but I am glad I have had my flight."

For artists, the greatest pain is the quandary they have to face in the pursuit of art. The deeper your love for art, the deeper you fall. "Without predicament, there is no new world. Once you find yourself falling into a predicament, the deeper you sink, the more exciting your creation will be." Li Keran said this in *Quandary and Knowing*. My pain keeps surfacing from the traditional paintings to the transformation in Northern Shaanxi, then the series of country, the series of scenes, the series of Tibet, the series of lotus, the series of calamus, and the series of Chinese characters. Every time I "seek change", I must go through the toughness and difficulties, like "burning candles weep, till no more tears they can shed", and "up to the towering building, strain my longing eye to the end of the world". It's like in a state of getting nowhere. However, when every new piece of artwork appears, all tumbling blocks vanished. In any case, "new element" is my lifelong pursuit.

When Dong Qichang talks about innovation, he said: "First we learn from the ancient masters, then learn from nature; digest all you have learnt, you will create your own." This is a long road. Nowadays, when traditional art has been constantly subverted, how many people are still willing to "go in (art) with the greatest strength and come out with

the greatest courage" (Li Keran)? In post-postmodern era, in fact, any art has its reason for existence. The realm is created by the mind and heart. The bigger the mind and heart, the wider the vision will be. "Everything has a way, and so does painting. The 'Tao' of painting: all kinds of things in the universe can be drawn into the painting as if you have mastered the entire universe, if you can see through the universe." (Dong Qichang) The realm is born from the heart. Each era has its own "clock", and different circumstances produce different artistic contexts. Art is a vivid way of expressing one's own life. Live your life in a trouble free manner, dance and sing with joy, be true to yourself, weep when sad, open your heart to allow it to be touched by others, do things to touch others, thus, live a meaningful life.

"Fulfillness with goodness is called beauty, fulfillness and brilliance are great"(Mencius), is the visual way I pursue. I have been looking for a source of inspiration in the fulfillness and brilliance, and pursuing an ethereal realm in the fulfillness and brilliance. I like everything that is close to nature. In my paintings, like in nature, there are full composition, decisive and vigorous straight lines, criss-crossing, bold and unrestrained brushstrokes; there are ink and colour in harmony, and the accumulated ink and the accumulated colour are alternately thick and fresh. The artistic conception is ethereal and contains time tension. These elements form the pictorial space, drifting between abstraction and imagery, fantasy and reality. The imaginary context is not only the object of art, but also the expression of intuition, and it is also the embodiment of my mind, which is transformed into my own artistic language by observing nature and life.

Aesthetician Zong Baihua said: "The so-called art is the moment of forgetting oneself in life." For example, Wang Xizhi's "Lanting Xu (Orchid Pavilion Preface)", Yan Zhenqing's "Draft of a Requiem to My Nephew", Su Dongpo's "The Cold Food Observance", and works of Bada Shanren, Xu Wei, Wu Changshuo... and Huang Binhong's works in his later years, those heart-moving paintings are all completed in a moment of ecstasy. As Zheng Banqiao said, "I love the old moss marks in ancient temples, and I used to write about wild cliffs and tree roots. When I painted, the real image of objects was gone, and there was no real resemblance but true souls." All the Western masters are the same, such as Van Gogh, Matisse, Picasso, Kandinsky, Pollock, De Kooning, Rauschenberg. In fact, all the touching paintings are done in ecstasy, such as "anattā (non-self)" in Buddhism and the state of "harmony between man and nature" in Taoism. I am rather sentimental. I can be easily moved, and impulsive with low emotional intelligence. Especially when creating, I often cannot hold back my emotions. Fortunately, I am following the path of art, which requires emotional venting, even fanatical emotional venting. Rodin said: "Art is the most sublime mission of man!" Of course, I often have selfless moments. During different periods, there are works completed in the state of selflessness, which still makes me feel very exhilarated today! I think when you trade your life for art, you will also manifest a "new" life.

It would not be possible for me to get to today in the pursuit of art without the continuous tolerance from my family members, and selfless enlightenment, encouragement and support from my mentors and friends.

As Tagore said: "Except the road through the night, there is no way to the light." I have been dedicated to climbing up on my path of art. This new book records my enthusiasm and loyalty to art. I think, and I act, under the shadows and lights arising from the mixture of brush and ink.

I hope this book would add the new Hong Kong era with vibrant and beautiful colours.

**June 19th, 2022 at The Hall of Boundlessness**

(I)  My

Study Path

（一）

求學

之路

1977 ———————— 1989

(1) My

Study Path

求學

之路

1977————1989

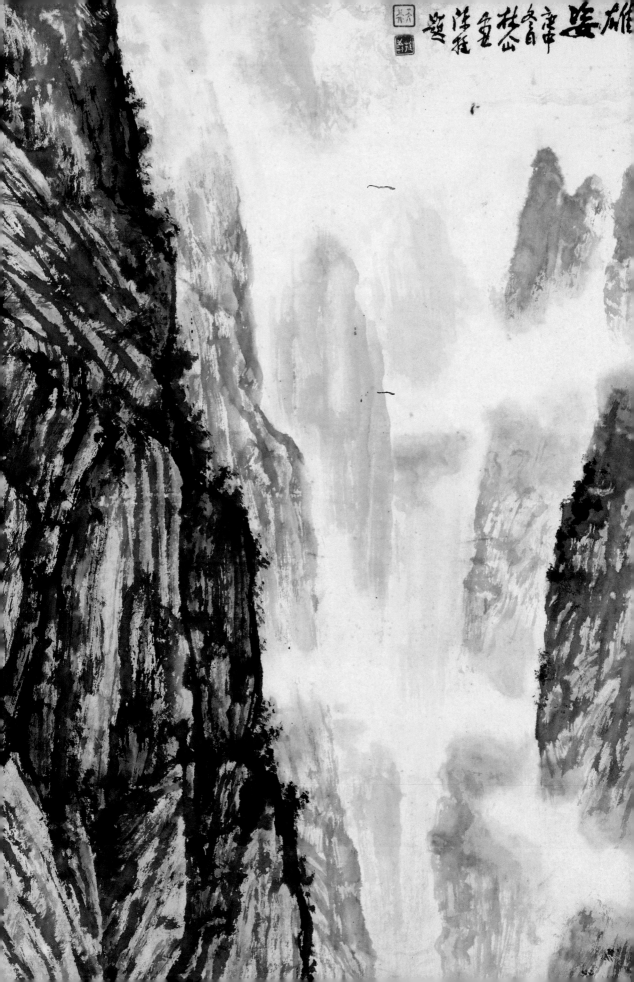

# 天行

# 畫語

1963 年 10 月 17 日，我出生在福州市北面蓮花峰山下古老的祖宅裏。父親是中學中文教師，母親是小學中文教師。熱愛文學的父親在康熙字典裏，為我找到一個特別的名字——「仚」。母親對我說，他們希望我站高望遠。母親還對我說，在我兩歲時，她指着天上的繁星，問我想去嗎？我說要去，她問我怎麼去呀？我說用梯子一把接一把爬上去。

我自幼體弱多病，但淘氣好玩——爬樹、抓魚、逃學……常有人來家告狀，父親在他們面前顯得正義凜然，怕人說教子無方，總要當面狠揍我一頓，直到告狀之人過意不去偷偷跑了。父親對我們兄弟倆都非常嚴厲，但我挨揍的次數比我弟弟多。其中一次逃學，是為了一朵雲彩。我在上學的路上，見到前面山頂，冉冉升起一朵亮麗的白雲。我想知道雲是怎麼升起的，於是好奇的我毫不猶豫地朝着它的方向，爬上蓮花峰山上的公路，翻山越嶺，尋找它的蹤影。那時的公路很久才有一輛車經過，也見不到人。在太陽快落山時，遇到一位老婆婆，她問我從哪裏來？要去哪裏？讓我快回去，說晚上山裏有狼。那天到家已深夜，父親沒問我去哪里，也沒揍我，所以至今仍然記得。

家鄉福州到處都是榕樹，故名榕城。在我家附近就有許多古老的榕樹，每一棵都高百尺，大十圍，其中一棵據說已逾千年，仍然枝壯葉茂，煥發青春。小時候我最愛爬上去躺在它們身上做白日夢。上中學後，我愛上了一座山，經常騎一個多小時單車去看她，到了山腳再爬一個多小時到山頂。那可是滋養我成長的一座山——鼓山（又稱石鼓名山）。唐代已在山頂建寺，從山腳踏上百年石階，沿途風光無限，兩旁是虯枝盤繞，蒼勁崢嶸的松樹，古人有云「天下名山皆古松」。不過鼓山的美與她的人文精神是分不開的，那漫山遍野的摩崖石刻，流淌着中華文化的博大精深；那數不清的睿智雋語，千百年來不知啟迪了多少往來的人們。半山亭的「欲罷不能」，快到山頂的「莫作心上過不去之事」，走到沒有門的山門，一副對聯「淨地何須掃，空門不用關」，到了大殿前有四個大字「知恩報恩」，還有「入勝」「忘歸」等。每次返榕，都要去朝聖一番，傾聽松風颯颯，感悟前人的智慧，從而回到兒時的夢境，享受愜意的時光。

十四歲那年突然覺得自己長大成人了，開始蓄起鬍鬚來。遇到一本《芥子園畫譜》，如獲至寶，於是廢寢忘餐地臨摹，並開始留意起身邊與文學藝術有關的人、事、物。有一次在母親任教的學校裏，見報上刊登一張畫，如幻似真，象真山水，但比真的還要美，頓感大自然的偉大，人類的渺小，它深深吸引着我的目光，而且在我心裏種下了這棵藝術之樹。這幅影響我的畫是李可染的《千巖競秀　萬壑爭流》圖，後來知道能達到此境者，如董其昌所講「以境之奇怪論，則畫不如山水；以筆墨之精妙論，則山水決不如畫」。又有一次，打開母親收藏的中國畫，那一幅幅痛快淋漓的筆墨，看得我如癡如醉。還有父親的藏書——托爾斯泰、莎士比亞、高爾基、魯迅、巴金、老舍、冰心……真想一日之內看完讀懂！後來，讀到朱光潛先生的一段話：「本來這個世界漆黑一片，因為有思想家、文學家、哲學家和藝術家才有了光。」原來我們都在這些光耀下前行着。

　　那年看了第一本長篇小說《水滸傳》，一百零八條好漢，深深吸引着我。路見不平、撥刀相助，武松、魯智深、李逵等這些可愛可親的英雄豪傑們，看得我手舞足蹈。不知是否受其影響，我開始迷上了武術，同學中有人的伯父開武館授徒，由他引薦，三個同學湊錢買了一個大西瓜送我作為拜師見面禮。後來因為師父忙於擴建房子，也就不了了之，但我還是堅持鍛煉。後來跟女朋友吳明芬的外公學少林龍椿拳，明芬的父親也是武術家，他教我地蹚拳。不久之後又拜萬籟聲為師學形意拳。移居香港後就少練習了，幾乎忘得一乾二淨。但我還是喜歡看打拳，隨着年紀增長漸喜歡上太極，十年前有幸跟董英傑孫媳婦董鄭小芬師父學楊式太極至今。中國武術一樣博大精深，講尚武精神，強調心正身正，勢不可去得太盡。當然，我不會因為對武術的愛好而減弱對藝術的崇敬之心，相反，它更豐富了我的成長。當時，在福建師範大學美術學院畢業的二舅，見我對中國畫有着濃厚興趣，送我一本《黃賓虹畫語錄》。薄薄的一本書，讓我如獲至寶，如飢似渴地傾注所有的身心，從中知道今天的中國畫，原來是歷代無數的大師們，代代相傳並發揚光大的！悠久、神祕而奧妙的中國畫藝術，成了我精神力量的來源，也是我追求的目標，從此立志要成為一個畫家。

　　父親見我喜歡畫畫，於是託同事為我找老師學畫。記得 1978 年 4 月的一天，父親帶我到商店買了一盒餅乾作為拜師禮。那個年代物資缺乏，商店沒有什麼東西賣。吳國光老師是越南華僑，文革前畢業於福建師範大學美術學院，任職福州七中美術教師（後來當上校長）。他儒雅純樸，多才多藝，中西藝術皆通，油畫、水彩、版畫、山水、花鳥、禽獸，鋼琴、小提琴、口琴、二胡，裁縫……不知有什麼是他不會的。那時崇拜吳老師的同學不止我一個，我們幾乎每天都在老師的工作室畫素描。

1979 年父親移居香港，翌年託朋友帶我去拜林光老師為師學中國畫。老師字秋痕，福州畫院畫家，那年七十歲，人稱「六絕」的琴、棋、詩、書、畫、拳，樣樣皆精，為人正直、正氣。他喜歡和三五知己飲酒論道，並經常帶上我，讓我感受到什麼是往來無白丁，談笑有鴻儒。有一次，我問他「秋痕」是什麼意思，他問：「你每次騎車來我這裏上課，途經閩江大橋時，有沒有留意春天時水漲完留下的痕跡？人來一趟世界不容易，應該要留下點痕跡於世。」如今，我凝望牆上先生的畫作，好像回到少年時，佇立先生身旁，聆聽他的教誨，藝術就是最好的痕跡！在跟隨老師半年後，他的摯友由印尼返上海探親，希望他們往上海一聚，先生和師母便帶着我一起前往上海。這是我第一次出遠門，非常激動。在上海時看了好多海派畫家作品，到了杭州也看到黃賓虹、吳昌碩等許多畫家的作品。下榻杭州賓館時，我見到大堂懸掛着一幅潘天壽巨製，便問先生：「這幅為什麼都是綫條？連瀑布也是綫條畫的？」先生說：「這就是潘天壽。」這是我首次遇到潘天壽作品的經歷，當時並不懂這句話的含義，原來這就是風格！在上黃山時，先生健步如飛，爬到平台休息時，先生興致勃勃打完一套鶴拳，我還在氣喘吁吁。住玉屏樓後清晨遠眺天都峰，我畫了第一幅國畫寫生。所謂「五嶽歸來不看山，黃山歸來不看嶽」。黃山山奇、松奇、雲奇，無不打動着我少年的心靈。當我坐上旅遊巴離開黃山時，忍不住回頭多看一眼，頓時熱淚盈眶！一個多月豐富多彩的行程結束了，先生卻不幸因病於是年 12 月去世。

　　第二年 5 月，師母帶我到先生生前摯友陳挺老師家，囑我拜他為師，繼續學習中國畫。七十歲的陳老師也是福州畫院畫家，以強烈個人風格的現代山水畫聞名於福建省畫壇，他那豪邁的畫風，早已讓我仰慕不已！就在此不久之前，我在展覽館見到陳老師的畫，激動不已！直至展館要關門，我邁出門口時，仍然依依不捨，頻頻回首，心想要是能拜他為師，此生足矣。今天，師母讓我夢想成真！同時也完成了她的心願！是年秋天，陳老師接到通知，要進行長途寫生以及博物館考察。我成了其中一名隨行人員，徐州、洛陽、西安、武漢、宜昌、長江三峽、重慶、成都、峨嵋山、樂山、桂林、廣州、汕頭、廈門。兩個月耳濡目染，增廣見聞，大開眼界的我，返榕後隨即投身創作《巫峽雄姿》《桂林煙雨》等作品，並陸續入選省市美展。

　　1984 年元旦，我離開了生於斯長於斯的家鄉福州，移居香港。香港的一切讓我感到既新鮮又陌生。言語不通的我，在一家絲花廠打了半年工後辭職在家畫畫，父親從內地返港，問我為什麼不去工作？我說：「我要當職業畫家。」第二天父親去內地了，留下兩個月未交的房租（當時每月租金是他幫我交的，還給

我留點零用錢）。就在這瞬間，我突然覺得自己長大成人了（第二次成長）。在香港從事藝術是不能維生的，接着我又開始為生計而忙，跟車送紙皮箱、電鍍廠打工、貨倉倉務員，這一年前後打了四份工，同時也學會了廣東話。

1985年，經過同鄉介紹，我開始畫油畫商品畫謀生，可以不出門在家畫，這是最大的自由。但當時技巧不熟，此外，我只允許自己畫半個月，其他時間則從事與藝術有關的事情，比如認識這個城市的風土人情、文化藝術，同時加入了幾個畫會：香港美術研究會（會長趙世光），香港美術會（會長丁志仁），華人現代藝術研究會（會長陳福善）。這些畫會每年在大會堂舉辦畫展，我參加時認識了許多畫友。當時，在其中一個畫會的展覽上，有一位畫壇前輩看完我的作品後說：「你畫得很好，但在香港當畫家會餓死，像我這樣先去賺錢，等賺夠錢再回來搞藝術。」當時想，我十三歲已將這棵藝術之樹的苗兒種在心田，難道要告訴她，等我賺夠錢再給你陽光和雨露，到那時她還在嗎？彈指一揮間，三十七年過去了，無論生活多麼艱辛，我都從未放棄；今天，依然默默地小心呵護。在1986年展出期間，作品被一位銀行家收藏，這是賣出的第一幅畫（售價為二千五百元港幣），給予我極大鼓舞！從此以後，我便開始賣畫為生。1987年開始，我的作品多次入選「當代香港藝術雙年展」等一系列重要展覽。那年還獲得香港繪畫比賽冠軍。

香港是中西文化交匯碰撞的大都會，許多外來的文化到這里，都在不知不覺中轉換為獨有的香港文化。這是由於香港擁有特殊的歷史環境，多元、開放、包容、自由以及遼闊的國際視野。所以香港的設計和其他藝術，都是在沒有任何包袱的情況下自由發揮，從而融入世界文明的。當時有不少畫家作品讓我感到驚異，如：呂壽琨結合中西的抽象性水墨；周綠雲的水墨宇宙，完全自由如夢如幻的想像時空；劉國松以多樣不同工具表現水墨新視野；王無邪、靳埭強等則以設計入畫，注重黃金分割，平面畫面有着歐洲工業革命意味；還有陳福善，他以自由的手法、斑斕的色彩和超現實畫面幽默詼諧地呈現出香港特色。這些藝術家當時都拓展了我的視野。

1987年，我與明芬旅行結婚。第一站北京，拜訪了北京畫院許多畫家，趙成民、張步、王明明、李小可、張仁芝、王文芳、楊剛、石齊、莊小雷等。他們的為人與作品都令我感動！也使我更加覺得自己還有很多不足之處。返港後，我有了想去中央美術學院繼續學習的念頭。

# Tian Xing's Thoughts 天行

On October 17th, 1963, I was born in the ancient ancestral house at the foot of Lotus Peak in the northern Fuzhou City. My father was a secondary school Chinese language teacher and my mother a primary school Chinese language teacher. My father, who loved literature, found a special name " 亣 " for me in the Kangxi Dictionary. Mother told me that they wanted me to stand at a higher place where I could look far. She also told me that when I was two years old, she pointed to the stars in the night sky and asked me if I wanted to go there. I said yes; then she asked me how. I said I would go up by using many ladders, one after another.

I was frail and in the state of ill health in childhood, but I was a truant and very naughty. I like to climb trees, catch fishes, but not to school. People often came to complain to my parents. My father would always beat me up, indicating that his son was not poorly educated, until the complainant felt sorry for me and left quietly. My father was very strict with both of my brother and me, but I got beaten up more often than my younger brother. I played truant a lot. On one occasion, on my way to school, I saw a bright white cloud rising from the top of the mountain in front of me. I wondered how the cloud rose. I was so curious and determined to chase after its direction without hesitation, walk up the road on Lotus Peak and climb over to the mountains. At that time, there was hardly any car or people on the road. I met an old woman at sunset. She asked me where I came from and where I was going. She also urged me to go back home quickly because there would be wolves in the mountains at night. It was late at night when I got home. My father did not ask me where I was. And he did not beat me, either. It was so unusual that I could still recall it to this day.

My hometown of Fuzhou is full of banyan trees everywhere, hence named "Banyan City". There are many ancient banyan trees near my house. Each one is one hundred feet high and has a circumference of ten feet. One of them is said to be more than a thousand years old, and it is still thriving and youthful. As a kid, I loved to climb up those trees and lie on them and daydream. After I went to secondary school, I fell in love with a mountain. I often rode a bicycle for more than an hour to get to the foot of the mountain, and then, again, spent over an hour climbing to the top of the mountain. That is a mountain that nourished my growth – Drum Mountain (also known as Shigu Mountain). In the Tang Dynasty, a temple was built on the top of the mountain. Walking up the hundred-year-old stone steps from the foot of the mountain, the scenery along the way is infinite. On

both sides, there are pine trees with twisted branches, vigorous and prosperous. There is an ancient saying that "all the famous mountains are really famous for their ancient old pines". However, the beauty of Drum Mountain is inseparable from her humanistic spirit. The rock carvings on the cliffs are all over the mountains, containing the broad and profound Chinese culture. Those countless wisdom and meaningful words have inspired many people who have come and gone for thousands of years. The stone carves such as "on the horns of a dilemma" can be seen in the Mid-Levels Pavilion; approaching the top of the mountain, there is "don't do anything you can't get over"; walking to the "Shanmen" without a door, there is a couplet "it is not necessary to sweep the clean land, nor does shut the empty door". In front of the main hall, there are four big characters carved to remind us "repaying kindness with gratitude". There are also "enchanted", "forget to return", and so on. Every time when I return to "Banyan City", I would make a pilgrimage, listening to the rustling of the pine breeze and comprehending the wisdom of the predecessors, which makes me return to the childhood dream and enjoy the pleasant time.

When I was 14, I suddenly felt like I had grown up and started growing a beard. When I first saw *Painting Manual of Mustard Seed Garden*, I began copying it without eating or sleeping. I also began to pay attention to things related to literature and art. Once in the school where my mother taught, I saw a painting published in the newspaper. It seemed like a fantasy as well as a real landscape, but it was more beautiful than the real one. I felt the greatness of nature and the insignificance of human beings. I was deeply attracted by it. The tree of art has been planted in my heart ever since. The painting was Li Keran's "Magnificent Mountains with Gushy Cascades". Later, I learnt that the state of this painting was like what Dong Qichang said, "In terms of peculiarity and wonderfulness of the nature, paintings are not as good as the scenery; in terms of the subtlety of brushwork and ink, the scenery is by no means inferior to paintings." When I opened the Chinese paintings collected by my mother, I was fascinated by those exhilarating paintings with blissful strokes of brushes and ink. As to my father's collection of books, including works of Tolstoy, Shakespeare, Gorky, Lu Xun, Ba Jin, Lao She, Bing Xin, I wished I could read them all in one day and could understand them completely. Later, I read a passage from Mr. Zhu Guangqian: "Originally, the world was dark; it is thinkers, writers, philosophers and artists who bring the light to the world." Suddenly, I realised that we were all moving forward under these lights.

It was the year when I read my first novel "Water Margin" and was attracted deeply by the 108 heroes. I came to know about how heroes intervened when seeing the injustice, and would applaud for courageous and amiable heroes like Wu Song, Lu Zhishen, Li Kui, etc. Stories in the novel made me so excited. I became obsessed with martial arts from then on, possibly as a result of the novel. Among my classmates, someone's uncle opened a martial arts school to teach apprentices. I was recommended to be an apprentice. Three classmates pooled money to buy a big watermelon for me as a gift to my martial art master (*Shifu*). Not for long, as "*Shifu*" was busy expanding his house, my lesson was done and over. But I continued practicing and exercising. Later, I learnt Shaolin Longzhuang Boxing following my girlfriend Ng Ming Fan's grandfather. Ming Fan's father is also a martial artist, and he taught me Ditangquan. Soon after, I became the apprentice to Wan Laisheng to learn Xingyiquan. After moving to Hong Kong, I practiced less and almost forgot everything I have learnt. Nevertheless, I still like to watch boxing. When I was getting older, I gradually fell in love with Tai Chi. Ten years ago, I was fortunate to meet with Dong Zheng Xiaofen "*Shifu*", wife of Dong Yingjie's grandson, and has been learning Yang Style Tai Chi to this day. Chinese martial arts are broad and profound, which emphasizes the spirit of martial arts and the righteousness of mind and body. It taught me never ever to go too far or overdo. Of course, my love for martial arts does not weaken my reverence for art; on the contrary, it enriches my life. One time, my uncle who graduated from the Academy of Fine Arts of Fujian Normal University, gave me a copy of *Quotations of Huang Binhong*, knowing that I had a strong interest in Chinese painting. It was a little book, but like a treasure which made my body and mind hungry and thirsty for its wisdom. From this book, I have learnt that today's Chinese painting is the great achievement of countless masters in the past, who have been taught and carried forward from generation to another! The long, mysterious and enigmatical art of Chinese painting has become the source of my spiritual strength as well as the goal I pursue. From then on, I was determined to become a painter.

My father, knowing my interest in painting, asked his colleagues to find a teacher for me to learn painting. One day in April 1978, my father took me to the store to buy a box of cookies for my apprenticeship. In those days, there were not much choices as gifts. Mr. Wu Guoguang is an overseas Chinese from Vietnam. Before the Cultural Revolution, he graduated from the Academy of Fine Arts of Fujian Normal University. He worked as an art teacher in Fuzhou No. 7 Secondary School (later became the principal). He is elegant and modest, extremely versatile. He is good at both Chinese and Western arts. He knows everything in my eyes, such as oil painting, watercolour, engraving, landscape, flowers and birds, animals, piano, violin, harmonica, erhu and tailor. I wonder if there was anything he did not know. At that time, I was not the only student amongst our classmates who admired Mr. Wu. We drew sketches at his studio almost every day.

In 1979, my father moved to Hong Kong. The following year, he asked his friend to take me to learn Chinese painting from Mr. Lin Guang. Mr. Lin had an alias "Qiuhen". He was a painter of Fuzhou Fine Arts Academy, and was 70 years old at that time. His achievements in *qin*(guqin), *qi*(Go), *shi*(poetry), *shu*(calligraphy), *hua*(painting), and *quan*(boxing), earned him the moniker "six excellence". He was an honest and upright person. He liked to drink and talk with his confidants, and often took me with him. During those occasions, I learnt the meaning of "no illiterate in association and only learnt scholar in companionship". Once, I asked Mr. Lin what "Qiuhen" meant. Literally it meant "autumn marks/traces". He said: "Every time you bicycle to my school, passing the Minjiang Bridge, have you noticed the traces left by the rising water in spring? It is not easy for a person to come to the world, so we should leave something in the world." When I gaze at Mr. Lin's paintings on the wall nowadays, I feel I was back to the times when I was a teenager, standing next to Mr. Lin and listening to him. Art is the best trace! After half a year, his close friend returned to Shanghai from Indonesia to visit relatives. His friend wanted Mr. Lin to meet in Shanghai, so Mr. Lin and his wife took me with them to Shanghai. That was my first travel far from home and I was very excited. In Shanghai, I saw many works of Shanghai-style painters. While in Hangzhou, I saw many works by Huang Binhong, Wu Changshuo and other painters. At the Hangzhou Hotel where we stayed, there was a monument-like giant painting by Pan Tianshou hanging in the lobby. I asked my teacher, "Why are all the lines in this picture? Why even the waterfall is drawn with lines?" Mr. Lin said, "This is Pan Tianshou." That was the first time I ever saw Pan Tianshou's works. I didn't understand the meaning of Mr. Lin's statement at the time. It turned out that he was talking about style! When climbing Mount Huangshan, Mr. Lin walked so fast almost like flying. When we climbed to the platform to rest, Mr. Lin finished a set of crane fists with great enthusiasm, while I was nearly out of breath. In Yuping Tower where we stayed, overlooking Tiandu Peak in the early morning, I painted the first Chinese painting in my life. As the saying goes, trips after the Five Great Mountains belittle trips to other mountains, while trip after Mount Huangshan belittles trips to the Five Great Mountains. The peculiar granite peaks, pine trees and clouds in Mount Huangshan touched me profoundly. Sitting in the tourist bus leaving Mount Huangshan, I couldn't help but turn my head to take a final look  and instantly burst into tears! After this splendid, interesting and eye-opening month-long trip, Mr. Lin unfortunately fell sick and passed away in December of the same year.

In May of the following year, Mr. Lin's wife, Mrs. Lin took me to the house of Mr. Chen Ting, a close friend of Mr. Lin, and asked me to follow Mr. Chen to continue my study in Chinese painting. The 70-year-old Mr. Chen was also a painter at the Fuzhou Fine Arts Academy. He was famous in Fujian Province for his modern landscape paintings with a strong personal style. His bold and daring style of painting had already won my admiration! Not long ago, I saw Mr. Chen's paintings in the exhibition hall, and was very moved and stirred emotionally! I lingered in front of his painting until the exhibition

hall was about to close. As I was stepping out of the door, I was still reluctant to leave, looking back frequently and imaging that how perfect my life would be if I could study under his guidance. Mrs. Lin made my dream come true! At the same time, her wish for me, too, reached completion! In the autumn of that year, Mr. Chen was appointed to do a long-distance-journey sketch and a museum inspection. I became one of Mr. Chen's team members. We traveled to at least 14 cities, including Xuzhou, Luoyang, Xi'an, Wuhan, Yichang, the Three Gorges of the Yangtze River, Chongqing, Chengdu, Mount Emei, Leshan, Guilin, Guangzhou, Shantou and Xiamen. The two months' immersion in road-sketch broadened my visions. Upon returning to "Banyan City", I immediately devoted myself to creating works such as "Majestic Appearance of Wu Gorge" and "Misty Rain in Guilin", which were successively selected for provincial and municipal art exhibitions.

On New Year's Day of 1984, I left Fuzhou, my hometown where I was born and raised, and moved to Hong Kong. Everything about Hong Kong was new and unfamiliar to me. I did not speak Cantonese. After working in a silk flower factory for half a year, I decided to quit the job to paint at home. One day, my father returned to Hong Kong from the Mainland and asked me why I didn't go to work. I said, "I want to be a professional painter." The next day, my father was off to the Mainland, leaving behind the two months' rent unpaid (he used to pay the rent every month with some additional pocket money). This time, at the split moment, I suddenly realised I had been made to become a grown up (for the second time). It was impossible to make a living by painting in Hong Kong back then; therefore, I started to work again in order to support myself financially. I rode with the truck driver to deliver cardboard boxes, worked at the electroplating factory, and took a warehouse clerk job. I did four different jobs around the year when I had the privilege of learning Cantonese.

In 1985, a friend from my hometown referred me to a job of making oil paintings and paintings of commodities so that I was able to make a living. The best thing about this job was that I could paint at home without going out, which offered the greatest freedom for me. Because I was not familiar with the oil painting skills at the time, I allocated myself only half time every month to paint. In the remaining half a month, I engaged in art-related activities, such as getting to know the local customs, culture and art of the city, and joining several painting clubs, including Hong Kong Art Researching Association (President Chiu Sai Kwong), the Hong Kong Art Club (President Ting Chih Jen), the Chinese Contemporary Artists' Guild (President Luis Chan). I participated in the art exhibitions held by these art associations in the City Hall every year and met many art friends. During one of the exhibitions of the art fair, a senior well-established artist said to me: "You are good at painting, but being a painter in Hong Kong will starve you to death. So you should be like me, go to make money first, and then come back to the art when you make enough money." On hearing this, I thought, I seeded the tree of art in my heart when I was thirteen years old. I couldn't imagine how I can tell my tree of art that

I could not feed her with sunshine and rain until I made enough money. Would she still be there? Time flies, thirty-six years have passed, no matter how hard life is, I have never given up. Today, I still meticulously take care of my tree of art. During the 1986 exhibition, my work was collected by a banker. It is the first painting I sold (at HK$2,500), which was a great encouragement! Thereafter, I have been selling paintings for a living. Since 1987, my works have been selected for many other important exhibitions such as the "Contemporary Hong Kong Art Biennial Exhibition". In the same year, I won the Hong Kong Painting Competition.

Hong Kong is a metropolis where Chinese and Western cultures meet and blend. As a result of the special historical background, diversity, openness, tolerance, freedom and broad international perspective of Hong Kong, Hong Kong's design and other arts can be freely developed without any burden of rules or stereotypes, so as to be integrated into the world civilisation. At that time, I was surprised by many Hong Kong painters' works, such as Lui Shou Kwan's abstract ink painting as a combination of Chinese and the West, Irene Chou's ink universe containing a completely free and dreamlike imaginary time and space, and Liu Kuo Sung's new horizons of ink painting with various tools. Wucius Wong and Kan Tai Keung have brought design concepts in their paintings and paid special attention to the golden segmentation, making their plane pictures with a sense of European industrial revolution. Luis Chan has used free approach, bright colours and surreal images to present the characteristics of Hong Kong in a humorous way. All those artists have broadened my vision at the time.

In 1987, Ming Fan and I travelled to get married. Our first stop was Beijing. We visited many painters in the Beijing Fine Art Academy, including Zhao Chengmin, Zhang Bu, Wang Mingming, Li Xiaoke, Zhang Renzhi, Wang Wenfang, Yang Gang, Shi Qi, Zhuang Xiaolei, etc. I was deeply touched by their characters and works! The journey to Beijing has made me realise my inadequacies in comparison to those outstanding painters. After returning to Hong Kong, I formed the idea of studying at the Central Academy of Fine Arts.

# 藝評

## Art Critics

秦嶺雪，〈序言〉（節錄），《林天行畫集》，一九九六年

中國古代哲人孔子云：三十而立。對於一位中國畫的畫家來說，三十歲似乎只是少年。然而，三十年華的林天行已經在香港和北京舉行過七次個展，出版兩本畫冊，參加了中國美術家協會，不少作品被海內外知音收藏，同時，在一間著名的藝術院校授課，可謂桃李滿門。和許多早慧的著名畫家一樣，林天行也有頗為獨特的經歷，承受過生活的煎熬。這類故事對於當今見多識廣的朋友似乎不會有什麼觸動。但如果我告訴讀者諸君：有一位少年，當他剛剛升上初中就一心一意想當畫家，以為「天將降大任於斯人也」，百折不回走自己認定的路；十五年過去了，這位自小以繪畫為使命的青年，畢業於中央美術學院，並在北京中國畫研究院舉行他的首次個人畫展，驚動了張仃、劉勃舒、王鏞以及京華國畫界一大批重要人物，給予鼓勵，對未來寄予厚望——親愛的讀者，你是否也有一份有志者事竟成的感喟？是否也要動情地獻上一束鮮花？

The Chinese philosopher, Confucius once said, "Standing firm at thirty." For a painter of Chinese painting, thirty years old is still considered a young age. However, at the age of thirty, Lam Tian Xing has already held seven solo exhibitions in both Hong Kong and Beijing, published two albums of paintings, and has already been a member of the China Artists Association. His works have been collected widely by local and overseas connoisseurs. In the meantime, he is also teaching at a renowned school of art. Like many other famous painters who matured early, Lam Tian Xing also had unique experiences and shouldered the hardship of life. This story may not touch you if you have seen much of the world. However, there was once a young man who had made up his mind to be an artist just when he entered the secondary school, believing that fate had a great mission for him, and he headed on the path he took regardless of numerous setbacks. After fifteen years, the young man graduated from the Central Academy of Fine Arts and presented his first solo exhibition at Research Institute of Traditional Chinese Painting. His works touched Zhang Ding, Liu Boshu, Wang Yong and a lot of important figures of Chinese painting in Beijing who encouraged him with high expectations. Dear readers, would you be touched by this story about "where there is a will there is a way"? Wouldn't you want to give your respect by presenting him with a bouquet of flowers?

**Qin Lingxue, Preface (excerpts), *Paintings of Lam Tian Xing*, 1996**

據我所知，林天行學畫經歷大致是這樣的：開始時師從吳國光、林光、陳挺等幾位在福建頗有影響的畫家，後來在北京中央美術學院中國畫系學習，並在很大程度上受到劉牧的點撥，再後來，移居香港，用他自己的話來說，叫──自己幹。

我對林天行的了解，準確地說是這兩年的事，在我參與或採訪國內一些重大展覽時，如果不出意外大多都能與之謀面，並通宵細品他帶來的凍頂烏龍，當然，對他的作品解讀亦由此而不斷疊加。

謝海，〈以傳統反傳統──論林天行水墨景象〉（節錄），《當代中國山水畫新篇章──關注林天行》，二〇〇二年

As far as I know, Lam Tian Xing's art journey is roughly as follows: at the beginning, he was instructed by Wu Guoguang, Lin Guang and Chen Ting who are influential painters in Fujian Province. Later, he studied at the Chinese Painting Department of the Central Academy of Fine Arts in Beijing, and was instructed, to a large extent, by Liu Mu. Much later, he moved to Hong Kong and, in his own words, relied on himself.

It has been about two years since I knew about Lam Tian Xing. When I participated in or reported on some major exhibitions in the Chinese mainland, I would meet him unless something happened. We spent the night chatting while enjoying the Tung Ting oolong that he brought, and at the same time, my understanding of his works has been gradually refreshed.

**Xie Hai, Traditional versus Anti-traditional – a Theory of Lam Tian Xing Ink Scene(excerpts),** *Contemporary Chinese Landscape Paintings – Lam Tian Xing,* **2002**

**1978 年靜物素描**
**Still Life Sketches**
1978

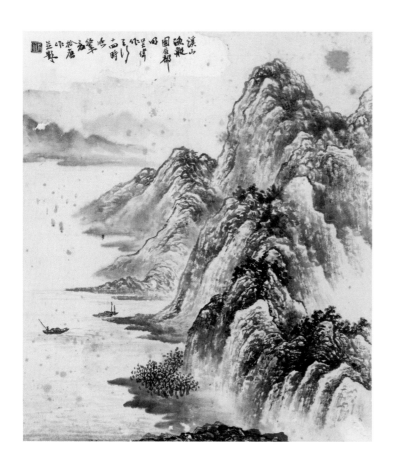

**仿明朝吳偉《溪山漁艇》（局部）**
**Fishing Boats on Rivers and Mountains, after Wu Wei (Ming Dynasty) (detail)**

水墨紙本
*Ink on Paper*
37x32cm ｜ 1977(signed at 2003)

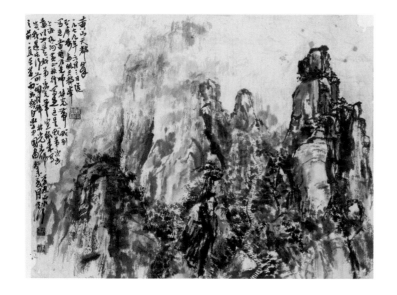

**黃山天都峰寫生**
**Sketch of Celestial Capital (Tiandu) Peak of Mount Huangshan**

水墨紙本
*Ink on Paper*
33x36cm ｜ 1979(signed at 2003)

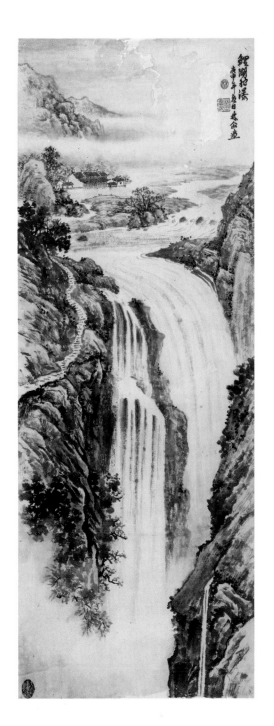

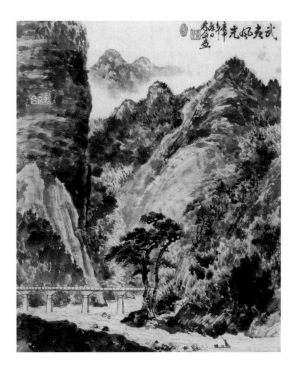

《鯉湖飛瀑》，仿恩師陳挺作品
**Carp Lake Falls, after Mr. Chen Ting**

水墨設色紙本
*Ink and Colour on Paper*
110x40cm ｜ 1980

《武夷風光》，仿恩師陳挺作品
**Scenery of Mount Wuyi, after Mr. Chen Ting**

水墨設色紙本
*Ink and Colour on Paper*
66x55cm ｜ 1980

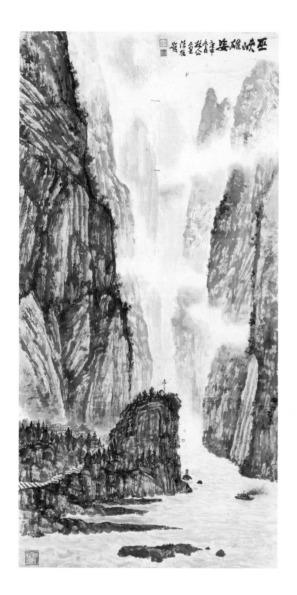

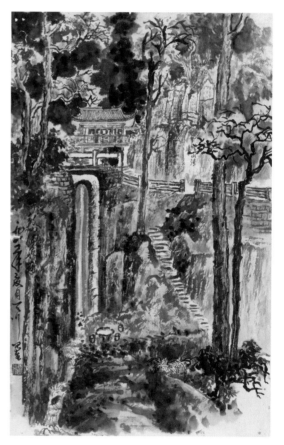

巫峽雄姿
**Majestic Appearance of Wu Gorge**

水墨設色紙本
*Ink and Colour on Paper*
100x50cm | 1980

鼓山湧泉寺寫生
**Sketch of Yongquan Temple of Mount Gu**

水墨設色紙本
*Ink and Colour on Paper*
55x35cm | 1981

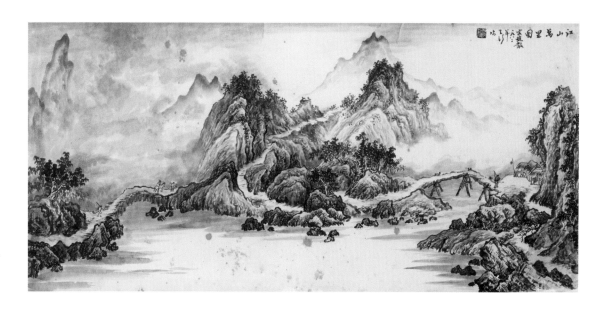

**仿宋朝趙黻《江山萬里圖》**
**Landscape of Ten Thousand Miles**
**of Rivers and Mountains, after**
**Zhao Fu (Song Dynasty)**

水墨紙本
*Ink on Paper*
42x88cm | 1982

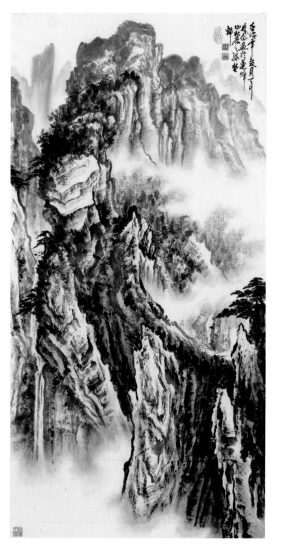

**蓮花峰山麓之綠埜軒**
**Luye Court at the Hillside of Lotus Peak**

水墨設色紙本
*Ink and Colour on Paper*
136x68cm | 1982

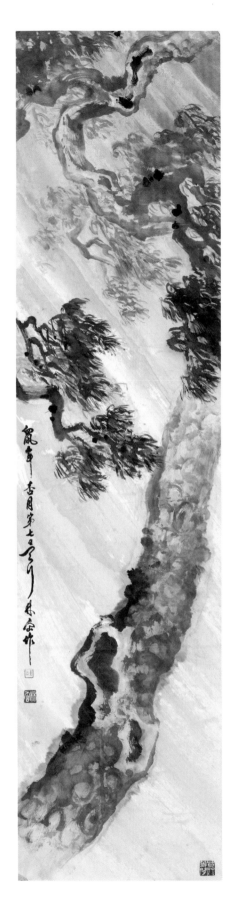

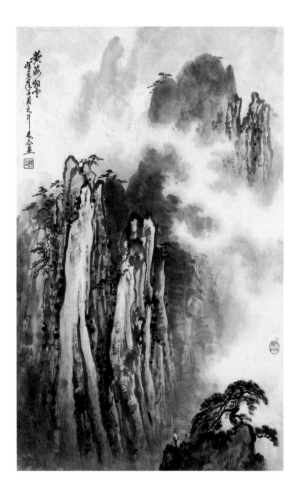

黃海煙雲
**Sea of Clouds of Mount Huangshan**

水墨設色紙本
*Ink and Colour on Paper*
68x42cm | 1983

風松
**Pines in the Wind**

水墨設色紙本
*Ink and Colour on Paper*
135x34cm | 1984

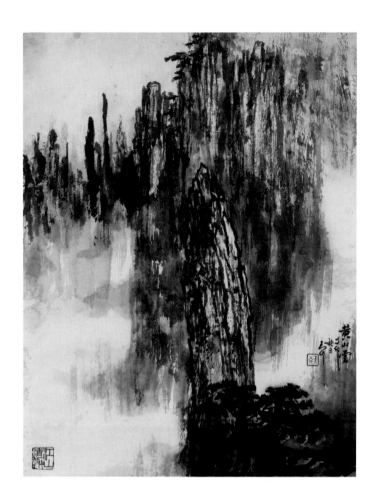

黄山雲寫生
**Sketch of Clouds of Mount Huangshan**

水墨設色紙本
*Ink and Colour on Paper*

52x40cm ｜ 1987

蘇州寫生
**Sketch of Suzhou**

水墨設色紙本
*Ink and Colour on Paper*

16x40cm ｜ 1987

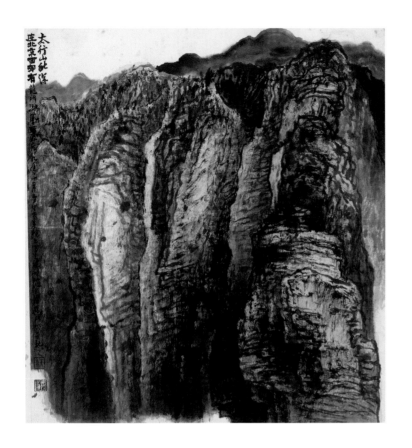

太行山寫生
**Sketch of Taihang Mountains**

水墨設色紙本
*Ink and Colour on Paper*

48x44cm ｜ 1989

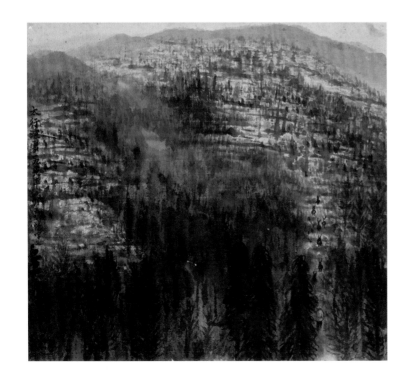

太行深處
**Deep in Taihang Mountains**

水墨設色紙本
*Ink and Colour on Paper*

42x47cm ｜ 1989

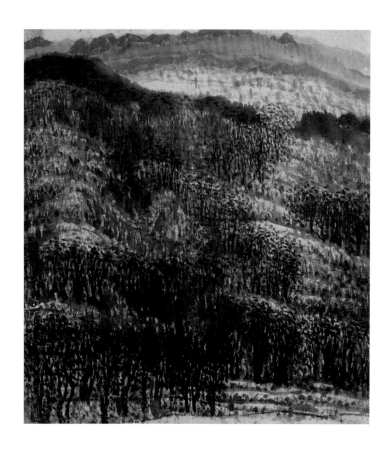

**太行山**
**Taihang Mountains**

水墨設色紙本
*Ink and Colour on Paper*
47x42cm ｜ 1989

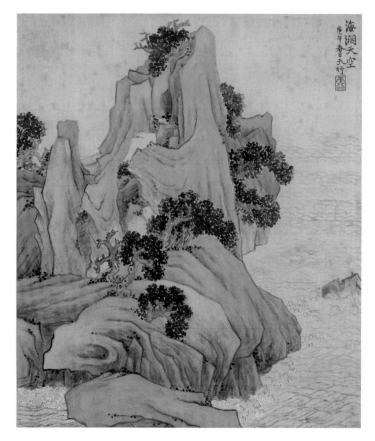

**仿清代任熊《海闊天空》**
**Boundless as the Sea and the Sky,**
**after Ren Xiong (Qing Dynasty)**

水墨設色紙本
*Ink and Colour on Paper*
40x34cm ｜ 1990

（二）

陝
北

求
變

（二）

陕北

求变

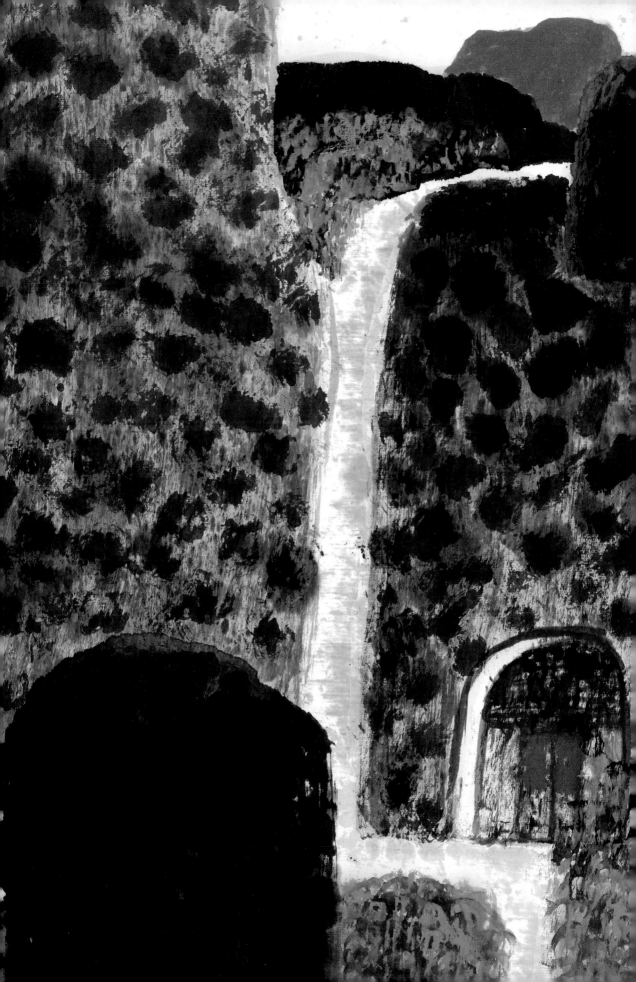

# 天 行
# 畫 語

1989 年 5 月，我坐在廣州開往北京的列車上，寫下兩句話：「融入北京現代藝術的洪流，走出一條屬於自己的路。」

中央美術學院樸實精進的校風深深感染了我。我在中國畫系山水畫工作室學習，導師有黃潤華、張憑、李行簡、賈又福、韓國臻、劉金貴等。還經常聆聽其他教授講課，有盧沉、李少文、王鏞教授等，有時還上門求教於周思聰、錢紹武、劉勃舒諸教授。此外，我也頻頻騎車去北京畫院、中國畫研究院、中央工藝美術學院，以及工藝美術學校拜師訪友，求教問道。同年 9 月，在同學于躍引薦下，我拜了第四位老師 —— 劉牧先生（當時任職於中國畫研究院）為師。我喜歡他的畫包含中西美學意味，富濃厚文人畫氣息，又有着民間藝術的奔放，作品含蓄而有張力。我更敬仰他為人剛正、莊重、平實、清心、學識淵博。他使我的觀念轉變，也影響了我日後的藝術歷程。

美院繁忙豐碩的一年很快過去了，1990 年秋季，我和同學們一起去陝北寫生。陝北是中華民族文化的發源地，對於久居江南的我既遙遠又陌生。我懷着好奇的心，乘坐一輛破爛不堪的中巴，沿着彎曲的小路艱難地行駛着。眼前是蒼茫的黃土地，漫山遍野五顏六色的莊稼，藍天里一朵白雲靜靜地躺在那裏，平平的山頂，突然從後面冒出一座尖尖的山。這是一個神奇的地方。我的視野完全被征服，我太愛她了。我們每天都在步行寫生，不知走過了多少黃土高坡。米脂、綏德、榆林、府谷、保德，也不知住過多少個窰洞，吃了多少麵食。回北

融入北京現代藝術的洪流，走出一條屬於自己的路。

京後，興奮無比的我開始投入創作。然而，一張一張的失敗，一張又一張的重新開始……其實，那幾年我一直都在求變、求異、求索！真是「蜀道難難於上青天」，我陷入了深深的困境。

那些年，我也看了很多西方大師的作品，喜歡的有很多。彼時，腦海裏浮現出克里姆特的畫，他裝飾性的點彩效果，畫面富有東方的神韻，我心想：何不借他山之石？就是點和塊的抽象思維。陝北破繭而出的蛻變，擋不住的波濤洶湧的情緒……是年 12 月，應邀在中國畫研究院舉辦我的首次個人畫展——「陝北系列」。四十幅構圖各異、手法不同的作品，雖然顯得不成熟，但已構出新境，畫出自己的面貌。展覽開幕那天，來賓擠滿了展廳，包括中央美術學院、北京畫院、中央工藝美術學院、工藝美術學校、中國畫研究院的許多教授和藝術家。周思聰老師指着其中一幅畫對盧沉教授說：「天行畫出了陝北的蒼茫。」劉勃舒院長還專為此展，邀請了數十位名家主持閉幕禮！

兩年的北京求學，此時算是畫上一個句號。路漫漫其修遠兮，吾將上下而求索！我的藝術之旅才剛剛開始。

# Tian Xing's
# Thoughts 天行

In May 1989, sitting on the train from Guangzhou to Beijing, I wrote down two sentences: "Assimilate the flow of modern art in Beijing, and build a path of my own."

The guileless and progressive atmosphere of the Central Academy of Fine Arts (CAFA) has deeply influenced me. I studied in the Landscape Painting Studio of the Chinese Painting Department, and my tutors included Professors Huang Runhua, Zhang Ping, Li Xingjian, Jia Youfu, Han Guozhen, Liu Jingui, etc. I also attended lectures by other professors, such as Professors Lu Chen, Li Shaowen and Wang Yong, and from time to time, I visited Professors Zhou Sicong, Qian Shaowu and Liu Boshu. In addition, I frequently cycled to the Beijing Fine Art Academy, Research Institute of Traditional Chinese Painting (now the China National Academy of Painting), the Central Academy of Arts and Design (CAAD), and the Arts and Crafts School to visit teachers and friends, and seek advice. In September of the same year, I became the student of Mr. Liu Mu (he was working at the Research Institute of Traditional Chinese Painting) on my classmate Yu Yue's recommendation. Mr. Liu is my fourth teacher. I like his paintings which contain Chinese and Western aesthetics, full of an aura of literati painting but unrestrained style of folk art. His works are subtle with a certain degree of tension. I admire his character of being upright, solemn, straightforward, pure-hearted and knowledgeable. He has changed my concepts about paintings and influenced my future artistic journey profoundly.

A busy and fruitful year in the CAFA passed quickly. In the autumn of 1990, I went to Northern Shaanxi with my classmates to sketch. Northern Shaanxi is the birthplace of Chinese culture. It was far and unfamiliar to me who had lived in the south of the Yangtze River for a long time. With a heart full of curiosity, I rode in a shabby mid-sized bus travelling along the winding, dusty and narrow road. In front of me was the vast yellow land, and the mountains and fields were full of colourful crops. In the blue sky, a white cloud was quietly wading. A sharp mountain peak suddenly appeared from the flat top of another mountain. This magical place conquered me completely and made me fall in love with her. We walked on the yellow land of the Loess Plateau every day to sketch. We

had been to Mizhi, Suide, Yulin, Fugu and Baode. I had no idea how many slit-like slopes we climbed, how many cave dwellings we lived in and how many noodles we ate. After returning to Beijing, I was very excited and immediately started putting all my efforts into creating new works. However, I failed, one painting after another; I restarted, a new one after another. In fact, in those years, I have been always seeking changes and differences, and exploring all means. Nevertheless, "it is more difficult to climb the Shu Road than going up the blue sky!" I was in a deep dilemma.

## *Assimilate the flow of modern art in Beijing, and build a path of my own.*

In those years, I read a lot of works by Western masters and admired a lot of them. At that time, Klimt's paintings emerged in my mind with the decorative pointillism effect and oriental charms in his paintings. I formed an idea that perhaps I might borrow "the stone from another mountain", that is, abstract thinking of dots and blocks. I can't stop the tempestuous emotions, undergoing such a great transformation taking shape from the cocoon in Northern Shaanxi. In December of that year, I was invited to hold my first solo exhibition – "Northern Shaanxi Series" at Research Institute of Traditional Chinese Painting. Forty works with different compositions and techniques presented a new realm with new style of my own, though immature. On the opening day of the exhibition, the exhibition hall was packed with guests, including many professors and artists from the CAFA, Beijing Fine Art Academy, CAAD, the Arts and Crafts School, and Research Institute of Traditional Chinese Painting. Professor Zhou Sicong, pointing to one of the paintings, said to Professor Lu Chen, "Tian Xing has painted the vastness of Northern Shaanxi." President Liu Boshu invited dozens of famous artists to preside over the closing ceremony for this exhibition!

My two-year study in Beijing had come to a close. The road of art is long and far. I shall explore and quest tirelessly. My art journey has just begun.

# 評

## Art
## Critics

林天行最早為國內畫壇所關注要從一九九〇年他從中央美術學院中國畫系畢業說起。那年十二月，由中國畫研究院（即今之國家畫院）院長劉勃舒主持，該院舉辦了林天行首次個展「陝北系列」。那些作品利用墨點與色點整合成塊，打破了傳統框架，卻又渾樸莊嚴，表達出對黃土高原文化發源地的迷戀與熱愛，得到了北京畫界和傳媒的好評。

嚴長元，《彩墨天行》（節錄），《中國文化報·美術周刊》，二〇〇九年四月二日

Since Lam Tian Xing graduated from the Chinese Painting Department of the Central Academy of Fine Arts (CAFA) in 1990, he appeared to be a rising star in the Chinese art circle. In December of that year, Research Institute of Traditional Chinese Painting (now the China National Academy of Painting) held Lam's first solo exhibition "Northern Shaanxi Series", hosted by the then Dean Professor Liu Boshu. In these works, Lam integrated ink and colour into blocks, breaking the traditional Chinese painting framework but in a vigorous, simple and solemn manner. These works embodied Lam's fascination with the birthplace of Loess Plateau culture and had won him great praises amongst the artists and the media in Beijing.

**Yan Changyuan, Ink Colour · Tian Xing (excerpts),** *China Culture Daily Art Weekly*, **2 April 2009**

在畫陝北、畫高原的畫家中，林天行是獨特的一個，因為他是從香港去的，他是第一個畫陝北並在北京舉辦了以《陝北系列》為題的展覽的香港青年畫家。一個在鬧市中的畫家想去畫他原先不熟悉的陝北，的確需要幾分勇氣。林天行為陝北之行作了好些年準備。這種準備包括在山水技法上廣收博采和藝術意境上漸次專注於樸實與深沉。後者尤其是他決心在香港山水畫壇中走出自己路子的勇氣所在。在陝北的日子裏，他是一個扎扎實實畫速寫的「苦學派」，而不像有的大陸畫家是以走以看以感受為主的「印象派」。因此，他從幾大本速寫中提煉出來的《陝北系列》，是有真切情感投入和有具體丘壑形象支撐起畫面結構的一批作品，他畫中出現的一種耐看的手筆和厚實的氛境，是很體現藝術價值的。

一個受快節奏生活薰染的畫家現在畫出了陝北高原的蒼茫、古老、緩慢延伸但內構緊勁的形象，一個以繽紛眩目的色光世界走出的畫家現在把握住了沉穩、凝重、淳郁的黃土本色，這不僅是林天行繪畫技法上的提高，而且是他藝術格調和藝術觀念上的升級或超越。我在看了他的展覽之前看了他的速寫本上的素材，我預言他的畫將以具體的生動打動觀眾，看了他的系列之後，我覺得除了描繪陝北的形象，他還把握了那片土地打動人們心靈的東西。這正是作為一個山水畫家步向成熟的標誌。

范迪安，〈黃土地的啟示——跋林天行《陝北系列》〉（節錄），
《台港文學選刊》，一九九一年

Amongst the artists who painted Northern Shaanxi and the plateau of the yellow earth, Lam Tian Xing is unique in his way. Lam is the first Hong Kong artist who painted the yellow earth and held an exhibition in Beijing. It requires a lot of courage for an artist from a bustle metropolis to take the challenge to paint Northern Shaanxi which he was unfamiliar with. Lam spent several years preparing his trip to Northern Shaanxi. He worked on landscape painting techniques by studying from various artists, thus developed his own artistic conception and eventually focused on simple and strong expressive style. This experience once again encouraged him to further develop his unique bold style in landscape painting in Hong Kong. These days in Northern Shaanxi, he worked extremely hard on his sketching skills on landscape, unlike other Chinese artists who more or less worked like "impressionist". Therefore, Lam's Northern Shaanxi series clearly showed his strong feelings and dedicated emotional engagement. The images of hills and gullies of this series are sustained with defined structures that are representative of the atmosphere of the territory with a strong impression. The artistic values of those paintings are truly reflected in this series.

Though living in a fast-paced metropolis, Lam is able to paint the images of the vast, ancient, slowly expanding but compact Northern Shaanxi. He also grasps the tranquility, dignity, simple and melancholy of the Northern Shaanxi yellow earth (the Loess), despite coming from a multicoloured world. This is not only a sign of improvement in his techniques but also a transcending of his art conception and style. I have read his sketchbooks before the exhibition and thus anticipated that his paintings would make a vivid impression on his audience. Now, seeing his paintings, other than lively depicting the scenery of Northern Shaanxi, he has also grasped something that could touch people's heart. This is exactly the milestone of an artist moving towards maturity.

**Fan Di'an, Inspiration of the Yellow Earth (The Loess) –**
**Postscript for Lam Tian Xing "Northern Shaanxi Series" (excerpts),** *Taigang wenxue xuankan*, **1991**

陝北寫生
**Northern Shaanxi Sketch**

鉛筆紙本
*Pencil on Paper*
25x25cm ｜ 1990

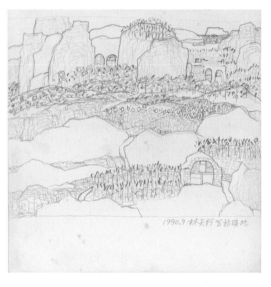

陝北寫生
**Northern Shaanxi Sketch**

鉛筆紙本
*Pencil on Paper*
25x25cm ｜ 1990

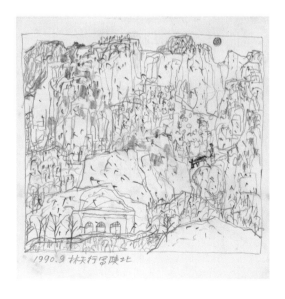

陝北寫生
**Northern Shaanxi Sketch**

鉛筆紙本
*Pencil on Paper*
25x25cm ｜ 1990

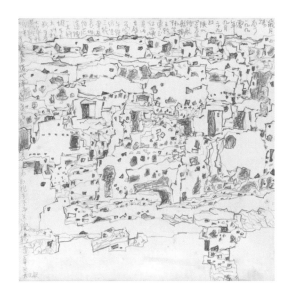

陝北寫生
**Northern Shaanxi Sketch**

鉛筆紙本
*Pencil on Paper*
25x25cm | 1990

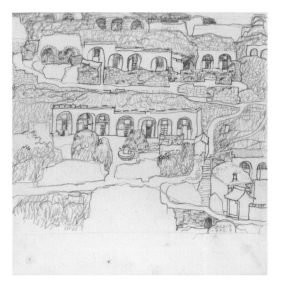

陝北寫生
**Northern Shaanxi Sketch**

鉛筆紙本
*Pencil on Paper*
25x25cm | 1990

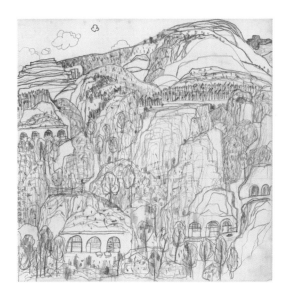

陝北綏德寫生
**Suide, Northern Shaanxi Sketch**

鉛筆紙本
*Pencil on Paper*
25x25cm | 1990

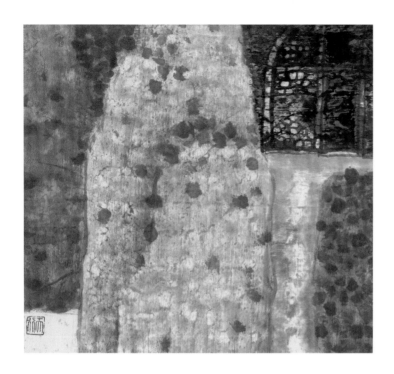

陝北系列 (一)
**Northern Shaanxi Series (1)**

水墨紙本
*Ink on Paper*

43x47cm | 1990

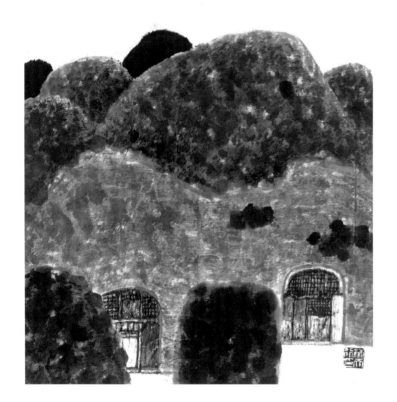

陝北系列 (二)
**Northern Shaanxi Series (2)**

水墨設色紙本
*Ink and Colour on Paper*

47x43cm | 1990

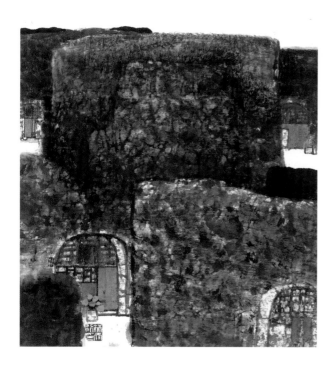

陝北系列 (三)
**Northern Shaanxi Series (3)**

水墨設色紙本
*Ink and Colour on Paper*
47x43cm | 1990

陝北系列 (四)
**Northern Shaanxi Series (4)**

水墨設色紙本
*Ink and Colour on Paper*
43x47cm | 1990

陝北系列（六）
**Northern Shaanxi Series (6)**

水墨設色紙本
*Ink and Colour on Paper*
47x43cm ｜ 1990

陝北系列（八）
**Northern Shaanxi Series (8)**

水墨設色紙本
*Ink and Colour on Paper*
43x47cm ｜ 1990

**山路**
**Path**

水墨設色紙本
*Ink and Colour on Paper*

68x68cm | 1990

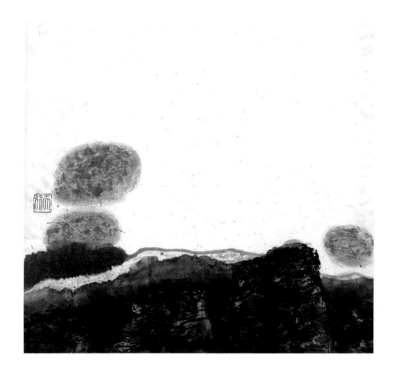

**陝北系列**
**Northern Shaanxi Series**

水墨設色紙本
*Ink and Colour on Paper*

68x68cm | 1990

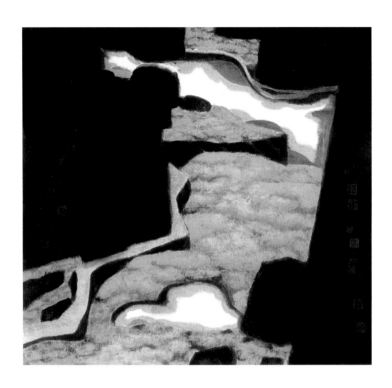

**生命的過程**
**Process of Life**

水墨設色紙本
*Ink and Colour on Paper*
88x95cm ｜ 1991

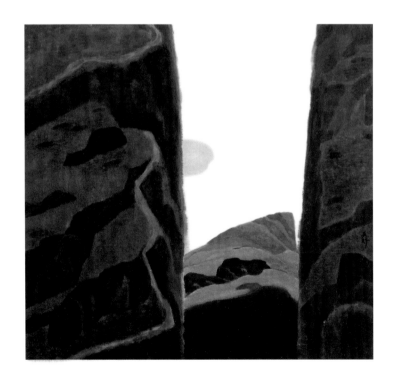

**嚮往**
**Yearning**

水墨設色紙本
*Ink and Colour on Paper*
88x95cm ｜ 1991

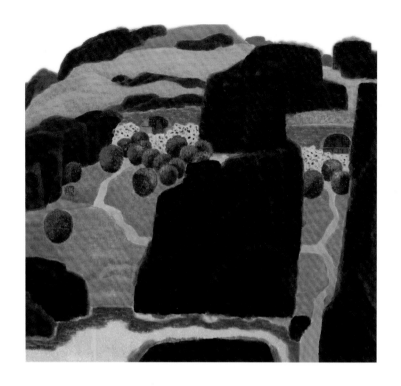

**我迷戀着這塊土地**
**I am Infatuated with this Land**

水墨設色紙本
*Ink and Colour on Paper*
88x95cm | 1991

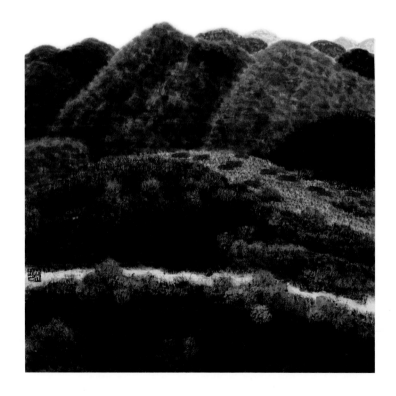

**秋路**
**Path in the Autumn**

水墨設色紙本
*Ink and Colour on Paper*
68x68cm | 1991

㈢

景象

香港

1996 ——— 1999

香港

景象

（三）

Hong Kong

(III) Scene.

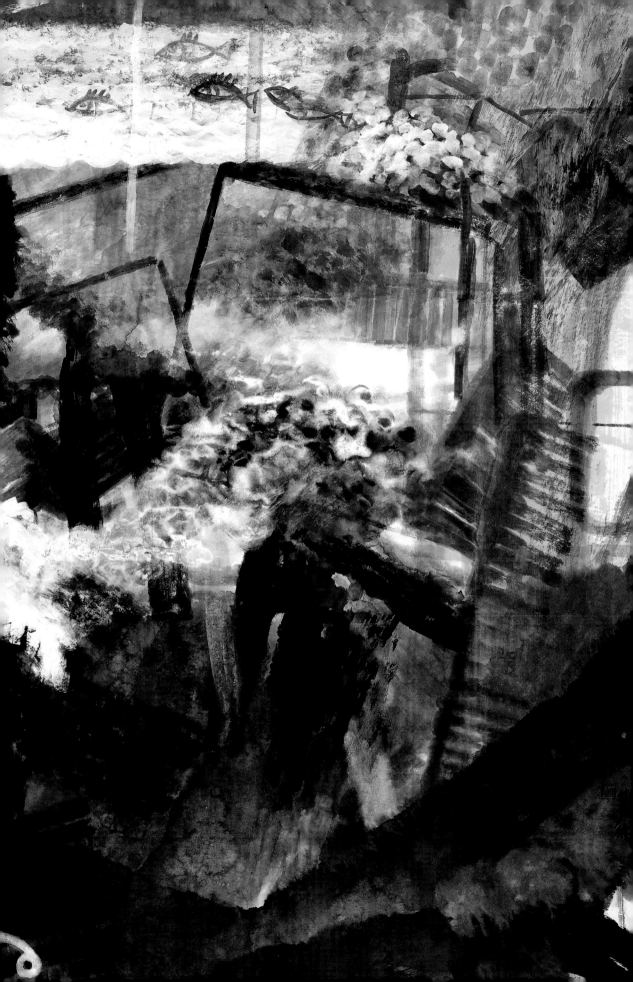

# 天行
# 畫語

1999 年我以「景象香港」為名，在香港藝術中心舉辦個展，近百幅作品都是在兩年之間完成的。1997 年我曾以同樣的題材，在同樣的地方舉辦過畫展。兩次畫展的不同之處在於，1999 年的「景象香港」因我開拓了視野而更加豐富多彩，作品樸素並嚴謹了許多，它是我在原有的觀念上重新審視而呈現出的「意象彩墨畫」。

記得 1984 年剛移居到香港時，這裏的一切對我來說都是陌生的，也是神祕的。當時在尖沙咀海旁，看着滿眼直綫的石屎森林和車水馬龍的高架橋，頓感茫然。怎樣才能以中國畫的形式來表現她呢？面對社會的迅速變遷，以及新思潮的不斷湧現，中國畫原來的模式顯然難以駕馭今天的景象。

十年後，我再次燃起要畫香港的欲望。古人可以「點石成金」，把一塊石頭畫出靈性，並賦予崇高的象徵，我們也同樣可以為眼前的物象傳情達意，賦予新生。只有激情澎湃才能激起激情，只有精神飽滿的人才能畫出精神。只要找到美的規律和正確的觀念，然後靜觀萬物，自然皆能自得。

創作是詮釋對生活的理解，是感悟的昇華。香港是充滿活力的國際大都會，四處都展現出生機勃勃的景象。然而，維港兩岸摩天大樓以外的新界，更讓我着迷。繁忙的國際貨櫃碼頭，高低不同的房屋，無處不在的郊野公園和周邊的樹林，連綿不斷的山路，水塘、大海、古廟、板樟、鞦韆、巴士、小巴，甚至一道曙光，一朵掉落窗前的雲彩……這些都成了我表現的符號。

　　我喜歡異想天開，自由自在地表達對生活瞬間的體悟；喜歡作鳥瞰觀景，以大觀小，任意發揮大自然的形態；喜歡以豪邁奔放的筆觸，厚、重、艷、滿的畫面，使墨色交融，縱橫交錯，遊離在抽象與意象之間，時而重彩積色，時而多層積墨，時而光影通透。

　　如果說這些是我眼中的景象，倒不如說是我將心中的景象轉化為手中的景象。其實畫什麼，怎麼畫都不重要，重要的是找到一種不受題材限制的表現手法，從而展開你「心象」的旅程。

# Tian Xing's Thoughts 天行

In 1999, I held a solo exhibition at the Hong Kong Arts Centre on the theme of "Scenes · Hong Kong". Nearly 100 works were completed within two years. Before that I had held an art exhibition in the same place with the same theme in 1997. The difference between the two exhibitions is that the latest one is more colourful, because I have broadened my horizons, and my works became simpler and even more rigorous. "Scenes · Hong Kong" is "imagery colour ink painting" which has been created by re-examining my original artistic concept.

When I moved to Hong Kong in 1984, everything here was unfamiliar and mysterious to me. At that time, I often sat at the seaside of Tsim Sha Tsui, looking at the concrete jungle and the flyovers, I came to a loss. How can I present Hong Kong in the form of Chinese painting? In the face of rapid social changes and the continuous emergence of new trends of thought, it is obviously difficult to adopt the traditional way of Chinese painting to today's scenes.

Ten years later, my desire to paint Hong Kong was rekindled. The ancients could "touch to change stone into gold", then a stone can also be painted to give it a sublime symbol. I believe that we can also express our feelings and give a new life to the objects before our eyes. Only those with great passion can fire up fervour and only people with ethereal minds can give his drawings the spirit. If one can find the law of beauty with righteousness, he would content himself and find peace by observing the natural surroundings.

Art Creation is the process of interpreting our understanding of life and sublimating our feelings. Hong Kong is a vibrant cosmopolitan city with vitality everywhere. However, the New Territories beyond the skyscrapers on both sides of the Victoria Harbour has fascinated me even more. There are busy international container terminals, houses of different heights, country parks everywhere and surrounding woods, continuous mountain roads, ponds, the sea, ancient temples, benches, swings, buses and minibuses, and even a light of dawn, or the clouds falling in front of the window. All of these have become the symbols I use.

I like to indulge in the wildest fantasy and express my understanding of life's moments freely. I like to observe from a bird's eye view, seeing the small from the viewpoint of the large (*yi da guan Xiao*), and give full play to the form of nature. I also like to use bold brushstrokes and full composition with thick, heavy and bright colours, so that the ink colours blended together and crisscrossed between abstraction and imagery, switching between accumulated heavy colour and multi-layer ink, with transparent light and shadow.

These are scenes from my heart rather than my eyes. As a matter of fact, it doesn't matter what you paint or how you paint. The most important thing is to find a way of expression that is not restricted by the subject matter, to start your journey of pursuing images from mind-and-heart.

# 藝評

## Art Critics

林天行是九人中較年輕的畫家，少具才情，喜作千里之行，邊城古鎮，實地寫生，用色大膽，筆觸豪放，其盈丈巨幅，氣勢逼人。

王無邪，《港水港墨》（節錄），二〇一一年

Lam Tian Xing, the youngest artist in this exhibition, emerged as an unusual talent at an early age. During his frequent and long travels, he has created bold drawings of remote towns and ancient villages with ink and watercolour, showing strong visual impact in huge dimensions.

**Wucius Wong, *Shui Mo Hong Kong* (excerpts), 2011**

用現代構成加重彩，結合傳統筆墨、現實符號來描繪現代都市和現代生活，既寫實又寫意的，甚至有超現實意味在裏面，讓人有無限想像的空間，恐怕在中國畫歷史上你是第一人。

孔雁，天行訪談（節錄），二〇一〇年四月於香港大也堂

You have combined heavy colours, modern compositions, traditional brush and ink techniques and symbols to depict modern cities and lives. You are unprecedented in the history of Chinese painting in the way that your paintings reflect reality in an expressive, almost surreal way, leaving plenty of rooms for imaginations.

**Kong Yan, interview with Lam (excerpts), in 2010 at The Hall of Boundlessness**

林天行是從內地移居香港而建立鮮明獨特風格的畫家。他生於中國福州，早年曾隨多位名家研習繪畫。一九八四年移居香港，他擅繪繪山水、風景，自印象派畫風的色調和光綫處理中取得靈感，又揉合中國畫的筆意和墨法，以寫意和半抽象化的手法造境移情。他擅於利用點、綫和塊面剪裁風景，墨色渲染自由揮灑，具有一種朦朧之美。其意象具有中國文人畫那種詩情意，色調對比鮮明斑駁，任意揮灑。其畫作中亦不乏描繪香港城市景色，表現了囂擾生活以外的一種詩意情懷，體現了畫家將水墨畫詩境再造，別具創意。

鄧海超，《港水港墨》（節錄），二〇一一年

Lam Tian Xing is an artist defined by his iconoclastic spirit. Born in Fuzhou, China, he has benefited from the mentorship of several renowned masters. In 1984, he moved to Hong Kong. Well versed in landscape and scenery, he has drawn inspiration from the colour tone and treatment of light from the Impressionism, which he then integrated with the concepts and methods of brush and ink in Chinese painting, and adopted the freehand (*xieyi*) painting style and a half abstract approach in creating a scene and shifting sentiments. Accomplished in using dots, lines, planes and blocks in fleshing out a scene, the artist takes free liberty with ink diffusion (*xuanran*) and brings a misty beauty to his canvas. His imagery painting has the poetic language of Chinese literati painting, with bright contrast for colours, and freely sprinkling and swaying brushworks. A main fixture in his oeuvre, his cityscape of Hong Kong offers an oasis of poetic sentiments in the midst of the bustling city life, attesting to the artist's originality in reinventing the poetic realm of ink painting.

**Tang Hoi Chiu,** *Shui Mo Hong Kong* **(excerpts), 2011**

Lam Tian Xing's paintings have become what they are today, roughly starting in 1996. In a letter to his friends that year, he wrote: "I began to express the 'scenes' of Hong Kong and the New Territories in 1996. I have never sketched a scene from life, but relying entirely on silent observations, memories, imaginations and a sincere heart. Of course, more importantly, it makes me impulsive."

On such an impulse, Lam Tian Xing has chosen Hong Kong as the subject matter of his paintings which is a special modern city blended between Chinese and the Western cultures. He has opted for a vibrant style that undercuts traditional brushwork and ink while emphasizing colour and modern composition.

Whether at the time of production or with hindsight, not all works of "Scenes · Hong Kong" series are masterpieces that can be scrutinised in depth. It is the fact that he has not proposed a relatively systematic theoretical framework at that time. However, what the art circle really appreciates is the premature but novel "Scenes · Hong Kong" series.

Lam Tian Xing's "Scenes · Hong Kong" has become the brand image of "Hong Kong people paint Hong Kong" for a period of time. For Hong Kong people, those who have been to Hong Kong or those who know Hong Kong better, viewing Lam's works has become a way of recalling their memories of Hong Kong. At the same time, it is believed that his paintings have created a relaxed atmosphere for thinking.

This kind of thinking originates from that, using the language of painting, Lam has not only rewritten the new concept of ink painting in modern civilisation with creative imagination, strong will and palpable enthusiasm, but also illustrated the possibility and scope of developing further ink painting. More importantly, Lam Tian Xing's works have become an integral part of the recently popular "City and Ink Painting" series.

As the quasi-experimental ink painting, works in "Scenes · Hong Kong" series still appeared a bit rough and coarse, though very eye-catching, confident and talented. This is one of my basic viewpoints on Lam Tian Xing's recent works. In 1999, Lam published an album titled "Scenes · Hong Kong". The collection repeatedly derives symbols of modern civilisation, such as street lamps, cars, benches, as well as the "circle" of the traffic lights and the "olive shape" refined as the fish of life to strengthen the symbol of the concept and so on. Taking a corner of Hong Kong as the main image and using large blocks of loud primary colours, Lam tried hard to convey to his audience the colourful and bizarre magic of Hong Kong. However, in many works, the painter seems to stress his professional training and have to compromise. As a result, old brushwork and ink methods, and modern space have not blended together well, leaving a mixture of the lyric dream and old rules.

**Xie Hai, Traditional versus Anti-traditional—A Theory of Lam Tian Xing Ink Scene(excerpts),** *Contemporary Chinese Landscape Paintings—Lam Tian Xing,* **2002**

林天行的畫變成今天這個樣子，大致肇始於一九九六年。他在這一年給其朋友寫信時這樣寫道：「我從九六年開始表現香港、新界的『景象』，從沒有對景寫生，完全靠靜觀默察，靠記憶、靠想像力、靠一顆摯誠的心，當然更重要的是它能使我衝動。」

衝動之下，林天行的畫在題材上選擇香港——一個很特別的、在文化層面上受着來自中西方雙重擠壓的現代都市；在風格上選擇現代——一種削弱傳統筆墨，強調色彩和現代構成的識別系統。

無論在當時看，還是事後看，林天行的「景象·香港」系列作品並非件件都是可以深入推敲的精品之作，也沒有由此提出一個相對系統的理論框架，這是事實。但畫壇真正接受林天行或者說他的作品卻正是不怎麼成熟、卻又特別新穎的「景象·香港」，這也是事實。

林天行的「景象·香港」在某一段時間裏依然成了「香港人畫香港」的品牌形象。對於香港人、去過香港或者對香港比較了解的業內人而言，觀賞林的作品已經成為他們尋找記憶的一種方式，同時，人們還相信他能讓一個人在鬆弛的狀態下進行思考。

這種思考不僅是因為用繪畫語言創造的藝術家以富有創意的想像、堅挺的意志和可以觸摸到的熱情重寫水墨畫這個傳統畫種在現代文明之下的新概念，還為讀者圖式了水墨空間拓展的可能性，更重要的是林天行以自己執着行動使其作品演繹為近來被熱炒的「都市與水墨」中的一個部分。

「景象·香港」作為準實驗水墨，儘管非常引人注目，充滿自信與富於才氣，成品還是顯得有些粗糙。這是我對林天行近作的基本看法之一。一九九九年，畫家以「景象·香港」為題出了一本畫冊，在這本集子中作品裏反覆出現具有現代文明標志的路燈、汽車、坐椅、標志牌，以及紅綠燈演換的「圓」、作為生命的魚所提煉的「橄欖形」來加強概念的象徵性等等。以香港一隅為主體形象，畫面上有大塊響亮的原色，畫家似乎在努力傳達香港這個色彩斑斕且光怪陸離的神奇。不過，許多作品又想標明自己曾經科班的身分而不得已來取折中的方式——舊的筆墨程式調度和間離沒有更好地糅合在一起，使得抒情的夢幻和束縛一併被書寫在尺素之中。

謝海，〈以傳統反傳統——論林天行水墨景象〉（節錄），《當代中國山水畫新篇章——關注林天行》，二〇〇二年

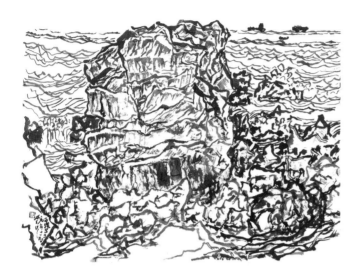

**石澳寫生**
**Sketching in Shek O**

水墨紙本
*Ink on Paper*
35x44cm ｜ 2019

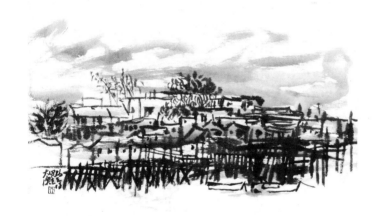

**大澳夕照**
**Sunset in Tai O**

水墨紙本
*Ink on Paper*
46x59cm ｜ 2019

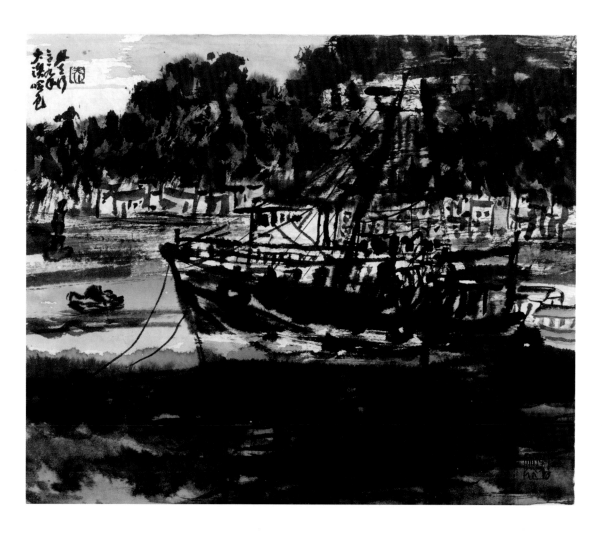

大澳寫生

**Sketching in Tai O**

水墨設色紙本

*Ink and Colour on Paper*

35x44cm ｜ 2019

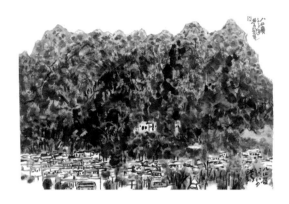

八仙嶺寫生
**Sketching in Pat Sin Leng**

水墨設色紙本
*Ink and Colour on Paper*
47x70cm | 2020

維港寫生
**Sketching in Victoria Harbour**

水墨設色紙本
*Ink and Colour on Paper*
47x70cm | 2020

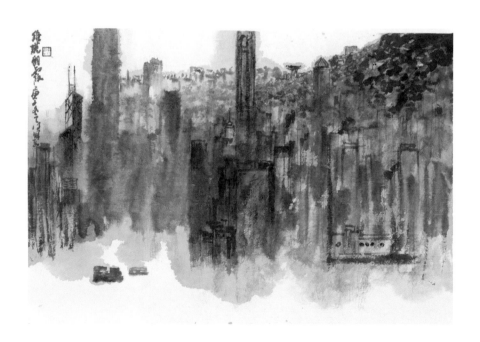

維港寫生
**Sketching in**
**Victoria Harbour**

水墨設色紙本
*Ink and Colour on Paper*
47x70cm | 2020

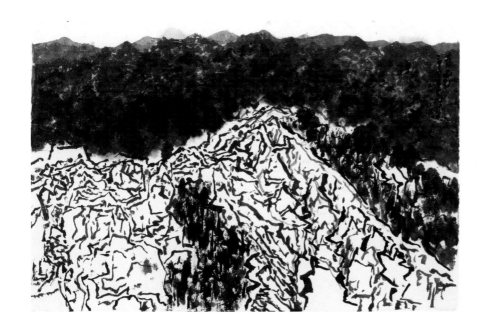

**屯門山色**
**Tuen Mun**
**Mountains**

水墨紙本
*Ink on Paper*
47x70cm ｜ 2020

**萬宜水庫寫生**
**Sketching at High**
**Island Reservoir**

水墨設色紙本
*Ink and Colour on Paper*
35x46cm ｜ 2020

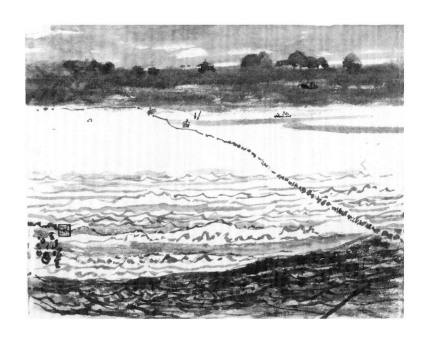

**貝澳海濱寫生**
**Sketching at Pui O Beach,**
**Lantau Island**

水墨紙本
*Ink on Paper*

35x46cm | 2020

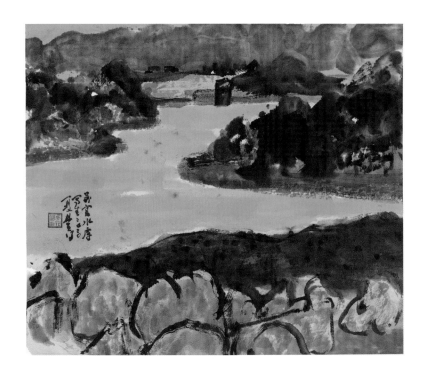

**萬宜水庫寫生**
**Sketching at High Island**
**Reservoir**

水墨設色紙本
*Ink and Colour on Paper*

32x40cm | 2020

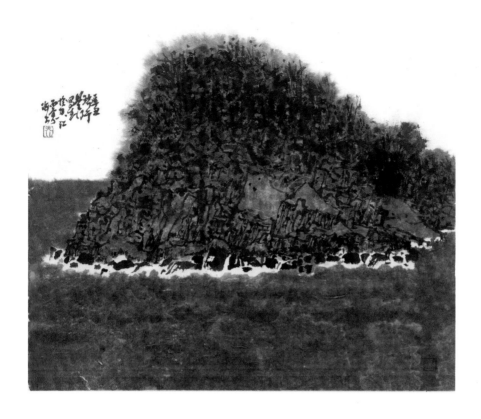

西貢海上寫生
**Sketching at Sai
Kung Sea**

水墨紙本
*Ink on Paper*
45x48cm ｜ 2021

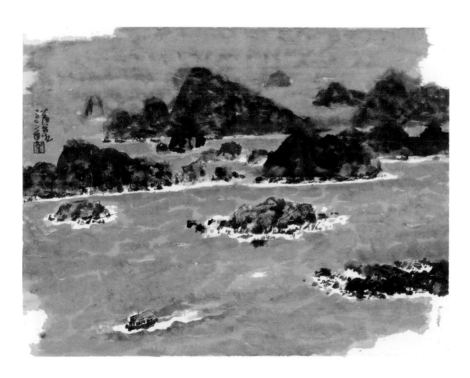

西貢寫生
**Sketching in Sai
Kung**

水墨設色紙本
*Ink and Colour on Paper*
43x58cm ｜ 2022

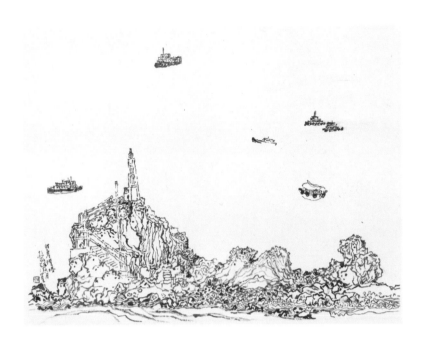

鯉魚門燈塔寫生
**Sketch of Lei Yue Mun
Lighthouse**

水墨紙本
*Ink on Paper*
35x46cm｜2020

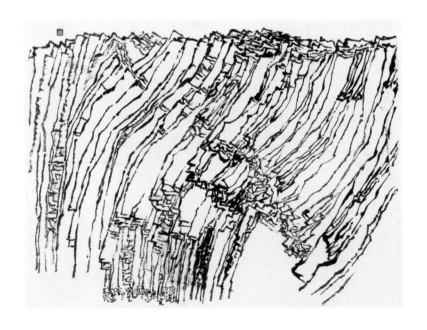

香港西貢地質公園寫生
**Sketching in Hong Kong
Geopark, Sai Kung**

水墨紙本
*Ink on Paper*
35x46cm｜2020

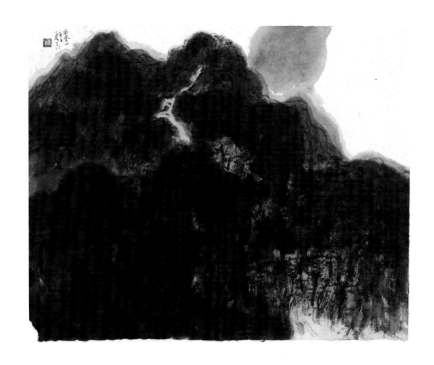

**鳳凰山寫生**
**Sketching on Lantau Peak**

水墨設色紙本
*Ink and Colour on Paper*
38x47cm ｜ 2020

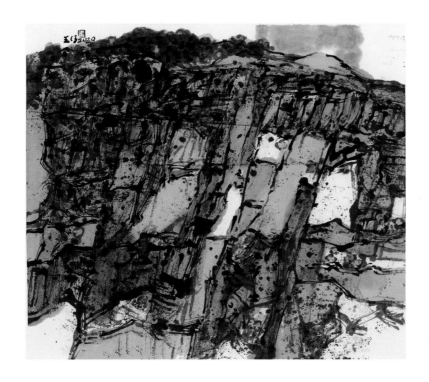

**鯉魚門山色**
**Lei Yue Mun Mountains**

水墨設色紙本
*Ink and Colour on Paper*
35x40cm ｜ 2020

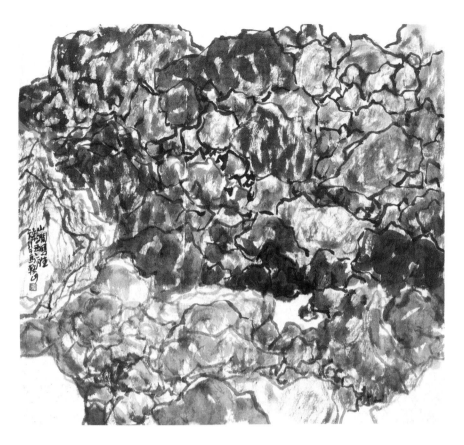

**馬鞍山山澗寫生**
**Sketch of Mountain**
**Stream at Ma On**
**Shan**

水墨紙本
*Ink on Paper*
44x48cm | 2021

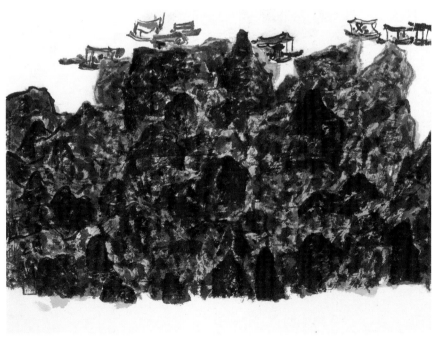

**赤柱寫生**
**Sketching at**
**Stanley**

水墨設色紙本
*Ink and Colour on Paper*
34x46cm | 2021

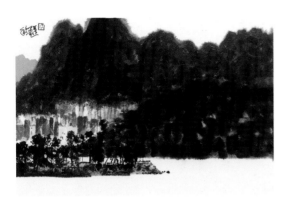

**馬鞍山寫生**
**Sketching at Ma On Shan**

水墨設色紙本
*Ink and Colour on Paper*

40x59cm ｜ 2021

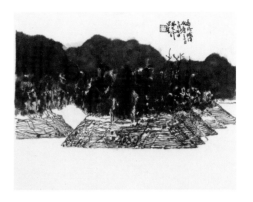

**香港城門水塘寫生**
**Sketching at Shing Mun Reservoir, Hong Kong**

水墨紙本
*Ink on Paper*

37x48cm ｜ 2021

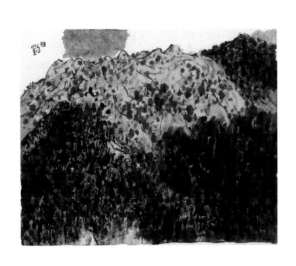

**大帽山寫生**
**Sketching at Tai Mo Shan**

水墨設色紙本
*Ink and Colour on Paper*

36x44cm ｜ 2021

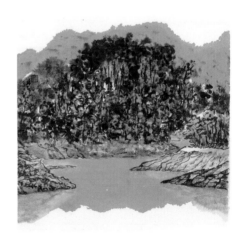

**香港城門水塘寫生**
**Sketching at Shing Mun Reservoir, Hong Kong**

水墨設色紙本
*Ink and Colour on Paper*

45x48cm ｜ 2022

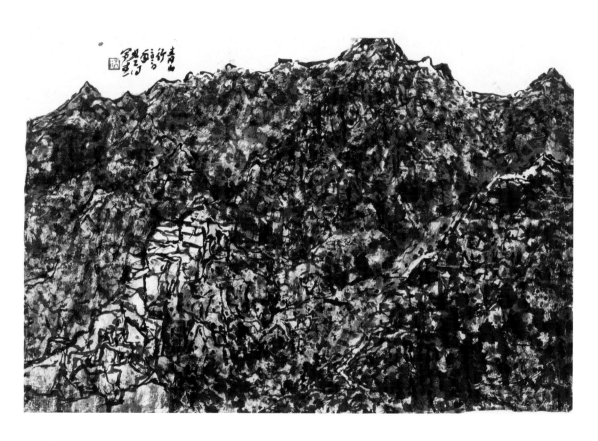

青山行，寫生
**Sketching at Castle Peak**

水墨紙本
*Ink on Paper*
47×70cm ｜ 2020

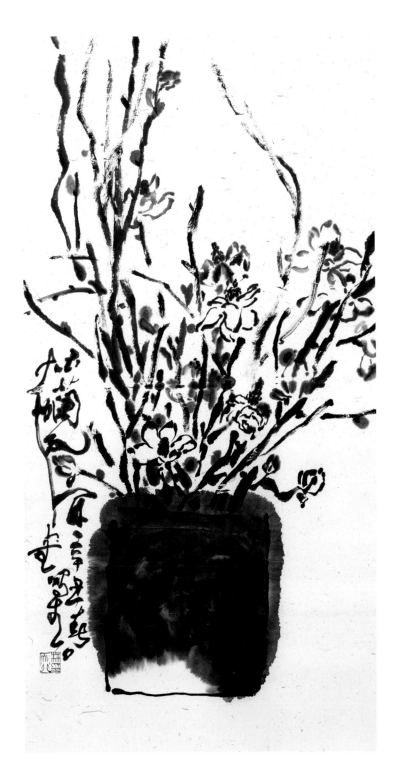

**玉蘭花寫生**
**Sketch of Magnolia**

水墨紙本
*Ink on Paper*
138x70cm | 2021

# 鄉村系列
# COUNTRY SERIES

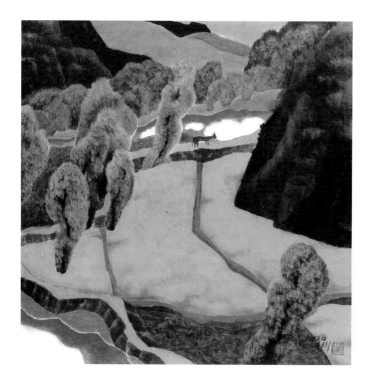

**綠色的風**
**Green Wind**

水墨設色紙本
*Ink and Colour on Paper*
69x69cm │ 1992

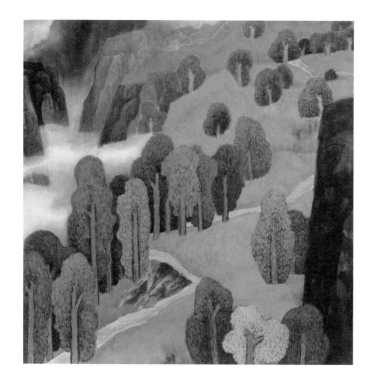

**寂靜的山道**
**Tranquil Mountain Road**

水墨設色紙本
*Ink and Colour on Paper*
68x68cm │ 1993

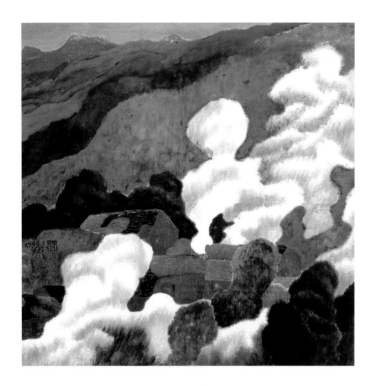

**家家晚唱**
**Each and Every Family Sing in the Evening**

水墨設色紙本
*Ink and Colour on Paper*
68x68cm | 1993

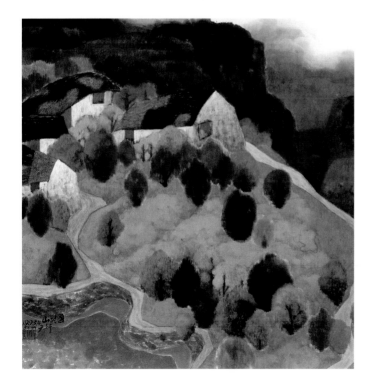

**宿雨初收**
**Overnight Rain Just Taking in**

水墨設色紙本
*Ink and Colour on Paper*
68x68cm | 1993

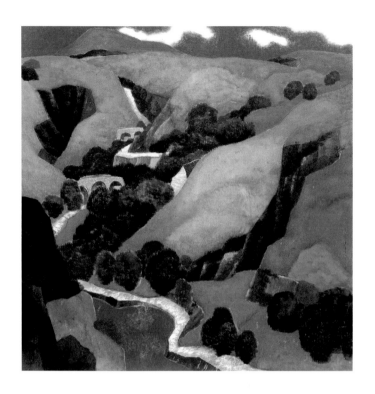

**遙遠的地方**
**Remote Land**

水墨設色紙本
*Ink and Colour on Paper*
68x68cm｜1993

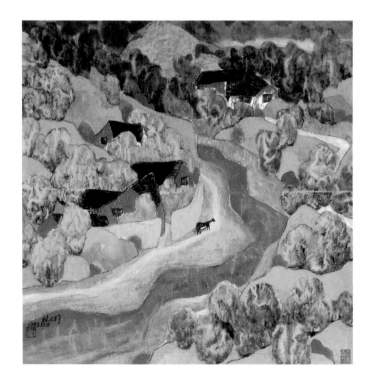

**藍色的溪水**
**Blue Rivulet**

水墨設色紙本
*Ink and Colour on Paper*
69x69cm｜1993

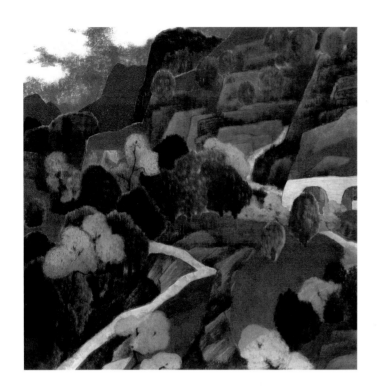

**美麗的十月**
**Beautiful October**

水墨設色紙本
*Ink and Colour on Paper*

68x68cm ｜ 1993

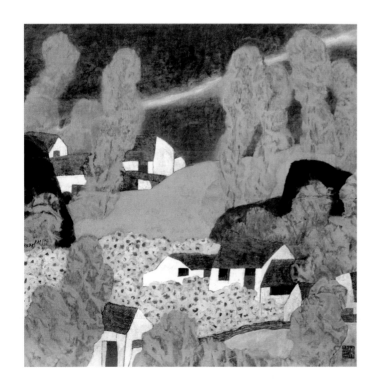

**開滿黃花的庭院**
**Grounds Blooming Full of Day Lily**

水墨設色紙本
*Ink and Colour on Paper*

69x69cm ｜ 1993

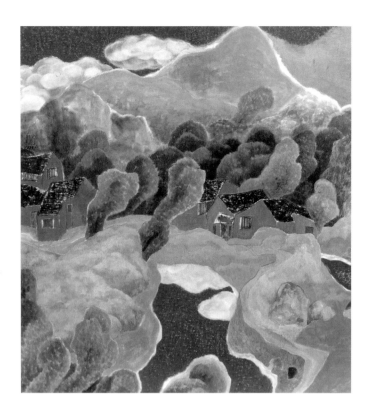

**山頭悄悄飄過了紅雲**
**Red Clouds Floated Past Hilltop**

水墨設色紙本
*Ink and Colour on Paper*
89x96cm | 1994

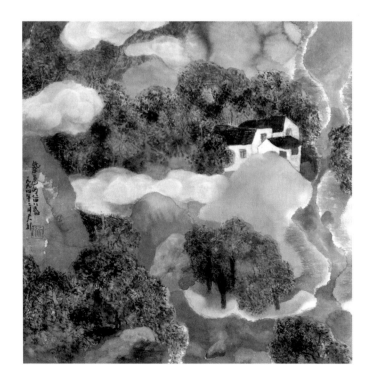

**紫色的黃昏**
**Purple Twilight**

水墨設色紙本
*Ink and Colour on Paper*
68x68cm | 1994

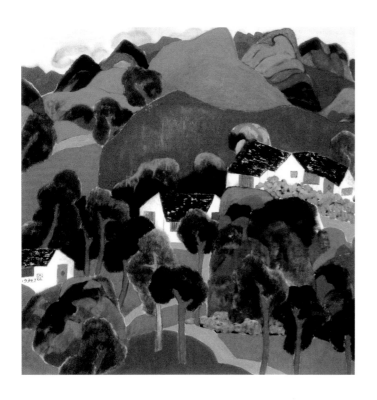

**藍色的村莊**
**Blue Village**

水墨設色紙本
*Ink and Colour on Paper*
70x70cm | 1994

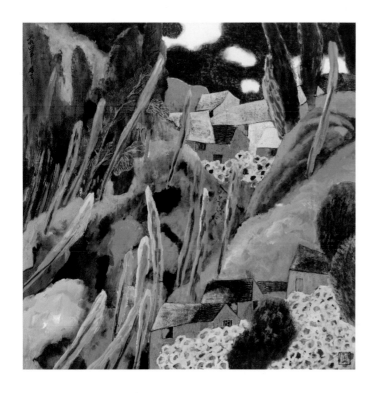

**有向日葵的村莊**
**A Village with Sunflowers**

水墨設色紙本
*Ink and Colour on Paper*
68x68cm | 1994

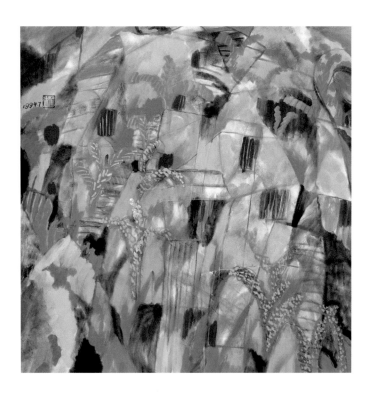

**嚮往**
**Yearning**

水墨設色紙本
*Ink and Colour on Paper*
70x70cm ｜ 1994

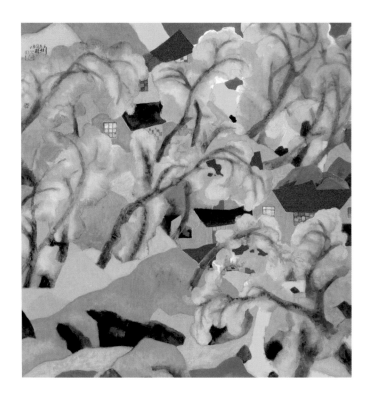

**窗裏窗外的清風**
**Breeze by the Window**

水墨設色紙本
*Ink and Colour on Paper*
98x90cm ｜ 1995

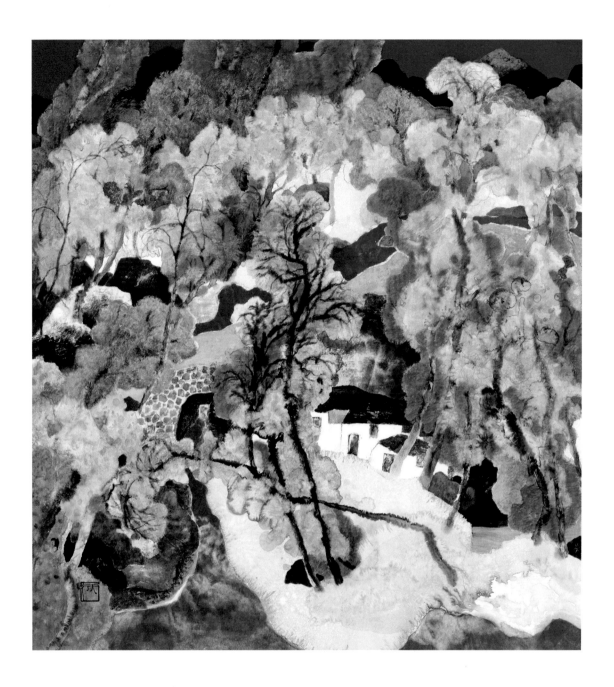

秋天的話
**Word of Autumn**

水墨設色紙本

*Ink and Colour on Paper*

97x89cm | 1994

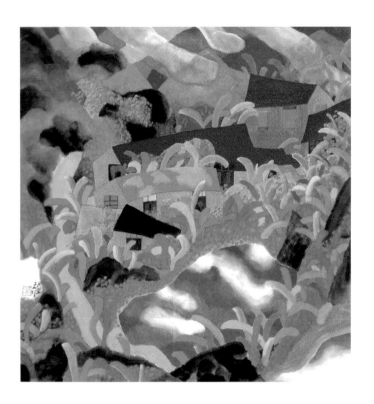

**屋前屋後的雲朵**
**Clouds around the House**

水墨設色紙本
*Ink and Colour on Paper*
98x90cm ｜ 1995

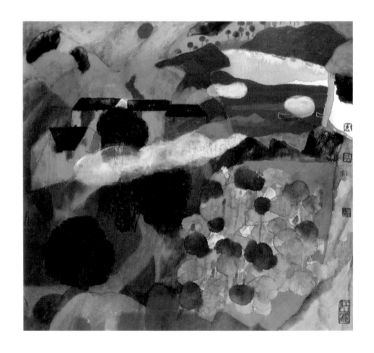

**山景**
**Mountain Scene**

水墨設色紙本
*Ink and Colour on Paper*
54x59cm ｜ 1996

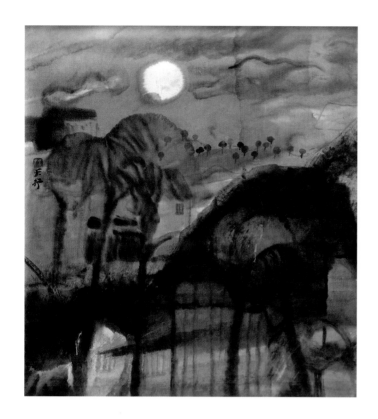

**秋月**
**Autumn Moon**

水墨設色紙本
*Ink and Colour on Paper*
59x54cm ｜ 1996

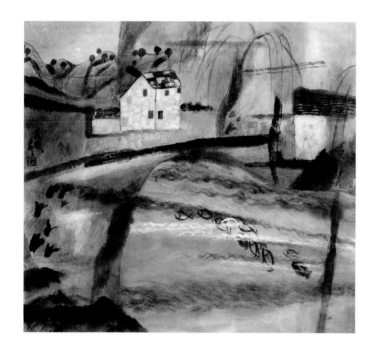

**晨曦**
**First Rays of the Rising Sun**

水墨設色紙本
*Ink and Colour on Paper*
54x59cm ｜ 1996

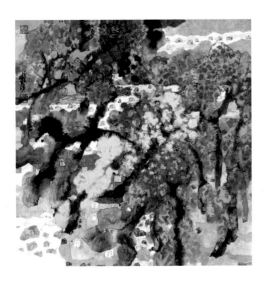

**秋聲**
**Whispering in Autumn**

水墨設色紙本
*Ink and Colour on Paper*
68x68cm｜2002

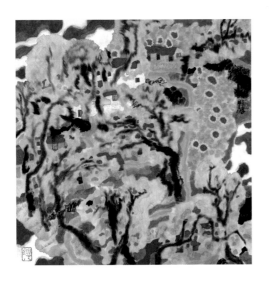

**夏居**
**Summer House**

水墨設色紙本
*Ink and Colour on Paper*
68x68cm｜2005

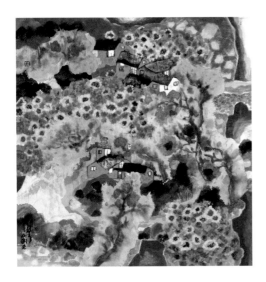

**開滿葵花的家園**
**Home Full of Blooming Sunflowers**

水墨設色紙本
*Ink and Colour on Paper*
68x68cm｜2005

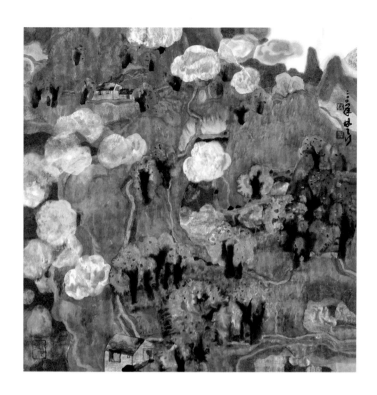

**新界雲霞**
**Evanescence**

水墨設色紙本
*Ink and Colour on Paper*
68x68cm | 2005

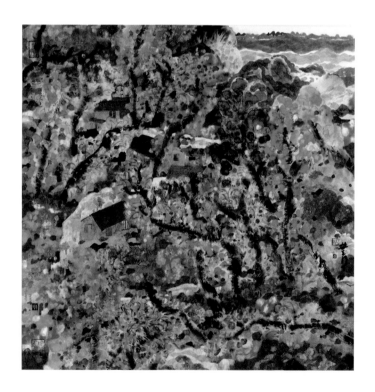

**秋林裏的荷塘**
**Lotus Pond in Autumn**

水墨設色紙本
*Ink and Colour on Paper*
68x68cm | 2008

# 景象系列
# SCENES SERIES

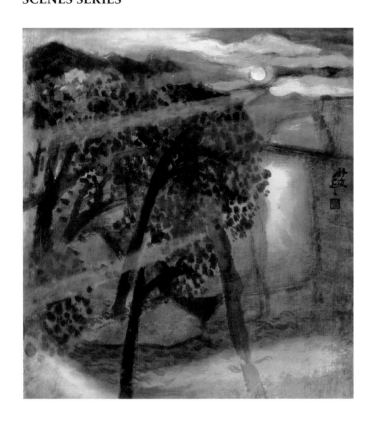

**靜夜**
**Serene Night**

水墨設色紙本
*Ink and Colour on Paper*
59x54cm | 1996

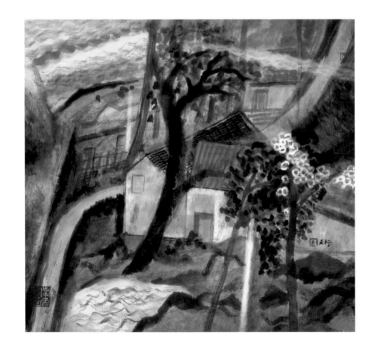

**海傍小路**
**A Path by the Sea**

水墨設色紙本
*Ink and Colour on Paper*
54x59cm | 1996

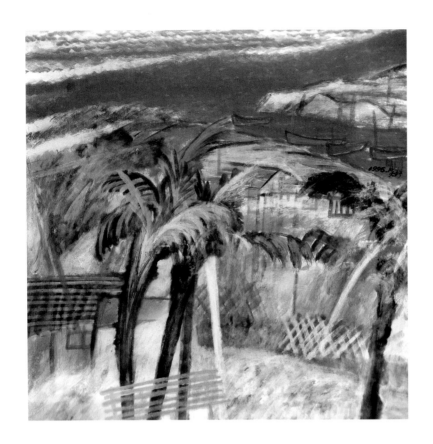

**家園**
**Home Garden**

水墨設色紙本
*Ink and Colour on Paper*
70x70cm | 1996

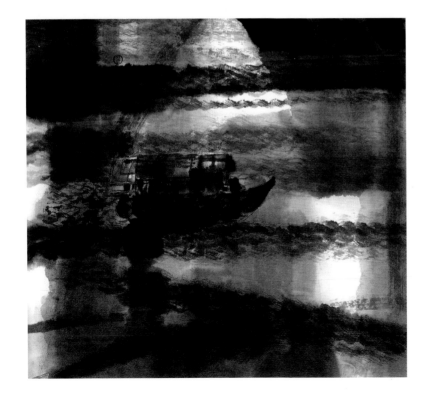

**夜海**
**The Sea of the Night**

水墨設色紙本
*Ink and Colour on Paper*
24x27cm | 1996

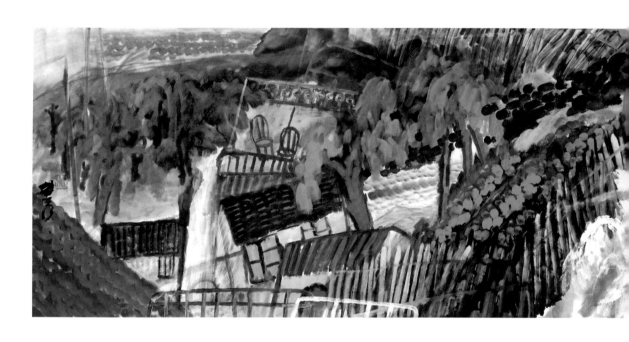

**新界秋色**
**Autumn in New Territories**

水墨設色紙本
*Ink and Colour on Paper*

54×235cm | 1996

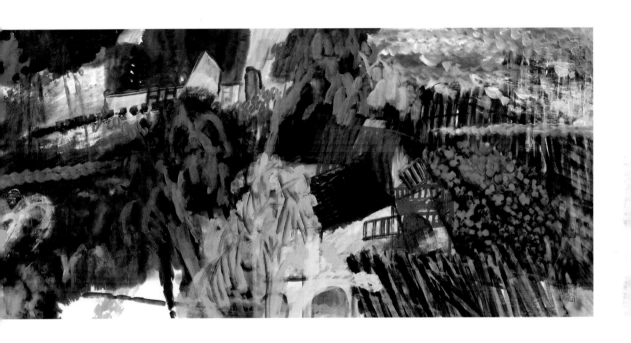

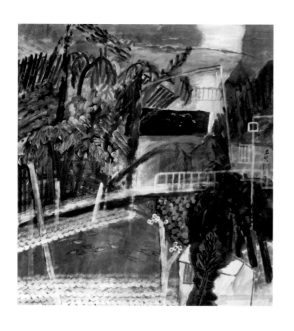

漁塘
**The Fish Pond**

水墨設色紙本
*Ink and Colour on Paper*
95x88cm | 1997

藍海下的村莊
**Village beyond the Blue Sea**

水墨設色紙本
*Ink and Colour on Paper*
95x88cm | 1997

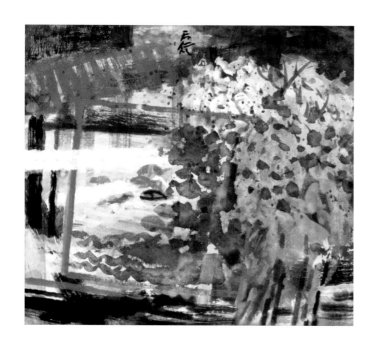

庭院漫遊
**Loitering in the Park**

水墨設色紙本
*Ink and Colour on Paper*
24x27cm | 1998

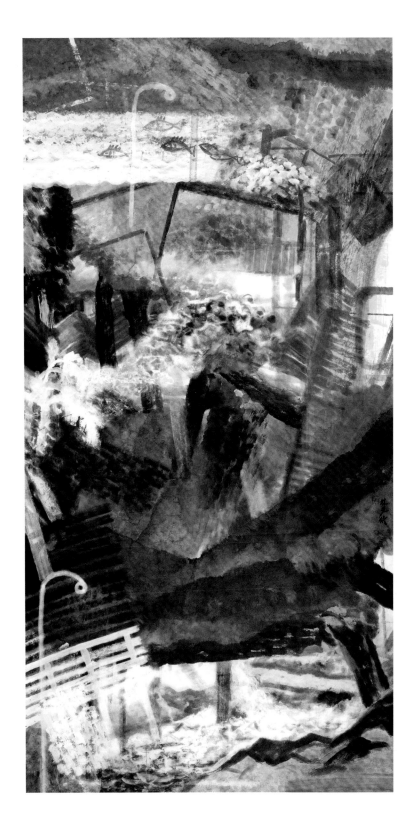

**新界晴雨**
**Sunny Rain in New Territories**

水墨設色紙本
*Ink and Colour on Paper*
248x124cm | 1998

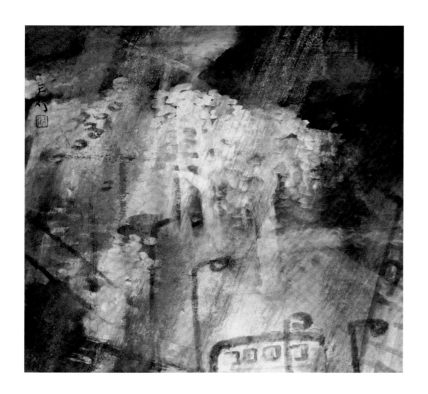

**窗外夜雨**
**A Rainy Night Outside**

水墨設色紙本
*Ink and Colour on Paper*
24x27cm ｜ 1998

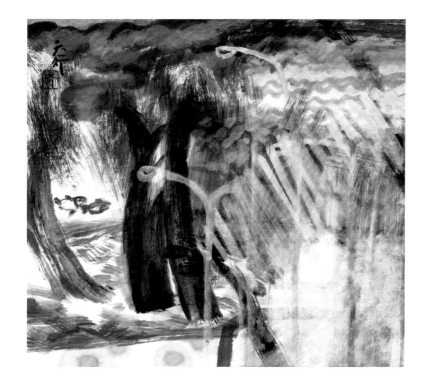

**傾聽**
**Affending**

水墨紙本
*Ink on Paper*
24x27cm ｜ 1998

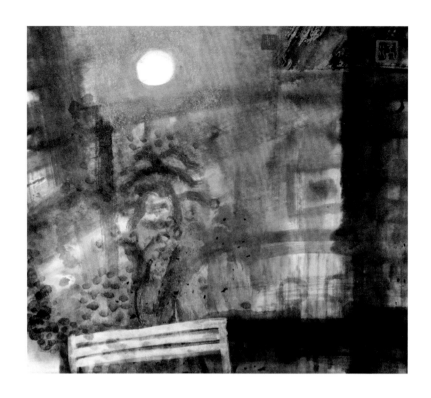

月夜
**Moon Night**

水墨設色紙本
*Ink and Colour on Paper*
24x27cm | 1998

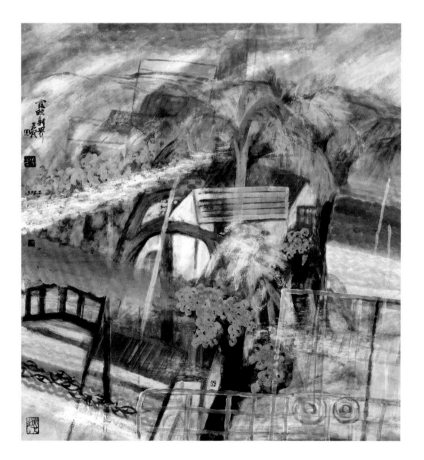

霞映新界
**Summer Reflection in New Territories**

水墨設色紙本
*Ink and Colour on Paper*
97x89cm | 1998

**過客**
**Passer By**

水墨設色紙本
*Ink and Colour on Paper*
18x24cm ｜ 1998

**秋霧迷濛**
**Autumn Mist**

水墨設色紙本
*Ink and Colour on Paper*
18x24cm ｜ 1998

**新界的陽光（一）**
**Sunlight in New Territories (1)**

水墨設色紙本
*Ink and Colour on Paper*
24x27cm ｜ 1998

**秋林**
**Live in Autumn**

水墨設色紙本
*Ink and Colour on Paper*
24x27cm │ 1999

**曙色初現**
**Sunlight and**
**Shades of Clouds**

水墨設色紙本
*Ink and Colour on Paper*
24x27cm │ 1999

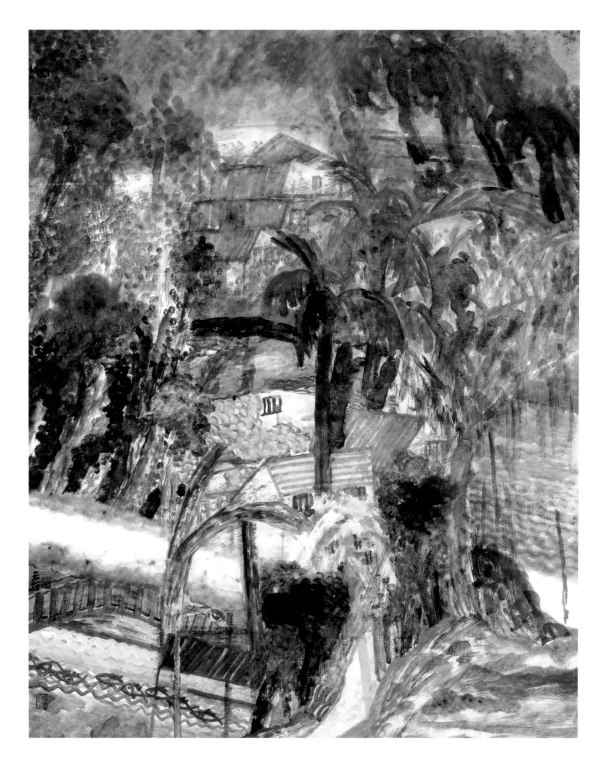

新界風光
**Scene in New Territories**

水墨設色紙本
*Ink and Colour on Paper*
182x144cm ｜ 1999

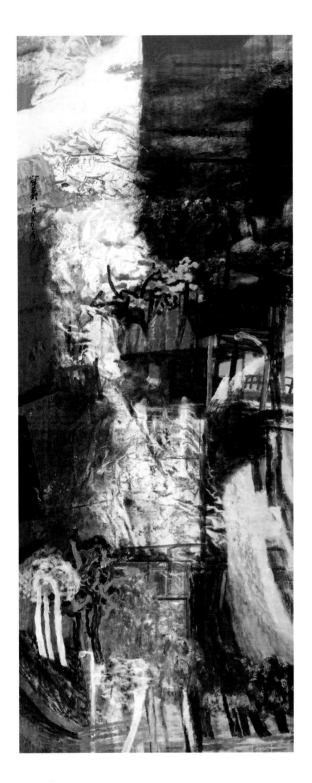

**天光雲影**
**Sunlight and Shades of Clouds**

水墨設色紙本
*Ink and Colour on Paper*
364x144cm | 1999

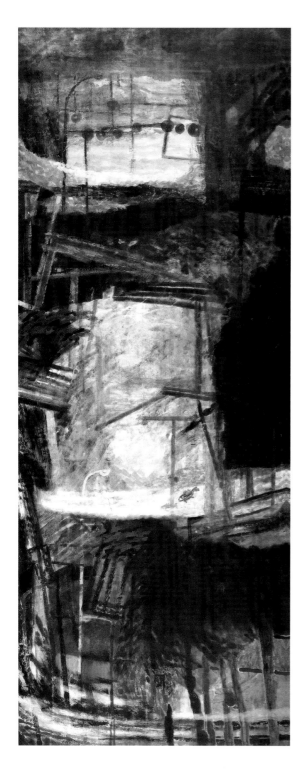

**新界曉色**
**Morning in New Territories**

水墨設色紙本
*Ink and Colour on Paper*
364x146cm | 1999

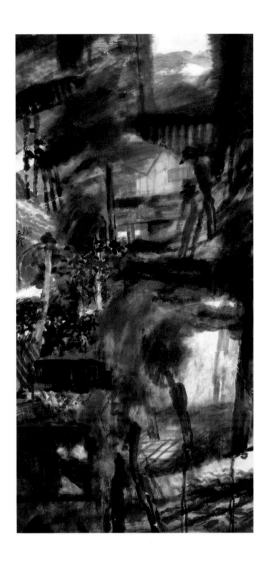

葵芳邨（一）
**Kwai Fong Estate (1)**

水墨設色紙本
*Ink and Colour on Paper*
132x66cm | 1999

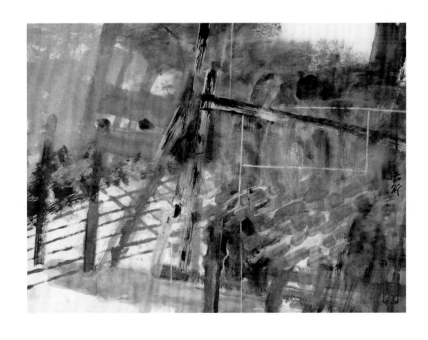

葵芳邨（三）
**Kwai Fong Estate (3)**

水墨設色紙本
*Ink and Colour on Paper*
55x73cm | 1999

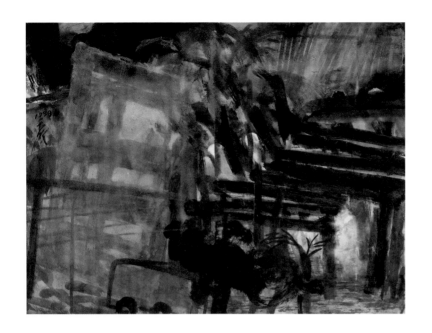

夜色（四）
**The Colour of the Night** (4)

水墨設色紙本
*Ink and Colour on Paper*
55x73cm ｜ 1999

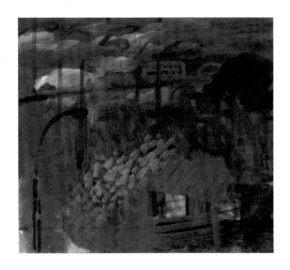

青山公路
**Castle Peak Road**

水墨設色紙本
*Ink and Colour on Paper*
24x27cm ｜ 1999

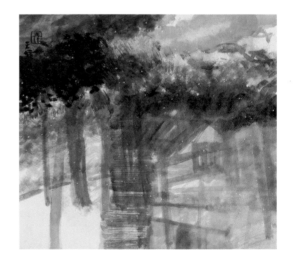

朝霧
**Morning Clouds**

水墨設色紙本
*Ink and Colour on Paper*
24x27cm ｜ 1999

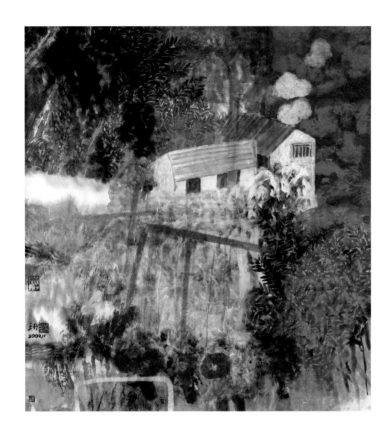

**和唱**
**Join in the Singing**

水墨設色紙本
*Ink and Colour on Paper*
98x90cm | 2000

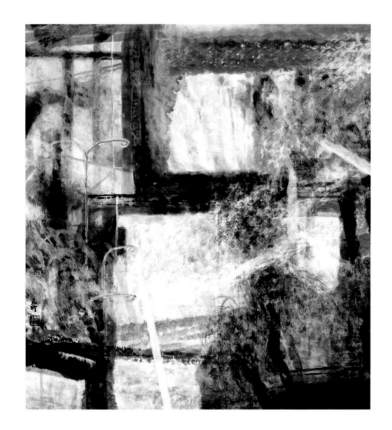

**風中景象**
**The View in Breeze**

水墨設色紙本
*Ink and Colour on Paper*
98x90cm | 2000

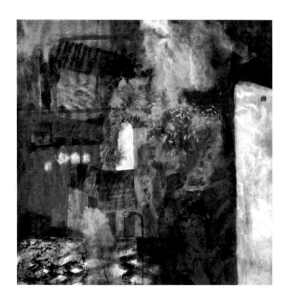

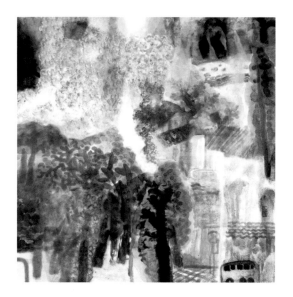

自然的輝煌
**Glory of Nature**

水墨設色紙本
*Ink and Colour on Paper*
98x90cm | 2000

晨曲（二）
**Morning Song (2)**

水墨設色紙本
*Ink and Colour on Paper*
71x70cm | 2001

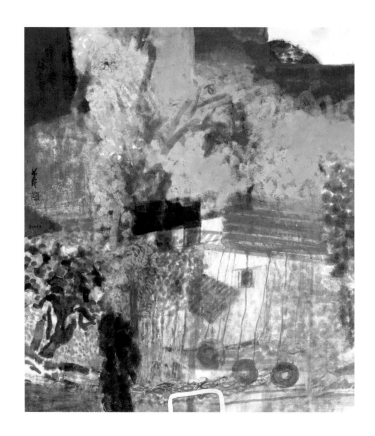

家園
**Homeland**

水墨設色紙本
*Ink and Colour on Paper*
109x97cm | 2001

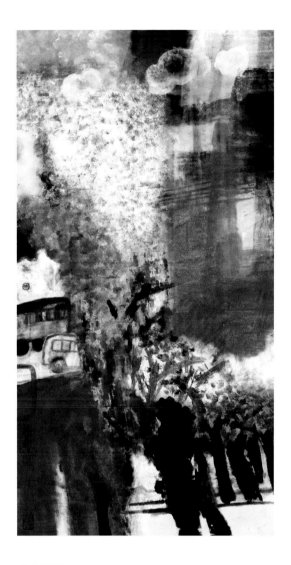

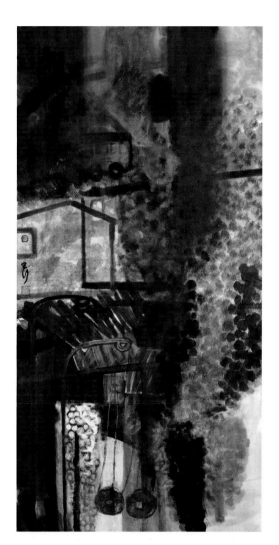

林中煙雲
**Mist in the Woods**

水墨設色紙本
*Ink and Colour on Paper*
130x69cm | 2001

窗外
**A View from My Window**

水墨設色紙本
*Ink and Colour on Paper*
132x68cm | 2003

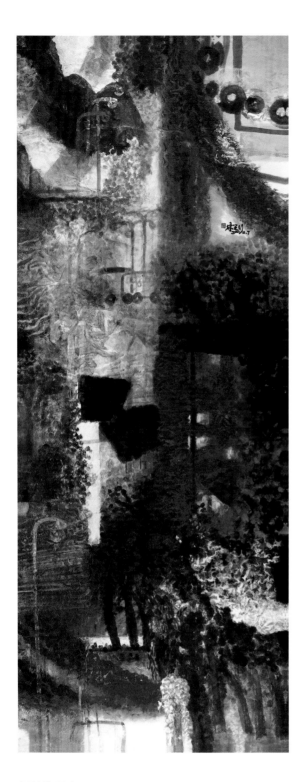

新界的陽光
**Sunlight in New Territories**

水墨設色紙本
*Ink and Colour on Paper*
364x146cm | 2002

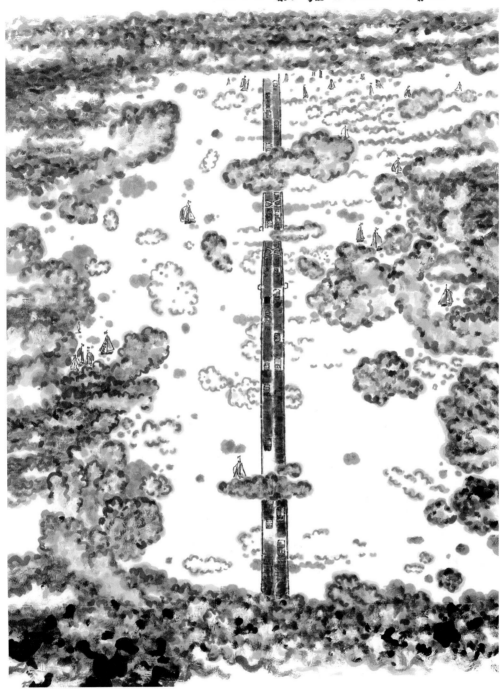

走進大灣區
**Into the Greater Bay Area**

水墨設色紙本
*Ink and Colour on Paper*

215x145cm ｜ 2022

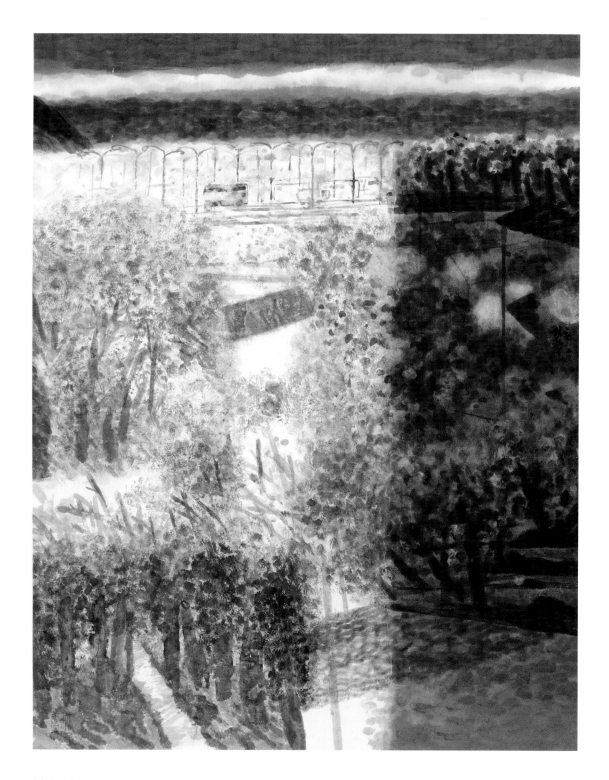

**新界日出**
**Sunrise in New Territories**

水墨設色紙本

*Ink and Colour on Paper*

184x144cm | 2022

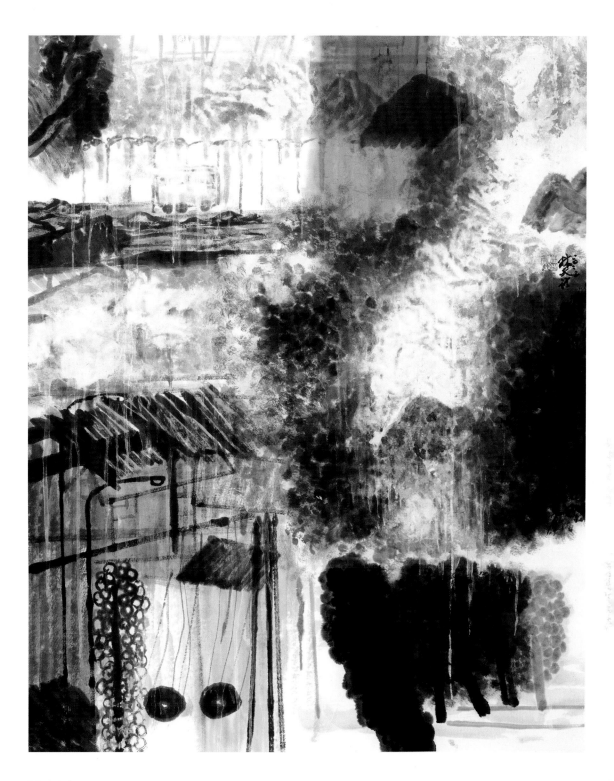

煙雨時光
**Time in the Misty Rain**

水墨設色紙本
*Ink and Colour on Paper*

184x144cm | 2022

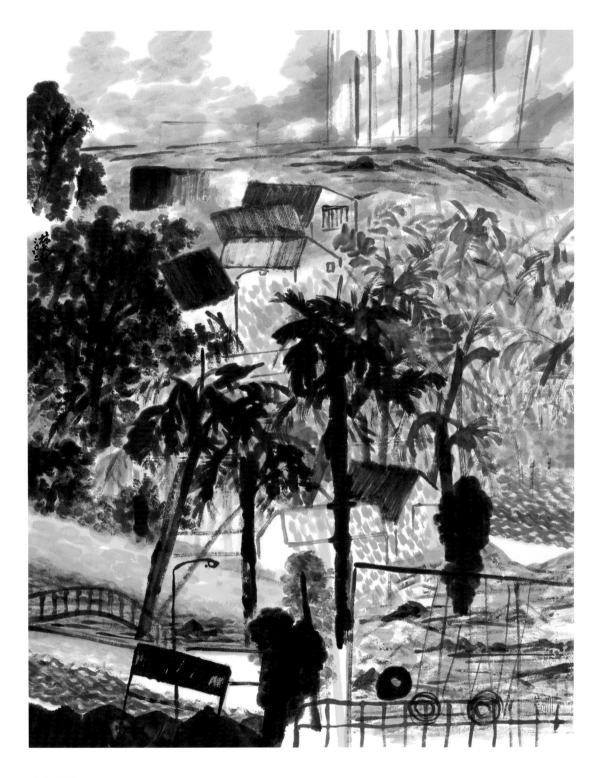

山上山下
**Hill**

水墨設色紙本
*Ink and Colour on Paper*
184x144cm ｜ 2022

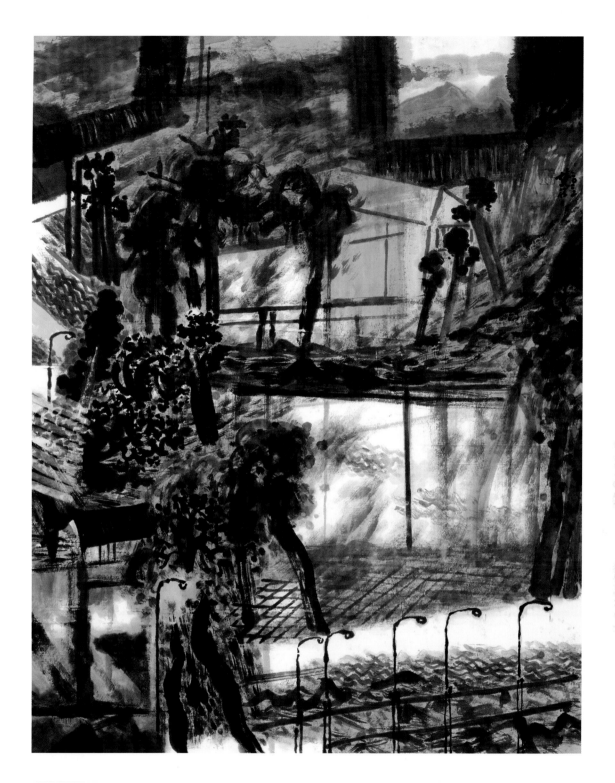

**窗前窗後**

**By the Window**

水墨設色紙本

*Ink and Colour on Paper*

184x144cm ｜ 2022

㊃

生死

西藏

（四）

生死

西藏

# 天 畫
# 行 語

西藏的高山、雪域，是我生死相許的地方。

多年來魂牽夢縈，手執畫筆，從未間斷過描寫她的傳奇。二十三年前，我在這神祕的高原上，無法抗拒她那動人心魄的美，縱使有嚴重的高山症，也絕不放棄緊緊抓住生命以及靈魂的聖山。

那連綿不斷的玉砌冰雕，雄奇瑰麗；天山相接，亂雲飛渡，蒼茫無邊，像山的海洋。這里陽光充沛，到處飛揚着五彩經幡；陣陣洪亮的誦經聲，旋繞在寺廟的上空；從無停過的轉經輪，給人帶來希望；那攜着家人的朝聖者，目光堅定而慈悲；還有藏民那陽光般燦爛的笑容……每當我想起，總有莫名的喜悅！

1999 年夏，畫友王守清來電問：「去西藏嗎？」當時我正忙於創作四幅景象香港丈二大畫，由於疲累過度感冒了，但還是經受不起神祕高原的誘惑，毅然踏上雪域之旅。哪知到達拉薩後呼吸困難，全身乏力，當晚開始頭痛難眠，深夜更堪。翌日至診所吸氧氣兩小時後，前往八廓街。大昭寺門前的轉經道上，人們虔誠禮佛，人群熙熙攘攘。下午又往羅布林卡。當傍晚走到色拉寺，正揮筆寫生之際，刺骨的頭痛又開始了，寺前走過的那個喇嘛，正是此刻下筆的。夜晚頭痛到想撞牆一死了之。第二天清晨，帶着僵硬不堪、痛楚難忍的脖子，一秒鐘也沒有停止過的頭痛，往私家診所吸氧（因時間太早拉薩醫院還未開，但已經有好幾十人躺在地上待救）。有人勸我趕快離開，否則會有生命危險。然而，置身於神祕又迷人，自然與人文風光皆美麗的地方，还有那深情的藏民，我怎捨得離去呢！文成公主說，「拉薩是一朵潔白蓮花的花蕊，四周的群山就像蓮花的八瓣，護佑着花蕊」，此時縱使走近死神，我還是選擇留下。當天晚上又一次頭痛失眠。凌晨緊閉雙眼，忽然之間滿天鮮花飛舞着，不，那是荷花。上午忍痛拜訪著名畫家 —— 西藏美術家協會主席韓書力先生。他見到我雙眉緊鎖痛苦難當的樣子，立即拿了一顆藥給我吃。神奇的事發生了，十分鐘後我已安然無恙，神態自若了。這是蓮的啟示嗎？接着，我繼續走完餘下的行程，羊卓雍湖、日喀則的扎什倫布寺等，最後前往敦煌。

生死之旅結束了。返港後，高山症的後遺症隨即而至，背痛，無力，口乾。於是展開了求醫之旅，香港、北京、台灣、福州，均告無效。2003 年一次偶然機會，學生何碧默邀我上瑜珈課，就此消解了我三年的痛楚，故一直堅持練習至今。

從西藏返港後，香港藝穗會邀請我們赴西藏寫生的三人舉辦「走出西藏」展。於是，我在高山症後遺症的痛苦中，開始創作西藏主題。以什麼手法呈現西藏的神祕壯美呢？我又一次陷入了幽思。西藏的藝術有唐卡、壁畫和滿山遍野的岩畫，宗教色彩濃烈。它是自然風光與人文精神相輝映的奧妙之境。然而，長期以來傳統的中國山水畫家卻少有涉及，我沒有找到可借鑒的圖式，只好再次打開想像的翅膀，翱翔於神山聖殿。

我開始了新的探索，嘗試了許多不同手法：綫描、潑墨、潑彩和色墨交融等。不過，無論什麼技巧，都不是最終目的，最重要的還是體現出西藏宗教的神聖感，高山雪域的遼闊與神祕的魅力！那種敬畏神、敬畏大自然的樂天精神！

2003 年第二次進藏，這次是前往四川和雲南藏區的康定、新都橋、雅江、理塘、桑堆、鄉城、德欽、中甸、香格里拉、麗江、大理、昆明。在從成都進入康定的大山中，人就像隻螞蟻。汽車在陡峭狹窄的山路上行駛，有半個車輪懸掛在半空中，下面就是懸崖，大家提着心，哈欠都不敢打，就這樣在驚心動魄之中，開始了藏區寫生之旅。從澎湃的怒江到恬靜嫵媚的香格里拉，一路描寫這許多曼妙風光。返港後又一次激情滿溢，在原來的西藏創作上添磚加瓦，增加了新元素，更加豐富了畫面。

當年我在拉薩餐廳聽聞，到過西藏的人是英雄，到過阿里的人是英雄中的英雄。返港後，所有有關阿里的介紹書和攝影集，我都買回來研究。原來阿里有無邊無際的土林，有三百多年前古格王朝的遺址，有上千年歷史故事感人的托林寺，它們均有當年以純金畫的精彩壁畫。這一切都是讓我衝動前往的原因

（跟英雄無關）。2005 年，我相約畫友王守清，和北京兩位師兄前往阿里。因懼阿里之旅辛苦，故我設計先到林芝一遊。這裏是西藏的江南，森林茂密，景色優美。然後我們返回拉薩向阿里出發，當越野車開到薩嘎過夜時，大師兄杜杰患上高山症，缺氧頭痛，立即被送到診所吸氧。翌日他堅持返京，師兄于躍護送。我和守清堅持前進，經過了無人區，經過了海拔 5,216 米的馬欽木拉山口，經過了神山和聖湖，第七天終於到達盼望了五年的阿里扎達土林。興奮之情難以形容，放下行李，奮不顧身投入寫生。在 3,760 米的高原，在滾滾獅泉河上的托林寺門口，我展開二十米長的宣紙，完全忘我揮灑三個小時。三百六十度景觀躍然紙上，每段景的開合、輕重、繁簡、疏密、鬆緊、留白以及畫眼等都是在瞬間完成的。

刻骨銘心的阿里之旅結束了，我和王守清乘坐四十五個小時的長途車前往新疆。車在一望無際如月球上的沙石地上行駛，越過宏偉壯觀的昆崙山到達新疆葉城，開始新疆之旅，途經喀什、庫爾勒、吐魯番、烏魯木齊。

返港後，激動的心情久久不能平復。三次藏地之行歷歷在目，激起三段愛的激情，陸續誕生了《神山晴雨》《山中不知歲月》《聖湖月出》《偶遇》《遙遠的祝福》《吉祥的日子》等作品，一發不可收拾。2006 年創作了《潔淨的地方》（364x146cm，西藏美術館收藏），蕭穆、靜寂、潔淨、神聖，是我對西藏寺院的感受；層層疊疊通向天際的寺院，覺悟中的僧侶們似乎正在聆聽神的⋯⋯ 那年還創作了一组八條屏，《神聖的地方》(235x53cm)，這是去阿里途中的感受，我把它轉換成四季景色。那潔白雪山腳下翠綠的草地，還有掉落聖湖的彩雲，一路上風中招展的經幡，月光又給千年的佛塔披上不受歲月摧殘的衣裳，好讓未來的人們也能瞻仰它的容顏。2006 年，我在香港大會堂低座舉辦了「天行西藏」展，展出百幅西藏主題作品，以及二十米《土林神遊》寫生手卷，這是香港史上首次以西藏為主題的個人大型展覽。

歲月如梭，自從 1999 年首次赴西藏寫生至今已二十三年矣。多年来，經常在許多國家和地區舉辦西藏主題個人畫展，北京、香港、首爾、新加坡、米蘭等，每一次都充滿激情與期待。在日光城拉薩生命垂危，夢境中星空飄落了蓮花。每當我抒寫高原時，心裏總是想起滿天飛舞的蓮花，而畫蓮花時心中同樣湧現出神山聖湖和昭示吉祥的經幡。它們都給予我新生，它們都給予我神奇的力量。

# Tian Xing's Thoughts 天行

The towering sky-scraping mountains and snowy landscapes of Tibet are the places which determine my life and death.

With a brush in my hand, I have never stopped describing the legend of Tibet where I have been dreaming about for many years. Twenty-three years ago, on this mysterious plateau, I couldn't resist her breathtaking beauty. Though suffering from severe altitude sickness, I never gave up, but held tight on the Holy mountain, the symbol of life and soul.

Tibet's continuous jade-like ice sculptures are magnificent and breathtaking, connecting the sky and the mountains. Over the sky, the unrest rising clouds seemingly run quickly across the river, and the vastness of the margin is boundless; the mountains are wide and immense like an ocean. In this sun-drenched place, colourful prayer flags are flying everywhere, with bursts of loud chanting sounds surrounding the temple, bringing hope to people; Those pilgrims, taking along with their family, show unyielding firmness and merciful compassions in their eyes; the Tibetans always look cheerful with big smiles. Whenever I think about it, I feel delighted beyond words.

In the summer of 1999, my friend Wong Sau Ching called me and asked: "Would you like to go to Tibet?" At the time, I was busy creating four large-scale paintings about Hong Kong. I was so exhausted that I caught a cold. But I could not resist the temptation of the mysterious plateau and resolutely embarked on a journey to the snowy mountains. Unexpectedly, after arriving in Lhasa, I had difficulty in breathing and was losing strengths. I started to have headaches and could not sleep that night, and it was getting worse as the night moved on. The next day, after taking oxygen for two hours at the clinic, I went to Barkhor Street. On the Rotating scriptures road in front of the Jokhang Temple, people devoutly worshipped the Buddha, and the crowd was bustling. In the afternoon I went to Norbulingka again. When I walked to the Sera Monastery in the evening and was scribbling and sketching, the biting headache started again. The headache I had at night made me want to hit a wall and die. The next morning, with a stiff and unbearable painful neck, and a severe headache that did not stop for a second, I went to a private

clinic to inhale oxygen. (It was too early that the Lhasa hospital had yet to open, but there were already dozens of people lying on the ground and waiting to be rescued). Someone advised me to leave as soon as possible, otherwise my life would be in danger. However, in a mysterious and charming land with beautiful, natural and cultural scenery, and the affectionate Tibetans, how could I be willing to leave! Princess Wencheng said, "Lhasa is the stamen, the heart, of a white lotus, and the surrounding mountains are like eight petals of a lotus, protecting the stamens." I would choose to stay even if death was approaching. I was suffering from another terrible headache and insomnia at night. In the early morning, though my eyes closed tightly, suddenly the sky was full of flowers. No, it was lotus. In the morning, with a painful body, I visited the famous painter, Mr. Han Shuli, Chairman of the Tibetan Artists Association. When he saw my knitted brows in pain, he immediately gave me a pill. It was miraculous that ten minutes later I became lively and sound. was this *Lian*'s (lotus) revelation? Then, I continued my journey to Yamdrok Lake, Tashilhunpo Monastery in Shigatse, etc., and finally went to Dunhuang.

The journey of life and death was over. When I returned to Hong Kong, the sequelae of altitude sickness followed. I suffered from back pain, weakness and dry mouth. A trip seeking medical treatment began, from Hong Kong, Beijing, Taiwan and Fuzhou, but all efforts ended in vain. In 2003, by chance, student Jolene Ho invited me to take a yoga class, which relieved my pain lasting for three years. Ever since, I have been practicing yoga until this day.

After returning to Hong Kong from Tibet, the Hong Kong Fringe Club invited three of us, who sketched in Tibet, to hold an "Out of Tibet" exhibition. Therefore, enduring the pain caused by altitude sickness, I started to create works about Tibet. How could I present the mysterious beauty of Tibet? I was lost in deep thoughts again. Tibetan art includes thangkas (a Tibetan portrait painted with mineral pigments on cotton or silk), murals, and rock paintings all over the mountains, which is full of religious implications and is a mysterious realm combining natural scenery and humanities. However, for a long time, Tibetan art has been rarely seen in works of traditional Chinese landscape painters, and therefore left few structured framework for reference. I had no choice but to open the wings of imagination again and soar over to sacred temples and holy mountains.

I started a new exploration and tried many different techniques, including line drawing, splashing ink, splashing colour, blending colour and ink, etc. However, techniques and skills were not the ultimate goal. The most important thing was how to reflect the sacredness of Tibetan religion, and the vastness and mysterious charm of the mountains and snowy landscapes! What an optimistic spirit Tibetans have in awe of the God and the nature!

In 2003, on my second trip to Tibet, I went to several Tibetan habitats of Sichuan and Yunnan Provinces as following: Kangding, Xinduqiao, Yajiang, Litang, Sangdui, Xiangcheng, Deqin, Zhongdian, Shangri-La, Lijiang, Dali and Kunming. In the mountain roads from Chengdu to Kangding, people looked as small as ants. The car was driving on a steep and narrow mountain road with half a wheel hanging in the air. Below was the cliff. Everyone was mindful and did not dare to yawn. In this thrilling and hair-raising way, I started the journey of sketching in Tibet. From the surging Nu River to the serene and charming Shangri-La, I sketched much beautiful scenery along the way. After returning to Hong Kong, I was full of passion again, adding new elements to the original Tibetan creations and enriching them.

Back then I heard, in a Lhasa restaurant, that those who have been to Tibet were heroes, and people who have been to Ali was hero of heroes. Before returning to Hong Kong, I bought all the introductory books and photography books about Ali for further study and research. It turns out that, in Ali, there are boundless soil forests (a type of geological heritage), ruins of the Guge Dynasty more than 300 years ago, and thousands of years of touching history of the Toling Monastery. They all have wonderful murals painted in pure gold. All these made me feel a compulsion to go to Ali (it has nothing to do with heroes). In 2005, I invited Wong Sau Ching and two senior schoolmates from Beijing to go to Ali. Afraid of the hardship of the trip to Ali, I decided to go to Nyingchi first. Nyingchi is located in the southern part of Tibet, with dense forests and beautiful scenery. Afterwards, we returned to Lhasa and set off for Ali. When our vehicle arrived at Saga for the night, senior schoolmate Du Jie suffered from altitude sickness and hypoxia with a grievous headache. He was immediately sent to the clinic for oxygen. The next day, he insisted on returning to Beijing and was escorted by another senior schoolmate Yu Yue. Sau Ching and I continued to advance, passing the uninhabited region,  the Macinmula Pass at an altitude of 5,216 meters, the sacred mountain and the holy lake. On the seventh day, we finally arrived at the Zanda soil forest, which we had been looking forward to for five years. The excitement, of Sau Ching and I experienced, was beyond words. We put down our luggage and devoted ourselves to sketching immediately. At an altitude of 3,760 meter, at the gate of the Toling Monastery built on the bank of the Shiquan River, unfolding the 20-meter-long rice paper, we engrossed in sketching completely for three hours, without knowing the time passing by. The 360-degree view spread on the paper, as if alive; the opening and closing, weight, complexity, density, elasticity, blank space and "*hua yan*" (the artist's thoughts and feelings of each scene), were all completed in an instant.

The unforgettable journey of Ali was over. Wong Sau Ching and I spent 45 hours taking bus to Xinjiang. The bus drove on the extremely vast sandy ground, as if on the moon, crossing the majestic Kunlun Mountains to reach Yecheng of Xinqiang. In Xinqiang, we stopped at Kashgar, Korla, Turpan and Urumqi.

I could not calm myself down after returning to Hong Kong for a long time. The three trips to Tibet were vivid in my mind, prompting my passions and loves. Works such as "After the Rain", "Timelessness in Mountains", "Moonlight on Sacred Lakes", "Hello There", "Faraway Blessing", and "Auspicious Days" were successively born. The "Place of Purity" (364x146cm, collected by the Tibet Art Museum) made in 2006 is solemn, quiet, clean, and sacred, which was what I felt about Tibetan monasteries. Layers after layers, monasteries seemed to approach the sky, and awakened monks seemed to be listening to the words of gods... That year, I also created a set of eight screens, "Holy Place" (235x53cm). This group of paintings expresses the feelings of my heart on the way to Ali which I converted into the scenery of the four seasons. There are green grass at the foot of the pure and white snow mountain, the colourful clouds falling into the holy lake, and the prayer flags fluttering in the wind along the way. The moonlight seems to put clothes on the thousand-year-old pagoda that would not be ravaged by time, so that people in the future can also pay their respects to its face. In 2006, I held the "Tibet – A Cosmovital Vision" exhibition at the lower block of the Hong Kong City Hall, exhibiting hundreds of Tibetan-themed works, as well as a 20-meter long hand-scroll of the soil forest. This was the first time, in Hong Kong history, that an individual held such a large exhibition with the theme of Tibet.

Time flies. It has been 23 years since I first went to Tibet to sketch in 1999. Over the years, I have held Tibet-themed solo exhibitions in many countries and regions, such as Beijing, Hong Kong, Seoul, Singapore and Milan. Each time I am full of passion and expectation. In Lhasa, the city of Sunlight, lotus flowers fell from the starry sky in my dream when I was at the path to death. Whenever I want to depict the plateau, I always think of the lotus dancing in the sky. While painting the lotus, the sacred mountain, the holy lake and the auspicious prayer flags also appear in my heart. They all gave me a new life and empowered me with magic.

藝評

Art Critics

陳君，〈穿行於神山聖湖間〉（節錄），《天行西藏》，二〇〇七年

聽說天行又要舉辦西藏畫展了，真是驚訝於他對西藏的百畫不厭，而且越畫越深，西藏對他的震撼和記憶實在是太深刻了，這種震撼不僅僅是來自於視覺方面的煥然一新，更多的是來自於心靈表達的渴望。兩年前我為他的《西藏行》寫下片言拙文，今天看他仍然如此熱衷於表達內心對西藏的感受，不知不覺中受到他的感染，我在想，究竟是什麼樣的力量使他難以作罷？據我了解，天行先後三次探訪西藏，每次身心和意志都受到嚴峻的考驗，回到香港調整一階段後就開始動手，前前後後畫西藏主題的作品多達三百餘幅，在不畫西藏的時候多半是在畫一些荷花，我感覺他是在西藏和荷花中尋找一種品質，追求一種純淨和高尚。天行生活在繁華的香港，國際的大都市，而他的心卻是那樣的寧靜和高遠，他生活得散淡而自在，平實又快樂，我認為他找到了一種屬於自己的平衡，在他的印象和理解中，雖然自然生活條件艱苦甚至在常人看來有點險惡，但是西藏人的精神世界卻是快樂無比的，他們有着自己的信仰和追求。

On hearing that Lam Tian Xing is to hold another exhibition on the subject of Tibet, I cannot help but was impressed with his perseverance. Tibet has indeed given the artist such a temptation that he could never stop painting this subject. Ultimately it is more a spiritual encounter than visual. Two years ago I wrote an article to compliment Lam's last exhibition. Today when I see his persistence in expressing his feelings about Tibet, I am deeply moved and kept pondering: what motivated him in this pursuit? As far as I know, Lam has visited Tibet three times since 1999. During each visit, he put his mind, body and soul to the test. After his return and refreshment, he would start painting. There are more than 300 works on the theme of Tibet painted by Tian Xing over a period of time. When Tian Xing is not painting Tibet, he is mostly painting lotus flowers. I feel that he has been searching for unique characteristics in Tibet and lotus flowers, and pursuing a kind of purity and nobility. Living in the prosperous Hong Kong, an international metropolis, Tian Xing is so peaceful and lofty. He lives a casual and comfortable life, simple and plain yet happy. I think he has found a balance that belongs only to himself. I once said that Tian Xing's Tibetan paintings would not make people feel bitter at all. In the eyes of Tian Xing, although the natural living conditions are difficult and even a little threading dire and sinister, the spiritual world of Tibetans is full of happiness and they have their own beliefs and pursuits.

**Chen Jun, Through the Holy Mountains and Sacred Lakes (excerpts),** *Tibet—A Cosmovital Vision*, **2007**

天行畫室內橫着長案並堆放了很多擺設，他就地展開了這幅畫達兩千厘米（七十五英尺），名為《西藏寫生》的水墨長卷。這幅畫細敘着他三次踏足西藏的視覺及感情故事。天行用強而有力的筆觸，將巖石峭壁透過濃淡墨表達得淋漓盡致。這幅寫生展現了平原和高山，還有飽歷激流冰雪侵蝕的奇石，見證了西藏的艱難歲月。天行的筆觸展示了他那場馬拉松式的遊歷，腳下的長卷將我一步一步地引入這艱辛的旅程，感覺有如身受。這靈動的圖案比無數的照片還要生動。收起長卷，天行又拿出一幅二米高的巨作。這幅畫跟前者有很大的對比。整個畫面渲染着重重疊疊的淡墨和朦朦朧朧的色塊。迷濛中兩朵粉紅色的荷花高低有致地半露風華。我剛從西藏險境出來，乍遇芳華，頓覺美不勝收，乃近期難得一遇的經歷。

天行的山水為近代中國藝術及現代中國水墨畫漆上了輝煌的一頁，更為中國水墨加上深度，他將兩個傳統理性地糅合，成功地創造出一個理想而滿有畫意的山水風格。

金馬倫，〈林天行的美術〉（節錄），《今日中國藝術家》，二〇〇八年

From a large pile of what are obviously ink and colour works, Lam chooses an example and unrolls it on the floor between his long-cluttered desk and arrangements of stacked material. This is a brushed painting in black ink which is 2,000 centimetres (about 75 feets) long, named "Location Sketch of Tibet". It recounts the visual and sensual story of his reactions on his three visits to Tibet. By the vigour and the impetus of his brush loaded with black Chinese ink, and every shade from deepest Stygian through the greys of its dryer moments, Lam offers an account of the startling variety of rock and crag, and of silent lower areas among soaring mountains, sudden stub-shaped rock towers created by time and torrents and the shatter of ice in the savage seasons of Tibet. Tian Xing's brushstrokes showcased his marathon journey. The long scroll under his feet led me step by step into his arduous journey, which was like my own experience. This articulated and dynamic painting was more vivid than thousands of photos. Putting away the long scroll, Tian Xing took out another two-meter-high masterpiece. This painting is in great contrast to the former. The entire picture is rendered with a focus on overlapping light ink and hazy colour patches. Two pink lotus flowers are swaying irregularly in the mist and showing their grace and beauty. Just coming out of the dangerous life-threatening ambience of Tibet, I am attracted by such unspeakable beauty in my first encounter with the lotus and have a rare experience.

Tian Xing's works have added a modern chapter of great accomplishment and depth to the recent Chinese art and contemporary Chinese ink painting. He does so by a remarkable use and ideally managed combination of the fundamentals of the two traditions.

**Nigel Cameron, The Art of Lam Tian Xing (excerpts),** *Chinese Artists of Today,* **2008**

其巨構「西藏寫生長卷」自現
實山水中取材，綫條粗獷而乾
濕互用，施墨渲染變化萬千，
充分表現了畫家能將中國古代
諸家的筆墨技法融合變化。

鄧海超，《港水港墨》（節錄），
二〇一一年

In "Long-scroll Location Sketch of Tibet", he found
elements from real-life landscape and rendered them in
jagged lines in both wet and dry brushes, resulting in
an evanescent ink-wash effect that testifies to the artist's
ability in converging and innovating the ink painting
techniques of various ancient Chinese painting schools.

**Tang Hoi Chiu,** *Shui Mo Hong Kong* **(excerpts), 2011**

林天行畫筆下的西藏雪域，色彩斑斕，如夢如幻，非雪域的色彩如是，而是心靈的想像使然。將神祕的雪域歸於一種絢爛、深邃的色彩構成，並賦予其雄渾、深厚的情感內涵，反映了畫家對人生極限體驗的追尋。從畫家的精神歷程而言，林天行就如同西行的行者，由中國的東方向西部雪域跋涉，他在凝視，也在思考，從城市的喧囂進入高原的大平靜，他在這個過程中追尋、感悟着生命的真義。林天行為那些瑰麗的雪域圖景所震撼，人迹所至之處，虔誠的僧侶，寺院的紅牆，都隱喻着這片土地上人們神祕、平靜、自足的精神生活。

林天行與那些執着於西藏異域圖景的風情畫家不同，他對西藏的表達是一種「心會」，他雖然也有數十米的寫生長卷，但即使在寫生中，他也沒有拘泥於雪域的表象，他將自己的畫筆緊緊關聯着西藏的精神本質。在創作中，他又將中國畫特有的寫意本質發揮得淋漓盡致，即使是純粹的、大塊面的色彩，也多有筆觸在其中，體現着畫家內心的情緒，傳達着畫家的生命人格。相對而言，林天行對神山聖湖系列的表現更易與中國傳統文化精神相呼應，而寺院系列則更注重塊面的構成，更具有現代意味，在那些符號化的樹木、僧侶、院牆等的構成中，能明顯感受到他對建構新的藝術表達語彙的努力。

張榮東，〈彩墨雪域〉（節錄），《林天行》，二〇〇七年

The gorgeous and dreamlike colour of snow land from Lam Tian Xing's works is not the real colour of Tibet, but his imagination of spirit. He ascribes the mysterious snow land to a structure of flaming and deep colours, and gives it profound affection, which reflects the pursuit of extreme life experience by the artist. For the development of spirit, Lam Tian Xing is just like a west-headed pedestrian, who trudged from east to west of China until he reached the snow land. He has been gazing, and also pondering, from bustling city to silent plateau. During this process, he explores and experiences the essence of life. He is shocked by the majestic snowy landscapes; in places where human presence is traced, there are devotional monasteries and red walls of temples, all of which represent their mysterious, tranquil and self-sufficient inner life.

Lam Tian Xing is different from those artists that enchanted with the fantastic scenery of Tibet; his expression about Tibet is the "perception by heart". Although he creates sketches for about tens of meters long, he does not limit them to the appearance of snowy scenery, but represents the essence of spiritual Tibet by his brush. He has presented the special character of Chinese painting incisively and vividly. Even some pure or agglomerate colours hide strokes which reflect the painter's emotion and demonstrate his personality. The series of holy mountains and sacred lakes corresponds to traditional Chinese culture and spirit, while his monasteries series focuses much on the composition of blocks with modern implications. His endeavours to construct a new framework of art expression are explicitly seen from the composition of these symbolic trees, monks and walls in his paintings.

**Zhang Rongdong, Colourful Snow Land (excerpts),** *Lam Tian Xing,* **2007**

**2003 年藏區寫生路綫圖**

**Itinerary Map for Sketching in Tibetan-inhabited
areas (2003)**

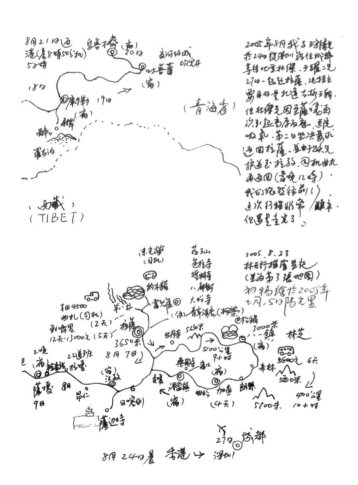

**2005 年西藏寫生路綫圖**

**Itinerary Map for Sketching in Tibet (2005)**

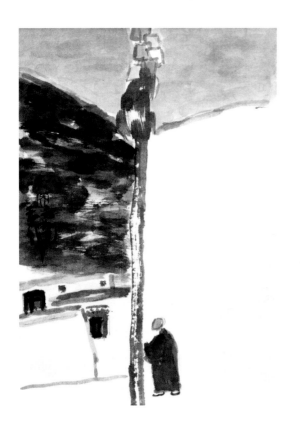

西藏寫生（一）
**Tibetan Sketch (1)**

水墨設色紙本
*Ink and Colour on Paper*
34.5x25cm ｜ 1999

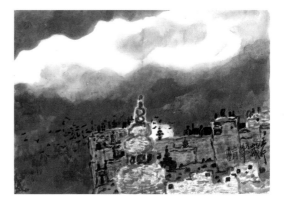

西藏寫生（八）
**Tibetan Sketch (8)**

水墨設色紙本
*Ink and Colour on Paper*
34.5x49.5cm ｜ 1999

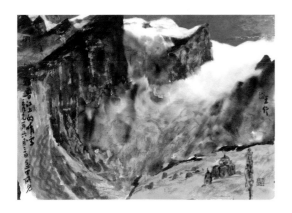

西藏寫生（六）
**Tibetan Sketch (6)**

水墨設色紙本
*Ink and Colour on Paper*
34.5x49.5cm ｜ 1999

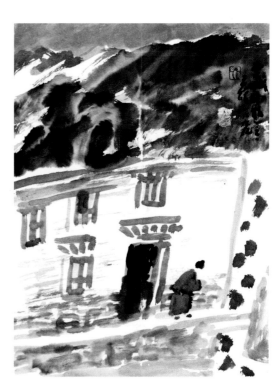

西藏寫生（十三）
**Tibetan Sketch (13)**

水墨設色紙本
*Ink and Colour on Paper*
33x25cm ｜ 1999

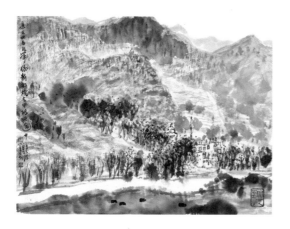

藏區康定寫生
**Sketching in Kangding, Tibetan-inhabited Region**

水墨紙本
*Ink on Paper*

41x55cm | 2003

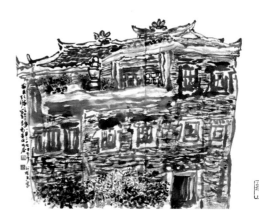

藏區康定寫生
**Sketching in Kangding, Tibetan-inhabited Region**

水墨紙本
*Ink on Paper*

41x55cm | 2003

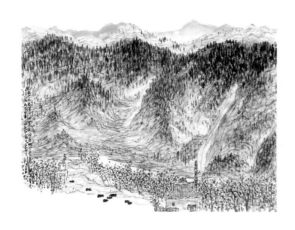

藏區康定寫生
**Sketching in Kangding, Tibetan-inhabited Region**

水墨紙本
*Ink on Paper*

41x55cm | 2003

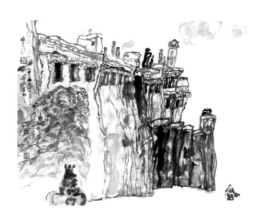

藏區康定寫生
**Sketching in Kangding, Tibetan-inhabited Region**

水墨紙本
*Ink on Paper*

45x63cm | 2005

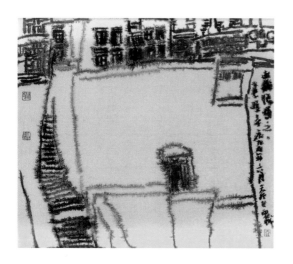

道
**The Path**

水墨紙本
*Ink on Paper*
42x47cm ｜ 2000

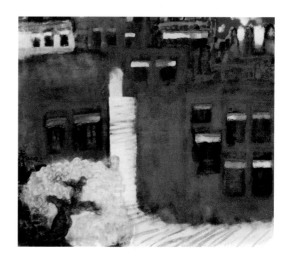

閃亮的窗景
**Windows**

水墨設色紙本
*Ink and Colour on Paper*
42x47cm ｜ 2002

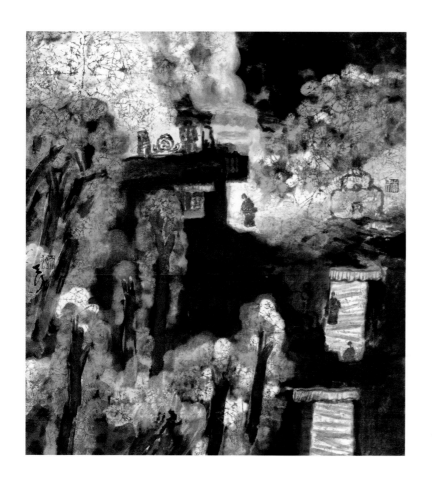

黃葉滿山的寺院
**Monastery with Autumn Landscape**

水墨設色紙本
*Ink and Colour on Paper*
80x70cm ｜ 2003

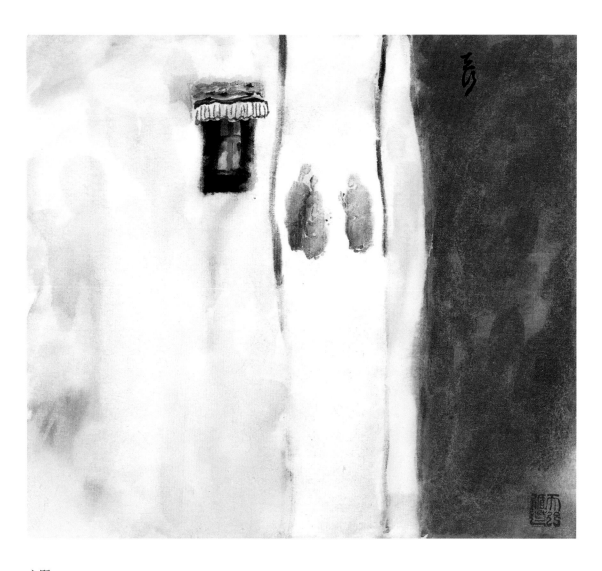

心願
**Buddha Bless You**

水墨設色紙本
*Ink and Colour on Paper*
24x27cm | 2004

**神聖的日子**
**A Holy Day**

水墨設色紙本
*Ink and Colour on Paper*
97×90cm ｜ 2004

**祝福**
**Blessings**

水墨設色紙本
*Ink and Colour on Paper*
70x70cm ｜ 2004

**絢麗的家園**
**Glorious Homeland**

水墨設色紙本
*Ink and Colour on Paper*
70x70cm ｜ 2004

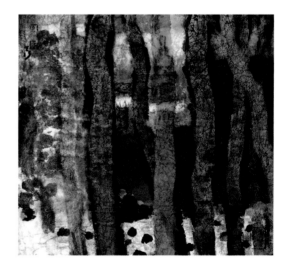

**林中論經**
**Teachings in the Woods**

水墨設色紙本
*Ink and Colour on Paper*
24x27cm ｜ 2005

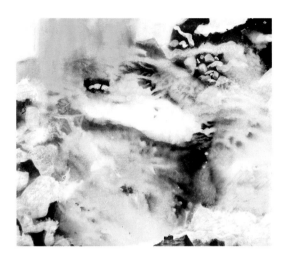

**神山晴雨**
**After the Rain**

水墨設色紙本
*Ink and Colour on Paper*
45x53cm | 2006

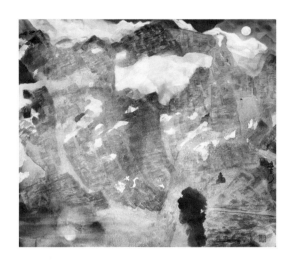

**靜夜**
**Quiet Night**

水墨設色紙本
*Ink and Colour on Paper*
45x53cm | 2006

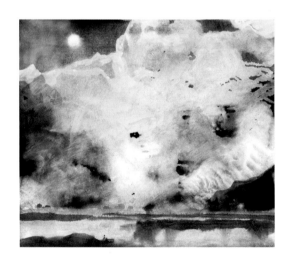

**聖湖靜月**
**Quiet Night at Sacred Lakes**

水墨設色紙本
*Ink and Colour on Paper*
45x53cm | 2006

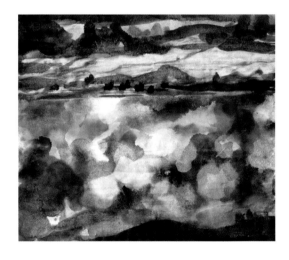

**掉落聖湖的彩霞**
**Colourful Clouds**

水墨設色紙本
*Ink and Colour on Paper*
45x53cm | 2006

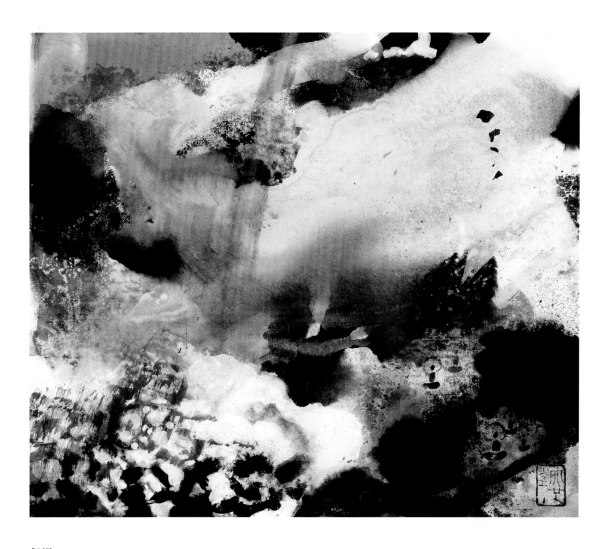

**偶遇**
**Hello Here**

水墨設色紙本
*Ink and Colour on Paper*
45x53cm | 2006

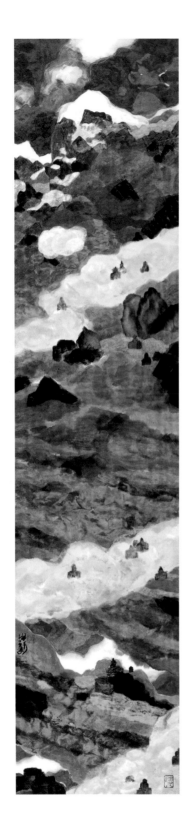
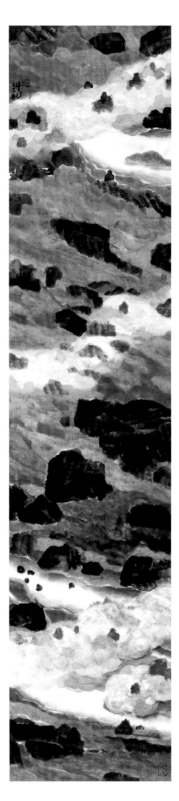

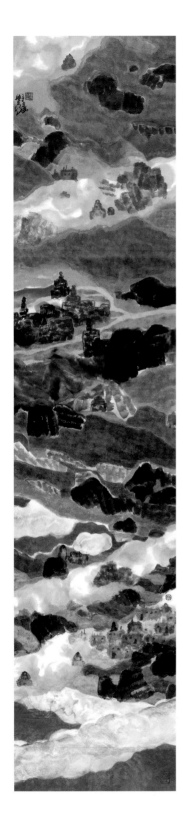
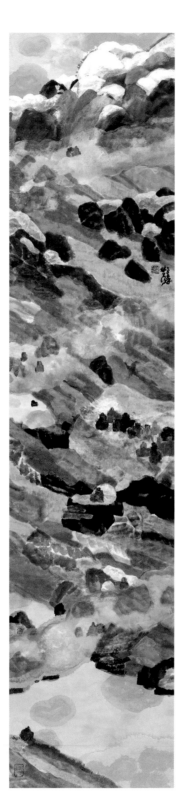

**神聖的地方（一至四）**
**Holy Place (1-4)**

水墨設色紙本
*Ink and Colour on Paper*
235x53cm x4 ｜ 2006

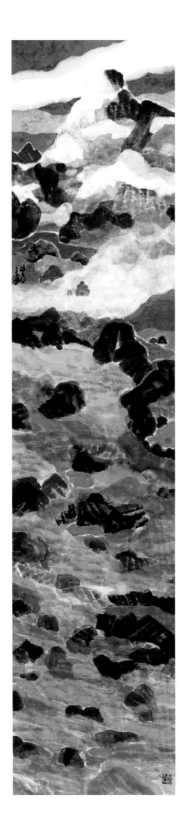
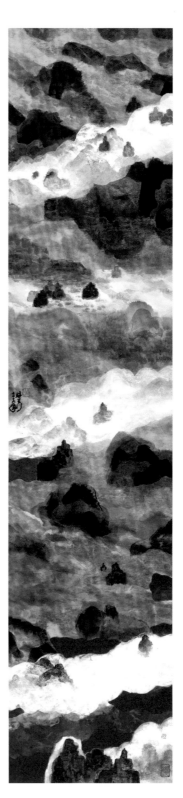

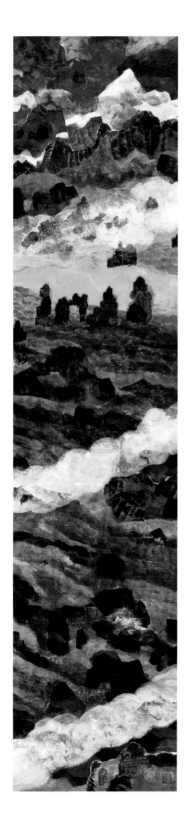
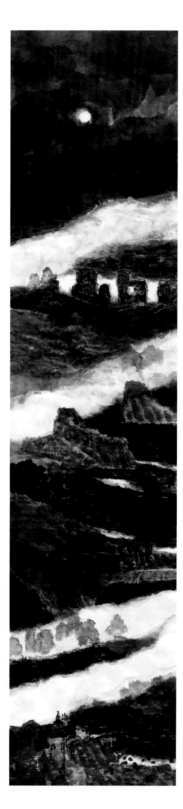

**神聖的地方（五至八）**
**Holy Place (5-8)**

水墨設色紙本
*Ink and Colour on Paper*
235x53cm x4 ｜ 2006

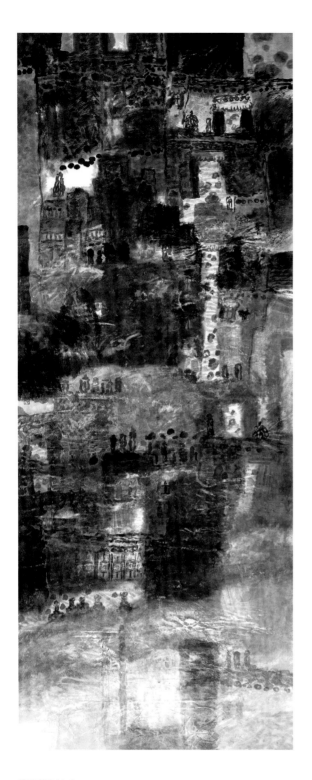

**潔淨的地方**
**Place of Purity**

水墨設色紙本
*Ink and Colour on Paper*

364x146cm ｜ 2006

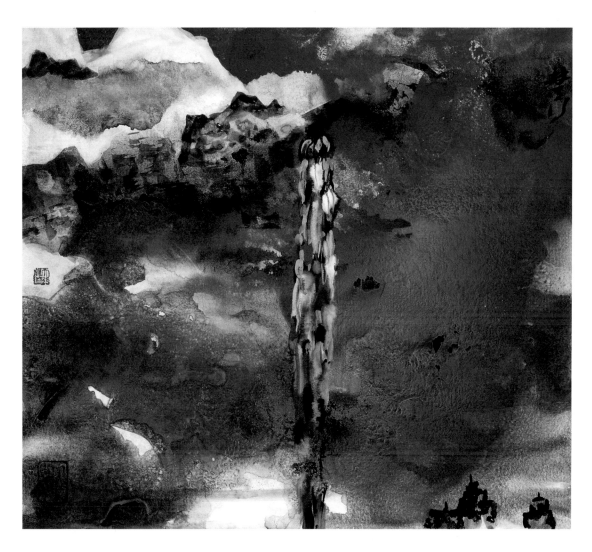

遙遠的祝福（二）
**Faraway Blessing (2)**

水墨設色紙本
*Ink and Colour on Paper*
45x53cm | 2007

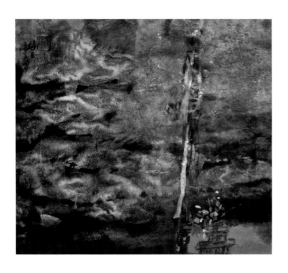

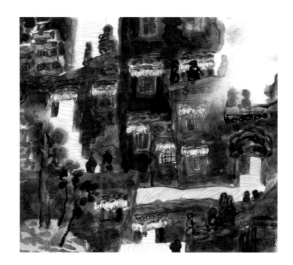

**遙遠的祝福**
**Faraway Blessing**

水墨設色紙本

*Ink and Colour on Paper*

42x47cm ｜ 2006

**門裏門外的僧人**
**Monasteries by the Gates**

水墨設色紙本

*Ink and Colour on Paper*

45x53cm ｜ 2007

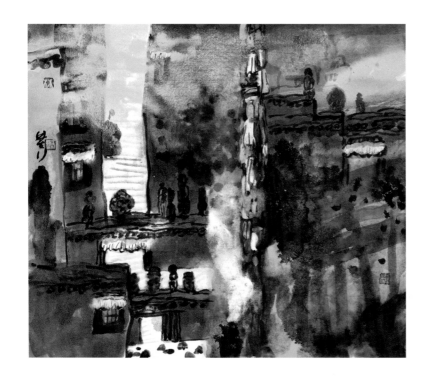

**美麗的日子**
**Beautiful Days**

水墨設色紙本

*Ink and Colour on Paper*

45x53cm ｜ 2007

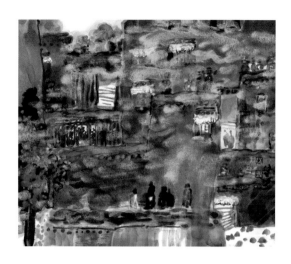

**紫雲**
**Purple Clouds**

水墨設色紙本
*Ink and Colour on Paper*

45x53cm ｜ 2007

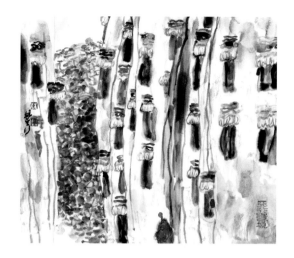

**返（二）**
**Home Coming (2)**

水墨設色紙本
*Ink and Colour on Paper*

45x53cm ｜ 2007

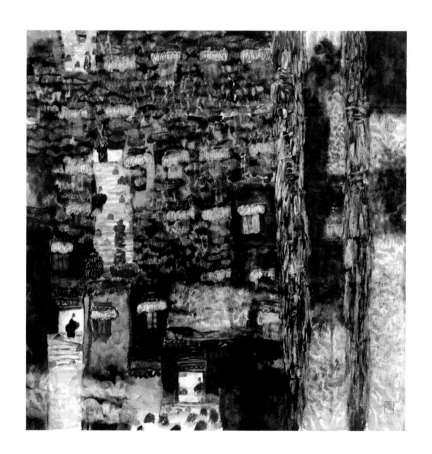

**吉祥的日子**
**Auspicious Day**

水墨設色紙本
*Ink and Colour on Paper*

120x116cm ｜ 2008

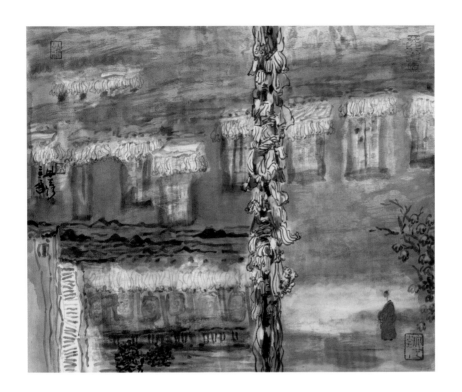

吉祥的日子
**Auspicious Days**

水墨設色紙本
*Ink and Colour on Paper*

50x60cm ｜ 2011

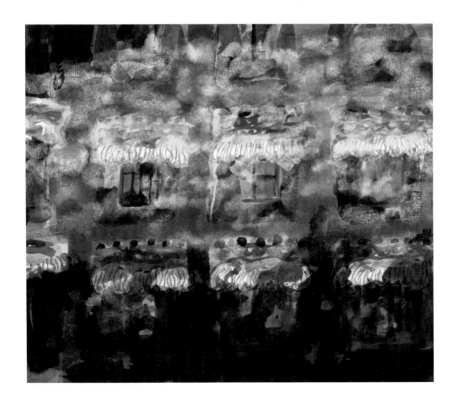

西藏·窗 (一)
**Windows of Tibet (1)**

水墨設色紙本
*Ink and Colour on Paper*

45x53cm ｜ 2011

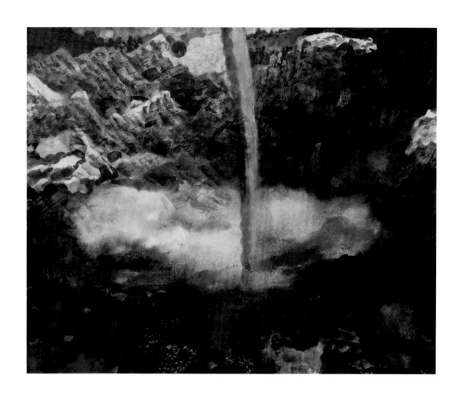

西藏神山彩虹（一）
**Rainbow in Holy
Mountain of Tibet (1)**

水墨設色紙本
*Ink and Colour on Paper*

45x53cm ｜ 2012

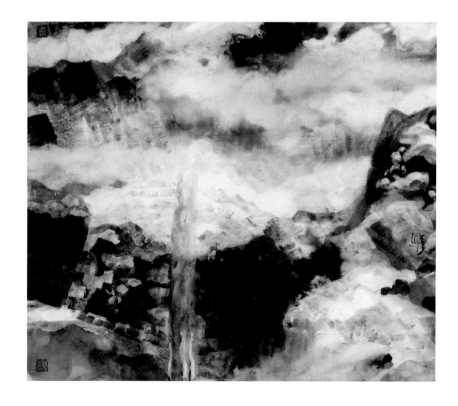

祈
**Prayers**

水墨設色紙本
*Ink and Colour on Paper*

45x53cm ｜ 2006-2012

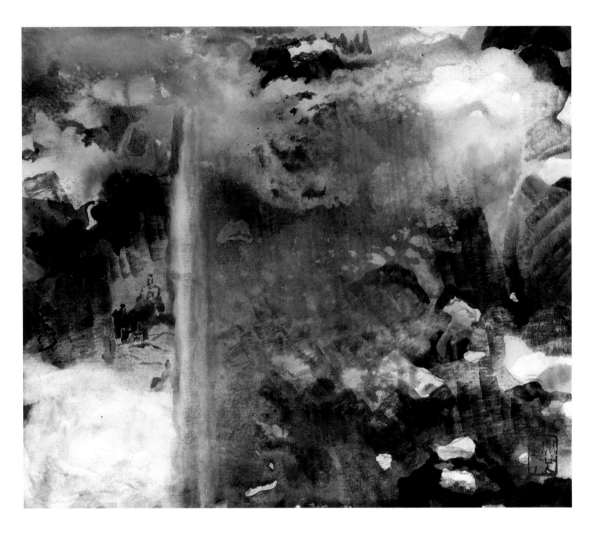

落入神山的彩虹（二）
**Rainbow in Holy Mountain of Tibet (2)**

水墨設色紙本
*Ink and Colour on Paper*
45x53cm | 2012

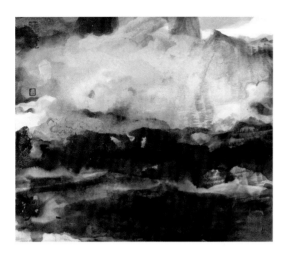

**神山聖湖 (二)**
**Holy Mountains and Sacred Lakes of Tibet (2)**

水墨設色紙本
*Ink and Colour on Paper*

45x53cm ｜ 2012

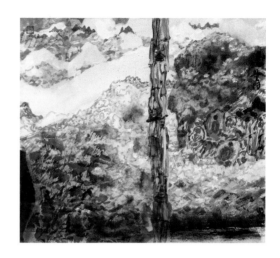

**難忘的地方 (四)**
**Unforgettable Place (4)**

水墨設色紙本
*Ink and Colour on Paper*

45x53cm ｜ 2019

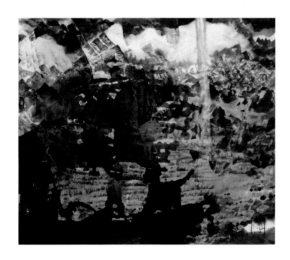

**難忘的地方 (二)**
**Unforgettable Place (2)**

水墨設色紙本
*Ink and Colour on Paper*

45x53cm ｜ 2019

**雲朵**
**Clouds**

水墨設色紙本
*Ink and Colour on Paper*

42x47cm ｜ 2002-2020

㊄

蓮荷

悟道

2003————2020

(V) Lotus

Enlightenment

荷蓮

悟道

2003 ——— 2020

# 畫語　天行

　　小時候，母親告訴我，祖屋後面那座最高的山有一個名字，叫蓮花峰。但那時我不曉得山和蓮花有什麼關係。

　　隨着學習中國畫，我漸漸知道了蓮的內涵。

　　敦煌壁畫中純樸婀娜的荷花，《愛蓮說》中對蓮花「出污泥而不染」的崇高讚美，都讓我陶醉。陳淳、齊白石、張大千，這些畫荷大家使我着迷。但，最讓我心動的還是徐渭的狂放，八大山人意蘊深邃的綫條穿插出奇異而富神韻的空間，還有莫奈的瑰麗色彩和繽紛光影，他們都曾影響過我的審美意趣。

　　一葉一菩薩，一花一世界。1999 年我在雪域西藏嚴重缺氧、生命垂危之際，夢見滿天飛舞的荷花。我在那充滿愛的天際裏，心靈受到鼓舞，得到力量。菩薩有千百億化身，荷難道不也是一樣嗎？荷啟示我以不同的方式讚美她！

　　畫荷之前，山水風景重彩是我研究的方向。題材的轉變帶來了多方面的變異：自然變形，隨意幻化，各種不同的強烈色彩取代了以往的符號與空間，「使色如使墨」的手法，通過意象彩墨表現我的感受，並總是試圖把山水畫元素注入到荷蓮裏，讓她跟今天的世界以及我的際遇有所關連。

　　我喜歡以不同方式呈現荷的獨特。飽滿的畫面，凸顯虛空粉碎，空靈意境；潑墨、潑彩，墨破色、色破墨，綫色並用；或以揉皺的宣紙印拓荷葉、山川，其間穿插荷桿，點出花意，或陽光雨露，或冰雪紛飛；時有多次重複，借鑒各種筆法墨法以及許多不同方式反覆進行，造成跡象的多次衍化，越來越通透，越來越虛幻，彷彿置身於幻境之中，物我兩忘。於是，出現近似「抽象」的畫面，我稱之為「彩墨意象」。

　　在此簡單介紹幾幅不同時期畫的荷蓮：

《待放》（24x27cm，2004）。虛幻的畫面，以白色覆蓋在墨上，營造出一種迷濛景象。若有若無、若隱若現的小荷，代表新生的脆弱，但卻充滿朝氣。

《若雪》（45x53cm，2004）。當時從梅里雪山歸來（西藏地區），對她仍然魂牽夢縈。畫荷時情不自禁浮現出她的容顏，似雪非雪，似花非花，故名「若雪」。

《湧》（50x60cm，2007）。潔白的荷，在遼闊的大地上，慈光普照。這幅畫當時在香港一家畫廊展出時，吸引了一對法國年輕夫婦。他們站在畫前看了兩個小時。由於畫廊不接受旅行支票，他們第二天又來了，還是看了兩個小時。第三天他們把《湧》接走了，並且留下了一句話：「為了收藏這幅畫，少去了兩個國家。」原來他們是旅遊結婚。

《霞光》（45x53cm，2008）。印象派把畫板搬到戶外，表現自然光影；中國畫則以綫條粗細表現陰陽向背。黃賓虹的「光如龍走」，李可染的「逆光」，林風眠的「戲曲舞台光」，都豐富了中國畫美術史。我認為現代文明是由「光」開始的，我們生活在「光的世界」裏，不僅五光十色，豐富多彩，而且變幻莫測。至於我，無論什麼題材的作品都有着不同的光影表現手法，光影既屬於這個時代，也是我心中理想的光影。在柔和的光影裏，展現出霞光中充滿力量的直綫，其結構猶如現代建築，在晨曦初露中，晃晃悠悠。

《雪霏霏》（124x248cm，2010）。聽說 2009 年是北京多年未遇的最冷的冬天，而我就在最冷冬天裏最冷的一天，到北京郊區看望朋友。午餐之後，朋友說前面有荷塘，我頓時精神為之一振，感到溫馨。朋友陪我前往，距離雖不遠，但嚴寒下，走到半路雙腿已輪流抽筋，就這樣拖着雙腳到了荷塘。陽光下，乾枯的荷葉簇擁着掛滿蓮蓬的荷桿。在冬日愜意的瞬間，我站在結冰的荷塘上，與荷共舞！冰天訪荷令人難忘，返港後，充滿激情的《雪霏霏》誕生了。

《天光雲影》（70x89cm，拼貼，2013）。把完整的荷撕成一瓣瓣，象掉落大地的花瓣，然後重新組織，意味着生生不息。留白的地方再加上花、葉，斑斕如時光流逝，真有「半池荷花半池雲」的意境。

《隱》（45x53cm，2021）。帶着陽光的小雨，像天上灑落的甘露，畫面如夢如幻，光影瑰麗，閃耀如燦爛繁星，自然而含蓄。

她們僅是我千百幅荷蓮畫作中的一小部分，代表我不同時期的心聲和經歷。有的絢爛至極，有的平淡寂靜。在湖光山色中坐看雲起，舉杯高歌，這就是我的人生寫照。

# Tian Xing's Thoughts 天行

When I was a child, my mother told me that the highest mountain behind the ancestral house was named Lotus Peak. But then I didn't know the connection between the mountain and lotus.

As I studied Chinese painting, I gradually came to understand the connotation of lotus.

The simple and graceful lotus flowers in Dunhuang frescoes, and the lofty praise of the lotus for "(being) unadulterated despite coming from mud" in "Ode to the Lotus", exhilarated me. Those great masters in lotus painting such as Chen Chun, Qi Baishi and Zhang Daqian, fascinated me. However, what impressed me the most is Xu Wei's willful and unrestrained characteristics, the profound and intense lines of Bada Shanren which intersperse a queer, eccentric and charming space, and Monet's magnificent colours with glaring light and shadow. They have all influenced my aesthetic taste.

"A bodhisattva in a leaf, a world in a flower" means that the whole world can be seen from a flower, and the whole Bodhi tree can be represented by one leaf. In 1999, I was on the verge of death due to anoxia in the snowy Tibet, I then saw lotus flowers flying all over the sky in my dream. I was inspired by a sky full of love. If Bodhisattvas have tens of billions of incarnations, isn't it the same with the lotus? It is inspiration from lotus that I should praise her in different ways!

Before painting lotus, the "*zhongcai*" – heavy or strong colour of landscapes was the direction of my studies. Changes in the subject matter have brought about diversification in my paintings: natural deformation, random illusion, various strong colours have replaced the previous symbols and spaces; by "using colour as ink", I have expressed my feelings through imagery colour ink. I have always tried to add the elements of landscape painting into the lotus, so that the lotus could be related to today's world and my own experiences.

I like presenting the uniqueness of the lotus in different ways. I depict lotus with a full-bodied picture to highlight the shattering of the void and ethereal artistic conception. I use splash ink, splash colour, ink to break colour, colour to break ink, and combination of lines and colour. I use crumpled rice paper to make a rubbing of lotus leaves, mountains and rivers interspersed with lotus stalks, dapping out flowers, and presenting sun and rain, or flying snow and ice. There were many repetitions, time after time, during which I learnt from various brushwork and ink techniques, and tried recurrently in many different ways. Those attempts have brought about multiple derivations of the subjects which became more and more transparent, and more and more delusional, as if being in an illusion where self and nature merge into one. I was in a state of realm in which the subject of my painting and the object of the creation had been completely integrated and forgotten during the creation. As a result, a nearly "abstract" picture has been created, which I call "colour ink imagery".

The following is a brief introduction to several lotus paintings I created in different periods.

"Promise of Summer" (24x27cm, 2004). The imaginary picture with the white covering the ink, creates a misty scene. Intangible little lotus represents the fragility of the new life, but is full of vigour.

"Snow-White" (45x53cm, 2004). After I returned from Meili Snow Mountain (Tibet), I still had a fascination with her. When I painted Lotus, I couldn't help but see Meili Snow Mountain again, like snow but not snow, like flowers but not flowers, hence I named this painting "*Ruoxue*" (like snow) in Chinese.

"Surging" (50x60cm, 2007). The white lotus, on the vast land, shines with auspicious light. The painting attracted a young French couple when it was exhibited at a gallery in Hong Kong. They stood in front of the painting and looked at it for two hours. Since the gallery did not accept travellers' cheque, they came back the next day and still looked at it for two hours. On the third day, they bought "Surging" and said: "For this painting, we have to skip two countries included in our original travel plan." It turned out that they were on their travel-marriage trip and Hong Kong was one of their stops.

"Rays of Morning" (45x53cm, 2008). Impressionists moved the drawing board outdoors to express natural light and shadow; Chinese painters used the thickness of the lines to present *yin* and *yang*. Huang Binhong's "Light Like a Dragon Walking", Li Keran's "Backlight", and Lin Fengmian's "Opera Stage Light" have all enriched the history of Chinese painting art. In my view, modern civilisation starts with "light", and we live in a "world of light" that is not only colourful, but also full of surprise. As for me, no matter what the subject of the works is, there are different ways of expressing light and shadow

which belongs to this era as well as the ideal in my heart. In the soft light and shadow, "Rays of Morning" shows straight lines full of power, and its structure is like a modern building, swaying and swinging in the early morning sun.

"In the Snow" (124x248cm, 2010). I heard that the winter of 2009 was the coldest one in Beijing in recent years. On the coldest day of the coldest winter, I went to the suburbs of Beijing to visit a friend. After lunch, my friend invited me to go to a nearby lotus pond. I was instantly refreshed and felt warm. Although it was not far, under the severe cold, my legs were cramping in turn so that I had to drag my feet to the lotus pond. In the sun, the lotus stalks, full of lotus pods, were surrounded by dried lotus leaves. In the pleasant moment of winter, I stood on the frozen lotus pond and danced with the lotus! It was unforgettable experience visiting lotus on such a freezing cold day. After returning to Hong Kong, the passionate "In the Snow" was born.

"Daylight with the Reflection of Cloud" (70x89cm, collage, 2013). I tore the painted lotus into pieces, like petals falling onto the earth, and then reorganised, representing endless life. The blank space was added with flowers and leaves, as colourful and beautiful as time pass through. It really has the artistic conception of "half pond lotus and half pond clouds".

"Hidden" (45x53cm, 2021). The sunny rain is like the nectar sprinkled from the sky, which makes the picture like a dream with magnificent light and shadow, like shining stars, natural and subtle.

These works are only a small part of my thousands of lotus paintings, representing my thoughts and experiences in different periods. Some are brilliant, while some are quiet. Surrounded by natural beauty of lakes and mountains, enjoying the rising clouds, raising a glass of wine and singing a joyful song, I enjoy my art and my life.

# 藝評

# Art Critics

林天行畫的荷塘，色彩繽紛，光影繁複，呈現了香遠益清的朝暉夕陰，雖然用的是傳統筆墨，然而在構圖與設色上，卻很接近西方油畫的賦彩，層層堆疊，互相暈染，完全吸取了西方繪畫的技巧與繁複多變的審美追求，以全新的方式，而且是毫無忌憚，毫無傳統包袱的羈絆，天馬行空，展現了畫家內心的體會，畫出了荷塘美景，也畫出荷花文化內涵的意境。

⋯⋯我們看到了，從張大千的潑墨重彩到林天行的層疊賦彩，就是畫荷傳統創新探索的歷程。

鄭培凱，〈荷花天行〉（節錄），《荷・天行》

二〇一三年

Lam Tian Xing's paintings are a parade of colour with intricate displays of shadow and light, sunlight and dusk. His composition and colour techniques are closely comparable to the colour of Western oil paintings, though using the Chinese traditional brushwork. In this brand new approach, he not only assimilates the Western overlapping and colour gradating skills, but also reveals his inner feelings and empathies without any fear of or constraint from traditional burdens. He paints more than just the beautiful scenery of the pond. His painting incorporates cultural connotations of his artistic conception of the lotus.

…we see the course of innovation and exploration from the splash-ink and heavy-colour of Zhang Daqian to the overlapping and colour gradation of Lam Tian Xing.

Cheng Pei Kai, Lotus Tian Xing (excerpts), *Lotus · Tian Xing*, 2013

林天行的水墨荷花源於生活，中得心源，在畫法上一空依傍，幾乎很少傳統的因子。因為積累深厚，畫家總是非常自信地恣意揮灑，從容點染，以燦爛之筆創造夢幻之境。有時輕盈，有時深沉近乎虛空，有時博大彌漫六合，令人震撼，令人驚嘆。

天行畫荷的另一特色是透明，純淨似水晶。花是透明的，所謂紅紅白白越女腮，早經吟誦，不足為奇，因為陽光下紅荷白荷的嬌美顯而易見。但荷花的箭桿也是透明的，彷彿可以看到水分的流動，顯得飽滿、生機盎然。而枝條的排列也經過精心安排。一般畫家總喜歡在箭桿上表現力度，為書畫同源提供例證。而林天行則別出心裁，從版畫，裝飾畫汲取營養，以柔克剛，於玲瓏剔透中顯現荷花的潔白無瑕。這種細節上的考究，不僅強調了荷花造型上的特點，而且和蓮葉的大寫意在畫面上取得平衡，它和三二游魚，一叢豐草共同烘托出林天行既豪放而又靈秀的畫風。

秦嶺雪，〈荷且不朽〉（節錄），《天行之荷》，二〇〇四年

It is without doubt that Tian Xing's lotus ink paintings sprang directly from life experience, and are creations crafted from the heart. These are rarely found from traditional elements. These paintings are spontaneous, full of assuredness and confidence. The vibrant dreamscapes that came from his brushes are strong yet ethereal, otherworldly yet imbued with the vastness of human experience. The viewers can only watch in awe and with thrills.

Transparency is another characteristic of Tian Xing's lotus paintings. The flowers are transparent and crystalline, rosy as cheeks of young maidens. There is nothing out of the ordinary since lotuses often have this appealing look under the sun. What distinguishes Tian Xing's lotuses is that even the stalks of the flowers are transparent such that one could almost see the robust and vivacious flowing of life's fluid in the veins, amidst the meticulously rendered tangled maze of strokes. Artists always attempt to express strength in the rendering of stalks – a remnant of the traditional view that painting and calligraphy shared the same origin. Tian Xing chooses instead to approach his lotus paintings from the perspective of graphic arts, emphasising the pliability and subjugating the so called strength to a supporting role, so as to bring to the fore the purity and unblemished look of the lotus from the resulting delicacy of refined arabesque. Such attention to details highlights the form of lotus blossoms, and keeps the flowers in equilibrium with the impressionistic treatment of lotus leaves. Adorned by leisure fish and verdant water plants, these lotus paintings have perfectly reflected Tian Xing's open but sensitive temperament.

**Qin Lingxue, Immotal Lotus (excerpts), *Lotus of Tian Xing*, 2004**

Recently, there has been a transformation in Tian Xing's lotus painting, which may be considered the second phase of his lotus creation. During the first phase he paid attention to colours, the latter however focused on brush and ink; the former more visual, the latter more spiritual; the first stage created mainly by blocks and planes, the second of lines; the former is loud and urban, the latter is inner-directed and spiritual; the former clamorous, the latter quiet; the former crude, the latter mature...

Tian Xing has contributed to introducing a style of spiritual symbolism to us by his unparalleled style of lotus painting.

**Hua Tianxue, The Lotus of Lam Tian Xing – Another Allegory (excerpts),** *The Lotus of My Heart*, **2004**

近一年來天行的荷花面貌有了一些改變，可以看作是他荷花系列的第二個階段。相比較來說，前一個階段偏於色彩，後一個階段偏於水墨；前一個階段更注重視覺性，後一個階段更注重精神性；前一個階段主要用塊面來構造，後一個階段更多用綫來表現；前一個階段多都市和張揚的氣息，後一個階段則主要是內斂的和精神的；前一個階段更喧囂，後一個階段更平靜；前一個階段年輕，後一個階段成熟……

可以說，天行的荷花是別樣的，在精神寄寓上是對我們的一種貢獻。

華天雪，〈另一種寄寓──看林天行畫新荷〉（節錄），《天行之荷》，

二〇〇四年

What Lam Tian Xing depicts is the calamus in the south. The calamus in the south is more diverse and graceful, compared to the calamus in the north. The calamus he painted in 2019 has beautiful lines and he focuses on the interweaving lines. By depicting the calamus, he has given vent to his artistic sentiments. He does not follow the brushstrokes of lines in traditional paintings, but creates intertwined lines reminiscent of Pollock. What he found is the constitutive line deriving from spiritual intuition by which the free and unrestrained temperament of calamus has been vividly presented.

**Zhang Rongdong, Impression of Tian Xing's Calamus Series (excerpts),** *Anthem of Calamus*, **2020**

林天行描繪的是南方的菖蒲，南方菖蒲比北方的菖蒲更姿態多樣，更具婉約的儀態之美。他在二〇一九年所作菖蒲，綫條優美，他專注於菖蒲綫條的交織，他指向的是菖蒲，宣洩的是胸中之逸氣，他並不沿襲傳統繪畫之綫條，他的綫條交織令人想到波洛克的綫，他找到的是構成式的綫，心靈直覺的綫，菖蒲自在瀟灑的氣質得到淋漓盡致的呈現。

張榮東，〈指向菖蒲神性之表現──林天行菖蒲系列印象〉（節錄），《楚頌新聲·菖蒲集》，

二〇二〇年

天行畫蓮荷，為人、處事，堪如蓮荷；天行畫蓮荷，繼承、思變，或比周子。

天行畫蓮荷，有自家面貌，承前而啟後。傳統畫蓮荷，先有勾填法，再有沒骨法；先工謹而後寫意，大寫意後有潑墨，天行肇始潑彩畫蓮荷，或是以畫道傳「愛蓮說」之道。看天行畫蓮荷，說是萬紫千紅並不為過。似乎，天宇萬化，世間萬機，皆能集結於胸幻作蓮荷畫圖，再假借豪邁的筆墨、慷慨的色彩澄灑，豪情藉畫圖便躍然紙上。且看，這奔騰流暢的筆墨色彩的內裏，是深邃的清靜。

劉牧，〈蓮漪〉（節錄），《蓮說》，二〇一八年

Tian Xing paints lotus. The way he behaves is very like lotus; his philosophy of inheritance and innovation is like Zhou Zi.

Tian Xing's lotus is absolutely unique. He has developed his own style, which has not only inherited his predecessors, but also inspired the successors. In Chinese traditional lotus painting, it appears first the method of sketching and filling with colours (*goutian*), and then the boneless (*mogu*) method; there is meticulous drawing and freehand drawing, followed by splashing ink. Tian Xing has begun his lotus paintings with splashing colours, which may express the philosophy in "Ode to the Lotus" by his lotus paintings. For Tian Xing's lotus paintings, it could be described as a blaze of colours. It seems that the universe is full of changes and the world is full of possibilities, which all can be gathered in the heart and become lotus paintings; and then, using bold brushwork, generous colour and splattering techniques, the lofty sentiments appear on the paper. Deep tranquility can be found inside the galloping and fluent brushwork and ink colour.

**Liu Mu, The Ripples of Lotus (excerpts),** *Love of Lotus*, **2018**

Lam Tian Xing said in an interview that he liked to draw lotus stems when creating lotus paintings. Sometimes he would lie on the ground to observe and admire the lotus stems. Most people usually look at the flowers and leaves of lotus from the top, which is opposite to Lam Tian Xing's perspective sometimes. From the bottom up, he can see the lotus stems interspersed with and criss-crossing each other, like the harmony of various musical instruments in a symphony, which is quite interesting. A different perspective from the tradition belongs to one of the distinctive features of Lam Tian Xing's lotus painting.

Lam Tian Xing's lotus paintings can be roughly divided into three phases. Before 2004, he had been exploring his personal style. In 2004, he held the first lotus painting exhibition "The Lotus of My Heart". Since then, he has continued to paint lotus, publish albums and hold exhibitions. The second phase is from 2004 to 2010. Finding an accurate artistic language, Lam Tian Xing used various images to express the lotus. He likened the lotus to all things and feelings, such as mountains and rivers, clouds, trees, the earth, forests, joy and sorrows, with the appearance of the lotus. The second feature is composition. He believes that the most compelling thing about the works left by masters at all times and in all countries, is the structure. The structure of each master has its own characteristics. For example, the composition of lotus paintings by Bada Shanren is so simple that there are only a few lines, which is a very clear feature. The composition of Tian Xing's lotus is much more complex and richer with little left blank. His lotus painting is often full of lotus flowers or staggered lotus stems, busy and warm. In addition, there are usually only lotus in Lam Tian Xing's lotus paintings, unlike traditional lotus paintings with carp and dragonflies. In his eyes, the lotus will never die.

**Ping'er, Impression of Lam Tian Xing (excerpts),** *China Today*, **October 2020**

The calamus in his works is agile, warm, deep, melancholy, passionate and romantic. That afternoon, I wrote these phrases:

"Don't move / You and spiritual grass / Don't talk / Regardless of the Tang and Song Dynasties / Who is talking about calamus? I still remember it more than half of my life / Why depict it? / In the deep purple, the flowers to bloom / Swipe the pen / Declare a grand season"

**Luo Guangping, About Calamus (excerpts),** *Anthem of Calamus*, **2020**

林天行在接受訪問時談到，他畫荷花時，很喜歡畫荷花，主要是看花和葉，從上往下看，但林天行的視角有時卻與此相反。從下往上看，他能看見荷莖相互穿插，縱橫交叉，彷彿交響樂中各種樂器的和鳴，別有一番趣味。有別於傳統的視角是林天行荷圖的技法特色之一。

有時他會趴在地下，專門欣賞荷莖。一般人觀看荷花，主要是看花和葉，

林天行的荷花繪畫大致分為三個時期。二〇〇四年，他舉辦了第一個荷花繪畫展覽《天行之荷》，從此不斷畫荷、出畫冊、辦展覽。二〇〇四年到二〇一〇年是第二階段。在找到一種準確的語言之後，林天行以各種不同的畫面去表現荷花。他將荷花比喻成所有的事物和感情，大山大水、雲、樹、大地、森林、喜怒哀樂等，都以荷花的外貌。

第二個特色是構圖。他認為，古今中外大家留下來的作品，最震撼人心之處在於結構。每位大家的結構都有自身特色，例如八大山人荷圖的結構簡潔得只有幾根綫條，特徵非常明顯。林天行荷圖的結構更為繁複豐富，留白極少，常常是一張作品上開滿了荷花，或是荷莖交錯，熱烈非凡。此外，林天行的荷圖裏，一般只單純地出現荷花，不像傳統的荷圖那樣時而出現鯉魚和蜻蜓的身影。在他眼中，荷花是沒有死亡的。

萍兒，〈每一刻都貫注深情——林天行印象〉（節錄），《今日中國》，二〇二〇年十月號

他筆下的菖蒲，蒼勁熱烈深沈憂鬱激情浪漫。那天午後，我寫下了這樣的句子：

「都不動／你和靈草／都不說／無論唐宋／誰道菖蒲 猶度半生卻憶／素寫為何？／深紫判處花開／揮筆／宣佈一場盛大的季節」

羅光萍，〈誰道菖蒲 猶度半生卻憶〉（節錄），《楚頌新聲‧菖蒲集》，二〇二〇年

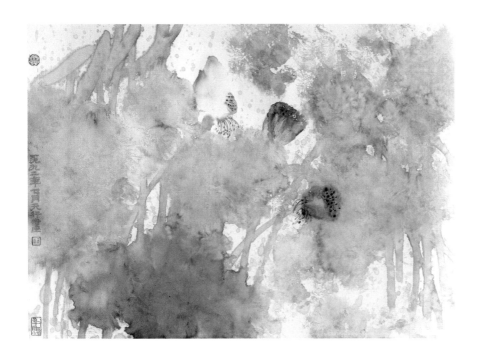

清秋
**Clear Autumn**

水墨設色紙本
*Ink and Colour on Paper*

52x72cm ｜ 1992

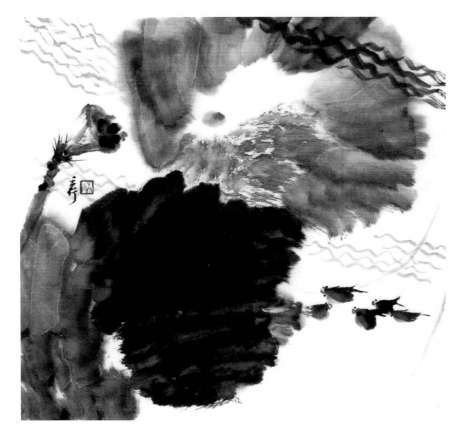

魚在月中游
**Fish in Moonlight**

水墨設色紙本
*Ink and Colour on Paper*

54x59cm ｜ 1996

**荷花流水**
**Drifting Lotus**

水墨設色紙本
*Ink and Colour on Paper*
54x59cm | 1996

**靜荷**
**Lotus in Stillness**

水墨設色紙本
*Ink and Colour on Paper*
70x70cm | 2002

**曉風**
**Morning Breeze**

水墨設色紙本
*Ink and Colour on Paper*
70x70cm | 2002

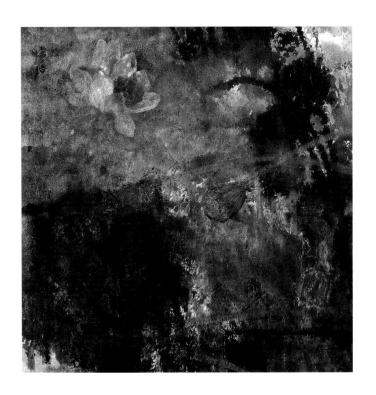

**心映**
**Impression**

水墨設色紙本
*Ink and Colour on Paper*
70x70cm｜2002

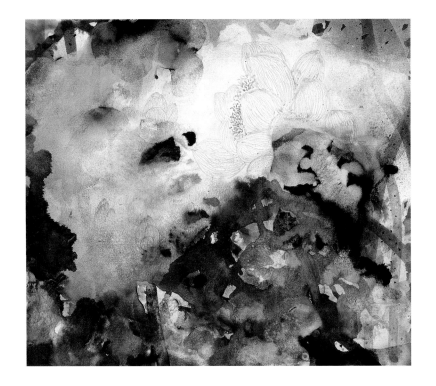

**雲霞**
**Glimmering Haze**

水墨設色紙本
*Ink and Colour on Paper*
45x53cm｜2004

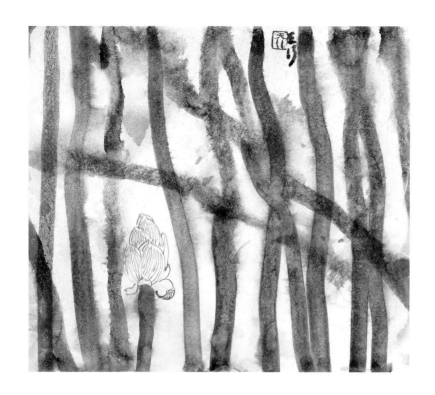

**初露**
**Fresh Dew**

水墨設色紙本
*Ink and Colour on Paper*
24x27cm | 2004

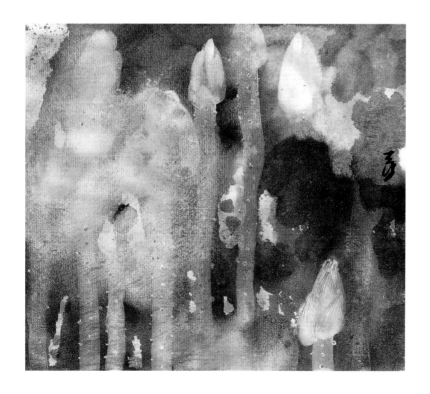

**待放**
**Promise of Summer**

水墨設色紙本
*Ink and Colour on Paper*
24x27cm | 2004

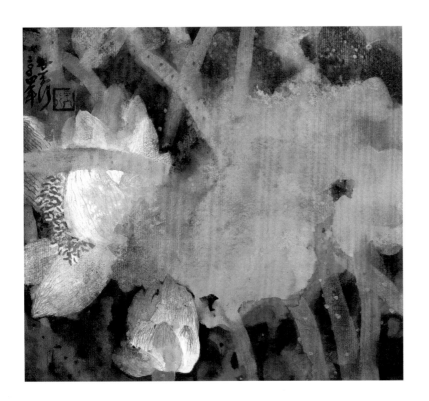

夏語
**Summer Whispers**

水墨設色紙本
*Ink and Colour on Paper*
24x27cm │ 2004

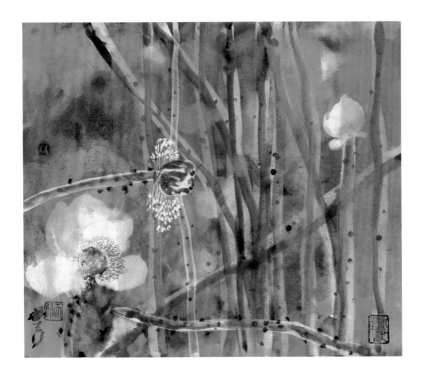

綠霧
**Verdant Haze**

水墨設色紙本
*Ink and Colour on Paper*
45x53cm │ 2007

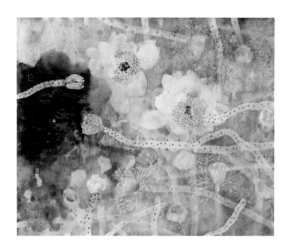

**歡**
**Happiness**

水墨設色紙本
*Ink and Colour on Paper*

50x60cm │ 2008

**霞光**
**Rays of Morning**

水墨設色紙本
*Ink and Colour on Paper*

45x53cm │ 2008

**蘊**
**Elegance**

水墨紙本
*Ink on Paper*

68x68cm │ 2009

**崇**
**Worship**

水墨設色紙本
*Ink and Colour on Paper*

68x68cm │ 2010

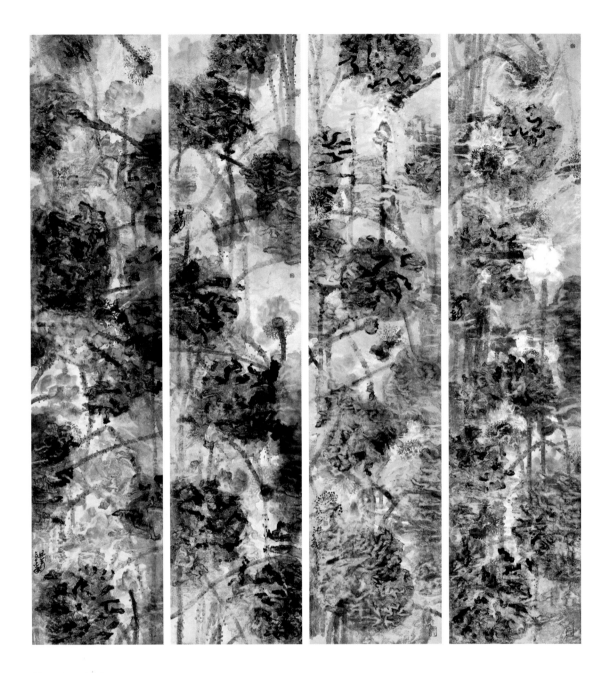

祥光 (一至四)
**Aurora of Blessings** (1-4)

水墨設色紙本
*Ink and Colour on Paper*
235x53cm x4 | 2007

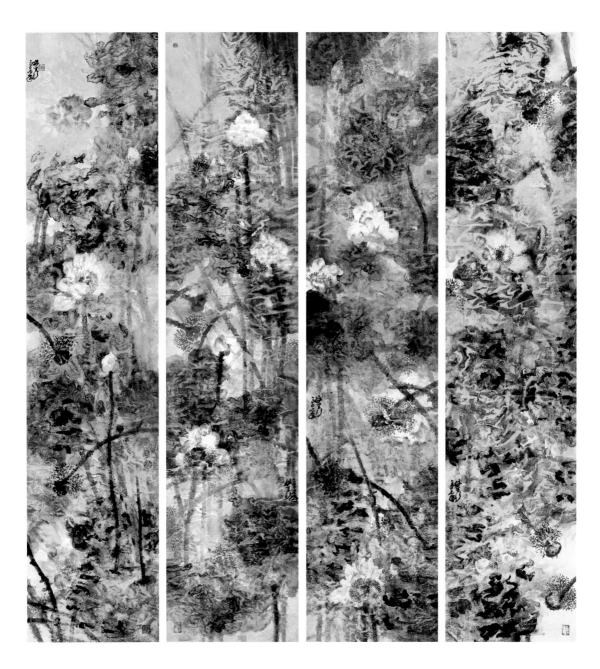

祥光 (五至八)
**Aurora of Blessings** (5-8)

水墨設色紙本
*Ink and Colour on Paper*
235x53cm x4 | 2007

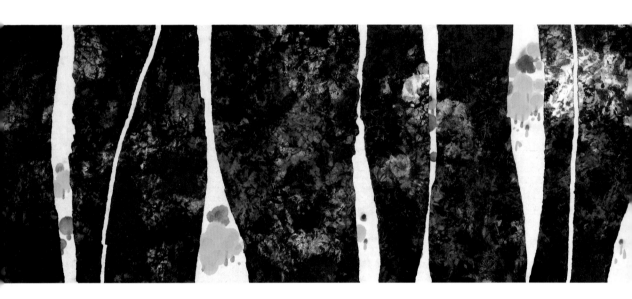

生生不息（一）
**Neverending** (1)

拼貼
*Collage*
34x184cm ｜ 2009

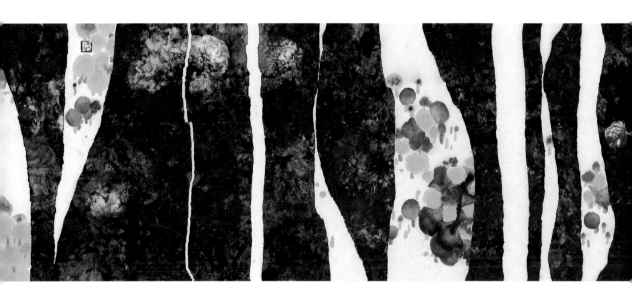

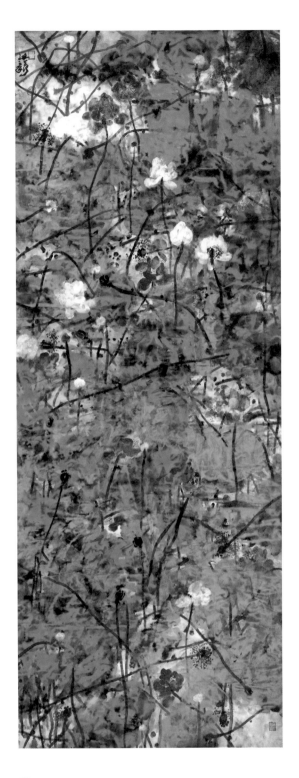

融
**Harmony**

水墨設色紙本
*Ink and Colour on Paper*
364x146cm | 2010

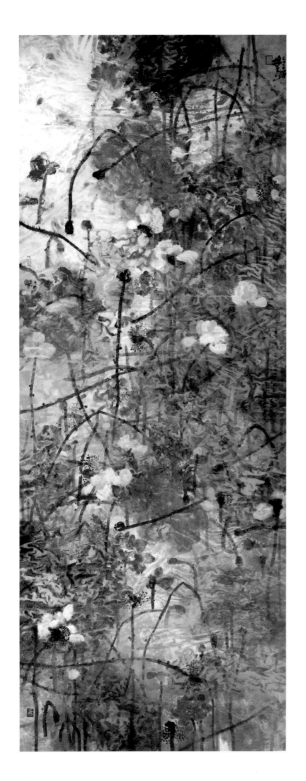

映

**Reflection**

水墨設色紙本

*Ink and Colour on Paper*

364x146cm | 2010

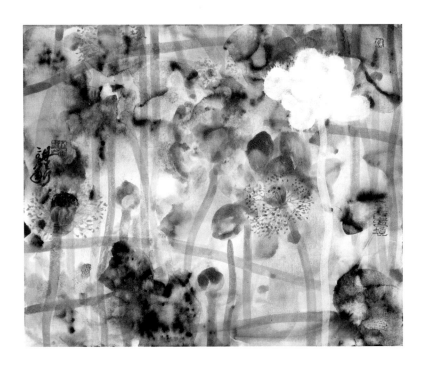

和唱
**Join in the Singing**

水墨設色紙本
*Ink and Colour on Paper*
50x60cm ｜ 2008-2010

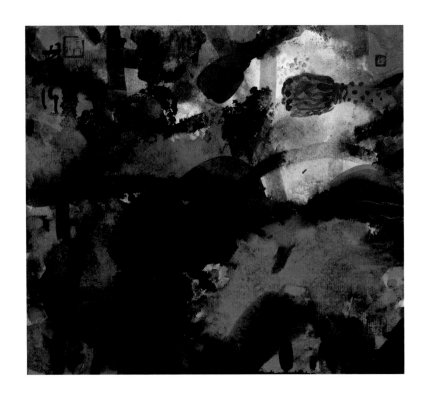

流光
**Shimmering**

水墨設色紙本
*Ink and Colour on Paper*
24x27cm ｜ 2008-2010

**涵**
**Inwardness**

水墨設色紙本
*Ink and Colour on Paper*

45x53cm | 2011

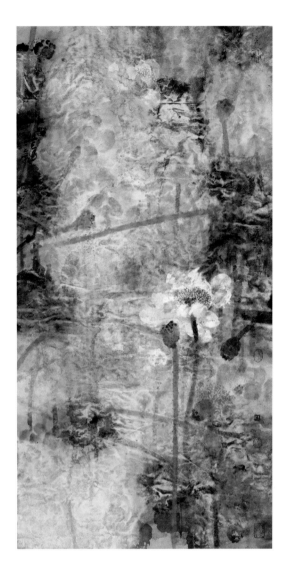

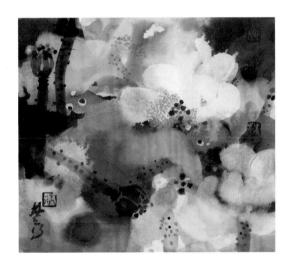

**觀**
**Gaze**

水墨設色紙本
*Ink and Colour on Paper*

24x27cm | 2012

**晴霧**
**Sunny Mist**

水墨設色紙本
*Ink and Colour on Paper*

132x68cm | 2012

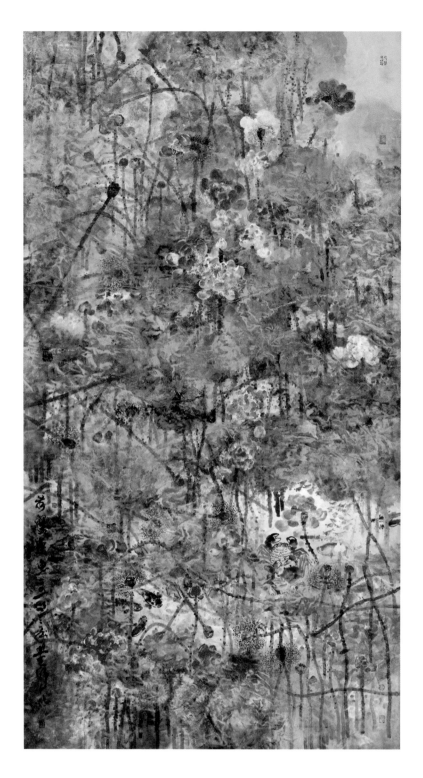

荷蟹蓮魚
**Livelihoods in the Pond**

水墨設色紙本
*Ink and Colour on Paper*
368x202cm | 2012

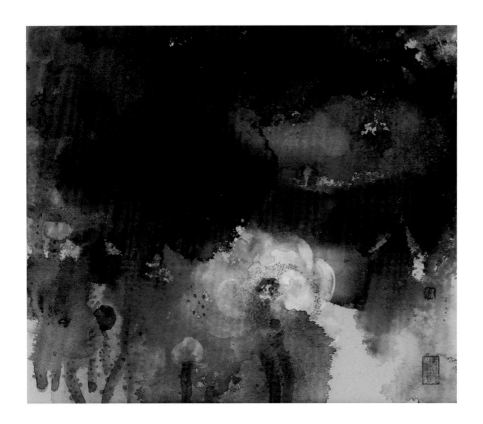

**靜緣**
**Placid**

水墨設色紙本
*Ink and Colour on Paper*
45x53cm ｜ 2013

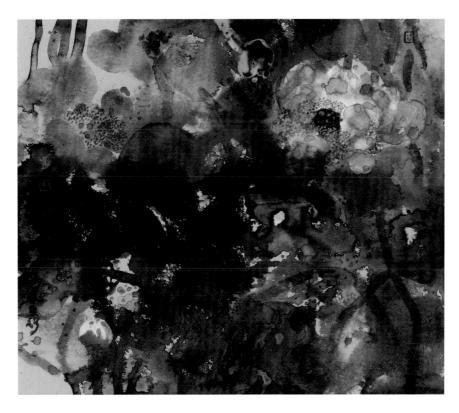

**蓮語**
**Whispering**

水墨設色紙本
*Ink and Colour on Paper*
45x53cm ｜ 2013

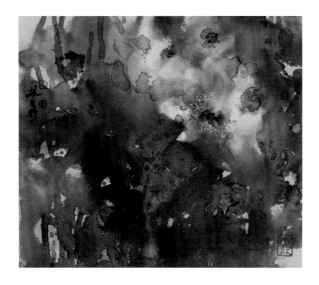

詩情
**Feelings**

水墨設色紙本
*Ink and Colour on Paper*

45x53cm ｜ 2013

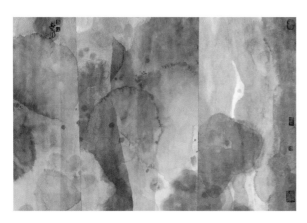

微光
**Glimmering**

拼貼
*Collage*

65x99cm ｜ 2013

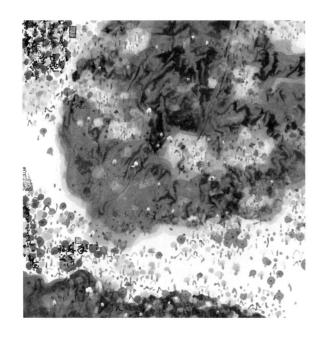

一池夏荷
**Summer Lotus**

水墨設色紙本
*Ink and Colour on Paper*

69x68cm ｜ 2013

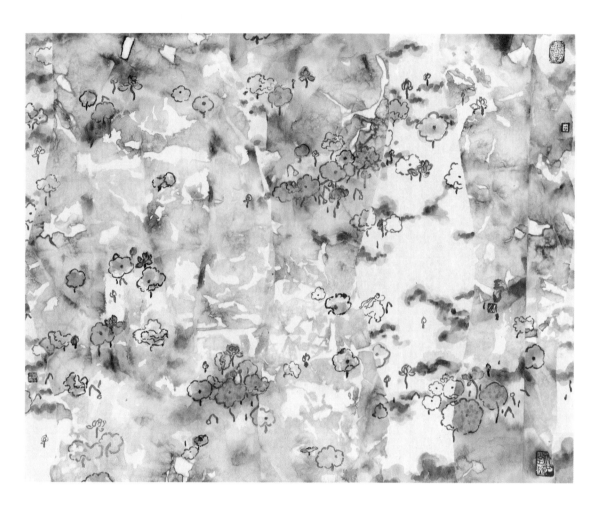

天光雲影
**Reflecting Lights**

拼貼

*Collage*

70x80cm | 2013

滿池荷香
**A Pond of Sweet Lotus**

拼貼
*Collage*

68x130cm | 2013

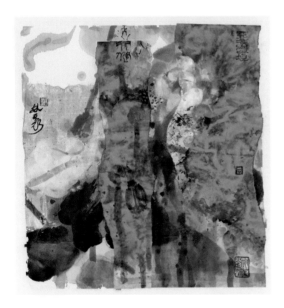

凝
**Gazing**

拼貼
*Collage*

47x45cm | 2013

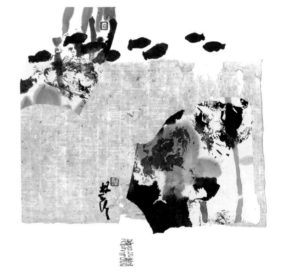

相印
**Double Images**

拼貼
*Collage*

45x47cm | 2013

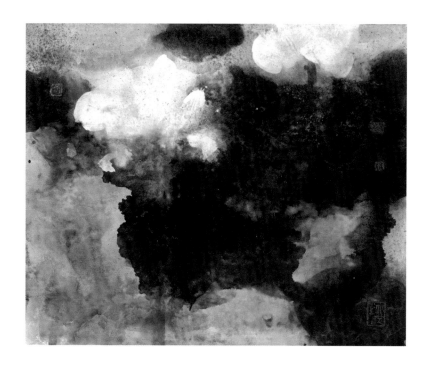

淨（二）
**Purity (2)**

水墨設色紙本
*Ink and Colour on Paper*
50x60cm ｜ 2014

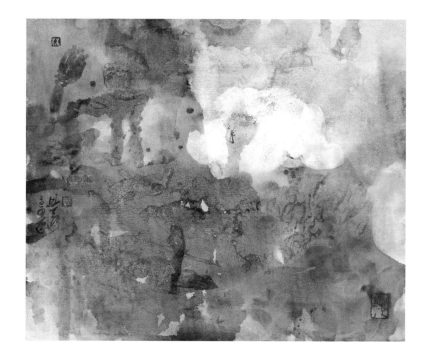

淨（三）
**Purity (3)**

水墨設色紙本
*Ink and Colour on Paper*
50x60cm ｜ 2014

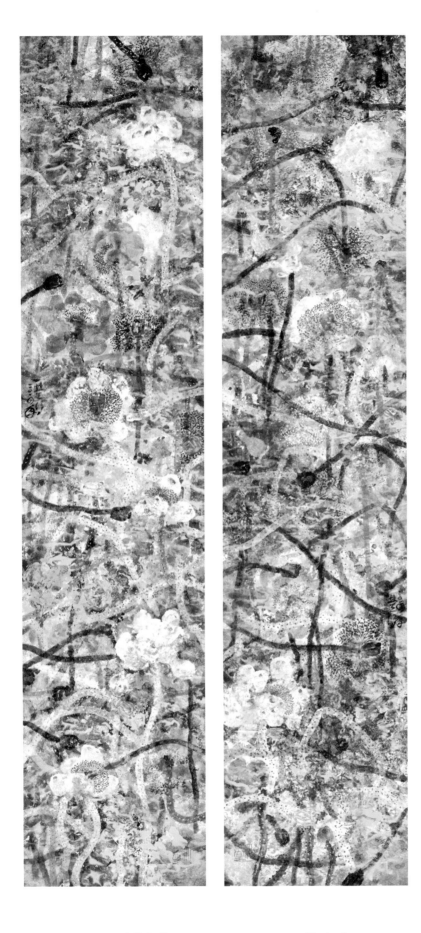

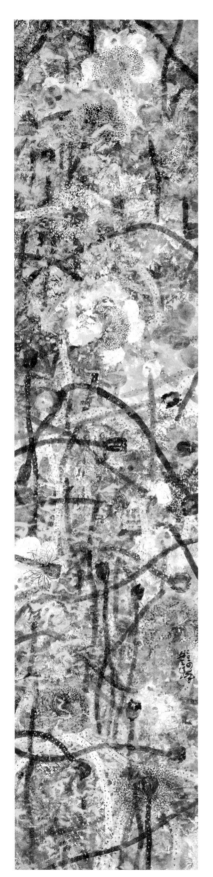
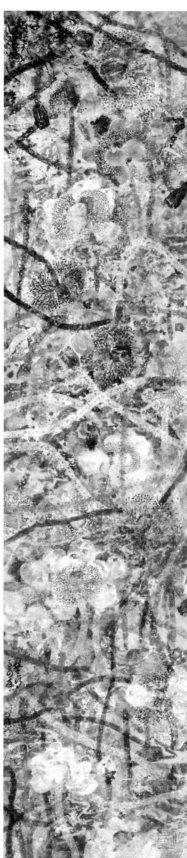

五彩的地方（一至四）
**Colourful Places (1-4)**

水墨設色紙本
*Ink and Colour on Paper*
235x54cm x4 | 2014

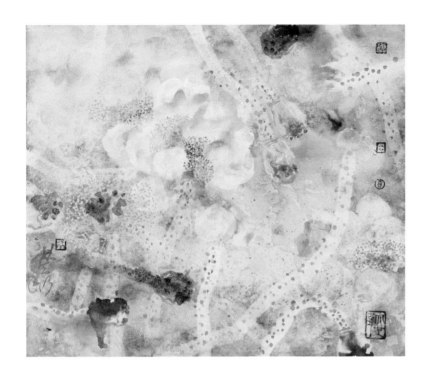

**融**
**Harmony**

水墨設色紙本
*Ink and Colour on Paper*
45x53cm │ 2014

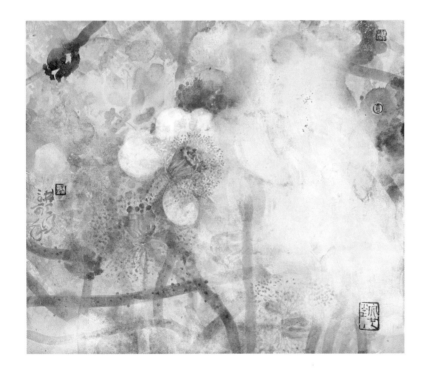

**暉映**
**Dazzling Sunlight**

水墨設色紙本
*Ink and Colour on Paper*
45x53cm │ 2014

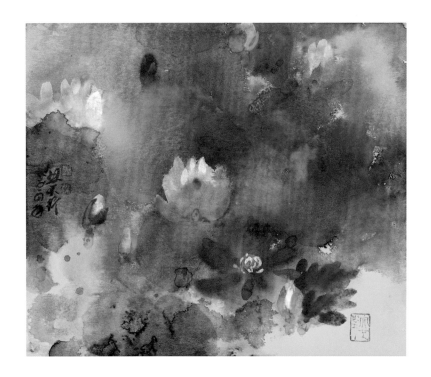

**靜聽**
**Perceiving**

水墨設色紙本
*Ink and Colour on Paper*

45x53cm | 2014

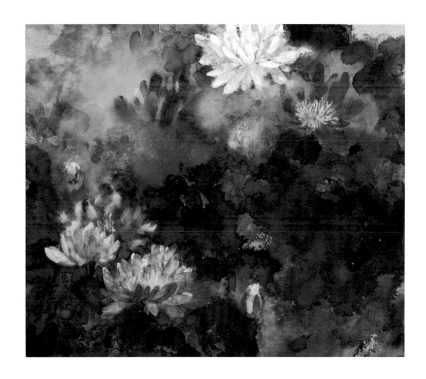

**漫開（二）**
**Diffusion (2)**

水墨設色紙本
*Ink and Colour on Paper*

45x53cm | 2014

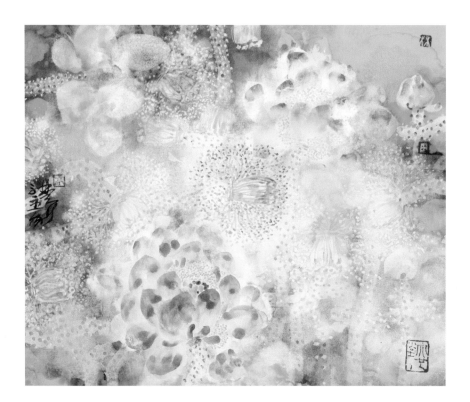

漫開
**Diffusion**

水墨設色紙本
*Ink and Colour on Paper*
45x53cm │ 2015

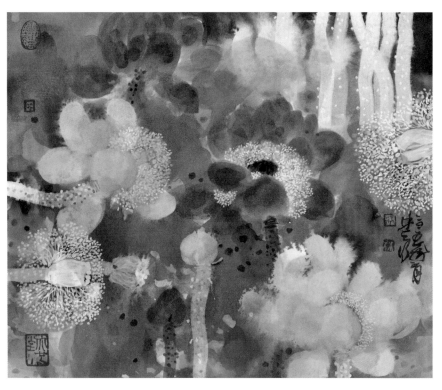

生輝
**Splendour**

水墨設色紙本
*Ink and Colour on Paper*
45x53cm │ 2015

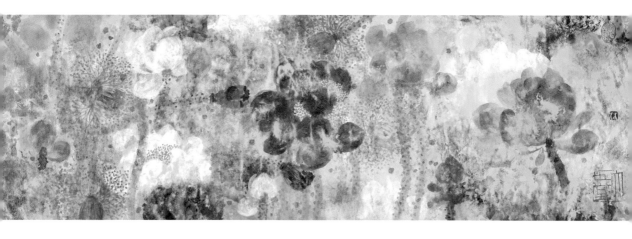

詠詩
**Chanting Poem**

水墨設色紙本
*Ink and Colour on Paper*
35x138cm ｜ 2015

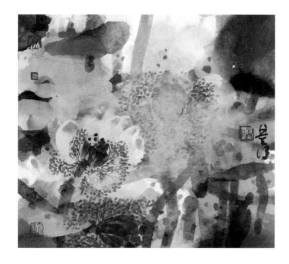

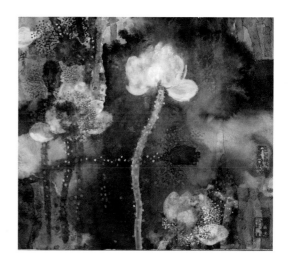

霞韻（一）
**Dancing in the Haze (1)**

水墨設色紙本
*Ink and Colour on Paper*
24x27cm ｜ 2016

雲霞
**Glimmering Haze**

水墨設色紙本
*Ink and Colour on Paper*
45x53cm ｜ 2016

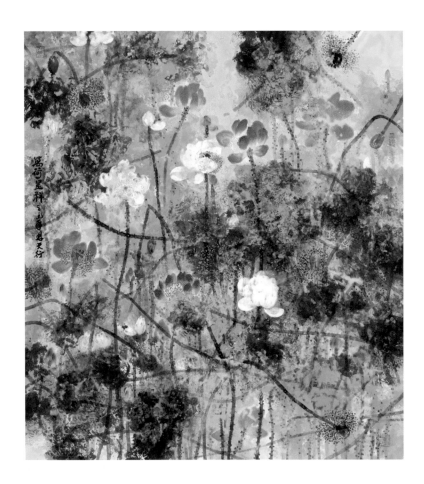

萬荷呈祥
**Auspicious in Lotus**

水墨設色紙本
*Ink and Colour on Paper*
174x156cm ｜ 2017

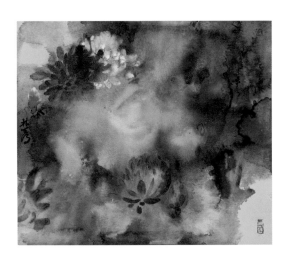

蓮説
**Narrating By Lotus**

水墨設色紙本
*Ink and Colour on Paper*
45x53cm ｜ 2017

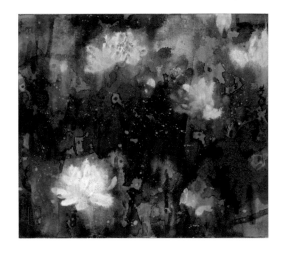

蓮悦
**Gleeful**

水墨設色紙本
*Ink and Colour on Paper*
45x53cm ｜ 2017

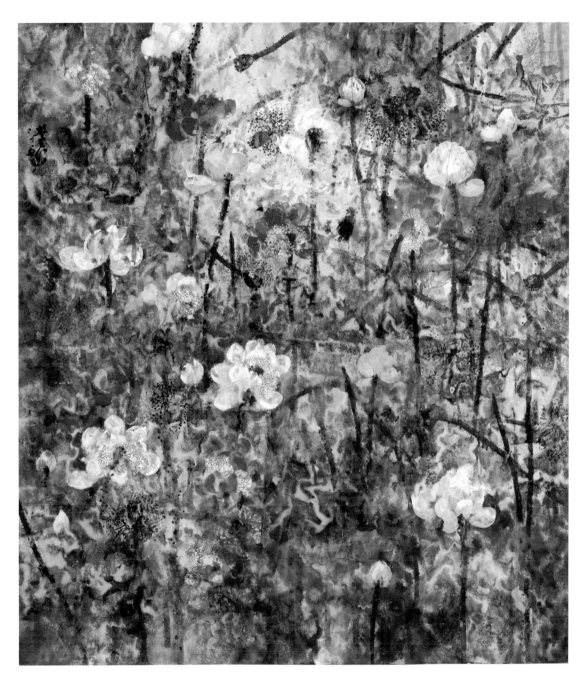

**耀荷**
**Glory of Lotus**

水墨設色紙本
*Ink and Colour on Paper*
174x156cm ｜ 2017

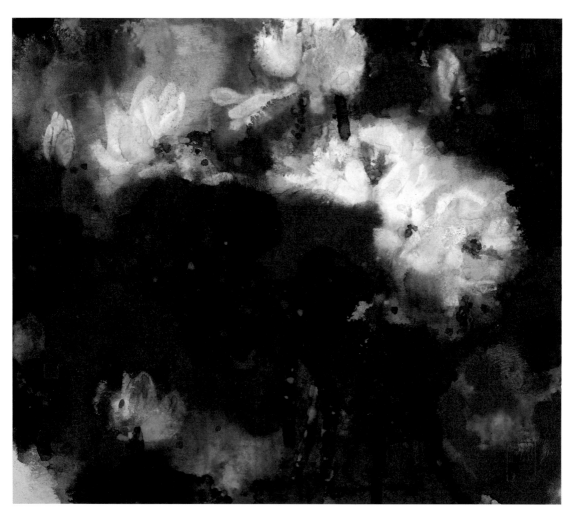

天光
**Daybreak**

水墨設色紙本
*Ink and Colour on Paper*
45x53cm │ 2017

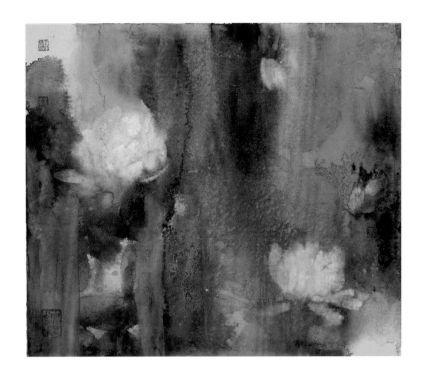

**雨色**
**Colours of the Rain**

水墨設色紙本
*Ink and Colour on Paper*
45x53cm | 2017

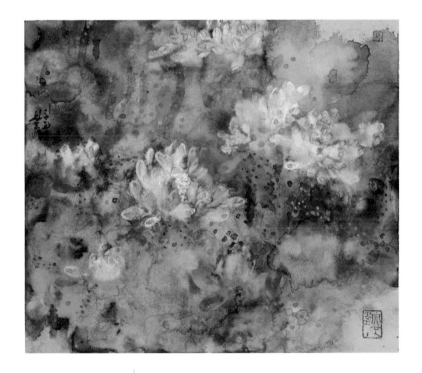

**緣起**
**First Encounter**

水墨設色紙本
*Ink and Colour on Paper*
45x53cm | 2017

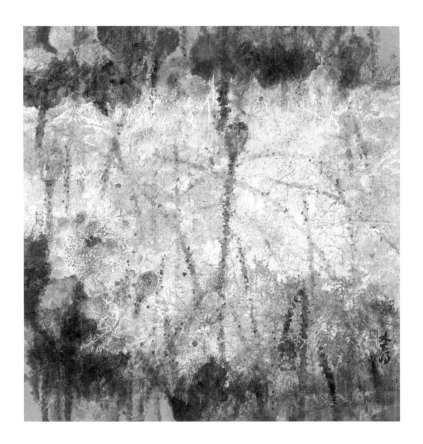

生輝
**Splendour**

水墨設色紙本
*Ink and Colour on Paper*
68x68cm | 2012-2017

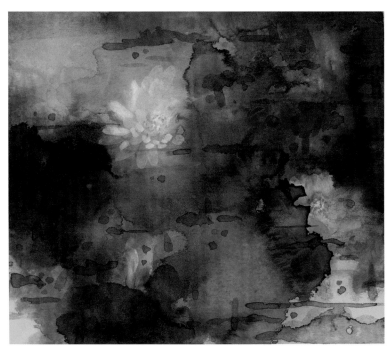

觀照
**Viewing**

水墨設色紙本
*Ink and Colour on Paper*
45x53cm | 2018

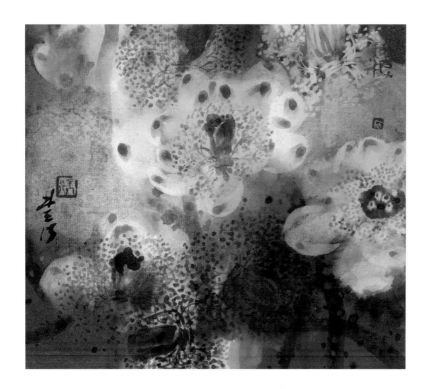

逸
**Carefree**

水墨設色紙本
*Ink and Colour on Paper*
24x27cm ｜ 2018

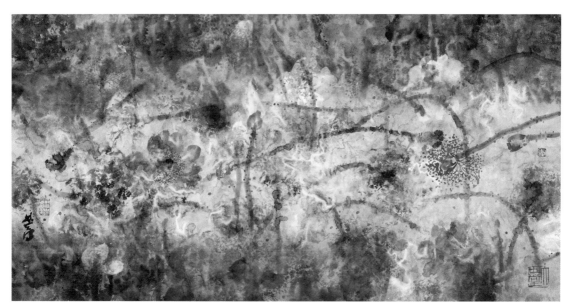

秋聲
**Sound of Autumn**

水墨設色紙本
*Ink and Colour on Paper*
68x138cm ｜ 2018

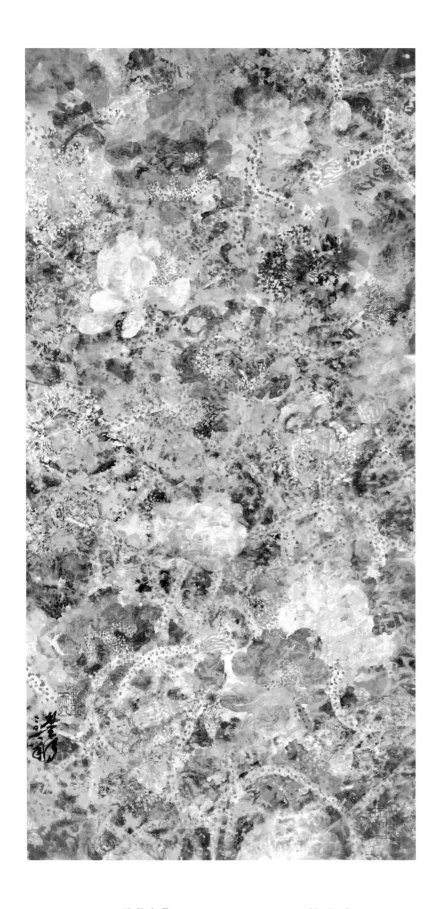

如詩
**Like A Poem**

水墨設色紙本
*Ink and Colour on Paper*
138x70cm | 2018

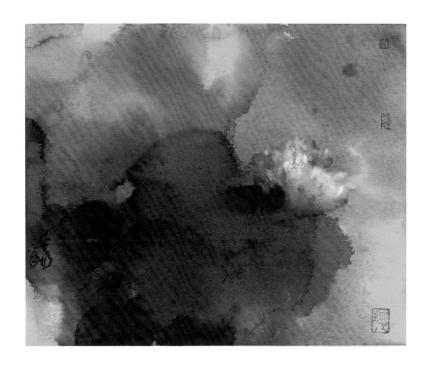

**如幻 (一)**
**Mysterious Fantasy (1)**

水墨設色紙本
*Ink and Colour on Paper*
50x60cm | 2018

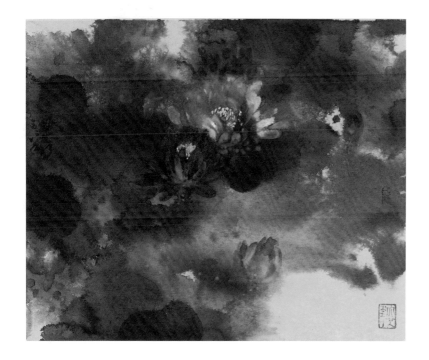

**如幻 (三)**
**Mysterious Fantasy (3)**

水墨設色紙本
*Ink and Colour on Paper*
50x60cm | 2018

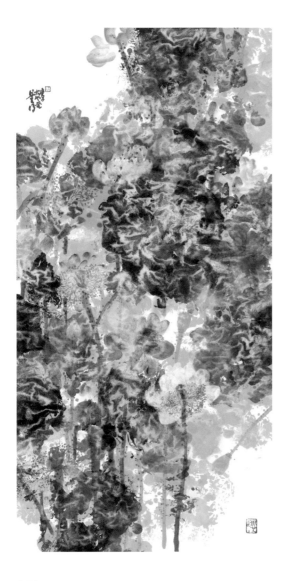

新境
**New Realm**

水墨設色紙本
*Ink and Colour on Paper*
138x68cm │ 2020

光耀
**Glory**

水墨設色紙本
*Ink and Colour on Paper*
45x53cm │ 2008-2020

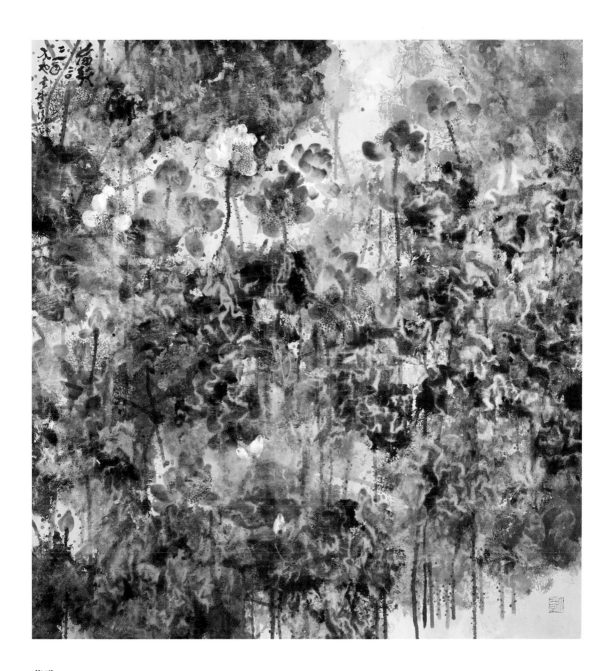

**荷歌**
**Song of Lotus**

水墨設色紙本
*Ink and Colour on Paper*
193x183cm | 2021

清境
**Tranquility**

水墨設色紙本
*Ink and Colour on Paper*

45x53cm ｜ 2021

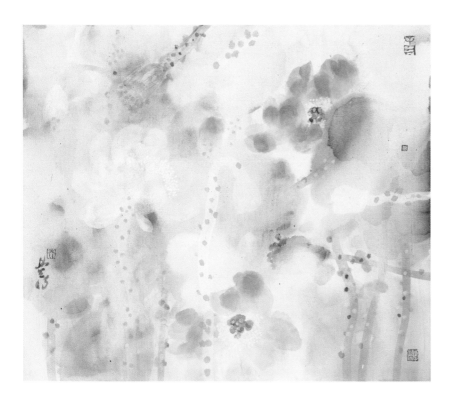

心遠
**Wisdom**

水墨設色紙本
*Ink and Colour on Paper*

45x53cm ｜ 2021

翠風
**Green Breeze**

水墨設色紙本
*Ink and Colour on Paper*

45x53cm ｜ 2021

悠
**Leisure**

水墨設色紙本
*Ink and Colour on Paper*

45x53cm ｜ 2021

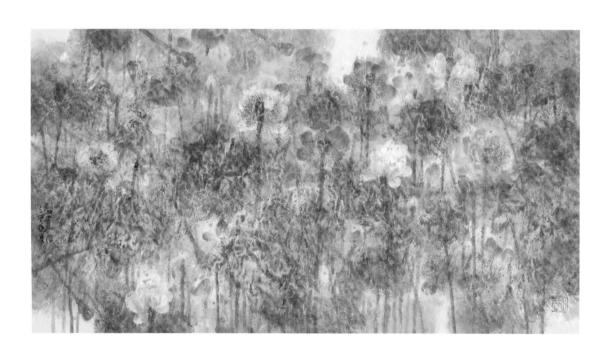

朝彩
**Morning Glow**

水墨設色紙本
*Ink and Colour on Paper*

90x176cm ｜ 2021

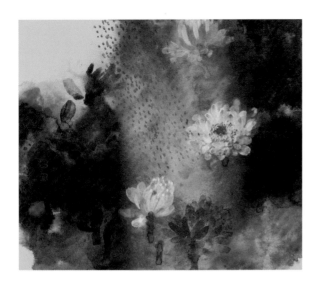

**蓮雨**
**In the Rain**

水墨設色紙本
*Ink and Colour on Paper*
45x53cm｜2021

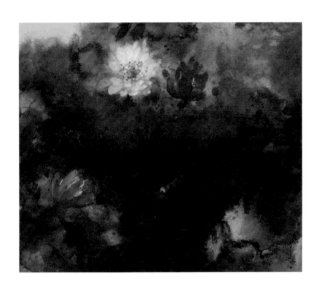

**蓮開**
**Blossom**

水墨設色紙本
*Ink and Colour on Paper*
45x53cm｜2021

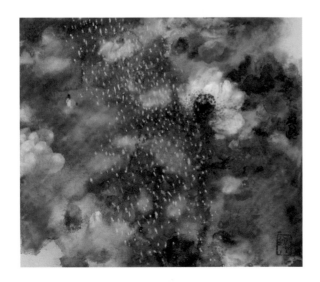

**隱**
**Hidden**

水墨設色紙本
*Ink and Colour on Paper*
45x53cm｜2021

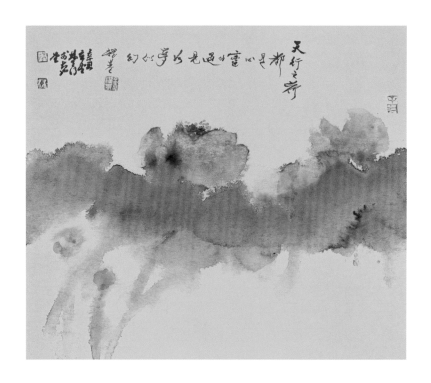

天行之荷（二）
金耀基題
**The Lotus of My Heart (2)**
**Calligraphy by King Yeo Chi**

水墨設色紙本
*Ink and Colour on Paper*
45x53cm ｜ 2021

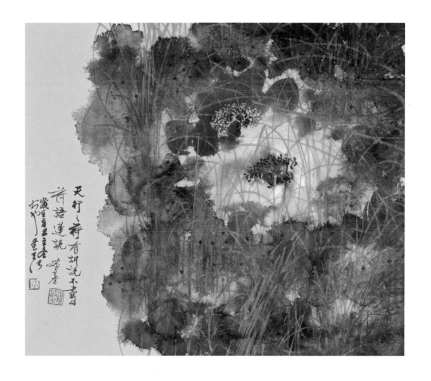

天行之荷（四）
金耀基題
**The Lotus of My Heart (4)**
**Calligraphy by King Yeo Chi**

水墨設色紙本
*Ink and Colour on Paper*
45x53cm ｜ 2021

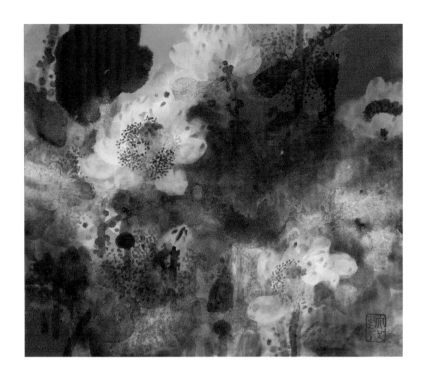

映霞
**Shimmering Clouds**

水墨設色紙本
*Ink and Colour on Paper*
45x53cm ｜ 2021

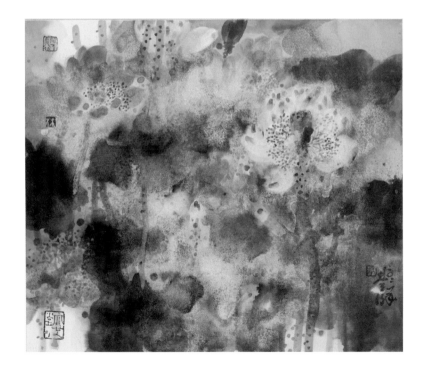

舒懷
**Delightful**

水墨設色紙本
*Ink and Colour on Paper*
45x53cm ｜ 2021

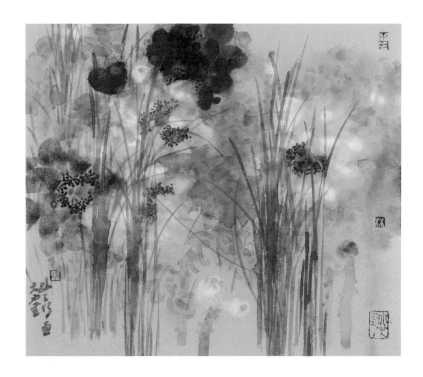

麗日
**Brilliant Sunshine**

水墨設色紙本
*Ink and Colour on Paper*

45x53cm｜2021

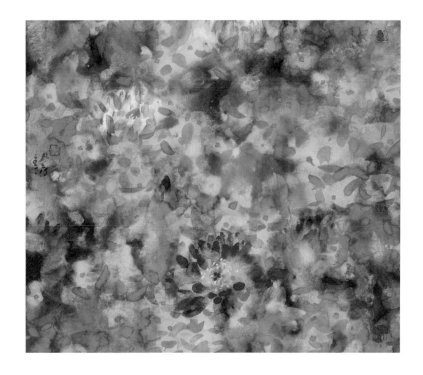

夏日
**Summer Day**

水墨設色紙本
*Ink and Colour on Paper*

45x53cm｜2021

# 菖蒲系列
## CALAMUS SERIES

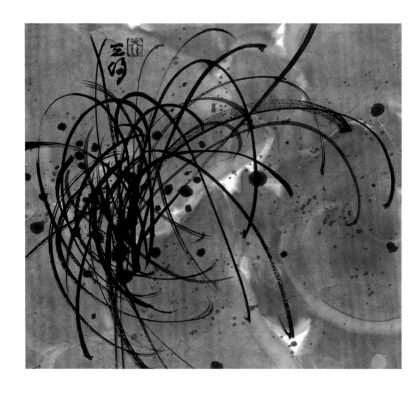

濛
**Misty**

水墨紙本
*Ink on Paper*
24x27cm ｜ 2019

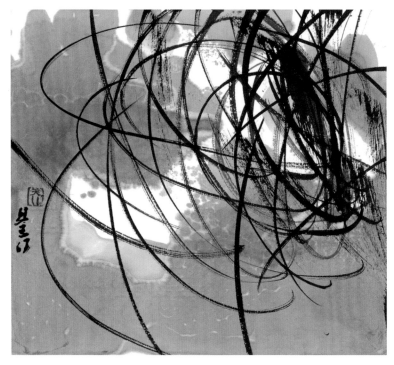

和
**Unison**

水墨設色紙本
*Ink and Colour on Paper*
24x27cm ｜ 2019

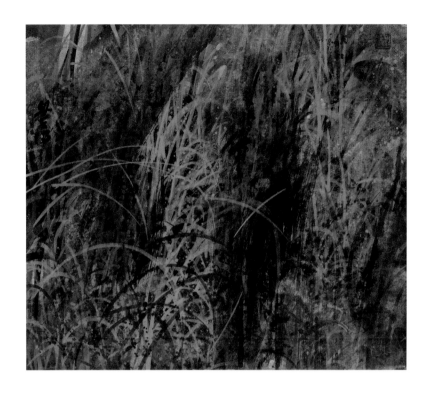

映
**Reflection**

水墨設色紙本
*Ink and Colour on Paper*
24x27cm｜2019

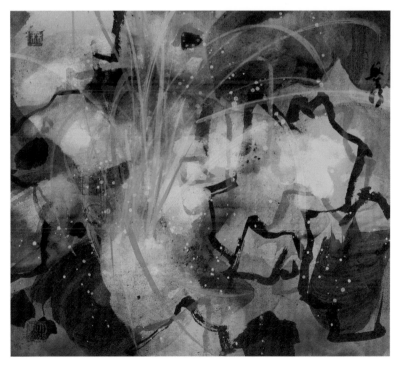

祈
**Prayer**

水墨設色紙本
*Ink and Colour on Paper*
24x27cm｜2019

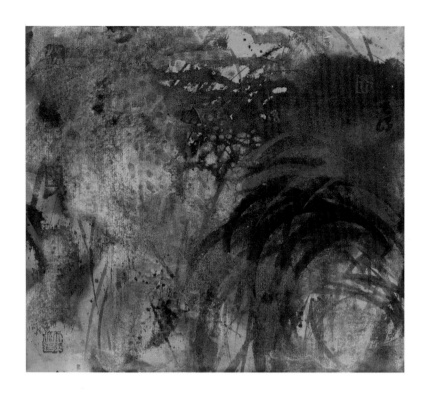

雨
**Rain**

水墨設色紙本
*Ink and Colour on Paper*
24x27cm ｜ 2019

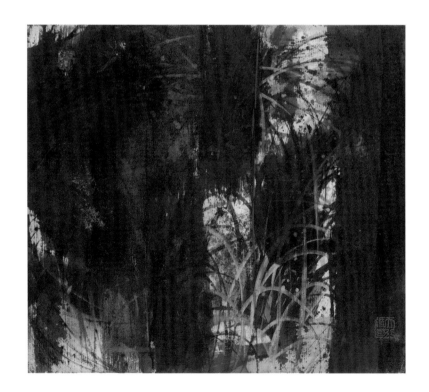

聽
**Listening**

水墨設色紙本
*Ink and Colour on Paper*
24x27cm ｜ 2019

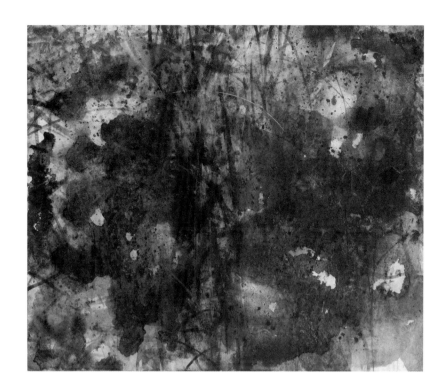

遇
**Rendezvous**

水墨設色紙本
*Ink and Colour on Paper*
45x53cm | 2019

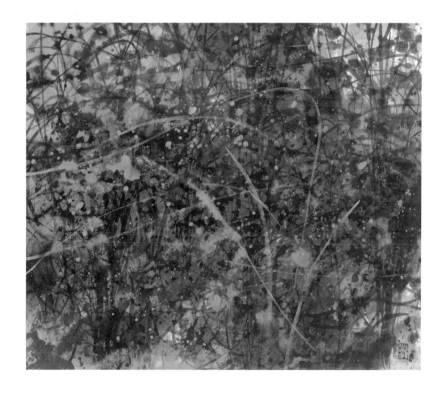

緣
**Fate**

水墨設色紙本
*Ink and Colour on Paper*
45x53cm | 2019

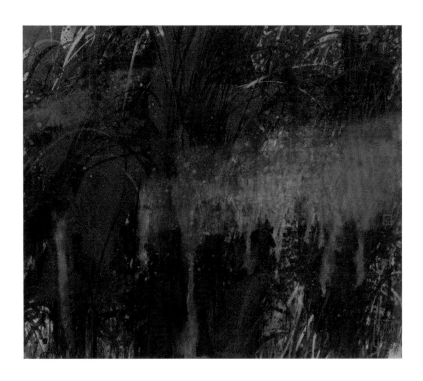

詠
**Chant**

水墨設色紙本
*Ink and Colour on Paper*
45x53cm │ 2019

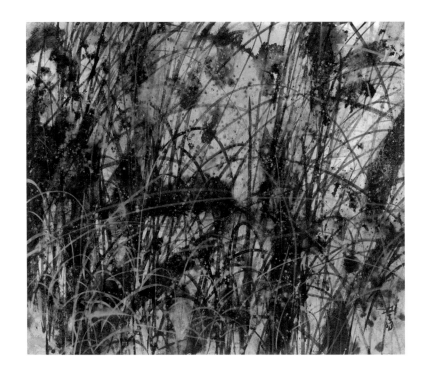

歌
**Chanting**

水墨設色紙本
*Ink and Colour on Paper*
45x53cm │ 2019

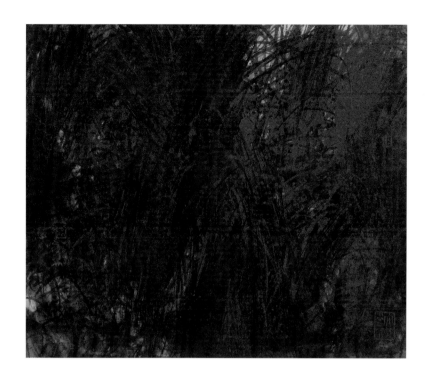

**覺**
**Awaking**

水墨設色紙本
*Ink and Colour on Paper*
45x53cm ｜ 2019

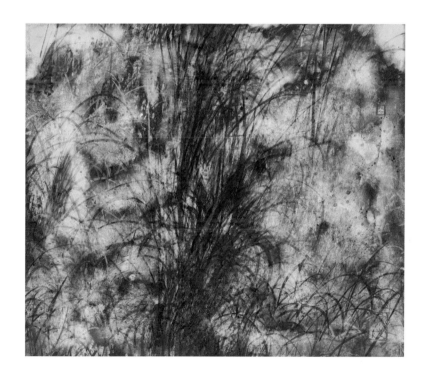

**幽**
**Quiet**

水墨設色紙本
*Ink and Colour on Paper*
45x53cm ｜ 2019

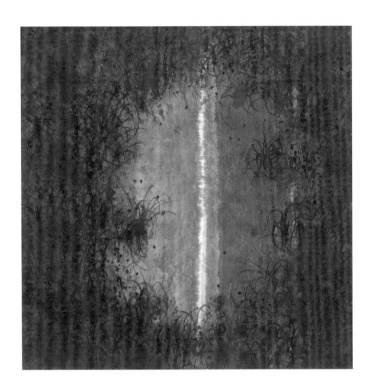

幽思（三）
**Mystic Thought (3)**

水墨紙本
*Ink on Paper*
74x72cm ｜ 2021

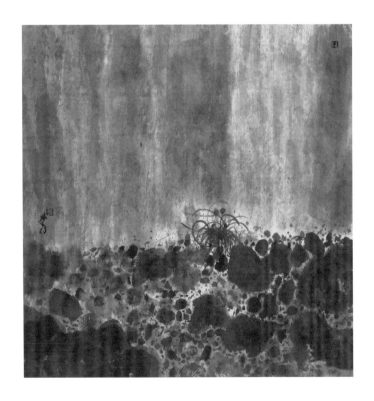

風姿
**Charm**

水墨紙本
*Ink on Paper*
74x72cm ｜ 2020

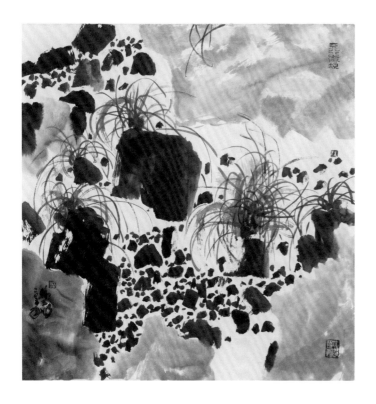

**如歌**
**As if a Song**

水墨紙本
*Ink on Paper*
74x72cm | 2020

**新舞**
**New Dance**

水墨紙本
*Ink on Paper*
74x72cm | 2020

**泉聲**
**Spring**

水墨紙本
*Ink on Paper*
74x72cm ｜ 2020

**清泉**
**Pure Spring**

水墨紙本
*Ink on Paper*
74x72cm ｜ 2020

新泉
**New Spring**

水墨紙本
*Ink on Paper*

74x72cm ｜ 2020

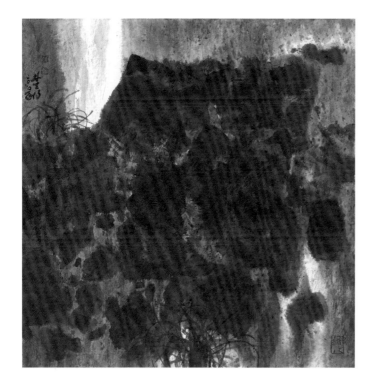

流光
**Flux of Light**

水墨紙本
*Ink on Paper*

74x72cm ｜ 2020

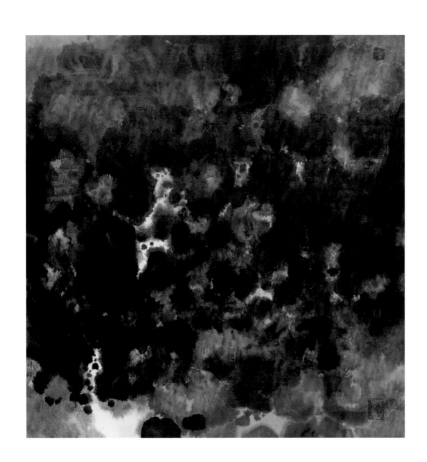

**聽泉**
**Sound of Spring**

水墨設色紙本
*Ink and Colour on Paper*
74x72cm ｜ 2020

**金秋**
**Golden Autumn**

水墨設色紙本
*Ink and Colour on Paper*
74x72cm ｜ 2020

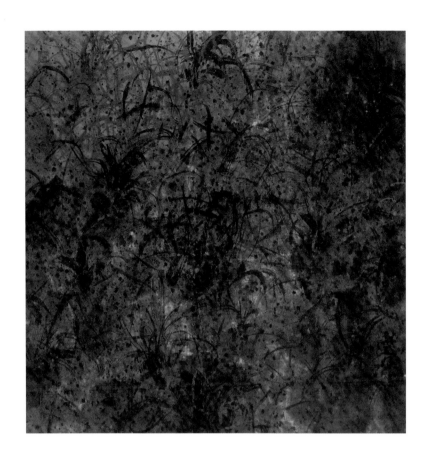

清波
**Clear Wave**

水墨設色紙本
*Ink and Colour on Paper*
74x72cm | 2020

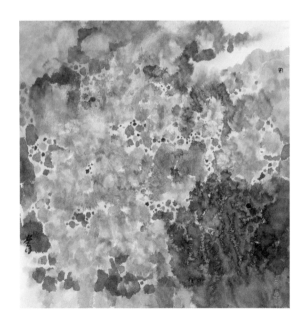

晨曦
**Dawn**

水墨設色紙本
*Ink and Colour on Paper*
74x72cm | 2020

㈥　心象　造景

（六）

造景

# 天行

## 畫語

中國畫是從「心」出發的，進而追求心覺體驗，在體驗中追求物我合一。這就是「天人合一」觀，合於理，合於情，合於道。進一步才是由真向善，由善到美的和諧統一。中國畫的發展依據是「儒、道、釋」的「道」，是思想精神。由貌形而傳神，由傳神而寫意，由意象到心象。

中國畫的發展，自古以來是由「心象」到「跡象」。借山川、草木、人物形象，追求筆墨與精神的體驗，得意味可以忘形象，正如蘇東坡所說「論畫以形似，見與兒童鄰」。

中國畫從開始就已顯示出形而上的抽象概念，追求「神韻」。講不盡之意在於畫外，形跡有限而意味無盡。古人描述書法的筆法，人物花卉的描法，山水畫的皴法，用的都是比喻。如「折釵股」「屋漏痕」，如「吳帶當風」「曹衣出水」，如「雨淋墻」「拖泥帶水」等。這些都包含形神兩個層面，意味豐富，充滿回味無窮的想像空間。

黃賓虹先生把形而上的筆墨歸納為五個字：平、留、圓、重、變。他畢生追求「渾厚華滋」。筆墨暗示着只有氣度非凡，胸藏萬卷詩書素養和豁達氣質，才能擁有其「筆墨精神」。今天我們見到那些歷代巨匠們留下來的作品，仍然可以感受到與天地河山共綿延的氣勢。

創造是藝術發展的規律。「五四運動」打倒「孔家店」，同時，也打倒了優秀的傳統文化藝術。百年來，在西方科學技術和文化的衝擊下，中國人的價值觀與審美觀產生了巨大變化。然而，中華民族以其偉大胸襟與包容，很快與這些外來文化融合並化為己用。

李可染完全是站在中國畫的立場上，運用許多西方技巧來進行創造的。如對景寫生，以大觀小，對中國畫的寫生進行了極為高明的創造，並使她得到發展。比如光影營造，運用傳統積墨創造出全新的山水畫風格樣式；頂天立地式滿構圖，以闊筆側鋒表現山石結構；以及獨有的「綫」法。李可染的創造豐富了中國山水畫的意境和筆墨意味。

林風眠的水墨畫富有詩意。他的墨色交融，山石以色帶皴，色彩豐富而厚重，畫面光影富戲劇舞台效果。吳冠中與林風眠一樣，都是運用許多西洋畫的方法來對中國畫進行創造。如色彩、用筆、畫面形式構成等，從而產生了獨特的「水墨」或「彩墨」畫面，加強了表現力，豐富了水墨畫的多元發展。

中西藝術兩個不同的系統，各有優劣，可以互補，但永遠不可能互相取代。只有互相借鑒、融合才會各自產生新的輝煌。

境由心生，象由心造。鄭板橋所說的「眼中之竹」「胸中之竹」「手中之竹」告訴我們，由心象到造景，是一個藝術境界的落實，是通過不斷體驗生活的昇華。在藝術的人生裏，每個階段都有着不一樣的「心象」，因此，我的畫同樣有着不可抗拒的時代與個人修煉的痕跡。

由 1990 年陝北系列开始到景象香港，從西藏、荷花到菖蒲系列，這些作品都是通過我自身的體驗，以及與傳統思想精神狀態的契合，並融入西方現當代觀念意識，在似與不似之間，創造出富東方神韻的當代性 —— 意象彩墨。

# Tian Xing's Thoughts 天行

Chinese painting starts from the "heart" (*xin*), and then, pursues the experience of the sense, and the unity of the object and the self. This is the concept of "harmony between humans and nature", which is in line with reason, emotion and "Tao". The next is the harmony and unity from truth to goodness, and from goodness to beauty. The development of Chinese painting is based on the "Tao" out of "Confucianism, Taoism and Buddhism", that is, inner contemplation. "Tao" is believed to be the evolution and operation mechanism of all things in the universe. Chinese painting has developed from appearance to vivid expression, to freehand brushwork, and finally from mind imagery to heart imagery.

The development of Chinese painting has been from "images from mind-and-heart" to "visual images" since ancient times. Artists have pursued the experience of brushwork and spirit by observing the images of mountains and rivers, vegetation, and human figures. Once you understand the artistic implications, you will forget the image. As Su Dongpo said, people who judges a painting by its similarity in form is not wiser than a child.

From the very beginning, Chinese painting has shown metaphysical abstract concepts and pursued "*shenyun*" – meaning spirit and gracefulness. The inexhaustible meaning goes beyond the painting, while the form is limited but the connotation is endless. The ancients used metaphors to describe the brushwork of calligraphy, the way of depicting figures and flowers, and the techniques of brush texturing in landscape painting, such as "folded hairpin strands (*she chai gu*)", "house leak marks (*wu lou hen*)", "Wu (Daozi)'s strands flapping in the wind, Cao (Zhongda)'s clothes from the water (*wudai dangfeng, caoyi chushui*)", "rain on the wall (*yu lin qiang*)", and "drag through mud and water (*tuo ni dai shui*)". Those expressive metaphors contain both physical and spiritual perspectives, leaving meaningful imaginative space with endless aftertastes.

Mr. Huang Binhong summed up the metaphysical brushwork into five characters: flat (*ping*), *liu*, round (*yuan*), heavy (*Zhong*), change (*bian*). His lifelong pursuit of "natural and powerful, lush and resplendent (*hun hou hua zi*)" has implied that only open-minded artists who possess rich knowledge could have the "soul of brushwork". Today, when we see the works left by the great masters, we can still feel the momentum that stretches along with the heavens, the earth, the rivers and the mountains.

Creation is the law of art development. The May 4th Movement overthrew the "*kongjia dian*" – Confucianism, as well as excellent traditional culture and art. Over the past century, under the impact of Western science, technology and culture, Chinese people's values and aesthetics have undergone tremendous changes. However, the great-minded and tolerant Chinese nation has quickly integrated these foreign cultures into its own cultural system.

Li Keran completely stood on the standpoint of Chinese painting and used many Western painting techniques to create. For instance, by making sketches of the scenery and using the scatter perspective method of large and small views, he made extremely brilliant creations on the sketching of Chinese paintings and made his new development; by creating the light and shadow effects and traditional ink accumulation, he created a new style of landscape painting; through the upright and full composition, he represented the rock structure by the flank of broad brushes; he also created unique "line" method. Li Keran's creation has enriched the artistic conception of Chinese landscape painting, and given the brush and ink new implications.

Lin Fengmian's ink paintings are poetic. In his paintings, ink and colours blend together; the mountains and rocks are textured in colours; with rich and heavy colours, the light and shadow makes the picture full of dramatic stage effects. Like Lin Fengmian, Wu Guanzhong used many Western painting methods to create Chinese paintings such as colour, brushwork and composition of the picture, thus creating the unique "ink painting" or "ink colour" picture, which has strengthened the expressive force and enriched the diversity of ink painting.

The two different schools of Chinese art and Western art, each with their own advantages and disadvantages, can complement each other, but can never replace each other. Both schools will create synergy only if they learn from and integrate with each other.

The realm is born from the mind-and-heart, and the image is created by the mind-and-heart. What Zheng Banqiao said about "the bamboo in the eyes", "the bamboo in the

chest" and "the bamboo in the hand" has told us that, the course of "images from mind-and-heart" to scenery creation, is the realisation of an artistic realm, and the sublimation of life through continuous experience. In the life of art, artists have a different "images from mind-and-heart" at each stage. Therefore, my paintings also bear the marks of the era and traces of my adventures.

From the Northern Shaanxi series in 1990 to scenes Hong Kong series, from Tibet, lotus to calamus series, those works are all based on the integration of my own experience and the traditional philosophy and spirit. Mixed with Western modern and contemporary concepts, between the similarity and the dissimilarity, I have created the "imagery ink colour", a contemporary art with oriental charm.

# 藝評

# Art Critics

天行這次的畫跟過去的畫有很大不同，我感到非常奇怪的是這次天行沒有拿大畫，拿的是一批小畫，而且這批小畫跟過去大畫的風格完全不一樣。過去的大畫畫的很有激情，很放。但是這些小畫畫的非常收，非常內斂。顯然是做了很多實驗，在色彩上有很多探索，我感覺天行在用心作畫，他的每個細節都感覺〔經過〕非常用心〔的〕思考〔，〕怎麼能畫得更精彩，〔怎樣畫出〕又抽象又有內斂的東西。

李寶林，〈香港當代水墨藝術展學術研討會發言紀錄〉（節錄），《回歸‧水墨藝術展》，二〇一五年

The paintings of the "Reunification · Ink Art Exhibition" are very different from the past works of Tian Xing. I am very surprised that there are no huge sized paintings, but instead a number of small paintings. The style of these small paintings are very different from the past large paintings as well. His large paintings are very expressive with surging passion; yet these small paintings are self-effacing. Obviously, he has undertaken many trials and made plenty of explorations on the colour combinations. Tian Xing is an artist who has been painting with his heart. He is tireless in thinking how to deal with fine details. He has always been thinking how to produce more excellent works and how to create something abstract yet implicit.

**Li Baolin, Speech at Hong Kong Contemporary Ink Art Exhibition Symposium (excerpts),** *Reunification · Ink Art Exhibition*, **2015**

唯香港青年畫家林天行縱橫交錯兼融色塊的風景意象起手不凡。

劉曦林，〈西體中用的抽象主義〉（節錄），《二十世紀中國畫史》，二〇一二年

Young artist Lam Tian Xing is the only painter who has created the extraordinary imagery of landscape with a criss-cross blend of colours.

**Liu Xilin, Western Techniques in the Chinese Abstract Paintings (excerpts),** *Chinese Painting History of the 20th Century*, **2012**

After years of work in the Chinese traditional ink painting, Lam has found his very unique ways of expressions without hesitation. The traditional sense of painting seems not so important any more. More important is the large block of brilliant colours which are sometimes heavy and sometimes elegant intertwined with strong brushstrokes; the ever changing scenery and the bustling atmosphere of Hong Kong coexist perfectly with his imaginary natural environment; the perfect composition and ethereal hope found in his paintings move freely between the concreted images and abstract symbols. Those seemingly random compositions are bold with agile flexibility because Lam allows his heart indulging freely with floating talents.

**Gu Weijie, Living in the Brilliant Moment (excerpts),** *Encounter*, **2001**

Looking at Lam Tian Xing's paintings is like reading a story of an open-minded chevalier in a Martial arts fiction or a melancholy and tranquil Literati in a poem.

**Lee Shuping, Open-minded Life Impression (excerpts),** *Encounter*, **2001**

從中國傳統的筆墨中摸索出來的林天行，在他的水墨作品裏已經毫不猶豫地得到了非常自我而獨特的表達方式。在這裏，傳統意義上的筆墨顯得不再那麼重要，重要的是更多令他心動的精彩；時而沉重時而清雅的大面積色塊與強烈的筆觸交織在一起，多變的景色和香港繁華氣息與想望中的自然環境共存，完滿的構圖與空靈的希望游離在具象和抽象之間。這些看似隨意的組合，因為林天行內心的放縱飄逸而賦予了大膽的靈動之感。

顧維潔，〈生活在爛漫時分〉（節錄），《相遇》，
二〇〇一年

在林天行的繪畫意境裏更多了一些武俠小說中俠士所特有的豁達之氣以及中國詩詞裏文人的憂鬱情懷與恬淡閒適的詩意。

李淑萍，〈豁達的生活印象〉（節錄），
《相遇》，二〇〇一年

我們在林天行的作品中就看不到這種猶
豫，林天行的藝術與香港早期藝術不同並
不暗指他的藝術更靠近大陸，恰恰相反的
是他的藝術仍然屬於香港藝術的一部分。
他的藝術的不同性更多的是建立在香港社
會的變化客觀要求重塑香港
的文化和藝術。這個變化客觀要求重塑香港
到這種需要，然而他在表現這種需求時卻
用了「藝術的靈魂」這一對象化術語和主
體「我」的奇異結合。這是用作品來表現
姿態，這一姿態將有助於我們衝破畫種的
限制，把水墨這一具有很強傳統限制性技
法解放出來，成為當代藝術空間的一個有
機因素。

冷林，〈林天行〉（節錄），《景象‧香港》
一九九九年

We do not see any hesitation in Lam's art. When we say his art is unlike
those of the earlier artists in Hong Kong, it does not mean that he is more like
those from the Chinese Mainland. Conversely, his divergence grows from the
social changes in Hong Kong, a city that demands a re-definition of its culture
and art. Lam has realised and responded to this demand by combining the
objective terms "soul of art" with the subjective "self". With his penetrating
artistic insight, he has chosen to make a gesture through artistic means,
with the hope that it would help to liberate Chinese brush painting from the
limitation of tradition, making it integrate into the world of contemporary art.

**Leng Lin, Lam Tian Xing (excerpts),** *Scenes · Hong Kong,* **1999**

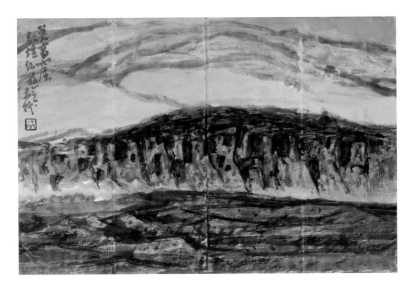

**莫高窟敦煌紀遊之一**
**Tour of Mogao Caves,**
**Dunhuang (1)**

水墨設色紙本
*Ink and Colour on Paper*
33x50cm | 1999

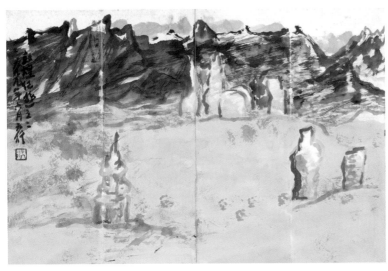

**莫高窟敦煌紀遊之二**
**Tour of Mogao Caves,**
**Dunhuang (2)**

水墨設色紙本
*Ink and Colour on Paper*
33x50cm | 1999

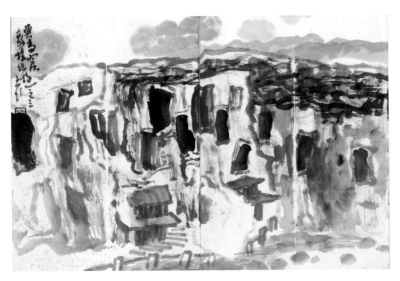

**莫高窟敦煌紀遊之三**
**Tour of Mogao Caves,**
**Dunhuang (3)**

水墨設色紙本
*Ink and Colour on Paper*
33x50cm | 1999

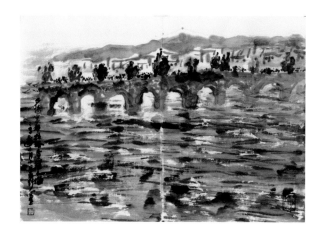

**歐洲寫生**
**Sketching in Europe**

水墨紙本
*Ink on Paper*
44x64cm | 2007

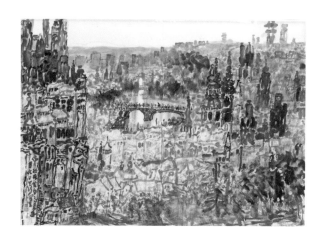

**布拉格黃昏寫生**
**Sketching in Prague at Dusk**

水墨紙本
*Ink on Paper*
44x64cm | 2007

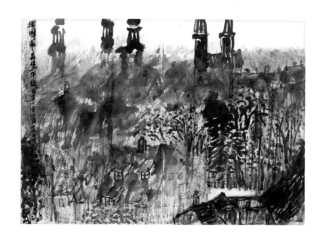

**德國羅森堡午後寫生**
**Afternoon Sketching in Rosenberg, Germany**

水墨紙本
*Ink on Paper*
44x64cm | 2007

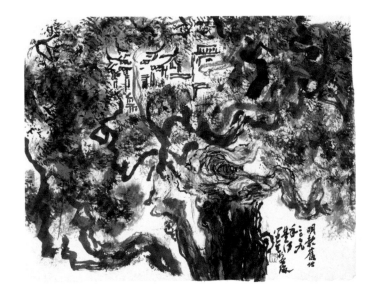

**泉州明教舊址寫生**
**Sketching at the Relics of Manichaean**
**Temple, Quanzhou**

水墨紙本
*Ink on Paper*
38x48cm | 2009

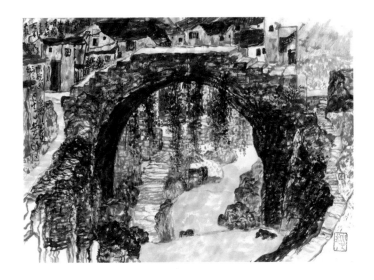

**安徽查濟寫生**
**Sketching at Zhaji, Anhui**

水墨紙本
*Ink on Paper*
49x69cm | 2012

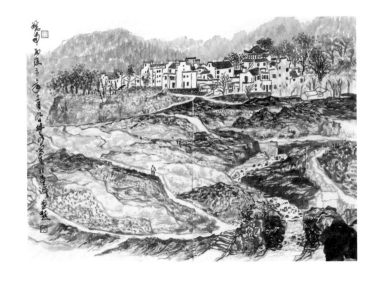

**安徽查濟寫生**
**Sketching in Zhaji, Anhui**

水墨紙本
*Ink on Paper*
49x69cm | 2012

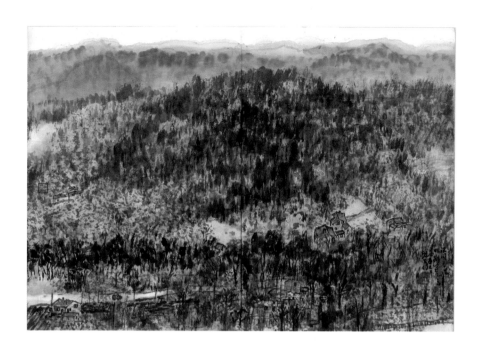

**法國普羅旺斯寫生**
**Sketching in**
**Provence, France**

水墨設色紙本
*Ink and Colour on Paper*
44x64cm | 2014

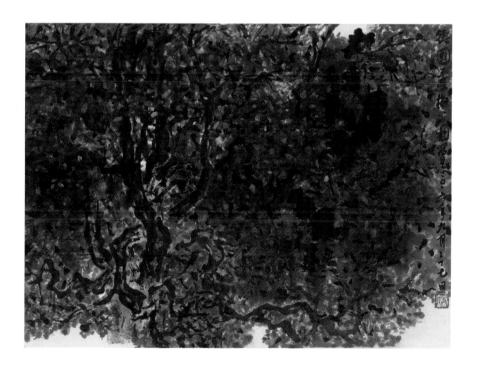

**德國不來梅寫生**
**Sketching in**
**Bremen, Germany**

水墨設色紙本
*Ink and Colour on Paper*
32.5x44cm | 2016

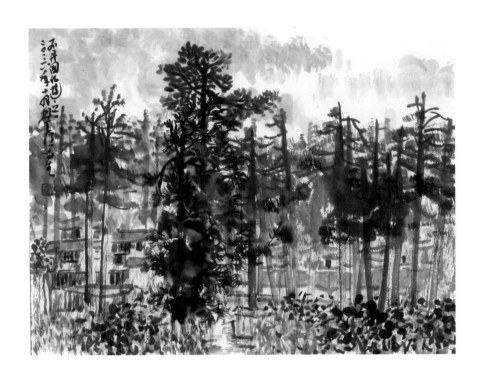

不丹寫生
**Sketching in Bhutan**

水墨設色紙本
*Ink and Colour on Paper*

42x56cm | 2016

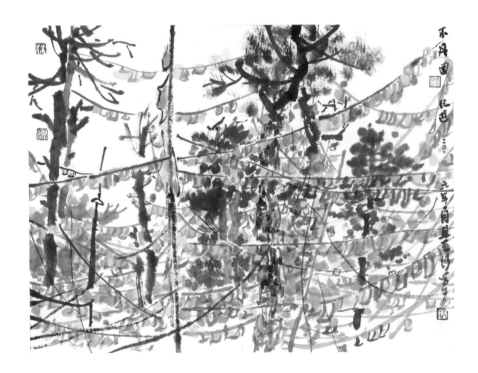

不丹寫生
**Sketching in Bhutan**

水墨設色紙本
*Ink and Colour on Paper*

42x56cm | 2016

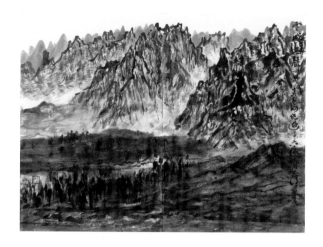

**祁連山寫生**
**Sketching in Qilian Mountains**

水墨紙本
*Ink on Paper*

42x56cm | 2016

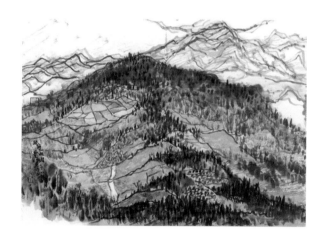

**西雙版納寫生**
**Sketching in Xishuangbanna, Yunnan**

水墨設色紙本
*Ink and Colour on Paper*

35×49cm | 2017

**西雙版納寫生**
**Sketching in Xishuangbanna, Yunnan**

水墨設色紙本
*Ink and Colour on Paper*

35×49cm | 2017

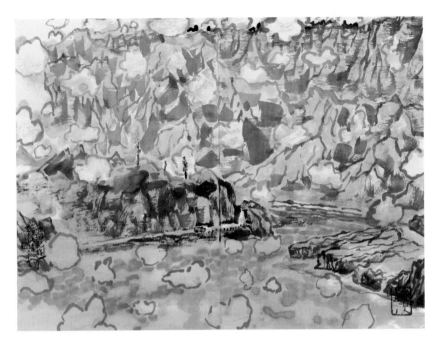

青海寫生 (一)
**Sketching in Qinghai (1)**

水墨設色紙本
*Ink and Colour on Paper*

42x56cm ｜ 2017

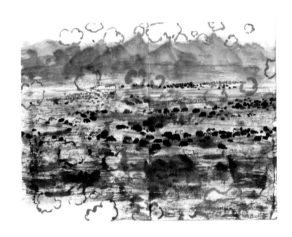

青海寫生 (二)
**Sketching in Qinghai (2)**

水墨紙本
*Ink on Paper*

42x56cm ｜ 2017

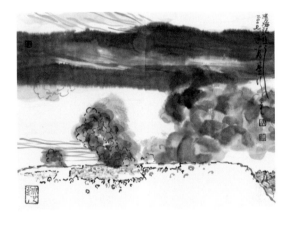

青海寫生 (三)
**Sketching in Qinghai (3)**

水墨紙本
*Ink on Paper*

42x56cm ｜ 2017

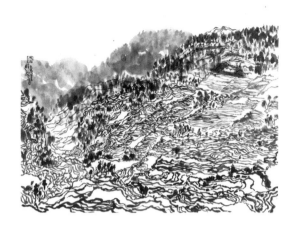

雲南元陽梯田寫生 (一)
**Sketching in Terraced Fields of
Yuanyang, Yunnan (1)**

水墨紙本
*Ink on Paper*

38x48cm | 2019

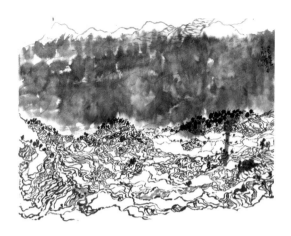

雲南元陽梯田寫生 (二)
**Sketching in Terraced Fields of
Yuanyang, Yunnan (2)**

水墨紙本
*Ink on Paper*

38x48cm | 2019

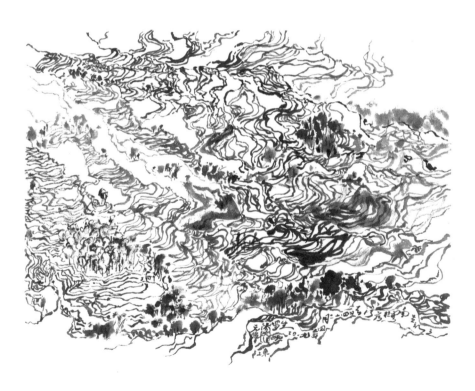

雲南元陽梯田寫生
(三)
**Sketching in
Terraced Fields of
Yuanyang, Yunnan
(3)**

水墨紙本
*Ink on Paper*

38x48cm | 2019

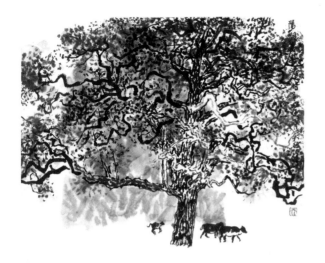

**陽朔寫生（二）**
**Sketching in Yangshuo, Guangxi (2)**

水墨紙本
*Ink on Paper*
35x45cm ｜ 2019

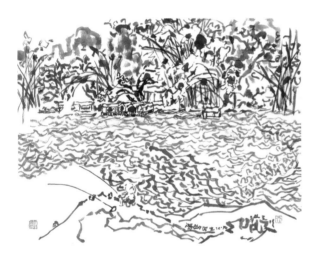

**陽朔寫生（五）**
**Sketching in Yangshuo, Guangxi (5)**

水墨紙本
*Ink on Paper*
38x48cm ｜ 2019

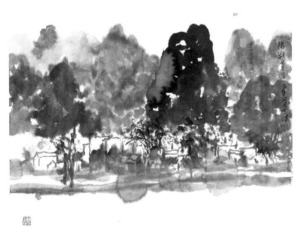

**陽朔寫生（六）**
**Sketching in Yangshuo, Guangxi (6)**

水墨紙本
*Ink on Paper*
38x48cm ｜ 2019

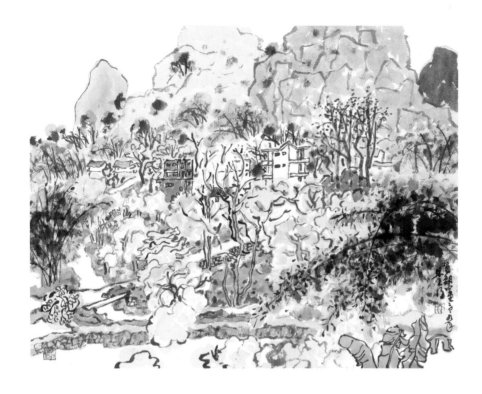

陽朔寫生（七）
**Sketching in Yangshuo, Guangxi (7)**

水墨設色紙本
*Ink and Colour on Paper*
38x48cm ｜ 2019

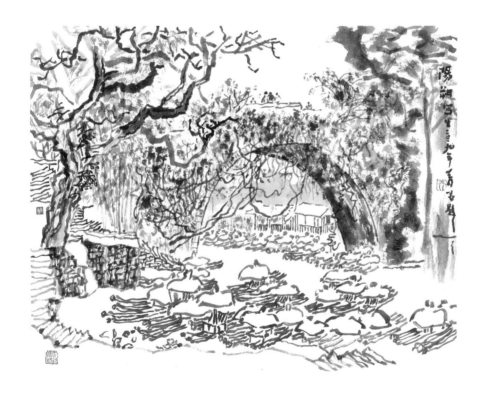

陽朔寫生（八）
**Sketching in Yangshuo, Guangxi (8)**

水墨設色紙本
*Ink and Colour on Paper*
38x48cm ｜ 2019

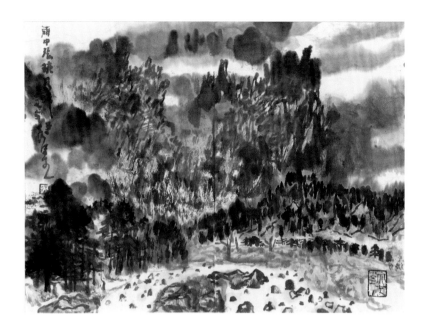

張掖馬蹄寺寫生（四）
**Sketching in Zhangye
Horseshoe Temple (4)**

水墨紙本
*Ink on Paper*
42x56cm ｜ 2017

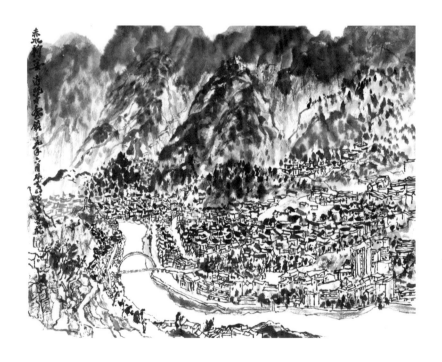

茅台鎮寫生
**Sketching in Maotai Town,
Guizhou**

水墨紙本
*Ink on Paper*
37.5x48cm ｜ 2019

深井清快塘寫生
**Sketching at Tsing Fai Tong,
Sham Tseng**

水墨設色紙本
*Ink and Colour on Paper*
46x35cm | 2020

深井清快塘寫生
**Sketching at Tsing Fai Tong, Sham Tseng**

水墨紙本
*Ink on Paper*
36x44cm | 2020

深井清快塘寫生
**Sketching at Tsing Fai Tong, Sham Tseng**

水墨設色紙本
*Ink and Colour on Paper*
36x44cm | 2020

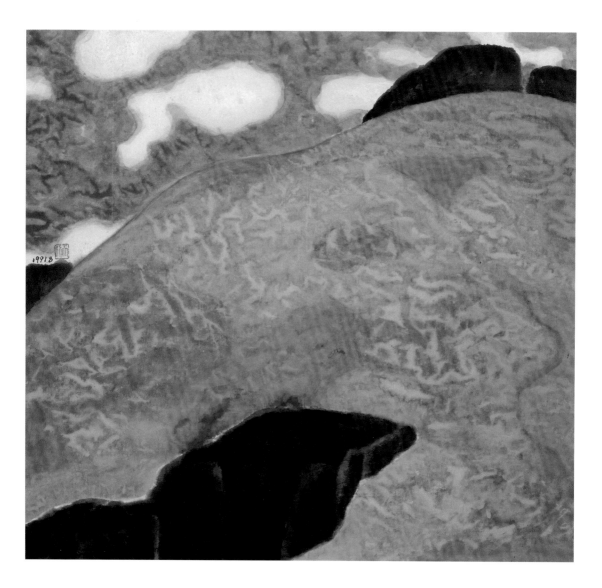

天光雲影

**Daylight with the Reflection of Cloud**

水墨設色紙本

*Ink and Colour on Paper*

88x95cm ｜ 1991

窗景
**By the Window**

水墨設色紙本
*Ink and Colour on Paper*
97x90cm | 2000

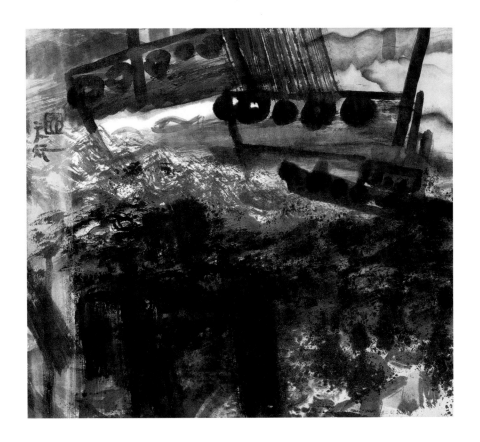

**樹梢行船**
**Boat Floating on
the Top of the Trees**

水墨設色紙本
*Ink and Colour on Paper*
24x27cm | 1998

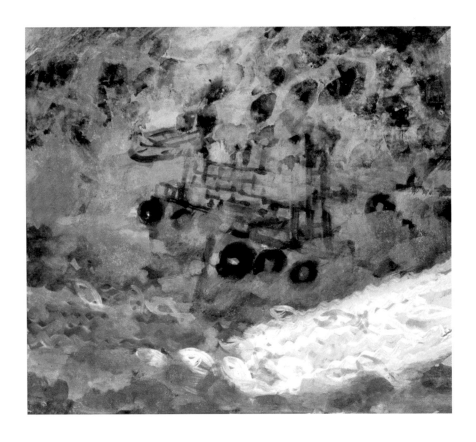

**黃耀的海港**
**Glittering Harbour**

水墨設色紙本
*Ink and Colour on Paper*
24x27cm | 1998

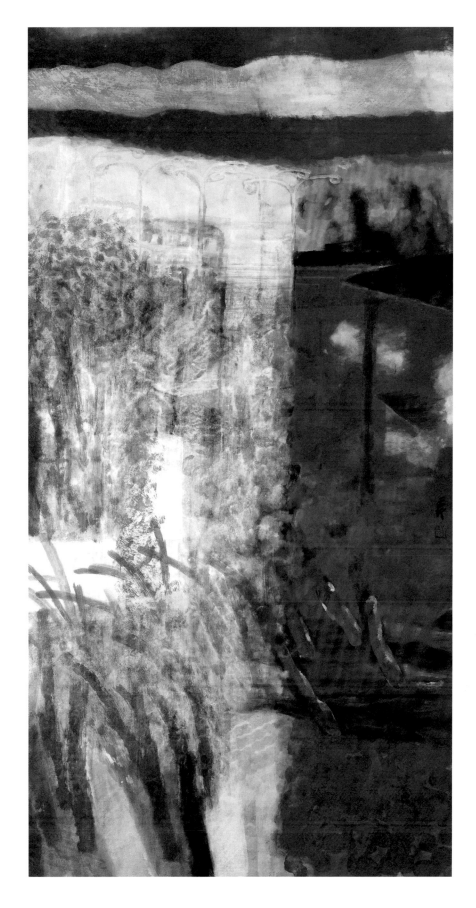

相遇
**Encounter**

水墨設色紙本
*Ink and Colour on Paper*
132x68cm | 2001

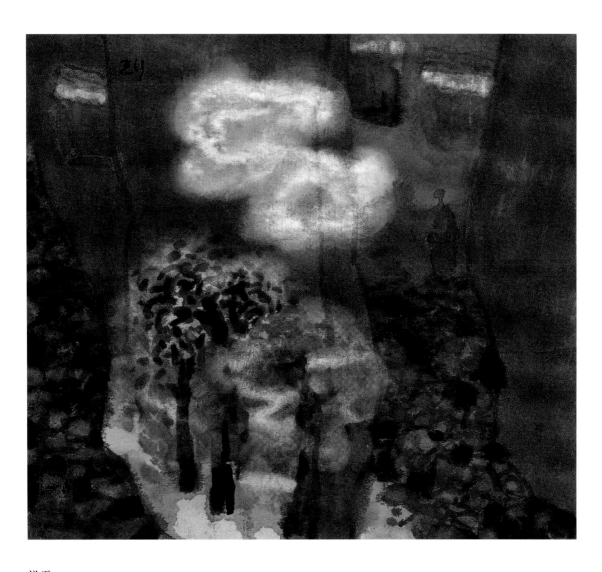

祥雲
**Auspicious Clouds**

水墨設色紙本
*Ink and Colour on Paper*
42x47cm | 2002

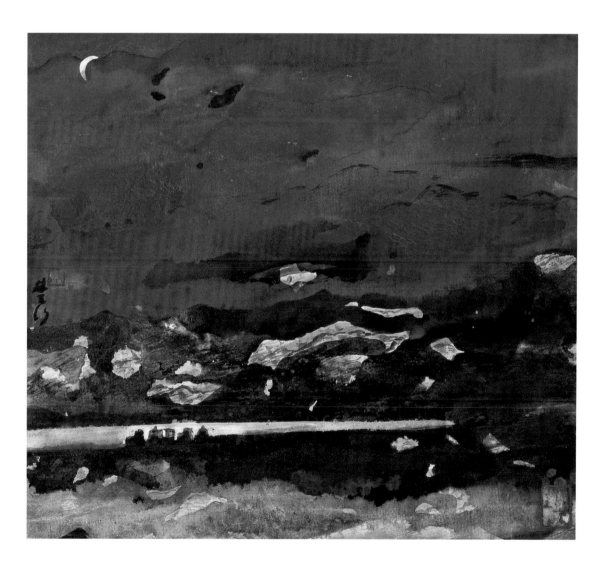

古塔月色
**Stupas in Moonlight**

水墨設色紙本
*Ink and Colour on Paper*
45x53cm │ 2006

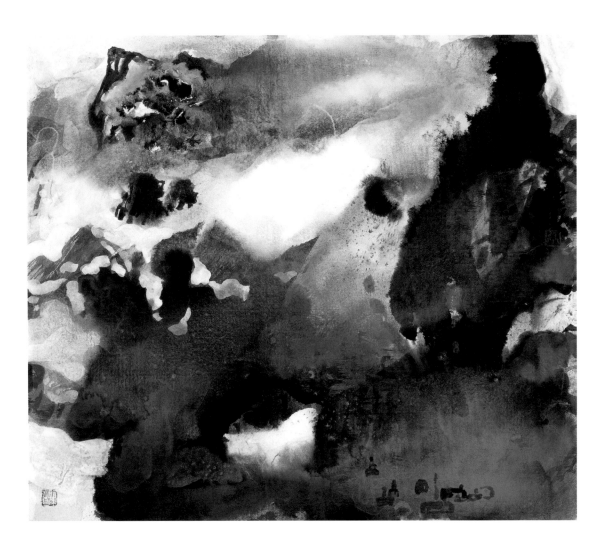

山中不知歲月
**Timelessness in Mountains**

水墨設色紙本
*Ink and Colour on Paper*
45x53cm | 2006

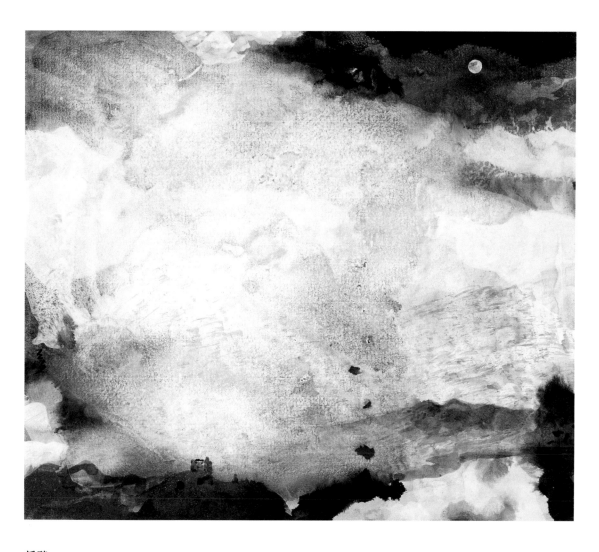

**靜聽**
Listening

水墨設色紙本
*Ink and Colour on Paper*
45x53cm ｜ 2006

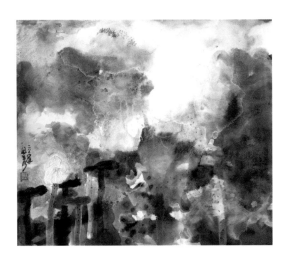

若雪
**Snow-White**

水墨設色紙本
*Ink and Colour on Paper*

45x53cm ｜ 2004

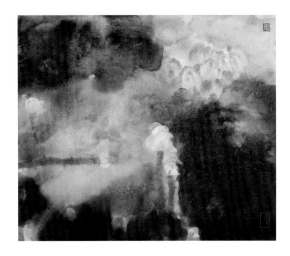

淨
**Purity**

水墨設色紙本
*Ink and Colour on Paper*

50x60cm ｜ 2011

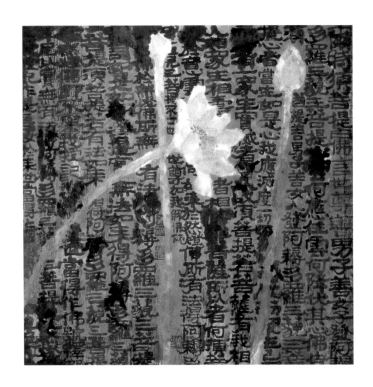

荷花心經
**Lotus Heart Sutra**

水墨設色紙本
*Ink and Colour on Paper*

68x68cm ｜ 1991

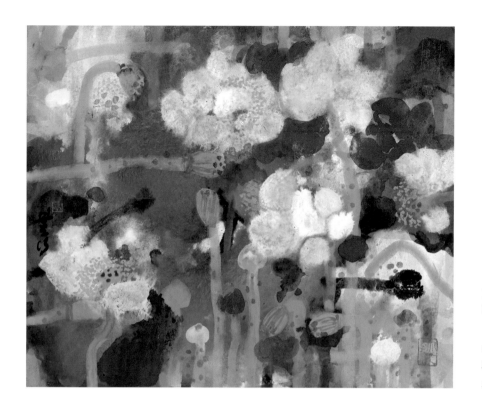

如詩
**Poetry**

水墨設色紙本
*Ink and Colour on Paper*

50x60cm | 2010

聽
**Listening**

水墨設色紙本
*Ink and Colour on Paper*

50x60cm | 2011

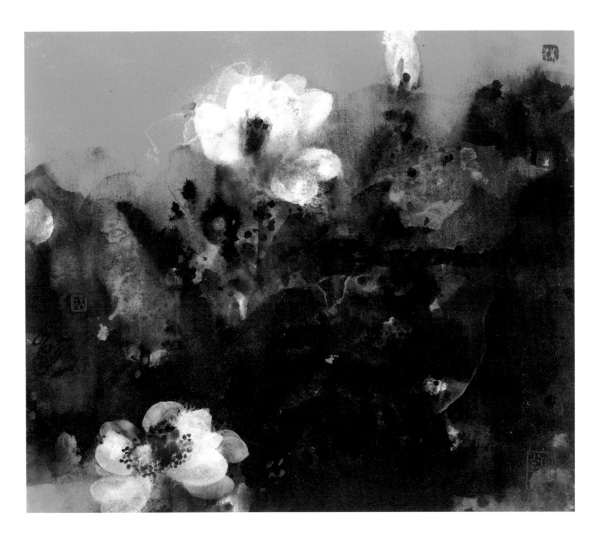

**藍色的荷塘**
**Blue Lotus Pond**

水墨設色紙本
*Ink and Colour on Paper*
45x53cm │ 2018

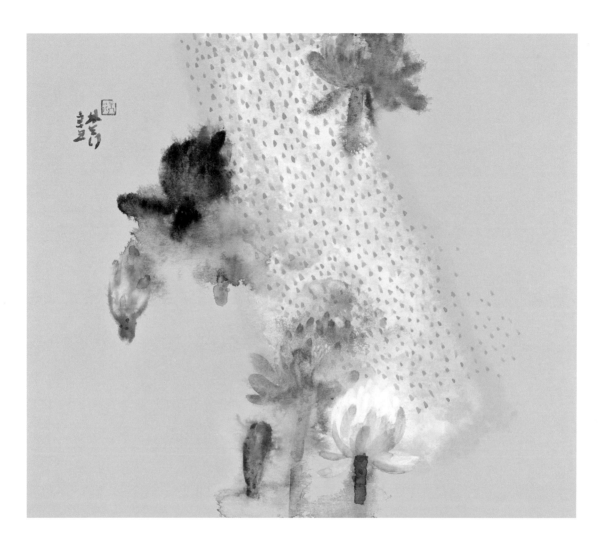

澄
**Clarity**

水墨設色紙本
*Ink and Colour on Paper*
45x53cm | 2021

幽思
**Mystic Thought**

水墨紙本
*Ink on Paper*
74x72cm ｜ 2020

溪雲
**Creek of Clouds**

水墨設色紙本
*Ink and Colour on Paper*
74x72cm ｜ 2020

永在
**Eternity**

水墨紙本
*Ink on Paper*
74x72cm ｜ 2020

祈
**Prayers**

水墨設色紙本
*Ink and Colour on Paper*
74x72cm ｜ 2021

㈦

突破

中西

（七）

突破

中西

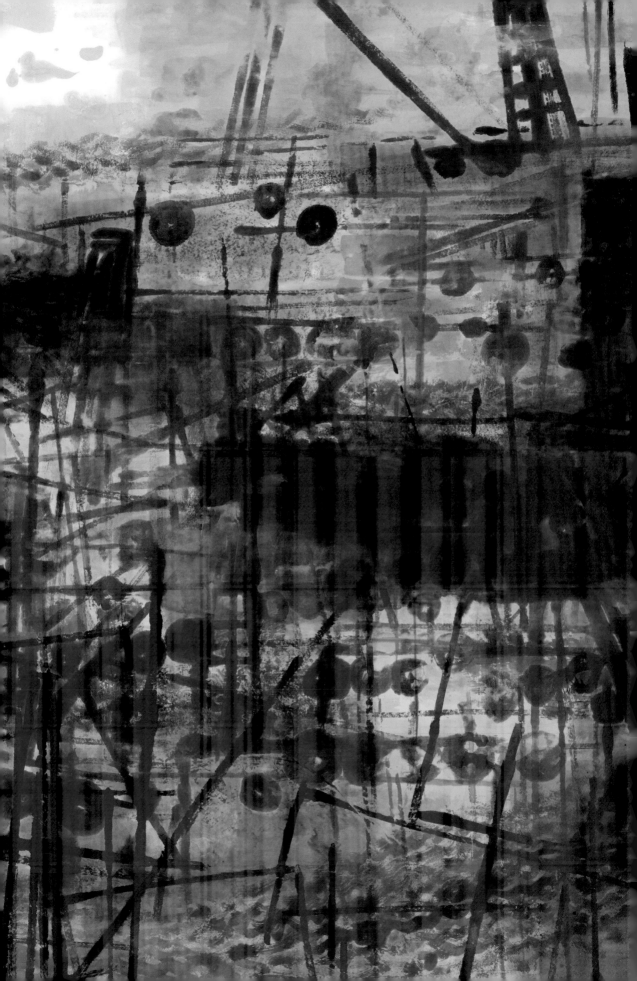

# 天行
## 畫語

藝術家對世界的認識方式是非常重要的。要表達什麼？如何表達？為什麼表達？都緣於對世界的認識。其獨特的視覺方式與生命中的覺悟，成就了無限種表達的可能性。

藝術越來越無法脫離整個人類文化以及對科技的依賴，當今的藝術已由各種各樣的方式呈現，未來的藝術將會出現更多不同模式。但我還是享受即時筆觸所顯現出來的快感，它映帶着激情與靈魂迴蕩，抒寫了我人生一篇篇響亮樂章。

八十年代我熱衷於描寫祖國名山大川。九〇年陝北歸來後改變畫風，開始了用西畫方式融入中國畫的試驗。我曾嘗試過許多不同的表達手法，最終打破傳統框框，以點彩或塊面組合，重新構建屬於今天的藝術。

對我的藝術實踐產生過影響的人很多，主要的有范寬、馬遠、徐渭、石濤、八大山人、龔賢、黃賓虹、林風眠、李可染，塞尚、克利、康定斯基、高更、德國表現主義、德庫寧……以及宗教壁畫、民間藝術。當然，啟發我的除了這些，還有大自然的萬物和生活中的際遇，它們都讓我有所感悟。我也因為尋找到表達的方式和途徑而創作靈感不斷。

「外師造化，中得心源」，中國畫藝術更着重的是「心源」的表達，通過「心源」的發揮創造出新時代的美學觀。

1995 年，我驀然發現生活多年的香港到處都是寶藏，尤其是新界的美讓我癡迷。激動的心情使我在靜觀默察後，瘋狂地想要表現她的迷人之處。香港是個充滿活力，自由、開放、包容、五光十色、富國際視野的大都會。該用什麼樣的手法才能表現出今天香港的魅力呢？

我開始從造形意義上尋求中國畫的當代狀態，打破三維空間的透視構圖，採用俯視角度，傾向於繪畫的圖案化、平面化，飽滿構圖，開始了藝術的新里程。在漫長的探究中，我逐漸解構傳統的形態，取、捨、重組，融入新符號。色彩在我的作品裏與墨具有同等價值，甚至取代了墨。點彩、塊面、多層色墨重疊，建築式的渾然直綫，縱橫交錯，穿梭其間。天、地、海、棕櫚樹、長椅、躉船、街燈……構建出超現實意味的「意象彩墨畫」，營造新時代的圖式空間。光影取代留白，飽滿多彩的畫面成就了另一種美學。

　　1998 年的《新界晴雨》（248x124cm，中國美術館收藏），使用了放射式的構成和鳥瞰視角。無盡的山和海，大片潑墨左右交錯。陽光射入縫隙凸顯奇異空間，帶着色彩的晴雨悠然落下，魚兒好似在空中跳耀，古老的大樹橫空插向天際，林中的房屋似乎在傾聽大海的聲音。只有寂靜的街燈佇立於大地上，靜觀萬物瞬變。體現香港人生活節奏緊張，努力不懈。

　　1998 年的《碼頭》（248x124cm，香港藝術館收藏），描繪了擁擠繁忙的碼頭，燈火輝煌，水天一色，富強烈節奏的綫條穿插其間，形成一座不夜城。展現出動感之都生生不息的風姿。

　　《夜色朗朗》（24x27cm，1998，大也堂收藏）。夏季裏的一天，深夜回家，在酩酊中下車，眼前朦朧一片。搖曳中的棕櫚樹，印象裏的小池，月光滿地，天橋穿過了高樓大廈，露出了一角迷濛的天空。此時，萬籟俱寂。

　　《幽思》（74x72cm，2020，余偉先生收藏）。疫情中，我找到菖蒲抗疫。菖蒲自古以來有驅邪避疫的含義，象徵堅毅與崇高。此畫使用鳥瞰的視野，滿池菖蒲，淡墨分割成大小兩面。中間突然一片留白，表示對生命的希望；另一扇門正在打開，寓意光明的到來。

　　藝術是表達思想與情感的載體，黑格爾說得好：「審美的感官需要文化修養……借助修養才能了解美、發現美。」他還說：「如果談到本領，最傑出的藝術本領就是想像。」讓我們打開想像的翅膀，自由自在地翱翔天際，去創造屬於今天「獨有的美」吧！

# Tian Xing's
# Thoughts 天行

The way that an artist perceives the world is very important. What is the artist trying to express? How to express it? And why? All are related to our knowledge of the world. The artist's unique method of visual expression and awareness of life have created infinite possibilities of expression.

Art has been increasingly inseparable from human culture and technology. Nowadays, art has been presented in a variety of ways, and there will be more different modes of art in the future, but I still enjoy the thrill of instant brushstrokes, which resonated with passion and soul, and composed the resounding chapters of my life.

In the 1980s, I was keen to delineate the famous mountains and rivers of the motherland. After returning from Northern Shaanxi in 1990, I changed my painting style and started the experiment of integrating Western painting into Chinese painting. I tried many different methods, and finally I broke the traditional framework and reconstructed the art that belongs to today with stippling or block-plane combination.

There are many people who have influenced my artistic practice, such as Fan Kuan, Ma Yuan, Xu Wei, Shi Tao, Bada Shanren, Gong Xian, Huang Binhong, Lin Fengmian, Li Keran, Cézanne, Klee, Kandinsky, Gauguin, German Expressionism and de Kooning. I have also been influenced by religious murals and folk art. Of course, all things in nature and the various encounters in life have inspired and enlightened me. I also have found my own way to express and therefore enabling my endless creative inspirations.

"Although learning from nature, the artist's inner feelings are indispensable source." The art of Chinese painting focuses more on the expression of "the source of the heart" by which we can create aesthetics in the new era.

In 1995, I suddenly discovered that Hong Kong, where I have lived for many years, was full of treasures, especially the beauty of the New Territories that fascinated me. After watching and observing the fascinating New Territories, I wanted to convey her charms madly. Hong Kong is a vibrant, free, open, inclusive and colourful international metropolis. How can I depict and reveal the charm of Hong Kong today?

I began to seek the contemporary disposition of Chinese painting in the sense of shape, getting away from the perspective composition of three-dimensional space. I adopted a top-down perspective, and opted for the patterned and flattened painting with full composition, thus starting a new milestone in my art journey. In the long-term exploration, I have gradually deconstructed traditional forms, retaining, discarding, reorganising, and incorporating new symbols. Colours attached the same importance as ink in my work, and sometimes have even replaced ink. I have used stippling, block and plane, and multi-layer ink colour overlap, with the criss-crossing straight lines in architectural style. The sky, the earth, the sea, palm trees, benches, pontoons and streetlamps have constructed a surreal "imagery ink colour painting", and created a schematic space in the new era. When light and shadow replace blank space, the full and colourful picture has created a different aesthetics.

In "Sunny Rain in New Territories" (248x124cm, 1998, collected by the National Art Museum of China), I used scattered composition and a bird's eye view. The endless mountains and seas are presented with large splashes of ink interlaced with each other. In the painting, you can see that the sun shines through the gap and highlights the fantastic space, the sunny colourful rain falls leisurely, fishes seem to dance in the air, the old giant trees are heading to the sky, and the houses in the forest seem to be listening to the sound of the sea. Only the silent streetlamps stand on the ground, watching the transients of everything. It reflects the hectic pace of life of Hong Kong people and their unremitting efforts.

"The Pier" (248x124cm, 1998, collected by the Hong Kong Museum of Art), depicts a crowded and busy wharf where lights are brilliant, water and sky merge in one colour, and lines with strong rhythm are interspersed. All make Hong Kong a city that never sleeps and showcase the ever-growing demeanor of a vibrant city.

"The Colour of the Night" (24x27cm, 1998, collected by The Hall of Boundlessness). One day in summer, when I came home late at night and got off the bus in a daze, my eyes were hazy. There were swaying palm trees, the pool, the moonlight on the ground, the footbridge passing through the skyscrapers, and a corner of the misty sky. At this time, everything was silent.

"Mystic Thought" (74x72cm, 2020, collected by Mr. Yu Wei). During the COVID-19 pandemic, I found calamus to fight it. Calamus has the implication of warding off evil spirits and epidemics since ancient times, symbolising perseverance and sublimeness. This painting adopts a bird's eye view, dividing a pond full of calamus into two sides of large and small by using the light ink. There is a blank space in the middle, expressing hope for life; another door is opening, implying the coming of the bright future.

Art is a vehicle for thoughts and emotions. Hegel said, "The sense of aesthetics requires cultural cultivation... It is only through cultivation that we can understand and discover beauty." He also said, "When it comes to skill, the most outstanding artistic skill is imagination." Shall we open the wings of our imagination, soar freely in the sky, and create the "one of a kind beauty" that belongs to today!

# 藝評

# Art Critics

林天行的水墨則以彩墨為主，畫面不僅打碎了自然時空的框架，進行了平面化的結構與色塊的視覺重構，而且色塊的經營也體現了很強的設計審美性，那些色塊的構置即使和自然有關也已經十分遙遠了。他的學術課題，在於如何在色塊與結構中體現水墨與色彩的關係，在平面分割之中現筆觸、筆性與結構的關係。

尚輝，〈水墨畫的深度文化跨越——香港水墨畫的當代價值〉（節錄），《港水港墨》，二〇一一年

Lam Tian Xing prefers the bright end of the ink colour spectrum, effecting a disintegration of the visuals from a natural time frame in composing a visual re-composition of graphical constructs and colour blocks. The constellation of the colour blocks has reflected strong design aesthetics, keeping a distance from nature. In exploring his academic interests, he has delved into how the dynamics between ink and colour are realised in the colour blocks and the composition, and in the division of the plane, how to reveal the connection between the brushstrokes and the character of the brush on one hand, and the composition on the other.

**Shang Hui, The Abyss of Cultural Border-crossing: The Value of Hong Kong Ink Painting in Contemporary Times (excerpts),** *Shui Mo Hong Kong***, 2011**

十多年來，我一直注意林天行君的藝術創作。在中國大陸和海外展覽會上，經常可以看到他的作品，他更舉行過許多次的個人作品展，我還曾到他香港的工作室看過他的畫。他的為人和他的作品給我的印象是，他身上具有兩種互相對立又非常可貴的品格：感情沉穩而又激越。他言語不多，做事扎實，一步一個腳印，行為相當穩健。但當他邁出大步的時候，卻果斷、堅定，毫不含糊。他的畫呢，創作態度嚴肅認真，工作程式一絲不苟，但不拘常規，充滿激情。大概他具有這兩種品質吧，他的藝術一直顯示出獨特的個性面貌：反叛傳統的樣式和承繼傳統的精神。

……他的畫和傳統中國畫有一脈相承的血緣聯繫。他從文人畫之前的傳統壁畫中吸收了不少營養，尤其在自由取景和色彩方面；他也接受了文人畫的用綫和自由書寫的不少技法；他從西畫塊面造型和畫面構成中得到許多啟發，他還大膽地把西畫的一些抽象手法拿來為我所用。這些知識、技法和手法，在天行手中有時是十八般武藝，各有其用處，在更多的情況下，是他特有的綜合「武器」，用以形成自己藝術特有的面貌。而統率這些武藝或武器的，是他執着於藝術的精神和真誠的內心感情，而這正是傳統中國畫的精神所在。

邵大箴，〈表達真情與愛——林天行的繪畫藝術〉（節錄），《今日中國藝術家》，二〇〇八年

I have been paying close attention to Lam's art for more than a decade. His works have appeared in many exhibitions in China and overseas, some of which are solo exhibitions. I have been to his studio in Hong Kong; like his personality, his works display a strong contrast of passion and rationale. Lam is not talkative. He is down-to-earth and steady, yet willing to take risks when circumstances arise. He is a serious artist. His works are well planned yet unconventional, always expressive. His dual personalities have given his art a unique character – to rebel against the form and to inherit from the spirit of the tradition.

…One can easily see the influence of traditional Chinese art on his paintings, for example, his use of the multi-point perspective and the colours of ancient mural painting as well as the linear and calligraphic qualities of the literati painting; moreover, Lam has also adopted the Western way of block structure and abstract visual elements. Such fusion of knowledge, techniques and skills have become Lam's unique "weapon" by which he has created the distinctiveness of his art. He has become such a master of this style that he can freely express himself in any subject matter. His achievement has originated from his love and passion for art, which coincides with the true spirit of traditional Chinese brush painting.

**Shao Dazhen, Expression of Love and Affection – Lam Tian Xing's Art of Painting (excerpts),** *Chinese Artists of Today*, **2008**

林天行原本是山水畫的科班生，一九九〇年畢業於中央美術學院國畫系山水畫專業，畢業後的十幾年間，他主要以都市山水、陝北和西藏等幾個系列的山水畫組畫樹立了自己的藝術面貌。八十年代末、九十年代初的太行、陝北寫生是他山水畫創作和藝術觀念的轉捩點。北方山水間的凝重、樸茂、渾厚的性格強烈地震撼了他，或者說契合了他的個性和精神追求，於是十幾年來熟悉的那些筆墨都在他的新表達中變得無處安置了。他開始捨棄，吸收，也開始創造，捨棄了中國畫的筆墨方法（尤其是綫），吸收了西畫的塊面、構成和色彩，創造了濃艷、稚拙的面貌。觀念上則變得更大膽和自由，傳統的「清規戒律」也變得越來越少。

天行的荷花系列是山水畫之外延展出的唯一一個「旁枝」，與他的山水畫有着相似的追求和面貌。天行說：「我是用山水畫的結構來畫荷花的。」的確，他的荷花有着北方山水式的厚重感，但這種厚重與吳昌碩的由金石書法轉化而來的筆墨的厚重不同，主要是由西畫式的塊面和色彩構造出來的。他注重構圖，而大的塊面分割就是他構圖的主要方法；他喜歡用透明性的顏色，可以層層疊加，厚重而能透氣，濃烈又不混沌。

華天雪，〈天行行得遠〉（節錄），《天行西藏》，二〇〇七年

Tian Xing was given professional training for an artist of Chinese landscape painting. He graduated from the Chinese Painting Department of the Central Academy of Fine Arts in 1990. For more than a decade after his graduation, the artist excelled in painting urban cityscapes and landscapes of Northern Shannxi and Tibet. The location sketches on Taihang Mountains and Northern Shannxi in the early 1990s marked the turning point of his new artistic conception. The sturdy, lush and lofty northern landscapes had a great impact on him, leading him to realise and pursue his true personality and spiritual needs. The conventional brush and ink technique proved to be insufficient for new expressions. Tian Xing started to abandon, assimilate and create. He abandoned the conventional brush and ink techniques (especially the linear approach) and assimilated the Western style of blocks, compositions and colours, thus creating a style of primitive and simple art with vivid colours. These paintings convey a bold and free concept without leaving room for rules and norms from the tradition.

Tian Xing's lotus series is a branch of his landscapes creation with analogous semblance. "I compose my lotus as if they are landscapes." he said. His lotus paintings are undoubtedly as sturdy as his northern landscapes, yet they differ from the strong brush and ink of Wu Changshuo. While Wu's is an adaptation of the seal script style, Lam borrows compositions of blocks and colours from Western paintings. He emphasises the composition, composing his pictures with large blocks. He builds up his images with layers of transparent colours, thick yet translucent, strong and vivid but not opaque.

**Hua Tianxue, A Far-flung Friend (excerpts),** *Tibet—A Cosmovital Vision,* **2007**

林天行用傳統的筆墨程式作實驗，斑斕的色彩和剛勁的綫條標示着文明生活的新秩序。

⋯⋯林天行的作品都完成於一九九九年，迎接新的千禧，畫家通過以文人文化為主導精神的中國水墨畫，以人文主義角度關注城市生活的種種問題，以帶出中國傳統文化中的和諧精神，調節西方那種人與自然和人與人之間的緊張關係。

朱錦鸞，《香港水墨藝術——後殖民地的國際景觀》（節錄），《信報財經月刊》，二○一○年六月號

Lam Tian Xing experiments with the traditional ink techniques, and uses boldly gorgeous block of multicolours and strong well-defined lines, thus marking a new milestone in painting civilisation.

This series of work was completed in 1999. Greeting the coming new millennium and based on the Chinese painting principle which dwelled on the literati culture, Lam was concerned with the various problems of urban life, which people were facing daily. He applied the harmonious spirit of the Chinese traditional culture to ease the tensions among the Western people, and those between the people and nature in the West. He brought a new balance to the world.

**Christina Chu, Hong Kong's Ink Art – The International Landscape in Post-Colonial Time (excerpts),** *Hong Kong Economic Journal Monthly,* **June 2010**

或許，水墨程式和現代水墨意識對於林天行來說是個難題，但畫家一步直指七寸對於當代水墨畫家而言卻是個課題。在這一點上我和林天行始終不能達成某種意義上的共識，甚至數次發生口誅筆伐的情況。他一直沉穩地回避我所說的他畫面中大叫大嚷表明自己的先鋒意識和前衛精神，並聲稱自己一直在做着調和中西的嘗試；我說他「景象·香港」的出籠作為實驗的突破口已超越了原始的本意，他說自己絕對不是「文化掮客」來兜售西方文明和西方流派，凡此種種，不一而足。但是，我覺得我們的分歧始終不在同一界面，因為我們各處鼓吹的始終不是一個問題。

在我看來，洋貨完全可以本土化，眼下的「掮客」可能就是日後的大師。不信？趙無極，朱德群就是例子，他們就是東方情韻在西方大行其道的。有什麼不好？

新的水墨創作除了是一種理想和活力外，它還是一種擺脫平庸、刻意求新的姿態。林天行的畫沒有聲色娛樂，歌舞昇平，不負責任地製造美化了的生活，只畫自己意念的「地域方言」、生活即景，正是暗合了所謂前衛的生存方式。

深究一步，林天行之所以一再標榜自己與傳統水墨有割不斷的姻緣，這也有他的道理。一九九〇年，天行離開中央美院時，正值「後'85」如火如茶之際，又逢「89新美術運動」餘波未了，相比較而言，那時他的畫的確算是平和的一路。這裏就誕生出一個很有意思的話題。大家都在搞前衛的時候，他來個傳統，反之，傳統被重提的今日，他又重新前衛起來。

……

到了一九九六年，到了「景象·香港」出現，林天行才真正找到了自己，他用一種看上去傳統水墨的關懷，把屯積的所有能量，包括對傳統的承繼、院校的打磨通過他暫時還恍惚的語態顯現出來，和他的激情交流後一起釋放出來。他一直認為自己是穿着舊行頭來做調和中西的偉業，而事實上，他卻是用傳統的技巧、批評傳統的態度，在做以傳統反傳統的行當。

或許，他從來沒有想過，傳統和反傳統僅僅也只是一步之遙，他所扮演的角度並不是他所期盼的那個坐標點，而這個坐標點又是他之所以成功的祕訣之所在。

謝海，〈以傳統反傳統——論林天行水墨景象〉（節錄），《當代中國山水畫新篇章——關注林天行》，二〇〇二年

Perhaps, the traditional ink painting and the modern ink consciousness is a tough question for Lam Tian Xing, but how to pinpoint the key issue is a topic which he had to deal with as a contemporary ink painter. On this point, Lam Tian Xing and I have never been able to reach a consensus, and we have even had several fierce debates in speech as well as in writing. He has been calmly avoiding my criticism of his alleged pioneering consciousness and avant-garde spirit, and claimed that he had been trying to reconcile Chinese and the Western art. I pointed out that the release of his "Scenes · Hong Kong" as a breakthrough in the experimental ink painting surpassed the original intention; he argued that he was definitely not a "cultural broker" to sell Western civilisation and genres, and so on. However, I do not think that our disagreement was in the same category, because what we advocated was not the same topic.

In my opinion, foreign products can be localized completely, and today's "brokers" may be tomorrow's masters. If people do not believe, they should learn Zao Wou Ki and Zhu Teh Chun. They are successful and popular examples in the West as artists from the East. Is there anything wrong with it?

The new ink creations are not only a kind of ideal and vitality, but also a gesture of breaking away from mediocracy and deliberately seeking differences. In Lam Tian Xing's paintings, he did not present amusements, joyful and peaceful life irresponsibly, but painted the "regional dialect" from his mind, and the scenes of life, which coincided with the so-called avant-garde way of life.

Taking the discussion further, Lam Tian Xing has his own reasons for his claim that he has a constant connection with traditional ink painting. In 1990, when Tian Xing left the Central Academy of Fine Arts, it was at the time when the "post-85" was in full swing, and the aftermath of the "89 New Art Movement" was still to come. In comparison, his painting style at that time could be considered mild and peaceful. Here comes an interesting topic. When everyone was avant-garde, he came back to the tradition; when the tradition was revived, he became avant-garde again.

…

In 1996, Lam Tian Xing finally found himself when "Scenes · Hong Kong" was created. With the love of traditional ink painting in his heart, he accumulated all energy over the years, including the inheritance of the tradition, and the polished skills and academic training, through his temporarily dazed voice, and released with his passion. He always thought that he was reconciling the East and the West in his old fashion. In fact, he has been using the tradition to get the anti-tradition result by deploying traditional skills to criticise tradition.

Perhaps he has never thought that tradition and anti-tradition differ only at a stone throw distance. The role he has played was not the reconciliation he expected, though the way of reconciling was exactly the crux of his success.

**Xie Hai, Traditional versus Anti-traditiona – A Theory of Lam Tian Xing Ink Scene(excerpts),** *Contemporary Chinese Landscape Paintings – Lam Tian Xing,* **2002**

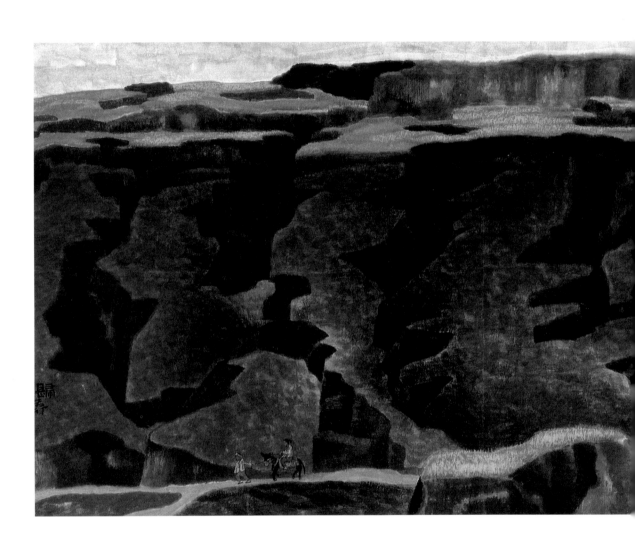

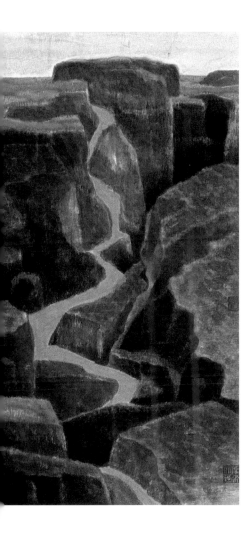

歸
**Homeward Journey**

水墨設色紙本
*Ink and Colour on Paper*
95x176cm | 1991

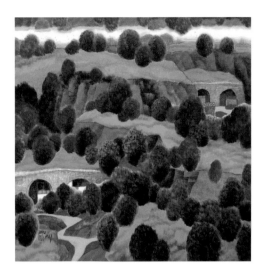

**山居**
**Hill House**

水墨設色紙本
*Ink and Colour on Paper*
68x68cm ｜ 1992

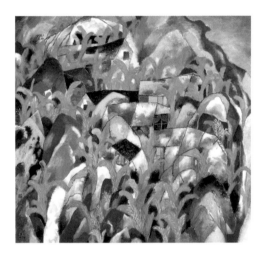

**嚮往 (二)**
**Yearning (2)**

水墨設色紙本
*Ink and Colour on Paper*
98x90cm ｜ 1995

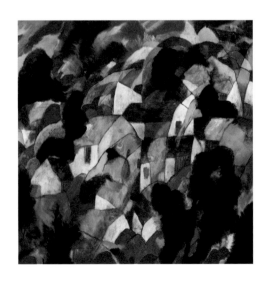

**山居**
**Hillside**

水墨設色紙本
*Ink and Colour on Paper*
68x68cm ｜ 1995

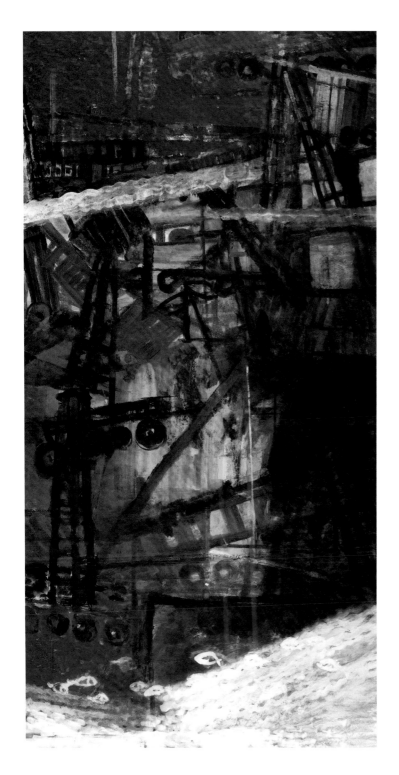

碼頭
**The Pier**

水墨設色紙本
*Ink and Colour on Paper*
248x124cm | 1998

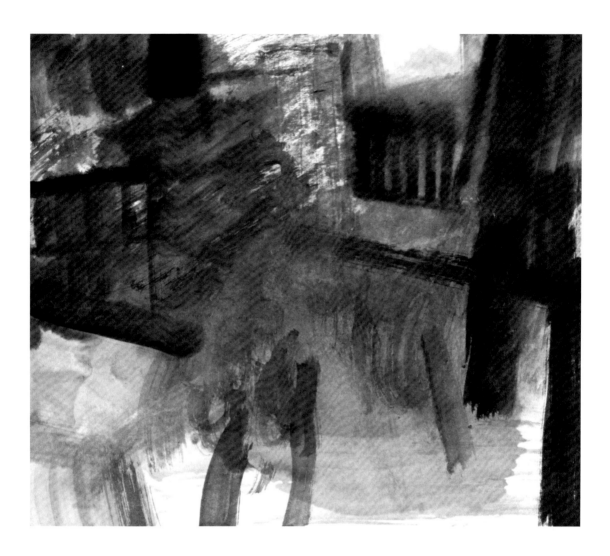

**夜色朗朗**
**The Colour of the Night**

水墨設色紙本
*Ink and Colour on Paper*
24x27cm | 1998

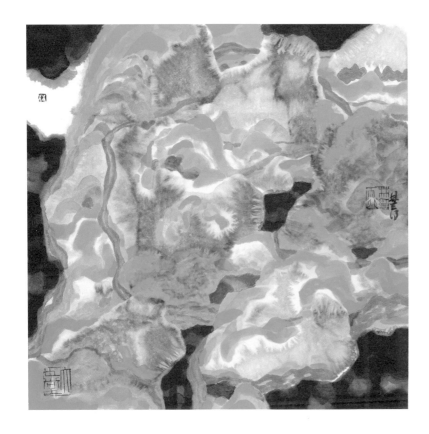

**塵外**
**Xanadu**

水墨設色紙本
*Ink and Colour on Paper*
68x68cm | 2015

**金黃色的朝霞**
**Golden Haze under Twilight**

水墨設色紙本
*Ink and Colour on Paper*
68x68cm | 2005

**山居**
**Hillside**

水墨設色紙本
*Ink and Colour on Paper*
110x98cm │ 2001-2015

**霞映**
**Reflection of the Sunset Glow**

水墨設色紙本
*Ink and Colour on Paper*
110x98cm │ 2001-2015

又見彩虹
**Seeing Rainbow Again**

水墨設色紙本

*Ink and Colour on Paper*

110x98cm | 2001-2015

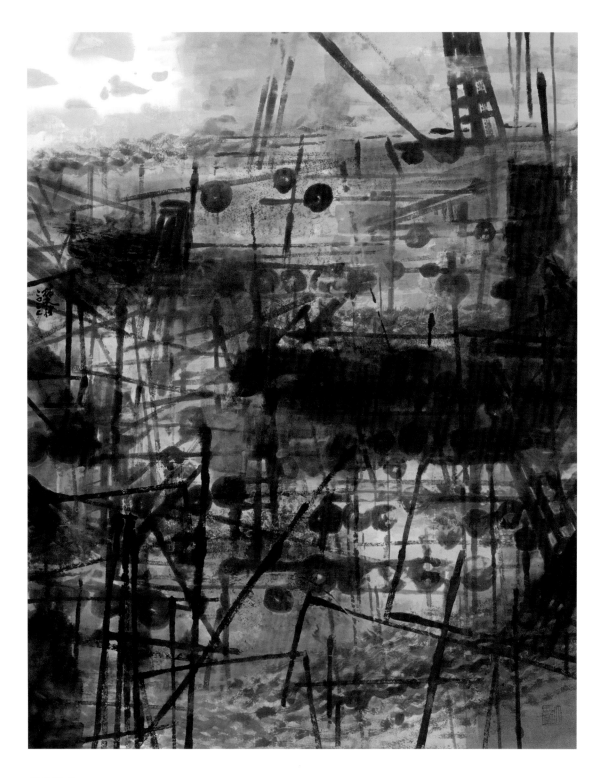

**海的故事**
**Story of the Sea**

水墨設色紙本
*Ink and Colour on Paper*
184x144cm ｜ 2022

**夕陽裏的佛塔**
**Stupa at Sunset**

水墨設色紙本
*Ink and Colour on Paper*
42x47cm | 2001

陽光裏的寺院
**Monastery in Sunshine**

水墨設色紙本
*Ink and Colour on Paper*

53x235cm │ 2006

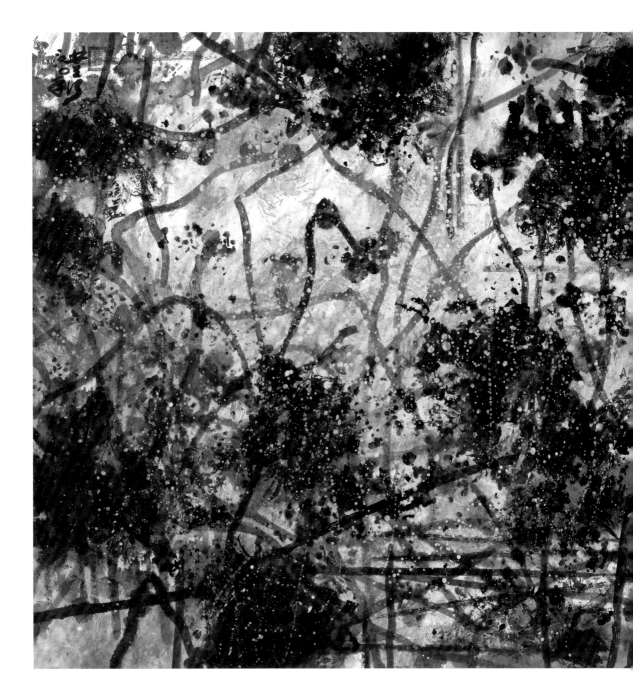

雪霏霏
**In the Snow**

水墨紙本
*Ink on Paper*
124x248cm | 2010

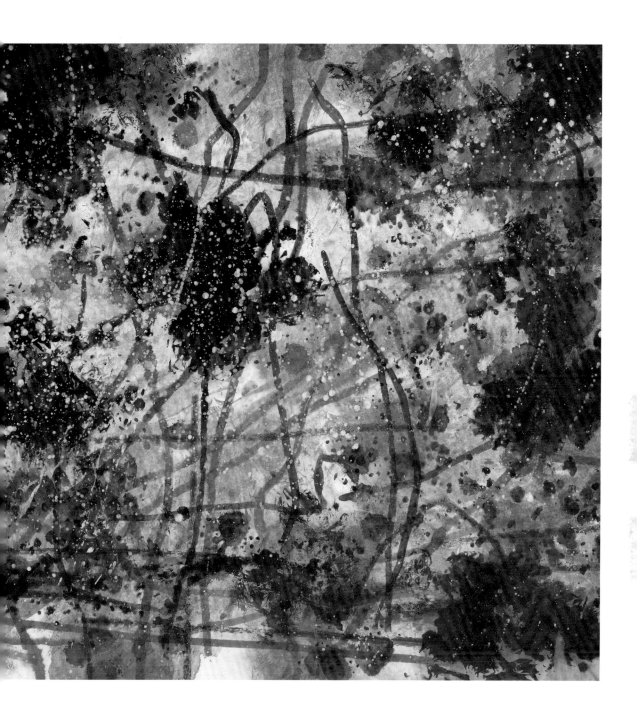

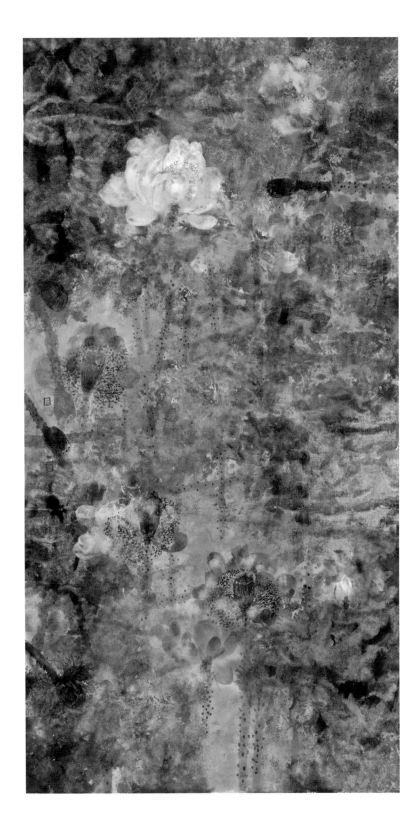

君子如荷（一）
**Like Gentleman Like Lotus (1)**

水墨設色紙本
*Ink and Colour on Paper*
139x69cm ｜ 2018

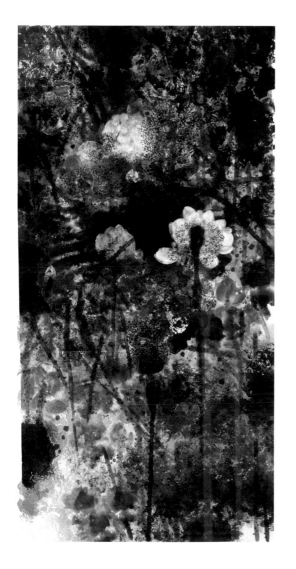

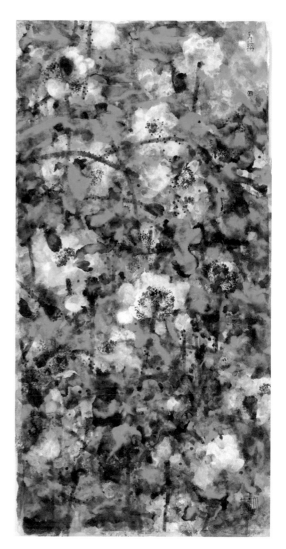

君子如荷（二）
**Like Gentleman Like Lotus (2)**

水墨設色紙本
*Ink and Colour on Paper*
139x69cm ｜ 2018

君子如荷（三）
**Like Gentleman Like Lotus (3)**

水墨設色紙本
*Ink and Colour on Paper*
139x69cm ｜ 2018

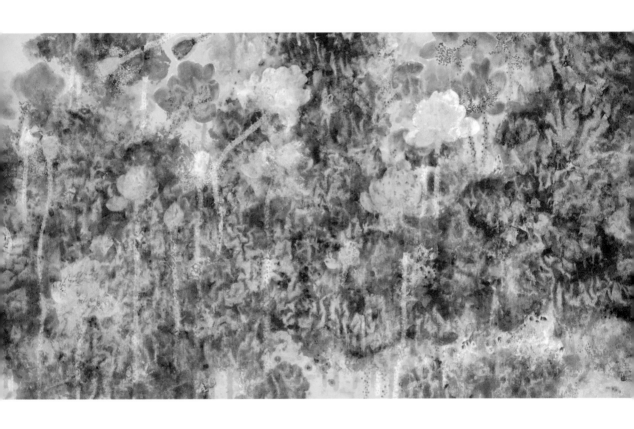

麗荷
**Glamorous Lotus**

水墨設色紙本
*Ink and Colour on Paper*
100x190cm │ 2021

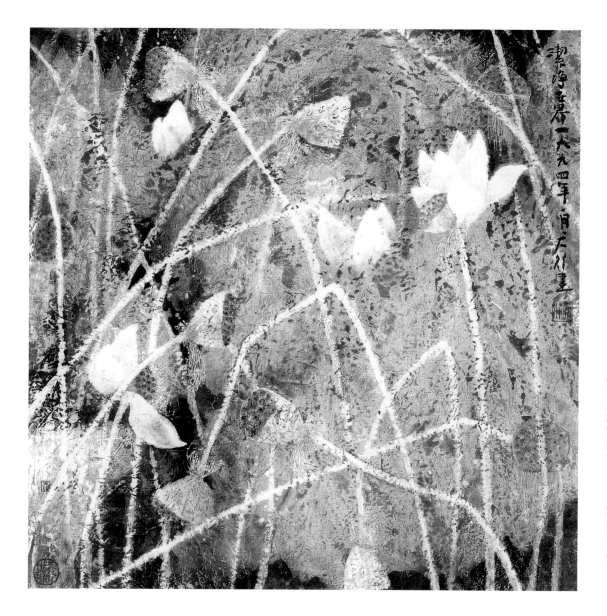

潔淨世界
**A World of Purity**

水墨設色紙本
*Ink and Colour on Paper*
70x70cm | 1994

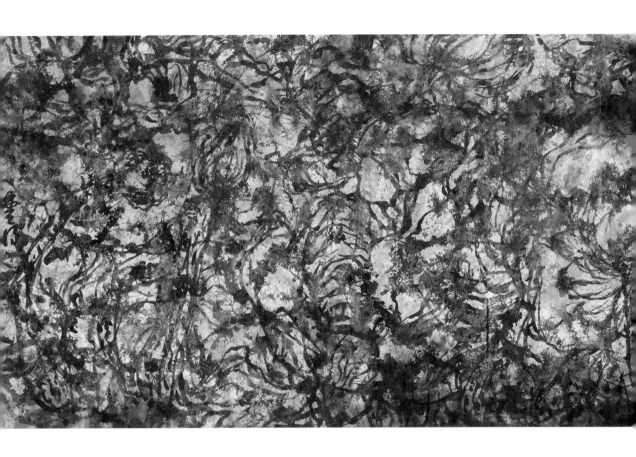

遠懷
**Longing**

水墨設色紙本
*Ink and Colour on Paper*
35x138cm ｜ 2022

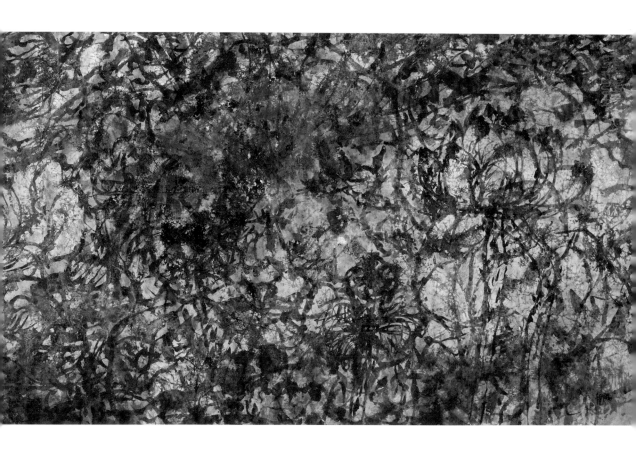

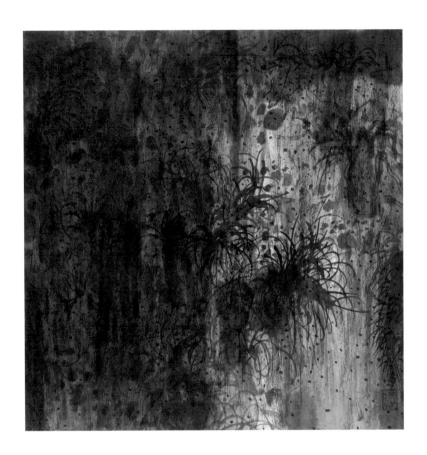

翠響
**Sound of Jade**

水墨設色紙本
*Ink and Colour on Paper*
74x72cm ｜ 2020

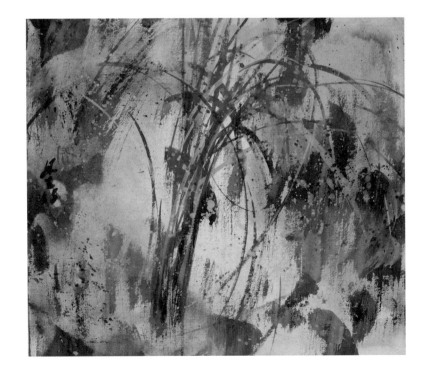

衍之一
**Growth (1)**

水墨設色紙本
*Ink and Colour on Paper*
24x27cm ｜ 2019

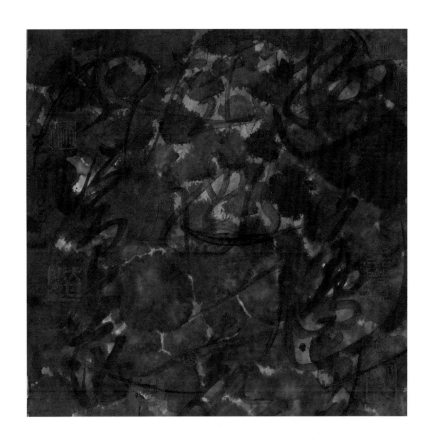

漢字起源
**Origin of Chinese Characters**

水墨設色紙本
*Ink and Colour on Paper*

35×35cm ｜ 2020

漢字系列——竹
**Chinese Characters Series –
Bamboo**

水墨紙本
*Ink on Paper*

68x68cm ｜ 2020

漢字系列——石
**Chinese Characters Series – Stone**

水墨紙本
*Ink on Paper*
68x68cm ｜ 2020

漢字起源 (二)
**Origin of Chinese Characters (2)**

水墨設色紙本
*Ink and Colour on Paper*

68x68cm ｜ 2020

漢字起源
**Origin of Chinese Characters**

水墨設色紙本
*Ink and Colour on Paper*

68x68cm ｜ 2020

遊
於

藝

（八）

遊

於

藝

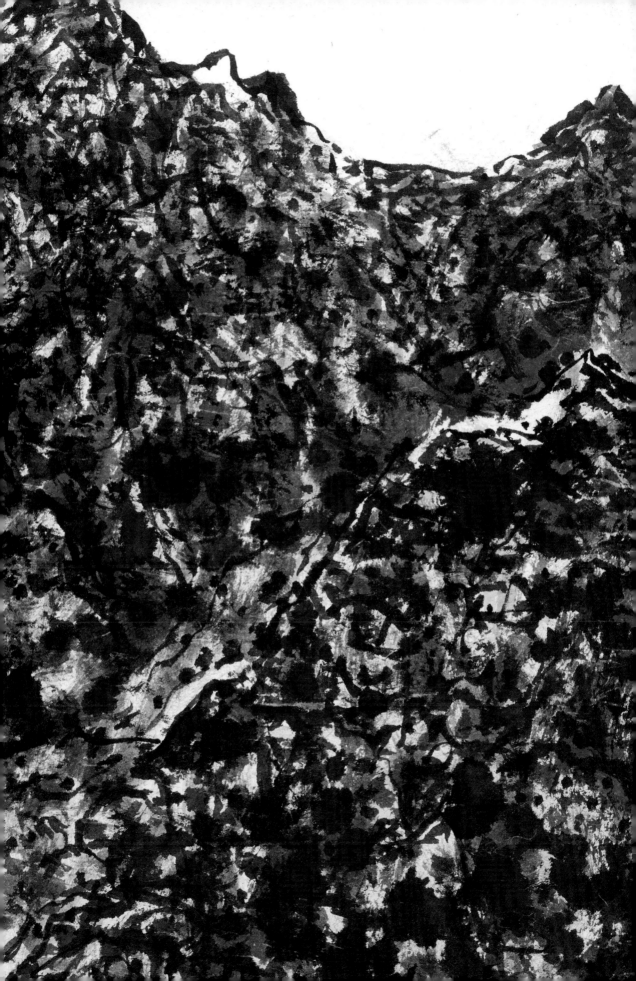

# 天行　畫語

　　我十三歲立志當畫家。很幸運地靠一支毛筆養家糊口，給子女供書教學，生活到現在。雖然道路不算坎坷，但也歷盡滄桑，多次在生活與藝術的十字路口徬徨、迷惘、困惑，甚至窘迫和痛苦。

　　然而，我從來沒有停止過迎風前行。艱辛的日子讓我更加感受到藝術巨大的力量！她改變了我的人生，讓我的世界無邊界。我為擁有藝術的人生仰天長嘯，舉杯高歌！我沉浸在生活與藝術的苦與樂之中。「沒有藝術就沒有我的生命！」這是我少年時的誓言。路漫漫其修遠兮……

　　恰如泰戈爾所言：「除了通過黑夜的道路，無以到達光明。」

# Tian Xing's Thoughts 天行

I was determined to be a painter when I was thirteen.

I am very lucky to be able to support my family and provide education to my children, until this day by painting. Although the road of my art life is not entirely bumpy, I have also experienced many vicissitudes of life. Many times, at the crossroads of life and art, I have been hesitant, confused, and even distressed and tormented.

However, I have never stopped moving forward against the wind. The difficult days made me feel the phenomenal power of art! Art has changed my life and made my world boundless. I raise my glass and sing for the life of art! I am immersed in the suffering and joy of life and art. "Without art, there would be no life!" This was my youth oath. The road ahead is long and far……

As Tagore said: "Except the road through the night, there is no way to reach the light."

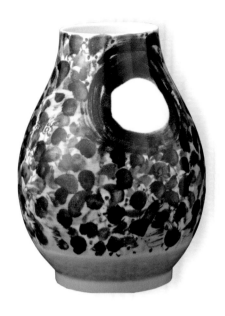

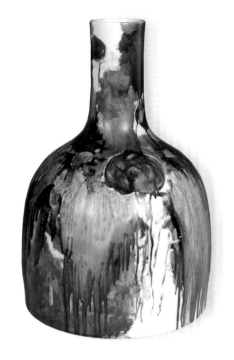

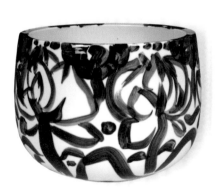

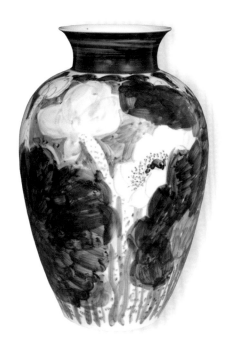

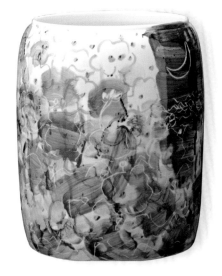

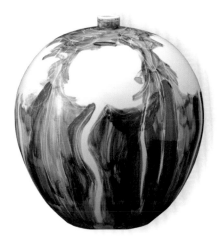

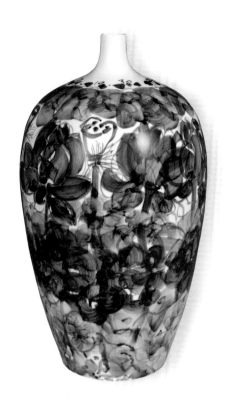

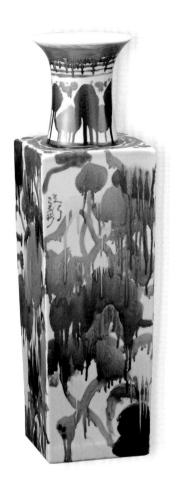

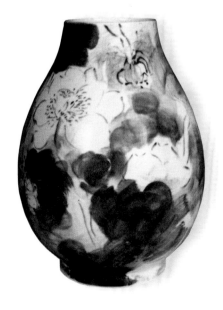

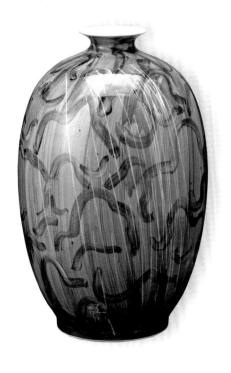

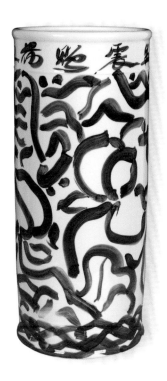

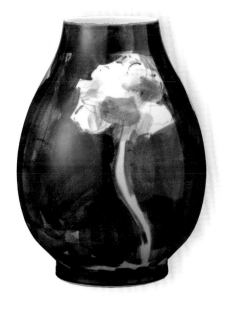

**瓷器**
**Porcelain**

2009

天新（董亞平）（一）
**Tian Xin (Dong Yaping) (1)**

紫砂壺刻畫
*Carving on Purple Clay Teapot*
2011

天新（董亞平）（二）
**Tian Xin (Dong Yaping) (2)**

紫砂壺刻畫
*Carving on Purple Clay Teapot*
2011

**思源（方彩娣）（一）**
**Si Yuan (Fang Caidi) (1)**

紫砂壺刻畫
*Carving on Purple Clay Teapot*
2011

**思源（方彩娣）（二）**
**Si Yuan (Fang Caidi) (2)**

紫砂壺刻畫
*Carving on Purple Clay Teapot*
2011

元盤（華氏）（一）
**Yuan Pan (Hua) (1)**

紫砂壺刻畫
*Carving on Purple Clay Teapot*
2011

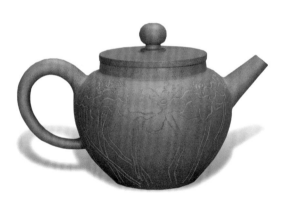

元盤（華氏）（二）
**Yuan Pan (Hua) (2)**

紫砂壺刻畫
*Carving on Purple Clay Teapot*
2011

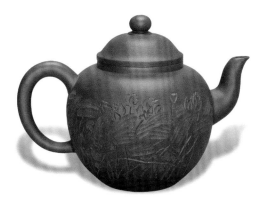

玉泉（龐現軍）（二）
**Yu Quan (Pang Xianjun) (2)**

紫砂壺刻畫
*Carving on Purple Clay Teapot*
2011

君子如蓮（黃方壺）（一）
**Like Gentleman Like Lotus (Yellow Fanghu-shaped Teapot) (1)**

紫砂壺刻畫
*Carving on Purple Clay Teapot*
2011

君子如蓮（黃方壺）（二）
**Like Gentleman Like Lotus (Yellow Fanghu-shaped Teapot) (2)**

紫砂壺刻畫
*Carving on Purple Clay Teapot*
2011

**君子如蓮 (黃壺) (一)**
**Like Gentleman Like Lotus (Yellow Teapot) (1)**

紫砂壺刻畫
*Carving on Purple Clay Teapot*
2011

**君子如蓮 (黃壺) (二)**
**Like Gentleman Like Lotus (Yellow Teapot) (2)**

紫砂壺刻畫
*Carving on Purple Clay Teapot*
2011

**君子如蓮 (黃壺) (三)**
**Like Gentleman Like Lotus (Yellow Teapot) (3)**

紫砂壺刻畫
*Carving on Purple Clay Teapot*
2011

**洋方（韋鍾雲）（一）**
**Foreign Square Pot (Wei Zhongyun) (1)**

紫砂壺刻畫
*Carving on Purple Clay Teapot*
2011

**洋方（韋鍾雲）（二）**
**Foreign Square Pot (Wei Zhongyun) (2)**

紫砂壺刻畫
*Carving on Purple Clay Teapot*
2011

**洋方（韋鍾雲）（三）**
**Foreign Square Pot (Wei Zhongyun) (3)**

紫砂壺刻畫
*Carving on Purple Clay Teapot*
2011

**洋方（韋鍾雲）（四）**
**Foreign Square Pot (Wei Zhongyun) (4)**

紫砂壺刻畫
*Carving on Purple Clay Teapot*
2011

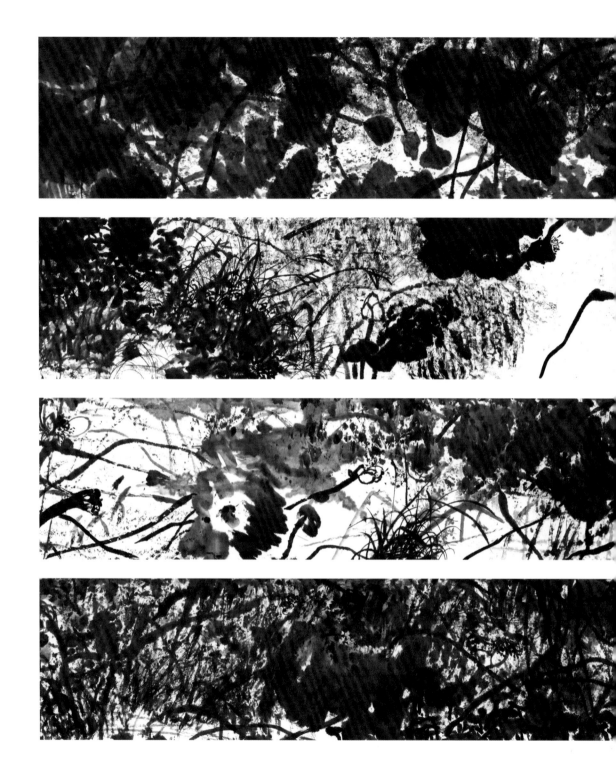

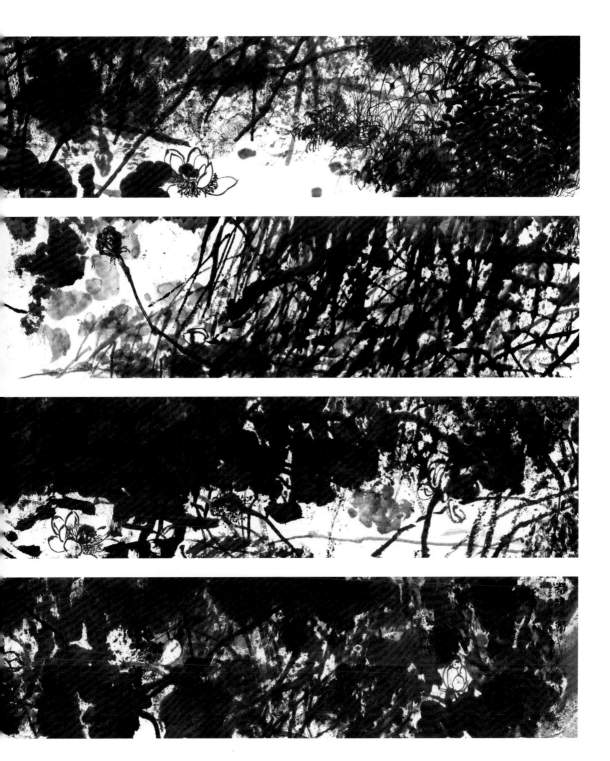

荷花寫生長卷——荷塘煙雨
**Long-scroll Sketch of Lotus—Lotus Pond in Mist Rain**

水墨紙本
*Ink on Paper*
45x1350cm | 2004

西藏寫生長卷——土林神遊
**Long-scroll Location Sketch of Tibet—Tolin Impression**

水墨紙本
*Ink on Paper*
46x2000cm | 2005

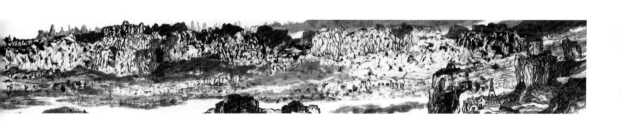

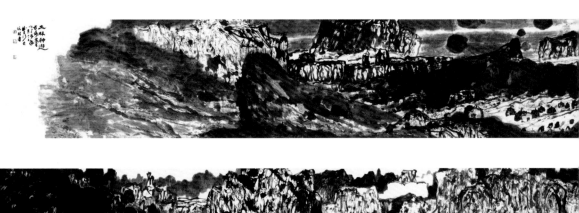

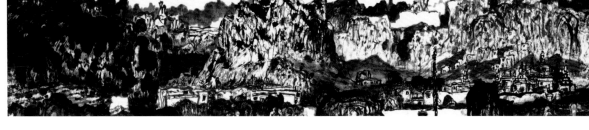

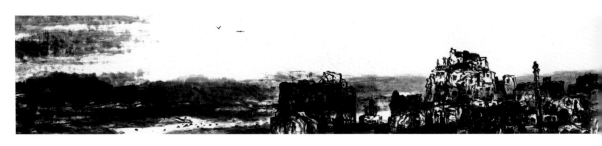

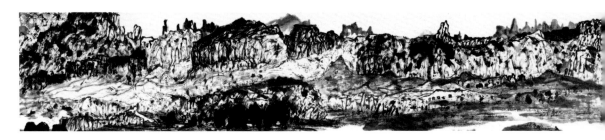

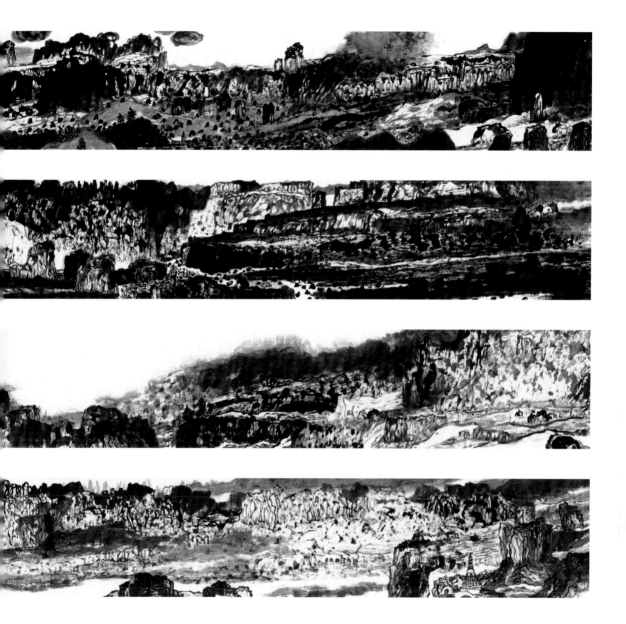

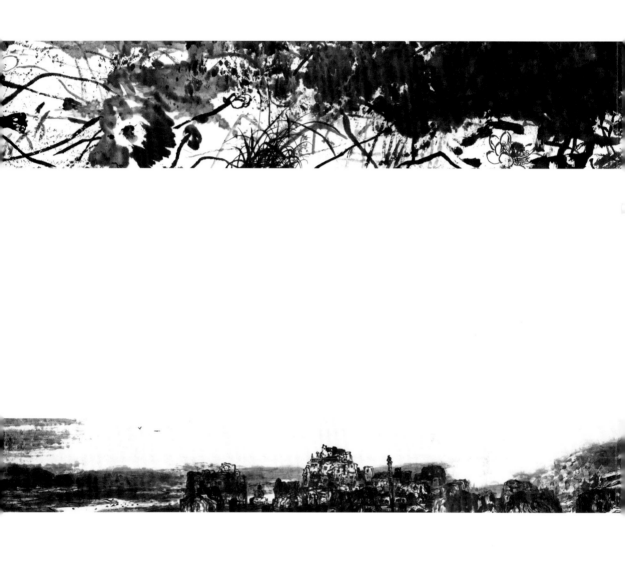

# 跋

# 難忘的人

對那些教我睜開雙眼，打開我胸襟，洗滌我靈魂的導師們，我心存敬意！同時，還有許多長期支持我的師友們，若沒有他們，「天行之路」將難以走到今天。

1984 年移居香港，父親在荃灣為我租了一間房子 —— 不到百呎的唐樓板間房。裏頭一張鐵皮書枱，一張可以折疊的四人飯桌和一張雙層鐵架床，還有三百元港幣。

就這樣，開始了新的生活，那一年我二十一歲。包租婆一家人住在隔壁，她們都很善良，有時會把煲好的湯給我喝。我經常沒錢交租，她們也不追我要，甚至有時還借錢給我。其中一次是因為一個師兄從福州來香港辦畫展，電話中說要來拜訪我，為了盡地主之誼，我向包租婆的女兒借了三百元港幣。

包租婆那十歲的外孫女經常鼓勵我說：「阿仚你一定會成為畫家的。」

1985 年經一個同鄉介紹，開始畫商品油畫，工作很自由，牆上釘兩塊三合板就可以工作了。但我對於商品油畫的各種技巧尚不熟練，故經常返福州求教陳挺老師。同時為了爭取多點時間從事藝術活動、學習、創作等，掙錢的時間就少了，生活總是很拮據。

我住在唐樓的四樓，下面是賣唱片的店鋪，從早到晚聽到的都是《酒乾倘賣無》。對面是一間書店，那是我的精神棲息地。有一次，見到一本桂林山水攝影集，非常喜歡，但當時身上只有一百塊錢。為了這本書一夜沒睡好，第二天一早去買回來，餘下三十元，吃了一週方便麵。

一天，有個住在屯門的畫友，來電邀請我到他家吃飯。我找到僅有的五塊錢，剛好足夠乘巴士往返。但由於換不到零錢，巴士也沒設找贖，最後我毅然

投下五塊錢。幸好遇友人在《大公報》工作的胞姐，恰巧代我領取了三百元稿費（當年我經常有作品投稿到《新晚報》，刊登一張可得一百五十元港幣）。

1987 年婚後，妻吳明芬來港定居。一無所有的我，向朋友借了七千元港幣。扔掉鐵架床，換了一張雙人床，添了一台風扇，買了兩桶白色乳膠漆刷牆。就這樣，兩個人的生活，從此展開了。

翌年，我們以 27,000 元港幣，買下一間在荃灣半山腰的雙層鐵皮屋（那裏俗稱木屋區，也稱貧民區）。這筆款項，是我問收我商品油畫的出口公司老板雷先生借的。他平時喜歡我的中國畫，並有收藏。他說這錢不用還了，給幾幅山水畫就可以了。

新的家，在山谷中，周圍都是樹林和蕉林，四季都鬱鬱蔥蔥。走到一條小溪澗，穿過十幾間鐵皮屋，就到了。房子雖然窄小簡陋，但經常有文化藝術界朋友在此舉杯高歌，暢談人生！書法家鄭光中由福州訪港，在這裏寫下了《陋室銘》贈我。

1989 年 1 月長子沙洲在這裏出生。

1989 年，中央美術學院中國畫系錄取了我。

為了安心去北京繼續深造，我們把剛出生不久的兒子送到福州讓我母親照顧，妻明芬留港工作。無論生活多麼艱辛，她都無怨無悔，迎刃向前，從無退卻，默默支持着我。

1990 年 12 月，緣於恩師劉牧當時供職於中國畫研究院畫廊（現為國家畫院），我得以在國家畫院舉辦首次個人畫展。

　　1991 年初返港，在一家畫廊舉辦首次香港個人畫展。由於觀念改變，畫風與題材均異於之前的風格，看慣了我過去山水畫的人說看不懂。有一個畫廊老板說：「你的畫太苦澀了，不會有人願意花錢買來掛在家裏的。」展覽結束，一張都沒賣出。

　　此時的我，拖住沈重的步履，不禁愁腸百結，如同陷入了泥濘沼澤，就地坐在荃灣地鐵站門口，頹廢、迷惘、失望……不知如何向妻明芬交代，兩年沒有收入還要花錢搞藝術。然而，我的信念是堅定的！

　　期間，友人引薦去香港大一藝術設計學院兼職做教師，但我還是要求只教半個月，餘下時間創作，收入僅夠糊口而已。

　　是年 12 月，施子清會長幫助我在香港藝術中心舉行了個人畫展。開幕典禮人山人海，由時任新華社香港分社副社長張浚生、劉國松教授、趙世光會長、鄭家鎮先生、施子清會長剪彩。此展作品以「陝北系列」為主，許多觀眾多次前來觀展，十幾幅作品被收藏，讓我增加了不少信心。

　　從那時起，我每年都要去一次北京，學習、交流、創作兩個月。

　　北京是我藝術成長的地方；香港是打開我視野的地方。

　　1994 年，經過兩年多的探索，我畫出一批自認與眾不同的作品，再次在藝術中心舉行個人畫展，並出版作品集。此展邀得萬青力教授為畫冊作序言，並得到畫友王守清和鄭家奇的幫助，展出空前成功。

　　這一年，申請四年的公屋批了下來，女兒莎娜出生。

　　畫友鄭家奇借給我五萬元裝修葵芳邨的公屋。我告別了居住七年的鐵皮屋，開始了新的藝術探索……

1997 年第三次在藝術中心舉辦個展，以水墨重彩表現新界風光主題，並出版作品集。

詩人秦嶺雪先生，亦師亦友。他到寒舍聽我講關於新作的故事，並為畫冊作序，且留下一張支票。在往後多次個人畫展中，他都有求必應為我作序，每一次展覽都留下支票。1989 年相識至今，他豪情睿智，俠肝義膽，是我黑夜裏的一盞明燈。

1997 年，畫友蔡海鷹把原來鯉魚門的家借我做工作室。我每天點對點在那邊畫畫。1999 年第四次在藝術中心舉行的「景象·香港」個展，大部分作品都是在鯉魚門工作室完成的，尤其是八尺和丈二的作品。

鯉魚門工作室景色雖美，但也不能長期佔用。1999 年 12 月，我在住處附近的工廠大廈，看上了一個地方（《畫室裏的一天》裏有介紹），月租五千元。當我簽下租約後才知道我又身無分文了。

終於有了自己的工作室，我推掉所有外面的教畫工作。本來想專心創作，可是，難！靠賣畫為生難，養家活兒更難！無奈之下，2000 年開始在工作室授課，但只限每周教三至四節課。

學生中，有不少在我困難和需要幫助時，悄悄地伸手援助。如談雅文，她 1994 年就跟隨着我，不離不棄，每一次展覽都離不開她的慷慨相助。陳燕卿和她一樣，無論大小內外事務都小心翼翼地為我處理。還有施秀菁、黎倩妮、彭麗雯、廖綺雲、碧默、胡麗珍、黃秀瓊、賀容真、朱麗燕、李雅麗等。我要特別感謝兩位學生賀容真、李雅麗為本書英文部分提供的幫助。沒有她們，「天行之路」將更加艱辛。

詩人萍兒，二十年前專訪我在畫廊辦的展覽。遲到的我說：「不好意思，昨晚喝醉了。」她眼閃金光，滿臉笑容說：「太好啦！」從此，我們不僅是酒友，每當我在藝途上顛簸流離，她都挺身而出，說是女中豪傑也不為過。

鄭培凱教授的夫人鄢秀教授，常以福州人為傲，讓我這生於斯長於斯的福州人，倍感親切。他們兩夫婦都喜歡我的畫，於 2013 年在香港城市大學中國文

化中心為我舉辦「荷．天行」個人畫展，並收藏多幅作品。無巧不成書，開幕典禮當天正是我五十歲生辰。此後，鄭教授多次為我的作品集作序著文。

為了《天行之路》的序言，金耀基校長用了一年時間來了解我每個創作階段的藝術理念與人生追求，並閱盡所有關於我的文章與畫作。可見偉大的學者都是抱着嚴謹的態度治學！他愛美食更愛酒。去年底，我們在集古齋聯展，晚宴上頻頻舉杯暢飲，大家手舞足蹈，氣氛熱烈。宴後金公見我腳步浮浮，執意送我回家。車到樓下還不放心，一位八十七歲高齡的長者扶着一個五十八歲的人上樓，進屋後見我沒事才放心離去。

范迪安院長在 1990 年曾為我的「陝北系列」展作跋，刊登在《海峽兩岸》雜誌。三十年來，范院長一直關心着我的藝術動向與理念，從他為我寫的序中可見一斑。

鄧海超館長對我的作品一直保持關注。他對我的藝術發展各階段和歷年作品進行了極為細緻的梳理，為本書撰寫了又一篇精彩的序言。

一年前，趙東曉博士跟我說，在聯合出版集團傅偉中董事長支持下，香港中華書局要為我出版一本畫傳，並邀金耀基校長作序。從此，我們見面的機會更多了。為了做好這本書，他對我的藝術人生做了一番深入了解，作出總體策劃，每個篇章都強調藝術與生命的契合，彰顯學術精神。我們多次與中華書局侯明總經理兼總編輯、顧瑜助理總編輯，還有設計師陳曦成開會研討，大家都全力以赴。

書終於面世了，我要真誠地感謝所有幫助我，支持我的朋友們！帶着你們的關愛與支持，我將繼續在藝術的天行道路上不斷前行。

# Unforgettable People in My Life

I have a great respect and admiration for my mentors who taught me to open my eyes, open my mind and cleanse my soul. At the same time, there are many teachers and friends who have supported me for a long time. Without them, the "art journey of Tian Xing" would not be able to get to where it is today.

I moved to Hong Kong in 1984. My father rented a room with a space of less than one hundred square feet in a tenement building for me in Tsuen Wan. There was a tin desk, a foldable dining table for four and a double-layer iron bed, and HKD300 in my pocket.

In this way, I started my new life in Hong Kong at the age of 21. The landlady and her family lived next door. They were very kind to me and sometimes gave me soup cooked by themselves. From time to time, I had no money to pay my rent, but they did not urge me for it, sometimes even lent me money. One of the occasions was a visit by a senior schoolmate from Fuzhou who was holding an art exhibition in Hong Kong. To demonstrate courtesy as a host, I borrowed HKD300 from the daughter of the landlady. The ten-year-old granddaughter of the landlady often encouraged me by saying, "You will definitely become a painter."

In 1985, on the recommendation of a fellow countryman, I started to create oil painting reproductions. This work gave me a lot of freedom, and all I needed to do was to nail two pieces of plywood on the wall and start to paint. However, I was not proficient in various techniques of oil painting reproductions, so I often went back to Fuzhou to seek advice from Mr. Chen Ting. At the same time, in order to spend more time to engage in artistic activities, I had to allocate fewer time in earning money, and was always hard for money.

I lived on the fourth floor of the tenement building. Below the floor was a music record store. From morning to night, all I heard was "*jiu gan tang mai wu*" [a very popular song in Hokkien, meaning "are there any empty wine bottles for sale?", the theme song of a film *da cuo che* (Papa, Can You Hear Me Sing?)] Across from my building was a bookstore, which was my spiritual habitat. Once, I saw a book of Guilin landscape photography and liked it very much, but I only had one hundred dollars in my pocket at the time. I tossed and turned, and couldn't sleep all night, so I went to buy the book early morning the next day. With the remaining thirty dollars, I had to eat the instant noodles for a week.

One day, a painting friend who lived in Tuen Mun called and invited me to his home for dinner. All I had was five dollars, just enough for a round trip by bus. However, I was

unable to change the five dollars into smaller denominations, and the bus did not set up a redemption. Finally, I had to use up five dollars for the bus fare, one way. Fortunately, sister of another friend, who worked in *Ta Kung Pao*, happened to receive HKD300 for the manuscript fee on my behalf. (At that time, I often submitted works to the *New Evening Post*, and I could get HKD150 for one work).

After getting married in 1987, my wife, Ng Ming Fan, came to Hong Kong and settled down. Without even a stiver, I borrowed HKD7,000 from a friend. I replaced the iron frame bed with a double bed, bought a fan and two buckets of white latex paint, and painted the walls. Simple as such, we started our life together.

The following year, we bought a double-story tin-sheeted house on the hillside of Tsuen Wan at HKD27,000 (the area was commonly known as the wooden house area, also known as the slum area). I borrowed the money from Mr. Lui, the owner of the export company that bought my oil paintings of commodities. He liked my Chinese paintings and collected a few. I was told that I did not need to settle the loan, but just gave him a few landscape paintings.

The new home, in the valley, was surrounded by woods and banana trees, lush in all seasons. Walk to a small stream, pass through a dozen tin huts, and you were there. Although the house was small and crude, many friends, from the cultural and art circles, visited here to sing and talk about life. The calligrapher Zheng Guangzhong visited Hong Kong from Fuzhou and wrote the *"lou shi ming (Epigraph on My Humble Abode)"* here as a gift to me.

In January 1989, my first son, Sha Chau was born here.

In 1989, I was admitted by the Chinese Painting Department of the Central Academy of Fine Arts. We sent our newborn son to Fuzhou to be taken care of by my mother, and my wife Ming Fan stayed in Hong Kong to work, so that I could concentrate on my study. No matter how hard life is, my wife, Ming Fan, has never shown any regrets, nor any remorse. She has always kept moving forward, and never retreated, but silently supported me.

In December 1990, my mentor Liu Mu, working at Research Institute of Traditional Chinese Painting (now the China National Academy of Painting), helped me to hold my first solo exhibition at the National Academy of Painting.

In early 1991, I returned to Hong Kong and held my first solo exhibition in a Hong Kong gallery. By then, the painting style and objects in my paintings had changed due to the transformation of artistic concepts. People who were familiar with my past landscape

paintings said that they did not understand my new style. A gallery owner said, "Your paintings are too bitter and astringent, and no one would want to pay for them to hang at home." Finally, there was not a single painting sold at the end of the exhibition.

At this time, I was dragging my heavy steps sadly, and felt like I had been falling into a muddy swamp. I was sitting right in front of the Tsuen Wan MTR Station, decadent, lost, and disappointed. I didn't know how to explain to my wife Ming Fan that I spent so much money to engage in art without any income for two years. However, my belief in art was firm!

During this period, a friend recommended me to be a part-time teacher at the First Institute of Art and Design. I made request to teach only half a month every month so as to have enough time to create. Thus, the income was barely enough to make ends meet.

In December of that year, President Sze Chi Ching helped me hold a solo exhibition at the Hong Kong Arts Centre. The opening ceremony was crowded with people. The invited guests for ribbon cutting included Zhang Junsheng, the then Vice President of Xinhua News Agency, Professor Liu Kuo Sung, President Chiu Sai Kwong, Mr. Cheng Kar Chun and President Sze Chi Ching. The works in this exhibition were mainly from the "Northern Shaanxi Series". Many audiences came to the exhibition many times, and more than a dozen works were collected, which boosted my confidence.

Since then, I went to Beijing annually and stayed for two months to study, maintain liaisons and create.

Beijing is the place where my art tree has been nourished; Hong Kong is the place where my horizons have been broadened.

In 1994, after more than two years of exploration, I created a group of works that I considered to be different. I held a personal exhibition at the Hong Kong Arts Centre again and published a collection of works. For this exhibition, I invited Professor Wan Qingli to write a preface for the album, and received the help of my friends Wong Sau Ching and Cheng Ka Kay. The exhibition was an unprecedented success.

The same year, my application for the public housing, after four-year waiting, was finally approved, and our daughter Sha Na was born.

My friend Cheng Ka Kay, a painter, lent me HKD50,000 to renovate the public housing in Kwai Fong Estate. I left the tin-sheeted house I lived in for seven years and started a new artistic exploration...

In 1997, I held a solo exhibition at the Hong Kong Arts Centre for the third time, with the theme of the scenery in the New Territories by using heavy ink colour, and published an album of paintings.

The poet Qin Lingxue is both a teacher and a friend. From time to time, he came to my humble house to listen to my story about the new work, and wrote preface to my album with leaving a check. In many subsequent solo exhibitions, he prepared prefaces upon my requests, and left a check for each exhibition. Since we met in 1989, his wisdom, chivalry and courage have always been a beacon in my dark night.

In 1997, another friend Choi Hoi Ying, a painter too, lent me his flat in Lei Yue Mun as a studio. I went there to draw every day, never missing a day. In 1999, my fourth solo exhibition "Scenes · Hong Kong" was held at the Hong Kong Arts Centre. Most of the works were completed in the Lei Yue Mun studio, especially the eight feet and twelve feet large works.

Although the scenery of Lei Yue Mun Studio was beautiful, it cannot be occupied for a long time. In December 1999, I found a place in a factory building near my residence (introduced in my essay "A Day in the Studio"), and the monthly rent was HKD5,000. I realised that I was penniless again after I signed the lease.

Finally, I got my own studio. I turned down all part-time teaching jobs in order to concentrate on creating, but it was difficult and unrealistic. Selling paintings for a living was difficult, and supporting a whole family was even more daunting. I had no choice but to start teaching in the studio in 2000, but only limited to three or four classes per week.

Many students have quietly reached out to help me when I was in difficulty and in need. For example, Tam Nga Man, she has followed me since 1994 and never gave up. Every exhibition is inseparable from her generous help. So is Chan Yin Hing who handles all internal and external affairs carefully for me. There are also Erica Sze, Sinley Lai, Amy Pang Lai Man, Ankana Livasiri, Jolene Ho, Reeni Oh, Wong Sau King, Ho Youn Tzen, Mrs. Mary Yeung and Alice Lee. My special thanks go to my students Ms. Ho Youn Tzen and Ms. Alice Lee for their valuable help with the English version of this book. Without them, the "art journey of Tian Xing" will be even more difficult.

Poet Ping'er interviewed me during my exhibition at the gallery twenty years ago. I was late and I said, "I'm sorry, I was drunk last night." With big smile and shining eyes, she said, "That's great!" We are now drinking buddies. Whenever I encounter difficulties on the artistic path, she has always stepped forward to support me. I can say without exaggeration that she is a women warrior.

Professor Cheng Pei Kai's wife, Professor Yan Xiu, is always proud of being from Fuzhou, which makes me, who was born and raised in Fuzhou, feel very cordial. Professor Cheng and Professor Yan like my paintings and have collected many works of mine. In 2013, they helped me hold the "Lotus·Tian Xing" solo exhibition at the Chinese Cultural Center of City University of Hong Kong. Coincidentally, it was my 50th birthday on the day of the opening ceremony. Since then, Professor Cheng has written prefaces to my collections for many times.

To write the preface for this book, President King Yeo Chi spent one year reading all the articles and paintings about me and understanding my artistic concept and life pursuit at each stage of my creation. All great scholars have done their research rigorously! He loves food more than wine. At the end of last year, we held a joint exhibition in Tsi Ku Chai. During the dinner party, we frequently raised our glasses and drank. Everyone danced with joy in a warm and exciting atmosphere. After the banquet, President King saw my unsteady footsteps, thus insisting on sending me home. When the car reached my home, he was still worried about me. An 87-year-old man helped a 58-year-old man going upstairs. After entering the house, he made sure that I was fine before leaving with assured ease.

In 1990, Dean Fan Di'an wrote a postscript to my "Northern Shaanxi Series" exhibition, which was published in the magazine *Cross-Strait* (a magazine promoting the understanding, communication and peace between the Mainland and Taiwan). For thirty years, Dean Fan has always been concerned about my artistic development, which can be seen from the preface to this book he wrote for me.

Director Tang Hoi Chiu has been concerned with my creations. In his preface to this book, he has conducted meticulous research on each stage of my art as well as all my works.

A year ago, Dr. Zhao Dongxiao told me that with the support of President Fu Weizhong of Sino United Publishing, Chung Hwa Book Company would publish a book about my art journey, and invite President King Yeo Chi to write a preface. Since then, we have had more opportunities to meet. To publish this book, Dr. Zhao has done in-depth research on my artistic life and made an overall plan. Each chapter of the book emphasises the connection between art and life and demonstrates academic pursuits. We held many meetings and had countless discussions with Ms. Hou Ming, the General Manager and the Editor-in-Chief of Chung Hwa, Dr. Gu Yu, the editor of this book and the Assistant Editor-in-Chief of Chung Hwa, and designer Mr. Chan Hei Shing. Everyone is giving their utmost best.

This book is finally released. I have to sincerely give my heartfelt thanks to all my friends who have always lent a helping hand and provided endless support for me! With your love and support, I will continue with my art journey.

# 作者簡介
## About the Author

**林天行於大也堂**
攝影：施秀菁
2022 年

**Lam Tian Xing at his studio "The Hall of Boundlessness"**

*Photo by Erica Sze*

2022

林天行，原名林仚，1963 年生於福州。1978 年始，先後拜吳國光、林光、陳挺、劉牧諸位先生為師，學習西洋畫和中國畫。1984 年移居香港。1989 年前往北京，就讀於中央美術學院中國畫系。

1981 年起，作品經常參加全國美術作品展、當代香港藝術雙年展、深圳國際水墨雙年展、百年中國畫展等重要展覽，及在世界各地參加過兩百多次聯展。曾在北京、香港、台灣、紐約、新加坡、柏林、首爾、米蘭、深圳等地舉辦六十多次個展。作品獲中國美術館、廣州美術館、深圳美術館、西藏美術館、香港藝術館、香港文化博物館以及世界各地許多機構和私人收藏。出版有《林天行畫集》《景象·香港》《天行之荷》《天行西藏》等三十多種畫集。

現為香港美協主席、中國美術家協會理事、中國文學藝術界聯合會全委會委員、中國美協香港會員分會主席、中國文聯香港會員總會常務副會長、香港國際藝術交流協會主席、四維彩墨顧問。

---

Lam Tian Xing, also known as Lam Sin, was born in 1963 in Fuzhou, Fujian Province. He began studying Western and Chinese paintings in 1978 and learnt from Mr. Wu Guoguang, Mr. Lin Guang, Mr. Chen Ting and Mr. Liu Mu. He moved to Hong Kong in 1984. In 1989, he returned to the Chinese Mainland to study at the Chinese Painting Department of the Central Academy of Fine Arts in Beijing.

Since 1981, he has participated in various exhibitions—China National Exhibition of Fine Arts, Contemporary Hong Kong Art Biennial Exhibition, The International Ink Art Biennial of Shenzhen, A Century of Chinese Painting Exhibition, etc. Lam has held over 60 solo exhibitions and participated in over 200 group exhibitions in different regions around the world such as China, Germany, Italy, Japan, Singapore, South Korea, United Kingdom and the United States. Lam's international experience has given him a broad artistic vision and brought global collectors. He has published more than 30 painting albums such as *Paintings of Lam Tian Xing, Scenes · Hong Kong, The Lotus of My Heart* and *Tibet—A Cosmovital Vision*.

Lam is currently the chairman of The Hong Kong Artists Association. He is also a committee member of China Artists Association, a committee member of China Federation of Literary and Art Circles (CFLAC), the chairman of China Artists Association Hong Kong Chapter, the executive vice chairman of CFLAC Hong Kong Member Association, the chairman of Hong Kong International Art Association and the consultant of The 4-D Art Club.

# 附錄一　林天行藝術年表

## Annex I Art Chronology of Lam Tian Xing

| 1963 | 出生 ｜ Birth |
|---|---|

原名林仚，號大也堂主。10 月 17 日出生於福建省福州市北面蓮花峰山下的村莊（晉安區新店西壠村）。父親林鴻昌，為中學中文教師，母親賴紅玉為小學中文教師。

童年始喜歡和大自然在一起，爬樹，抓魚，種花。往深山，聽飛禽走獸鳥聲，躺在松下巖石上看雲。

Lam Tian Xing, formerly known as Lam Sin, alias Master of The Hall of Boundlessness, is born on October 17th at a village under the Lotus Peak in the north of Fuzhou City, Fujian Province (Xilong Village, Xindian Town, Jin'an District). Father, Lam Hung Cheong, is a secondary school Chinese teacher, and his mother, Lai Hung Yuk, is a primary school Chinese teacher.

Since childhood, Tian Xing has liked being with nature, climbing trees, catching fish, and planting flowers. He has also liked going deep into the mountains, listening to the sounds of birds and beasts, lying on the rocks under the pine trees and watching the clouds.

| 1977 | 14 歲 ｜ 14 years old |
|---|---|

開始喜歡畫畫，臨摹《芥子園畫譜》等。

在母親學校見報刊上有一幅李可染的《千巖競秀 萬壑爭流》圖，為之感動。福建師範大學美術系畢業的二舅，贈給林天行一本《黃賓虹畫語錄》，令他從此迷上了中國畫，尤其山水畫，並立志此生做一個畫家。

Begins to like to draw and duplicates painting manuals such as *Painting Manual of Mustard Seed Garden*.

In mother's school, he sees Li Keran's "Magnificent Mountains with Gushy Cascades" and is deeply moved by it. His second uncle, a graduate from the Fine Arts Department of Fujian Normal University, gives him a copy of *Quotations of Huang Binhong*. Since then, Tian Xing has been fascinated by Chinese painting, especially landscape painting, and is determined to be a painter in life.

| 1978 | 15 歲 ｜ 15 years old |
|---|---|

4 月，父親攜天行拜吳國光先生學素描。先生畢業於福建師範大學美術系，時任福州第七中學美術教師（後為校長）。

In April, father takes him to learn sketches from Mr. Wu Guoguan who is a graduate of the Fine Arts Department of Fujian Normal University and a fine art teacher of Fuzhou No. 7 Secondary School (later the principal).

| 1979 | 16 歲 ｜ 16 years old |
|---|---|

父親移居香港。

4 月，父親託友人介紹，帶天行拜林光先生學中國畫。先生是福州畫院畫師，是年 71 歲。5 月先生帶天行去上海、杭州、黃山訪友寫生。12 月先生逝世。

Father moves to Hong Kong.

In April, father asks a friend to introduce Tian Xing to learn Chinese painting from Mr. Lin Guang, a 71-year-old painter of Fuzhou Fine Arts Academy. In May, Mr. Lin takes Tian Xing to Shanghai, Hangzhou and Mount Huangshan to visit friends and sketch. Mr. Lin passes away in December.

| | |
|---|---|
| **1980** | **17 歲 ｜ 17 years old** |
| | 5 月，師母（林光先生的夫人），攜天行拜陳挺先生學中國畫山水。先生也是福州畫院畫師，時年 70 歲。9 月先生帶天行去徐州、西安、洛陽、成都、峨嵋山、樂山、重慶、長江三峽、宜昌、武漢、桂林、廣州、汕頭、廈門，進行兩個月的旅行寫生。返榕城後開始創作。<br><br>In May, Mr. Lin Guang's wife takes Tian Xing to visit 70-year-old Mr. Chen Ting who is also a painter of Fuzhou Fine Arts Academy, to learn Chinese landscape painting. In September, Mr. Chen Ting takes Tian Xing to Xuzhou, Xi'an, Luoyang, Chengdu, Mount Emei, Leshan, Chongqing, the Three Gorges of the Yangtze River, Yichang, Wuhan, Guilin, Guangzhou, Shantou and Xiamen for a two-month sketching trip. After returning to the Banyan City (Fuzhou), Tian Xing starts to paint. |
| **1981** | **18 歲 ｜ 18 years old** |
| 入選<br>Works<br>Selected | 「福建省美術作品展」，福建省美術館，中國福州<br>"Fujian Provincial Art Exhibition", Fujian Provincial Art Museum, Fuzhou, China<br>「僑鄉風光畫展」，福建省美術館，中國福州<br>"Exhibition of Landscape of Overseas Chinese Hometown", Fujian Provincial Art Museum, Fuzhou, China |
| **1982** | **19 歲 ｜ 19 years old** |
| 入選<br>Works<br>Selected | 「新苗畫展」，福州市美術館，中國福州<br>"Youth Painting Exhibition", Fuzhou Art Museum, Fuzhou, China |
| **1983** | **20 歲 ｜ 20 years old** |
| 入選<br>Works<br>Selected | 山水畫入選「榕城之春──福州市美術作品展」，福州市美術館，中國福州<br>Landscape painting is selected into "Spring in the City of Banyans — Fuzhou Art Works Exhibition", Fuzhou Art Museum, Fuzhou, China |
| 加入<br>Joining | 福州市美協<br>Fuzhou Artists Association |
| 遊歷<br>Travels | 9 月去山東棗莊、濟南、泰山。<br>In September, goes to Zaozhuang, Ji'nan and Mount Tai of Shandong province. |
| **1984** | **21 歲 ｜ 21 years old** |
| | 移居香港。當了半年絲花廠工人；跟貨車搬紙皮箱兩個月；電鍍廠做了一個月；任貨倉倉務員兩個月。<br>Moves to Hong Kong. Works in a silk flower factory for half a year; moves cardboard boxes with a truck for two months; works in an electroplating factory for one month and works as a warehouse clerk for two months. |
| **1985** | **22 歲 ｜ 22 years old** |
| 加入<br>Joining | 開始藝術家的職業生涯。加入香港美術研究會（會長趙世光）、香港美術會（會長丁志仁）、華人現代藝術研究會（會長陳福善）。<br>Starts professional career as an artist. Joins the Hong Kong Art Researching Association (President Chiu Sai Kwong), the Hong Kong Art Club (President Ting Chih Jen), and the Chinese Contemporary Artists' Guild (President Luis Chan). |
| 參展<br>Exhibition | 「香港美術研究會年展」（多屆），香港大會堂，中國香港<br>"Hong Kong Art Researching Association Annual Exhibition" (multiple sessions), Hong Kong City Hall, Hong Kong, China |

| | |
|---|---|
| **1986** | **23 歲 ｜ 23 years old** |
| 參展<br>Exhibition | 「香港美術會年展」（多屆），香港大會堂，中國香港<br>"The Hong Kong Art Club Annual Exhibition" (multiple sessions), Hong Kong City Hall, Hong Kong, China<br>「華人現代藝術研究會年展」（多屆），香港大會堂，中國香港<br>"The Chinese Contemporary Artists' Guild Annual Exhibition" (multiple sessions), Hong Kong City Hall, Hong Kong, China |
| **1987** | **24 歲 ｜ 24 years old** |
| 入選<br>Works<br>Selected | 《黃海煙雲》，「當代香港藝術雙年展」，中國香港<br>"Sea of Clouds of Mount Huangshan", Contemporary Hong Kong Art Biennial Exhibition, Hong Kong, China |
| 參展<br>Exhibition | 「香港美術家作品聯展」，中國香港、武漢、福州（香港中華文化促進中心主辦）<br>"Joint Exhibition of Hong Kong Artists", Hong Kong, Wuhan and Fuzhou, China (organised by the Hong Kong Institute for Promotion of Chinese Culture) |
| 獎項<br>Awards | 「香港青年繪畫比賽」冠軍，中國香港<br>Champion of "Hong Kong Youth Painting Competition", Hong Kong, China |
| 寫生<br>Sketch<br>Trips | 武夷山，中國<br>Mount Wuyi, China |
| | 與吳明芬旅行結婚，到北京、南京、蘇州、上海、杭州一個月。期間拜訪北京畫院多位畫家。明芬來港定居。<br>Marries Ng Ming Fan. Planning a destination wedding, travels to Beijing, Nanjing, Suzhou, Shanghai and Hangzhou for a month, and visits many painters in the Beijing Fine Art Academy with Ming Fan.<br>Ming Fan moves to Hong Kong. |
| **1988** | **25 歲 ｜ 25 years old** |
| 參展<br>Exhibition | 「香港畫家作品巡迴展」，中國澳門、汕頭、深圳<br>"Touring Exhibition of Hong Kong Artists' Works", Macao, Shantou and Shenzhen, China<br>「第廿三屆蒙地卡羅當代藝術國際比賽」，摩納哥國家博物館，摩納哥<br>"The XXIII International Prix of Contemporary Art of Monte Carlo", National Museum of Monaco, Monaco<br>「藝術化生活」公開展覽，香港藝術中心，中國香港<br>"Living with Art" Open Exhibition, Hong Kong Arts Centre, Hong Kong, China |
| 慈善<br>Charity | 「賑濟東北大火義賣」，香港藝廊，中國香港<br>"Fund Raising Exhibition for the Dongbei Fire", Hong Kong Art Gallery, Hong Kong, China |
| 加入<br>Joining | 香港福建書畫研究會（為創會理事，會長施子清，副會長秦嶺雪）<br>Calligraphy and Painting Study Association of Hong Kong Fukienese (Founding Director; President Sze Chi Ching, Vice President Qin Lingxue) |

| | |
|---|---|
| **1989** | **26 歲 ｜ 26 years old** |

兒子沙洲在香港出生。

5 月赴北京中央美術學院中國畫系山水畫工作室進修。導師有黃潤華、李行簡、張憑、賈又福、韓國臻、盧沉、周思聰、王鏞、劉金貴等。是年中央美院寫生課，與同學于躍一起到太行山寫生。

經于躍引薦，拜劉牧先生為師。期間經常往北京畫院、中國畫研究院（現中國國家畫院）、中央工藝美術學院拜訪畫家學習。

Son, Sha Chau, is born in Hong Kong.

In May, goes to the Landscape Painting Studio of the Chinese Painting Department of the Central Academy of Fine Arts (CAFA) in Beijing for further study. Mentors include Huang Runhua, Li Xingjian, Zhang Ping, Jia Youfu, Han Guozhen, Lu Chen, Zhou Sicong, Wang Yong, Liu Jingui, etc. To complete the sketching class at CAFA, goes to Taihang Mountains to sketch with classmate Yu Yue.

Becomes the student of Mr. Liu Mu on Yu Yue's recommendation. Often visits painters at the Beijing Fine Art Academy, Research Institute of Traditional Chinese Painting (now the China National Academy of Painting), and the Central Academy of Arts and Design.

---

| | |
|---|---|
| 參展<br>Exhibition and<br>Works Collected | 「海會雲來——名家書畫展」慶祝大嶼山天壇大佛建成，香港大會堂，中國香港；寶蓮禪寺收藏<br>"Hai Hui Yun Lai — Eminent Calligraphy and Painting Exhibition" celebrating the completion of the Big Buddha in Lantau Island, Hong Kong City Hall, Hong Kong, China; collected by Po Lin Monastery<br>「香港福建書畫研究會年展」（歷屆），中國香港<br>"Calligraphy and Painting Study Association of Hong Kong Fukienese Annual Exhibition" (all sessions), Hong Kong, China |

---

| | |
|---|---|
| 加入<br>Joining | 福建省美術家協會<br>Fujian Artists Association |

---

| | |
|---|---|
| **1990** | **27 歲 ｜ 27 years old** |

在李行簡教授帶領下往湖南寫生（中央美院每年寫生課），到長沙、大庸、張家界、衡山、黃村等地。

結束中央美院一年的進修課程。

Under the supervision of Professor Li Xingjian, goes to Hunan to sketch (annual sketching class at CAFA), travelling Changsha, Dayong, Zhangjiajie, Hengshan, Huangcun and other places.

Finishes the one-year refresher course at CAFA.

---

| | |
|---|---|
| 首次<br>個展<br>First<br>Solo Exhibition | 12 月舉辦林天行首次個人畫展——「陝北系列」，中國北京，中國畫研究院畫廊主辦。<br>展出四十五幅作品。前來觀展的有張仃、鄒佩珠（李可染夫人）、劉勃舒、郎紹君、邵大箴、薛永年、杜大愷、袁運甫、李行簡、黃潤華、賈又福、王明明、王鏞、趙成民、劉牧、劉慶和、盧沉、周思聰、聶鷗、王迎春、楊力舟、龍瑞、鄧林、趙衛、楊剛、王文芳、張仁芝、張進、李曉琳、盧平、紀清遠、畢建勳、龔文楨、李錫田、杜杰、石晶、于躍、齊艷卿、魏冰、洪浩等畫壇師友。院長劉勃舒主持閉幕禮晚宴（邀請五十多位北京畫壇名家）。<br>In December, holds Lam Tian Xing's first solo exhibition "Northern Shaanxi Series" which is hosted by Research Institute of Traditional Chinese Painting in Beijing.<br>45 works are exhibited. Visitors to the exhibition include Zhang Ding, Zou Peizhu (wife of Mr. Li Keran), Liu Boshu, Lang Shaojun, Shao Dazhen, Xue Yongnian, Du Dakai, Yuan Yunfu, Li Xingjian, Huang Runhua, Jia Youfu, Wang Mingming, Wang Yong, Zhao Chengmin, Liu Mu, Liu Qinghe, Lu Chen , Zhou Sicong, Nie Ou, Wang Yingchun, Yang Lizhou, Long Rui, Deng Lin, Zhao Wei, Yang Gang, Wang Wenfang, Zhang Renzhi, Zhang Jin, Li Xiaolin, Lu Ping, Ji Qingyuan, Bi Jianxun, Gong Wenzhen, Li Xitian, Du Jie, Shi Jing, Yu Yue, Qi Yanqing, Wei Bing, Hong Hao, and other teachers and friends. Dean Liu Boshu presides at the closing ceremony dinner (more than 50 eminent painters in Beijing are invited). |

| | |
|---|---|
| 參展<br>Exhibition | 「福建藝術節名家作品邀請展」，福建省美術館，中國福州<br>"Fujian Art Festival Invitational Exhibition by Eminent Artists", Fujian Provincial Art Museum, Fuzhou, China |
| 收藏<br>Works<br>Collected | 「陝北系列」兩幅，中國畫研究院，中國北京<br>Two works in "Northern Shaanxi Series", Research Institute of Traditional Chinese Painting, Beijing, China |
| 寫生<br>Sketch<br>Trips | 9月與于躍、杜杰、許恩琦往陝北寫生，到榆林、米脂、綏德、神木、府谷、保德、大同等地，歷時一個月。<br>In September, along with Yu Yue, Du Jie and Hui Yan Ki, goes to Shanbei (Northern Shaanxi) to sketch for a month, travelling Yulin, Mizhi, Suide, Shenmu, Fugu, Baode and Datong. |

## 1991　28 歲 ｜ 28 years old

| | |
|---|---|
| 個展<br>Solo Exhibition | 「林天行畫展」，香港藝術中心，中國香港（中國畫研究院、香港福建書畫研究會主辦）<br>"Lam Tian Xing Painting Exhibition", Hong Kong Arts Centre, Hong Kong, China (jointly organised by Research Institute of Traditional Chinese Painting, and Calligraphy and Painting Study Association of Hong Kong Fukienese) |
| 應邀<br>Activities by<br>Invitation | 中國畫研究院駐院藝術家一個月，中國北京<br>Artist-in-Residence of Research Institute of Traditional Chinese Painting for a month, Beijing, China |
| 收藏<br>Works<br>Collected | 中國畫研究院，中國北京<br>Research Institute of Traditional Chinese Painting, Beijing, China<br>香港樹仁大學，中國香港<br>Hong Kong Shue Yan University, Hong Kong, China |
| 教學<br>Teaching | 擔任香港大一藝術設計學院導師，直至 1998 年。期間曾隨校去馬來西亞、新加坡、菲律賓，以及西安、泰山、濟南、孔廟、青島、長沙等地觀光交流。<br>Part-time teacher at the First Institute of Art and Design, Hong Kong until 1998. During the period, participates in the sightseeing and exchange programme of the Institute to Malaysia, Singapore, the Philippines, Xi'an, Mount Tai, Ji'nan, Temple and Cemetery of Confucius, Qingdao, Changsha, etc. |
| 遊歷<br>Travels | 赴北京創作訪友兩個月。<br>Visits friends and creates in Beijing for two months. |

## 1992　29 歲 ｜ 29 years old

| | |
|---|---|
| 入選<br>Works<br>Selected | 「當代香港藝術雙年展」，香港藝術館，中國香港<br>"Contemporary Hong Kong Art Biennial Exhibition", Hong Kong Museum of Art, Hong Kong, China |
| 參展<br>Exhibition | 「香港現代水墨畫聯展」，香港大會堂，中國香港<br>"Joint Exhibition of Hong Kong Modern Chinese Ink Painting", Hong Kong City Hall, Hong Kong, China<br>「香港國際水墨畫作品巡迴展」，中國北京、加拿大、中國台灣<br>"Hong Kong International Ink Painting Works Touring Exhibition", Beijing, China; Canada; Taiwan, China<br>「熱心教育之藝術家作品展」，香港西港城藝盟畫廊，中國香港<br>"Enthusiastic in Education: Artists' Works Exhibition", Hong Kong Artists Guild Gallery, Western Market, Hong Kong, China |
| 遊歷<br>Travels | 赴北京創作訪友兩個月。<br>Visits friends and creates in Beijing for two months. |

| | |
|---|---|
| **1993** | **30 歲 ｜ 30 years old** |
| 參展<br>Exhibition | 「亞細亞美術招待展」，韓國首爾<br>"Asia Invitation Art Exhibition in Seoul", Seoul, Korea<br>「當代中國畫名家邀請展」，利馬國家博物館，祕魯利馬<br>"Contemporary Chinese Painting Masters Invitational Exhibition", National Museum of Lima, Peru<br>「香港福建書畫研究會邀請展」，上海美術館，中國上海<br>"Calligraphy and Painting Study Association of Hong Kong Fukienese Invitational Exhibition", Shanghai Art Museum<br>(now the China Art Museum), Shanghai, China |
| 遊歷<br>Travels | 赴北京創作訪友兩個月。<br>Visits friends and creates in Beijing for two months. |
| **1994** | **31 歲 ｜ 31 years old**<br>女兒莎娜在香港出生。<br>Daughter, Sha Na, is born in Hong Kong. |
| 個展<br>Solo Exhibition | 「林天行畫展」，香港藝術中心，中國香港（中國畫研究院、香港福建書畫研究會主辦）<br>"Recent Paintings by Lam Tian Xing", Hong Kong Arts Centre, Hong Kong, China (jointly organised by Research<br>Institute of Traditional Chinese Painting, and Calligraphy and Painting Study Association of Hong Kong Fukienese)<br>「林天行」，香港藝穗會，中國香港<br>"Lam Tian Xing", the Hong Kong Fringe Club, Hong Kong, China |
| 入選<br>Works<br>Selected | 「當代香港藝術雙年展」，香港藝術館，中國香港<br>"Contemporary Hong Kong Art Biennial Exhibition", Hong Kong Museum of Art, Hong Kong, China |
| 參展<br>Exhibition | 「香港美術家協會成立典禮暨現代水墨畫展」，香港中華文化促進中心，中國香港<br>"Inauguration Ceremony of the Hong Kong Artist Association cum Modern Ink Painting Exhibition", Hong Kong<br>Institute for Promotion of Chinese Culture, Hong Kong, China<br>「香港福建書畫研究會邀請展」，福建省畫院、泉州博物館、廈門圖書館，中國福建<br>"Calligraphy and Painting Study Association of Hong Kong Fukienese Invitational Exhibition", Fujian Painting<br>Academy, Quanzhou Museum, Xiamen Municipal Library, Fujian, China |
| 獎項<br>Awards | 「楓葉獎 1994 國際水墨大賽」銅獎，中國北京、加拿大<br>Bronze Award, "International Wash-And-Ink Arts Exhibition 1994 Maple Leaf Award", Beijing, China and Canada |
| 收藏<br>Works<br>Collected | 香港藝術館（作品《秋天的話》長期於禮賓府展示），中國香港<br>Hong Kong Museum of Art ("Words of Autumn" has been displayed at Government House), Hong Kong, China |
| 出版<br>Publication | 《林天行畫集》，收藏家畫軒，中國香港<br>*Paintings of Lam Tian Xing*, Art House of Collectors, Hong Kong, China |
| 慈善<br>Charity | 「希望工程作品義展」，香港文化中心，中國香港<br>"Project Hope Exhibition", Hong Kong Cultural Centre, Hong Kong, China |
| **1995** | **32 歲 ｜ 32 years old** |
| 入選<br>Works<br>Selected | 「香港現代繪畫展」，福岡市美術館，日本福岡<br>"Contemporary Hong Kong Painting", Fukuoka Art Museum, Fukuoka, Japan |

| | |
|---|---|
| 入編<br>Works in<br>Compilation | 《當代山水・花鳥畫家創意手稿》，江西美術出版社，中國南昌<br>*Creative Manuscripts of Contemporary Landscape, Flower and Bird Painters*, Jiangxi Meishu Chubanshe, Nanchang, China |

## 1996　　33 歲 ｜ 33 years old

| | |
|---|---|
| 個展<br>Solo Exhibition | 「林天行新作展」，香港富豪機場酒店畫廊，中國香港<br>"Lam Tian Xing's New Works Exhibition", Gallery of Hong Kong Regal Airport Hotel, Hong Kong, China |
| 入選<br>Programme<br>Selected | 「藝術家留駐計劃」，香港市政局。進駐香港視覺藝術中心三個月，創作及舉辦兩場講座。<br>"Artist-in-Residency Programme", Hong Kong Urban Council. Resides in Hong Kong Visual Arts Centre for three months to create and hold two lectures. |
| 參展<br>Exhibition | 「廣州國際藝術博覽會——山水特別邀請展」，中國廣州<br>"Guangzhou International Art Fair — Special Invitational Exhibition for Landscape Painting ", Guangzhou, China<br>「國際美術交流展」，高雄文化中心，中國台灣<br>"International Art Exchange Exhibition", Kaohsiung Cultural Center, Taiwan, China |
| 出版<br>Publication | 《林天行畫集》，大也堂，中國香港（香港藝術發展局資助）<br>*Paintings of Lam Tian Xing*, The Hall of Boundlessness, Hong Kong, China (funded by Hong Kong Arts Development Council) |
| 慈善<br>Charity | 「水墨行動——為唐氏綜合症協會義賣畫展」，香港大會堂，中國香港<br>"Ink Movement — Art Exhibition for Down Syndrome Association Charity Sale", Hong Kong City Hall, Hong Kong, China |
| 遊歷<br>Travels | 赴北京創作訪友兩個月。<br>Visits friends and creates in Beijing for two months. |

## 1997　　34 歲 ｜ 34 years old

| | |
|---|---|
| 個展<br>Solo Exhibition | 「林天行畫展」，香港藝術中心，中國香港（香港藝術發展局資助）<br>"Lam Tian Xing Painting Exhibition", Hong Kong Arts Centre, Hong Kong, China (funded by Hong Kong Arts Development Council) |
| 參展<br>Exhibition | 「1997 國際藝術家邀請展」，三行畫廊，中國香港<br>"1997 Trigram Choice of International Artists", Trigram Gallery, Hong Kong, China<br>「全國中青年畫家中國畫邀請展」，廣州美術館，中國廣州<br>"National Invitational Exhibition of Chinese Paintings by Young and Middle-aged Painters", Guangzhou Museum of Art, Guangzhou, China<br>「當代山水印象：1997 著名中青年山水畫家邀請展」，中國美術館，中國北京 （中國美術館、中央美術學院學術研究部、中國畫研究院主辦）<br>參展畫家有林天行、盧禹舜、姚鳴京、何加林、林海鐘、林容生、朱道平、許俊、胡應康、曾先國、李東偉、劉文潔、崔曉東、趙衛、壽覺生。<br>"Contemporary Landscape Impression: 1997 Invitational Exhibition of Selected-age-group of Famous Landscape Painters", National Art Museum of China, Beijing, China (jointly organised by National Art Museum of China, Academic Research Department of the CAFA, and Research Institute of Traditional Chinese Painting)<br>The participating artists include Lam Tian Xing, Lu Yushun, Yao Mingjing, He Jialin, Lin Haizhong, Lin Rongsheng, Zhu Daoping, Xu Jun, Hu Yingkang, Zeng Xianguo, Li Dongwei, Liu Wenjie, Cui Xiaodong, Zhao Wei and Shou Juesheng. |

| | |
|---|---|
| 參展<br>Exhibition | 「回歸與展望:當代香港藝術 1997」,香港藝術館,中國香港<br>"Reunion and Vision: Contemporary Hong Kong Art 1997", Hong Kong Museum of Art, Hong Kong, China<br>「全國首屆中國畫邀請展 '97」,中國美術館、何香凝美術館,中國北京、深圳(中國美術家協會主辦)<br>"The First Invitation Exhibition of Chinese Painting 1997", National Art Museum of China, Beijing, China;<br>He Xiangning Art Museum, Shenzhen, China (organised by the China Artists Association)<br>「中國當代名家作品珠海邀請展」,中國珠海(珠海文聯、珠海美協主辦)<br>"Zhuhai Invitational Exhibition of Chinese Contemporary Famous Artists", Zhuhai, China (jointly organised by Zhuhai Federation of Literary and Art Circles, and Zhuhai Artists Association) |
| 收藏<br>Works<br>Collected | 中國美術館,中國北京<br>National Art Museum of China, Beijing, China<br>廣州美術館,中國廣州<br>Guangzhou Museum of Art, Guangzhou, China |
| 慈善<br>Charity | 「用行動與憧憬建設未來——慈善畫展」,香港大會堂,中國香港<br>"Charity Art Exhibition: Build the Future with Action and Vision", Hong Kong City Hall, Hong Kong, China |
| **1998** | **35 歲 │ 35 years old** |
| 個展<br>Solo Exhibition | 「林天行作品展」,香港富豪九龍酒店畫廊,中國香港<br>"Lam Tian Xing's Works Exhibition", Gallery of Hong Kong Regal Kowloon Hotel, Hong Kong, China |
| 參展<br>Exhibition | 「當代山水展:著名山水畫家 '98 邀請展」,深圳美術館,中國深圳<br>參展畫家有林天行、姚鳴京、崔曉東、張捷、何加林、林容生、許俊、胡應康、曾先國、王金石。<br>"Contemporary Landscape Exhibition: 1998 Invitational Exhibition of Famous Landscape Painters", Shenzhen Art Museum, Shenzhen, China<br>The participating artists include Lam Tian Xing, Yao Mingjing, Cui Xiaodong, Zhang Jie, He Jialin, Lin Rongsheng, Xu Jun, Hu Yingkang, Zeng Xianguo and Wang Jinshi.<br>「第一屆深圳國際水墨畫雙年展」,關山月美術館,中國深圳<br>"The First International Ink Painting Biennial of Shenzhen", Guan Shanyue Art Museum, Shenzhen, China<br>「'98 中國國際美術年:當代中國山水畫・油畫風景展」,中國美術館,中國北京;上海美術館,中國上海;廣東美術館,中國廣州<br>"'98 China Year of International Fine Arts: Contemporary Chinese Traditional and Oil Landscape Painting Exhibition", National Art Museum of China, Beijing, China; Shanghai Art Museum, Shanghai, China; Guangdong Art Museum, Guangzhou, China |
| 收藏<br>Works<br>Collected | 香港文化博物館,中國香港<br>Hong Kong Heritage Museum, Hong Kong, China<br>國泰航空公司,中國香港<br>Cathay Pacific Airways, Hong Kong, China |
| 創立<br>Founding | 香港國際藝術交流協會<br>Hong Kong International Art Association |
| 遊歷<br>Travels | 參加歐洲藝術考察團,在倫敦、馬德里、巴塞隆拿、畢爾包鄂、意大利等地飽覽各大美術博物館。<br>Participates in European art delegation and visits major art museums in London, Madrid, Barcelona, Bilbao, Italy and other places. |
| **1999** | **36 歲 │ 36 years old**<br>成立林天行工作室。<br>Establishes Lam Tian Xing Studio. |

| | |
|---|---|
| 個展<br>Solo Exhibition | 「景象‧香港——林天行畫展」，香港藝術中心，中國香港（香港國際藝術交流協會、香港三行畫廊主辦，香港藝術發展局資助）<br>"Scenes‧Hong Kong‧Lam Tian Xing Paintings", Hong Kong Arts Centre, Hong Kong, China (jointly organised by Hong Kong International Art Association and Trigram Gallery, Hong Kong; funded by Hong Kong Arts Development Council)<br>慧畫廊，新加坡<br>Wai Gallery, Singapore |
| 策展<br>Curation | 「香港當代中青年畫家代表作展」，香港藝術中心，中國香港<br>"Exhibition of Works by Contemporary Hong Kong Artists", Hong Kong Arts Centre, Hong Kong, China |
| 入選<br>Works<br>Selected | 「第九屆全國美術作品展」，中國美術館，中國北京<br>"The 9th National Exhibition of Fine Arts, China", National Art Museum of China, Beijing, China |
| 收藏<br>Works<br>Collected | 深圳美術館，中國深圳<br>Shenzhen Art Museum, Shenzhen, China<br>瑞士信貸銀行，中國香港<br>Credit Suisse Bank, Hong Kong, China |
| 出版<br>Publication | 《林天行——景象‧香港》，大也堂，中國香港（香港藝術發展局資助）<br>*Scenes‧Hong Kong‧Lam Tian Xing*, The Hall of Boundlessness, Hong Kong, China (funded by Hong Kong Arts Development Council) |
| 寫生<br>Sketch<br>Trips | 與王守清、楊百友赴西藏、敦煌、蘭州寫生，因感冒到拉薩遇高山症頭痛欲裂，返港後與病魔搏鬥三年。<br>Travels to Tibet, Dunhuang and Lanzhou with Wong Sau Ching and Yeung Pak Yau to sketch, suffering from altitude sickness and splitting headache in Lhasa due to a cold. The sequelae lasted for three years after returning to Hong Kong. |

## 2000　　37 歲 ｜ 37 years old

| | |
|---|---|
| 個展<br>Solo Exhibition | 「美國紐約國際藝術博覽會」，美國曼克頓<br>"Artexpo New York", Manhattan, USA<br>燕譽堂，中國香港<br>Oi Ling Antiques, Hong Kong, China |
| 參展<br>Exhibition | 「香港視藝新里程」，交易廣場，中國香港<br>"Hong Kong — New Vision", Exchange Square, Hong Kong, China<br>「第六屆中國藝術節——國際中國畫大展」，劉海粟美術館，中國常州<br>"The 6th session of the Chinese Art Festival — International Chinese Painting Exhibition", Liu Haisu Art Museum, Changzhou, China<br>「美術文獻展」，湖北美術館，中國武漢（湖北美術館、湖北美術出版社主辦）<br>"Documentary Exhibition of Fine Arts", Hubei Museum of Art, Wuhan, China (jointly organised by Hubei Museum of Art and Hubei Meishu Chubanshe)<br>乙城節 2001「藍人本色——藍亦藍之當代藝術版展覽」，香港大會堂，中國香港<br>"Blue is Blue — A Contemporary Art Interpretation Exhibition", City Festival 2001, Hong Kong City Hall, Hong Kong, China<br>「第二屆深圳國際水墨畫雙年展：水墨與都市」，關山月美術館，中國深圳<br>"The 2nd International Ink Painting Biennial of Shenzhen: Ink Painting and Metropolis", Guan Shanyue Art Museum, Shenzhen, China |

| | |
|---|---|
| 參展<br>Exhibition | 「走出西藏」三人展，香港藝穗會，中國香港（香港國際藝術交流協會主辦）<br>"Twilight Journey — Tibet" Trio-Exhibition, Hong Kong Fringe Club, Hong Kong, China (organised by the Hong Kong International Art Association)<br>「當代香港國際藝術展」，三行畫廊，中國香港<br>"Contemporary Hong Kong International Art Exhibition", Trigram Gallery, Hong Kong, China<br>「畫中認同——香港特別行政區政府海外藝術收藏品」，香港會議展覽中心，中國香港<br>"2000 Identities: Art in Hong Kong SAR Government Collections Abroad", Hong Kong Convention and Exhibition Centre, Hong Kong, China |
| 收藏<br>Works<br>Collected | 「景象系列」六幅作品，香港藝術館，中國香港<br>Six works from the "Scenes Series", Hong Kong Museum of Art, Hong Kong, China |
| 出版<br>Publication | 《當代中國畫家畫風——自敘》，河南美術出版社，中國鄭州<br>*The Painting Style of Contemporary Chinese Painters — Self-narrative*, Henan Meishu Chubanshe, Zhengzhou, China |

## 2001    38 歲 ｜ 38 years old

| | |
|---|---|
| 個展<br>Solo Exhibition | 「都市山水」，現代畫廊，中國台灣<br>"Cityscapes", Modern Art Gallery, Taiwan, China<br>慧畫廊，新加坡<br>Wai Gallery, Singapore |
| 入選<br>Works<br>Selected | 《林中煙雲》，「當代香港藝術雙年展」，香港藝術館，中國香港<br>"Mist in the Woods", "Contemporary Hong Kong Art Biennial Exhibition", Hong Kong Museum of Art, Hong Kong, China<br>《新界晴雨》，「百年中國畫展」，中國美術館，中國北京，並獲收藏<br>"Sunny Rain in New Territories" (collected), "20th Century Traditional Chinese Painting Exhibition", National Art Museum of China, Beijing<br>「香港之墨」，日本東京、新宿巡展<br>"Ink Painting of Hong Kong", Touring Exhibition in Tokyo and Shinjuku, Japan<br>「國際中國畫年展」，大連星海國際會展中心，中國大連<br>"International Chinese Painting Annual Exhibition", Dalian Xinghai Convention & Exhibition Center, Dalian, China<br>「中國當代美術家作品展」，上海金茂大廈，中國上海<br>"A Collection of Contemporary Chinese Artists", Jinmao Tower, Shanghai, China |
| 應邀<br>Activities by<br>Invitation | 首次應邀赴景德鎮畫瓷，同行有方俊、朱道平、陳綬祥、丁觀加、梅墨生、顧維潔、老費。<br>Paints porcelain in Jingdezhen by invitation for the first time, with Fang Jun, Zhu Daoping, Chen Shouxiang, Ding Guanjia, Mei Mosheng, Gu Weijie and Lao Fei. |
| 參展<br>Exhibition | 「兩岸三地藝術家工作室文件與作品展」，光華新聞文化中心，中國香港<br>"Exhibition of Manuscripts and Works from Art Studio in Mainland, Taiwan and Hong Kong", Kwang Hwa Information & Culture Center, Hong Kong, China<br>「藝述香江」，香港藝術館，中國香港<br>"Hong Kong: Artists' Vision", Hong Kong Museum of Art, Hong Kong, China<br>「0 畫派現代中國畫展」，山東美術館，中國濟南<br>"0 School Modern Chinese Painting Exhibition", Shandong Art Museum, Ji'nan, China |

| | |
|---|---|
| 出版<br>Publication | 《相遇》，現代畫廊，中國台灣<br>*Encounter*, Modern Art Gallery, Taiwan, China |
| **2002** | **39 歲 ｜ 39 years old** |
| 個展<br>Solo Exhibition | 「閃亮的西藏」，可創銘佳藝苑，中國北京<br>"Shining Tibet", Creation Art Gallery, Beijing, China |
| 入選<br>Works<br>Selected | 「第三屆深圳國際水墨雙年展」，關山月美術館，中國深圳<br>"The 3rd International Ink Painting Biennial of Shenzhen", Guan Shanyue Art Museum, Shenzhen, China<br>「首屆福建美術邀請展：全國閩籍當代藝術家作品展」，福建博物院，中國福州<br>"The 1st Fujian Fine Arts Invitational Exhibition: National Fujianese Contemporary Artists Exhibition", Fujian Museum, Fuzhou, China<br>「香港風情 · 水墨變奏」，倫敦大學，英國倫敦；香港藝術館，中國香港<br>"Hong Kong Cityscapes: Ink Painting in Transition", University of London, London, United Kingdom; Hong Kong Museum of Art, Hong Kong, China<br>「第一選擇：香港現代繪畫雕塑藝術展」，光華新聞文化中心，中國香港<br>"First Choice: An Exhibition of Painting and Sculpture by Contemporary Hong Kong Artists", Kwang Hua Information and Culture Center, Hong Kong, China |
| 參展<br>Exhibition | 「水墨解構」，香港文化中心，中國香港<br>"Anatomy of Ink Paintings", Hong Kong Cultural Centre, Hong Kong, China<br>「當代『水墨六家』：姚鳴京、朱雅梅、林容生、崔海、胡應康、林天行」，中國煙台<br>"Contemporary 'Ink Paintings of Six Painters' Exhibition: Yao Mingjing, Zhu Yamei, Lin Rongsheng, Cui Hai, Hu Yingkang, Lam Tian Xing", Yantai, China<br>「香港藝術雙年展外望」，香港文化中心，中國香港（三行畫廊主辦）<br>"In & Out of the Hong Kong Art Biennial", Hong Kong Cultural Centre, Hong Kong, China (organised by Trigram Gallery) |
| 收藏<br>Works<br>Collected | 中國美術館，中國北京<br>National Art Museum of China, Beijing, China<br>南京大學，中國南京<br>Nanjing University, Nanjing, China |
| 入編<br>Works in<br>Compilation | 《當代中國畫庫—山水卷》，河南美術出版社，中國鄭州<br>*Contemporary Chinese Painting Library — Volume of Landscape*, Henan Meishu Chubanshe, Zhengzhou, China |
| 出版<br>Publication | 《關注林天行——當代中國山水畫新篇章》，河北教育出版社，中國石家莊<br>*Concerning Lam Tian Xin: A New Generation of Contemporary Chinese Landscape Painting*, Hebei Jiaoyu Chubanshe, Shijiazhuang, China<br>《閃亮的西藏》，可創銘佳藝苑，中國北京；香港國際藝術交流協會，中國香港<br>*Shining Tibet*, Creation Art Gallery, Beijing, China; Hong Kong International Arts Association, Hong Kong, China |
| 創立<br>Founding | 與學生談雅文創辦「四維彩墨」畫會（會員均為大也堂學員）。<br>Establishes "The 4-D Art Club" painting group with student Tam Nga Man (All members are students of The Hall of Boundlessness). |
| 遊歷<br>Travels | 赴北京訪友兩個月。<br>Visits friends in Beijing for two months. |

| | |
|---|---|
| **2003** | **40 歲　\|　40 years old** |
| 個展<br>Solo Exhibition | 慧畫廊，新加坡<br>Wai Gallery, Singapore |
| 策展<br>Curation | 「四維彩墨展」林天行師生展，香港大會堂，中國香港<br>"The Ink Dimensions" by Lam Tian Xing and Students, Hong Kong City Hall, Hong Kong, China |
| 參展<br>Exhibition | 「新寫意水墨畫邀請展」，炎黃藝術館，中國北京<br>"Expressive Ink Painting Invitational Exhibition", Yan Huang Art Museum, Beijing, China |
| 慈善<br>Charity | 「活——慈善詩畫展」，太古廣場，中國香港（香港傷殘青年協會、泰研畫會主辦）<br>Live — Poetry and Painting Exhibition for Charity", Pacific Place, Hong Kong, China (jointly organised by the Hong Kong Federation of Handicapped Youth and the Mega Vision Contemporary Artist Guild) |
| 寫生<br>Sketch<br>Trips | 與王守清、杜杰、于躍四人藏區寫生，到成都、新都橋、塔公山、康定、理塘、大理、香格理拉、中甸、昆明。<br>Goes to Tibetan areas to sketch with Wong Sau Ching, Du Jie and Yu Yue, travelling to Chengdu, Xinduqiao, Tagongshan, Kangding, Litang, Dali, Shangri-La, Zhongdian and Kunming. |
| 遊歷<br>Travels | 赴北京訪友兩個月。<br>Visits friends in Beijing for two months. |
| **2004** | **41 歲　\|　41 years old** |
| 個展<br>Solo Exhibition | 「天行之荷」，香港大會堂，中國香港<br>"The Lotus of My Heart", Hong Kong City Hall, Hong Kong, China |
| 入選<br>Works<br>Selected | 「第十屆全國美術作品展」，關山月美術館，中國深圳<br>"The 10th National Exhibition of Fine Arts, China", Guan Shanyue Art Museum, Shenzhen, China |
| 應邀<br>Activities by<br>Invitation | 「武漢首屆美術文獻提名展」，湖北美術學院美術館，中國武漢<br>"The 1st Wuhan Nomination Exhibition of Fine Arts Literature", College Gallery of Hubei Institute of Fine Arts, Wuhan, China |
| 獎項<br>Awards | 「傅抱石獎：南京水墨畫傳媒三年展」，江蘇省美術館，中國南京<br>"Fu Baoshi Prize: Ink Wash Painting Media Exhibition Triennial of Nanjing", Jiangsu Art Museum, Nanjing, China |
| 出版<br>Publication | 《大器叢書——林天行》，河北教育出版社，中國石家莊<br>*China Series — Lin Tian Xing*, Hebei Jiaoyu Chubanshe, Shijiazhuang, China<br>《天行之荷》，香港國際藝術交流協會，中國香港<br>*The Lotus of My Heart*, Hong Kong International Art Association, Hong Kong, China |
| 遊歷<br>Travels | 赴北京訪友一個月。<br>Visits friends in Beijing for a month. |
| **2005** | **42 歲　\|　42 years old** |
| 個展<br>Solo Exhibition | 「天行之荷」，可創銘佳藝苑，中國北京<br>"The Lotus of My Heart", Creation Art Gallery, Beijing, China<br>「天行山水——相蓮展」，新竹文化中心，中國台灣<br>"Lotus and Landscape", Hsinchu County Cultural Centre, Taiwan, China<br>「天行·西藏」，State-Of-The-Arts Gallery，中國香港<br>"Tian Xing in Tibet", State-Of-The-Arts Gallery, Hong Kong, China |

| | |
|---|---|
| 策展<br>Curation | 「漫天紛華——四維彩墨會員作品展」林天行師生展，香港大會堂，中國香港<br>"Beauty of The Earth by The 4-D Art Club" by Lam Tian Xing and Students, Hong Kong City Hall, Hong Kong, China |
| 入選<br>Works<br>Selected | 作品《晨曲》隨神州六號升空。<br>"Morning Song" goes to space with Shenzhou 6. |
| 應邀<br>Activities by<br>Invitation | 「現代金陵水墨畫傳媒展」，江蘇省國畫院美術館，中國南京<br>"Contemporary Chinese Brush Paintings Exhibition by Jinling Media", Gallery of Jiangsu Traditional Chinese Painting Institute, Nanjing, China<br>「第二屆當代中國山水畫・油畫風景展」，中國美術館，中國北京<br>"The 2nd Exhibition of Contemporary Chinese Brush and Oil Landscape Paintings", National Art Museum of China, Beijing, China |
| 參展<br>Exhibition | 「中國美術館館藏陳列展」，中國美術館，中國北京<br>"Collected Works of National Art Museum of China", National Art Museum of China, Beijing, China<br>「首屆中國當代名家書畫收藏展」，故宮博物院，中國北京<br>"The 1st Exhibition of Painting and Calligraph Collection by Contemporary Chinese Artists", The Palace Museum, Beijing, China |
| 獎項<br>Awards | 《新界晴雨》獲李可染獎（中國畫研究院、李可染藝術基金會主辦）<br>"Sunny Rain in New Territories" is awarded Li Keran Prize (by Research Institute of Traditional Chinese Paintings and Li Keren Arts Foundation) |
| 收藏<br>Works<br>Collected | 香港四季酒店（五幅），中國香港<br>Four Seasons Hotel Hong Kong (five works), Hong Kong, China |
| 教學<br>Teaching | 「水墨畫課程」，香港視覺藝術中心，中國香港<br>Course on "Chinese Brush Paintings", Hong Kong Visual Arts Centre, Hong Kong, China |
| 寫生<br>Sketch<br>Trips | 與王守清、于躍、杜杰赴西藏寫生。到拉薩、羊八井、當雄、納木錯、林芝、巴松錯、八一鎮、米松、朗縣、加查縣、澤當、桑耶寺，返拉薩後再往日喀則、薩迦、拉孜、薩嘎（因杜杰患上高山症，由于躍送回北京）、神山、札達、古格王朝、土林托林寺（托林寺門前寫生二十米手卷，三小時完成），以及新疆葉城、喀什、庫爾勒、羅布泊、吐魯番、烏魯木齊。<br>Goes to Tibet to sketch with Wong Sau Ching, Yu Yue and Du Jie. Travels to Lhasa, Yangbajing, Dangxiong, Namtso, Nyingchi, Basongco, Bayi Town, Missong, Lang County, Jiacha County, Zedang, Samye Monastery, and then returns to Lhasa to Shigatse, Sakya, Lazi, Sa'an (Du Jie is sent back to Beijing by Yu Yue due to his altitude sickness), Shenshan, Zada, Guge Dynasty, Toling Monastery (creating a 20-meter hand scroll in front of the Toling Monastery within three hours), and Yecheng, Kashgar, Korla, Lop Nor, Turpan and Urumqi in Xinjiang. |
| **2006** | **43 歲 ｜ 43 years old** |
| 個展<br>Solo Exhibition | 「天行新界」，State-Of-The-Arts Gallery，中國香港<br>"Tian Xing in New Territories", State-Of-The-Arts Gallery, Hong Kong, China |
| 應邀<br>Activities by<br>Invitation | 「當代香港水墨大展 2006」，香港中央圖書館，中國香港；深圳畫院，中國深圳<br>"Contemporary Hong Kong Ink Painting Exhibition 2006", Hong Kong Central Library, Hong Kong, China; Shenzhen Fine Art Institute, Shenzhen, China |

| | |
|---|---|
| 收藏<br>Works<br>Collected | 香港文華東方酒店（17 幅），中國香港<br>Mandarin Oriental Hotel (17 works), Hong Kong, China<br>怡和集團（逾十幅），中國香港<br>Jardine Matheson Holdings Limited (more than ten works), Hong Kong, China<br>葉浩霖基金會，美國<br>Nathan Yip Foundation, USA |
| 講座<br>Presentation | 「我的創作」，中國國家畫院（前為中國畫研究院），中國北京<br>"My Creation", China National Academy of Painting, Beijing, China (formerly Research Institute of Traditional Chinese Painting) |
| 遊歷<br>Travels | 日本大阪、京都、東京<br>Osaka, Kyoto and Tokyo, Japan |
| 傳媒<br>Media Coverage | 有綫電視主持節目「漫談中國山水畫」，由隋朝第一幅山水畫《遊春圖》講到當代，為時一個月。<br>Hosts "On Chinese Landscape Paintings ", a one-month programme of Cable TV, commenting the painting art from the first landscape painting "You Chun Tu" in the Sui Dynasty to contemporary times.<br>「拉近文化」，有綫電視專訪<br>"Bringing Culture Closer", Cable TV interview<br>新城電台專訪<br>Metro Radio interview |
| **2007** | **44 歲 \| 44 years old** |
| 個展<br>Solo Exhibition | 「天行西藏」，香港大會堂，中國香港<br>"Tibet — A Cosmovital Vision", Hong Kong City Hall, Hong Kong, China<br>「天行西藏」，可創銘佳藝苑，中國北京<br>"Tibet — A Cosmovital Vision", Creation Art Gallery, Beijing, China<br>「天行西藏」，State-Of-The-Arts Gallery，中國香港<br>"Tibet — A Cosmovital Vision", State-Of-The-Arts Gallery, Hong Kong, China |
| 策展<br>Curation | 「香港當代藝術邀請展」，香港大會堂，中國香港（香港國際藝術交流協會主辦）<br>"Invitation Exhibition of Contemporary Hong Kong Artists", Hong Kong City Hall, Hong Kong, China (organised by Hong Kong International Art Association)<br>「彩墨景象——四維彩墨會員作品展」林天行師生展，香港大會堂，中國香港<br>"Ink–Colour–Phenomenon by The 4-D Art Club" by Lam Tian Xing and Students, Hong Kong City Hall, Hong Kong, China |
| 參展<br>Exhibition | 「水墨新貌——現代水墨畫聯展暨國際學術研討會」，中環廣場，中國香港（信和集團信和藝術主辦）<br>"The New Face of Ink Paintings: Modern Ink Painting Group Exhibition and Symposium", Central Plaza, Hong Kong, China (organised by Sino Art)<br>「當代中國畫名家作品學術交流展」，香港大會堂，中國香港<br>"Academic Exchange Exhibition of Contemporary Chinese Painting Masers' Works", Hong Kong City Hall, Hong Kong, China<br>「世紀偉業」，中國人民革命軍事博物館，中國北京<br>"Contemporary Grand Art Works of China", Chinese People's Revolutionary Military Museum, Beijing, China<br>"Annäherungen IV"，帕瑟瓦爾克，德國<br>"Annäherungen IV", Pasewalk, Germany<br>「全球華人書畫世紀大聯展」，香港中央圖書館，中國香港（中國文聯主辦）<br>"Global Chinese Painting and Calligraphy Exhibition of the Century", Hong Kong Central Library, Hong Kong, China (organised by China Federation of Literary and Art Circles) |

| | |
|---|---|
| 收藏<br>Works<br>Collected | 北京香格里拉酒店（16幅）<br>Shangri-La Hotel (16 works), Beijing, China<br>滙豐銀行總行，中國香港<br>HSBC Headquarters, Hong Kong, China |
| 出版<br>Publication | 《今日中國藝術家——「天行彩墨」全集》，甘肅人民美術出版社，中國蘭州<br>*Today's Chinese Artists: Lam Tian Xing — Colour and Ink of Tian Xing*, Gansu Renmin Meishu Chubanshe, Lanzhou, China<br>《林天行·西藏》，可創銘佳藝苑，中國北京<br>*Tian Xing · Vision of Tibet*, Creation Art Gallery, Beijing, China<br>《天行西藏》，香港國際藝術交流協會，中國香港<br>*Tibet — A Cosmovital Vision*, Hong Kong International Art Association, Hong Kong, China<br>《林天行西藏寫生長卷》，香港國際藝術交流協會，中國香港<br>*Location Sketch of Tibet*, Hong Kong International Art Association, Hong Kong, China<br>《林天行——中國畫名家書系》，四川美術出版社，中國成都<br>*Lam Tian Xing, Paintings of Chinese Artists*, Sichuan Meishu Chubanshe, Chengdu, China |
| 遊歷<br>Travels | 赴德國柏林展聯接三人展，期間往布拉格、德雷斯登、羅森堡、奧斯堡、包浩斯、佛羅倫斯、維也納、羅馬、威尼斯、米蘭、慕尼黑等。<br>Goes to Berlin, Germany, to participate in the joint exhibition of three artists. During the period, travels to Prague, Dresden, Rosenberg, Augsburg, Bauhaus, Florence, Vienna, Rome, Venice, Milan, Munich, etc.<br>多次赴北京。<br>Travels to Beijing frequently. |
| 傳媒<br>Media Coverage | 《文匯報》、有綫電視英文台、《香港經濟日報》、香港電台普通話台專訪<br>Interviewed by *Wen Wei Po*, Cable TV English Channel, *Hong Kong Economic Daily News*, and Radio Television Hong Kong Mandarin Channel |
| **2008** | **45 歲 ｜ 45 years old** |
| 入選<br>Works<br>Selected | 《維港兩岸》隨神州七號升太空。<br>"Sideview in Victoria Harbour" goes to space with Shenzhou 7. |
| 應邀<br>Activities by<br>Invitation | 「第六屆深圳國際水墨雙年展」，深圳畫院，中國深圳<br>"The 6th International Ink Painting Biennial of Shenzhen", Shenzhen Fine Art Institute, Shenzhen, China<br>「靈感高原——當代西藏主題繪畫邀請展」，中國國家畫院，中國北京<br>"Journey to Tibet: Collective Contemporary Paintings of Tibet Exhibition of Selected Artists", China National Academy of Painting, Beijing, China<br>「新時期中國畫之路 1978-2008」，中國美術館，中國北京<br>"The Road for Traditional Chinese Paintings in New Era 1978-2008", National Art Museum of China, Beijing, China<br>「正當代——盛世中國畫」，中華世紀壇，中國北京<br>"Contemporary · Saatchi China", China Millenium Monument, Beijing, China<br>「水墨文章」，湖北美術院，中國武漢<br>"Ink and Wash Articles", Hubei Institute of Fine Arts, Wuhan, China<br>「深港水墨交流作品展」（歷屆），深圳畫院，中國深圳<br>"Shenzhen and Hong Kong Ink Painting Exhibition" (all sessions), Shenzhen Fine Art Institute, Shenzhen, China<br>「當代藝術名家作品展」，河北美術館，中國石家莊<br>"Exhibition of Works by Contemporary Eminent Artists", Hebei Art Museum, Shijiazhuang, China |

| | |
|---|---|
| 收藏<br>Works<br>Collected | 澳門四季酒店，中國澳門<br>Four Seasons Hotel, Macao, China<br>聯合航空，美國<br>United Airlines, USA |
| 出版<br>Publication | 《天行荷》，青蛙出版社，中國香港<br>*Lotus in Tian Xing*, Frog Publisher, Hong Kong, China |
| 講座<br>Presentation | 香港專業教育學院，中國香港<br>Hong Kong Institute of Vocational Education, Hong Kong, China |
| **2009** | **46 歲 ｜ 46 years old** |
| 應邀<br>Activities by<br>Invitation | 景德鎮畫瓷，同行有齊劍楠、陳震生、王東聲、何建國、古泥、徐忠平、邊平山、汪為新、康文等。《畫語者》雜誌邀請。<br>Paints porcelain in Jingdezhen, with Qi Jiannan, Chen Zhensheng, Wang Dongsheng, He Jianguo, Gu Ni, Xu Zhongping, Bian Pingshan, Wang Weixin and Kang Wen, invited by *Illustrator* Magazine. |
| 參展<br>Exhibition | 「水墨文章：美術文獻——當代水墨陳列展」，武漢美術館，中國武漢<br>"Contemporary Ink Colour Exhibition", Wuhan Art Museum, Wuhan, China<br>「畫語者」藝術家展，石家莊美術館，中國石家莊<br>"Painter — Artist Exhibition", Shijiazhuang Art Gallery, Shijiazhuang, China<br>「中國南京 2009 全國中國畫名家邀請展」，南京書畫院，中國南京<br>"Collective Chinese Paintings Exhibition of Selected Artists in China", Jinling Art Museum, Nanjing, China<br>「水墨雙城」（歷屆），香港大會堂，中國香港；深圳畫院，中國深圳<br>"Ink Painting · Two Cities" (all sessions), Hong Kong City Hall, Hong Kong, China; Shenzhen Fine Art Institute, Shenzhen, China |
| 遊歷<br>Travels | 往北京多次。<br>Travels to Beijing frequently. |
| **2010** | **47 歲 ｜ 47 years old** |
| 個展<br>Solo Exhibition | 「天荷」，香港大會堂，中國香港<br>"The Divine Lotus", Hong Kong City Hall, Hong Kong, China<br>「荷境——林天行荷花作品展」，State-Of-The-Arts Gallery，中國香港<br>"Lotus Vista · Exhibition of Lotus Paintings by Lam Tian Xing", State-Of-The-Arts Gallery, Hong Kong, China |
| 策展<br>Curation | 「彩墨時光——四維彩墨會員作品展」師生展，香港大會堂，中國香港<br>"Colour · Ink · Time by The 4-D Art Club" by Lam Tian Xing and Students, Hong Kong City Hall, Hong Kong, China |
| 參展<br>Exhibition | 「亞洲藝術家聯盟第 25 屆亞洲國際美術展覽會」，國家現代藝術畫廊，蒙古烏蘭巴托（出席）<br>"The 25th Asian International Art Exhibition of the Federation of Asian Artists", Mongolian National Modern Art Gallery, Ulaanbaatar, Mongolia (attending)<br>「2010 中國著名畫家走進柳州」，柳州博物館，中國柳州<br>"Famous Chinese Painters go into Liuzhou in 2010", Liuzhou Museum, Liuzhou, China |
| 收藏<br>Works<br>Collected | 中國銀行（香港）總部，中國香港<br>Bank of China (Hong Kong) Headquarters, Hong Kong, China |

| | |
|---|---|
| 出版<br>Publication | 《天荷》，香港國際藝術交流協會，中國香港<br>*Lotus Vista*, Hong Kong International Art Association, Hong Kong, China |

## 2011　　48 歲 ｜ 48 years old

| | |
|---|---|
| 個展<br>Solo Exhibition | 「荷境——林天行荷花作品展」，香港海港城・美術館，中國香港（State-of-The-Arts Gallery 主辦）<br>"Lotus Vista・Exhibition of Lotus Paintings by Lam Tian Xing", Gallery by the Harbour, Harbour City, Hong Kong, China (organised by State-Of-The-Arts Gallery)<br>「林天行彩墨畫展」，香港馬會會所畫廊，中國北京<br>"Exhibition of Ink Paintings by Lam Tian Xing", Dragon Pace Gallery, Hong Kong Jockey Club Clubhouse, Beijing, China<br>「林天行——靈境」，米蘭布朗尼藝術空間<br>"Lam Tian Xing — Realm of Soul", Fabbica Borroni, Milan |
| 應邀<br>Activities by<br>Invitation | 深圳畫院客座藝術家，中國深圳<br>Guest artist of Shenzhen Fine Art Institute, Shenzhen, China<br>在北京工作室雕刻紫沙壺 100 件。<br>Carves 100 purple clay teapots at Beijing Studio. |
| 參展<br>Exhibition | 「亞洲藝術家聯盟第 26 屆亞洲國際美術展覽會」，韓國首爾（出席）<br>"The 25th Asian International Art Exhibition of the Federation of Asian Artists", Seoul, Korea (attending)<br>「港水港墨——香港水墨作品展」（香港九家），中國美術館，中國北京<br>"Shui Mo Hong Kong・Exhibition of Hong Kong Ink Paintings", National Art Museum of China, Beijing, China<br>「傑出香港畫家近作展」，深圳畫院，中國深圳<br>"Recent Works by Outstanding Hong Kong Painters", Shenzhen Fine Art Institute, Shenzhen, China<br>「紙上踏春」四人展，蒙田畫廊，中國上海<br>"Spring Outing on Paper — A Group Chinese Painting Exhibition", Montaigne Gallery, Shanghai, China<br>「東方既白——中國國家畫院建院 30 週年青年美術作品展」，中國國家畫院，中國北京<br>"Dongfang Jibai・Exhibition for Celebration of the 30th Anniversary of China National Academy of Painting", China National Academy of Painting, Beijing, China<br>「辛亥革命一百周年美術作品展」，中國美術館，中國北京<br>"Art Exhibition for Commemorating the 100th Anniversary of the Chinese Bourgeois Democratic Revolution", National Art Museum of China, Beijing, China<br>「中國色彩——繪畫大展」，無錫美術館，中國無錫<br>"Chinese Colour・Art of Painting Exhibition", Wuxi Art Gallery, Wuxi, China<br>「傳承寫生」第一回，北京中間美術館，中國北京<br>"Drawing from Nature: Three Generations of Artists", Inside-out Art Museum, Beijing, China<br>「盛世華章——中國當代名家作品展」，中國美術館，中國北京<br>"Masterpiece・Exhibition of Chinese Contemporary Artists Works", National Art Museum of China, Beijing, China |
| 收藏<br>Works<br>Collected | 中國美術館，中國北京<br>National Art Museum of China, Beijing, China<br>瑞士信貸銀行，中國香港<br>Credit Suisse Bank, Hong Kong, China<br>中央人民政府駐香港特別行政區聯絡辦公室，中國香港<br>Liaison Office of the Central People's Government in the Hong Kong Special Administrative Region, Hong Kong, China |

| | |
|---|---|
| 出版<br>Publication | 《靈境》，凱雋藝術空間，中國香港<br>*Realm of Soul*, Neuberg ArtSpace, Hong Kong, China |
| 加入<br>Joining | 中國美術家協會<br>China Artists Association |
| 會議<br>Meetings | 中國文聯第九次全國代表大會，中國北京<br>The 9th National Congress of the China Federation of Literary and Art Circles, Beijing, China<br>中國畫學會創會會議（創會理事），中國北京<br>Inaugural Meeting of Chinese Painting Institute (Founding Director), Beijing, China |
| 遊歷<br>Travels | 上海、南京、無錫、鎮江<br>Shanghai, Nanjing, Wuxi and Zhenjiang<br>成都、九寨溝、黃龍、樂山、宜賓、漏斗山、興文縣、石海、大足、重慶<br>Chengdu, Jiuzhaigou, Huanglong, Leshan, Yibin, Loudoushan, Xingwen County, Shihai, Dazu and Chongqing<br>吉林、長春、長白山、天池<br>Jilin, Changchun, Changbai Mountain and Tianchi<br>米蘭、威尼斯、瑞士、科莫湖<br>Milan, Venice, Switzerland and Lake Como<br>赴北京多次。<br>Travels to Beijing frequently. |
| **2012** | **49 歲 ｜ 49 years old** |
| 個展<br>Solo Exhibition | 「蓮樂——林天行彩墨畫展」，K 畫廊，韓國首爾<br>"The Joyous Lotus — Korea Debut Solo Exhibition of Chinese Ink Master Lam Tian Xing", The K Gallery, Seoul, Korea<br>「林天行彩墨畫展」，三石軒畫廊，中國香港<br>"Ink Paintings by Lam Tian Xing", San Shi Xuen, Hong Kong, China |
| 應邀<br>Activities by<br>Invitation | 「異質表達——2012 穗深港當代藝術邀請展」，圈子美術館，中國深圳<br>"Contemporary Art Exhibition of Guangzhou-Hong Kong 2012", Circle Art Centre, Shenzhen, China |
| 講座<br>Presentation | 香港藝術館視覺藝術中心水墨課程 12 講，中國香港<br>Twelve Lectures on Ink Painting, Visual Arts Centre, Hong Kong Museum of Art, Hong Kong, China<br>「薪火相傳——水墨畫老師培訓課程」二節，賽馬會創意藝術中心，中國香港<br>Two sessions of "The Ink Tradition — Train the Trainer Programme", Jockey Club Creative Arts Centre, Hong Kong, China |
| 寫生<br>Sketch<br>Trips | 查濟古鎮，安徽<br>Zhaji Ancient Town, Anhui, China |
| 遊歷<br>Travels | 延安、黃帝陵、壺口瀑布、華山<br>Yan'an, Mausoleum of Yellow Emperor, Hukou Waterfall and Mount Huashan<br>韓國首爾<br>Seoul, Korea<br>武漢、荊州<br>Wuhan and Jingzhou<br>赴北京多次。<br>Travels to Beijing frequently. |

| | |
|---|---|
| **2013** | **50 歲 ｜ 50 years old** |
| 個展<br>Solo Exhibition | 「荷・天行——林天行彩墨畫展」，香港城市大學濤聲藝廊，中國香港<br>"Lotus・Tian Xing", Singing Waves Gallery, City University of Hong Kong, Hong Kong, China<br>「靈・天行」，北京碸明萬荷美術館，中國北京<br>"Spirit・Tian Xing", Lotus Art Museum, Beijing, China |
| 策展<br>Curation | 「彩墨彩——四維彩墨會員作品展」師生展，香港大會堂，中國香港<br>"Vivid Colours: Vivid Expressions by The 4-D Art Club" by Lam Tian Xing and Students, Hong Kong City Hall, Hong Kong, China |
| 參展<br>Exhibition | 「可貴者膽——李可染畫院首屆院展」，中國美術館，中國北京<br>"The First Exhibition of Li Keran Academy of Painting", National Art Museum of China, Beijing, China<br>「館藏一百——香港藝術館中國繪畫特展」，香港藝術館，中國香港<br>"A Hundred Chinese Paintings from the Hong Kong Museum of Art", Hong Kong Museum of Art, Hong Kong, China<br>「繁囂・隱逸」五人聯展，中環交易廣場，中國香港<br>"Urban Hermits", Exchange Square, Hong Kong, China<br>「亞洲藝術家聯盟第 27 屆亞洲國際美術展」，拉查達蒙當代藝術中心，泰國曼谷<br>"The 27th Asian International Art Exhibition of the Federation of Asian Artists", Rajdumnern Contemporary Art Center, Bangkok, Thailand<br>「凱風和鳴——首屆全國中青年花鳥畫提名展」，保利藝術博物館，中國北京<br>"Kai Feng He Ming・The 1st Nomination Exhibition of Flower-and-Bird Paintings by Young Artists", Poly Art Museum, Beijing, China |
| 收藏<br>Works<br>Collected | 深圳畫院，中國深圳<br>Shenzhen Fine Art Institute, Shenzhen, China |
| 出版<br>Publication | 《荷・天行》，香港國際藝術交流協會，中國香港<br>*Lotus・Tian Xing*, Hong Kong International Art Association, Hong Kong, China |
| 講座<br>Presentation | 「文人畫」講座示範，香港藝術館，中國香港<br>"Literati Painting" Chinese Painting Demonstration, Hong Kong Museum of Art, Hong Kong, China<br>「怎樣欣賞中國畫」二節，中國銀行（香港）總部，中國香港<br>Two sessions of "How to Appreciate Chinese Paintings", Bank of China (Hong Kong) Headquarters, Hong Kong, China |
| 遊歷<br>Travels | 日本東京、京都、奈良<br>Tokyo, Kyoto and Nara, Japan<br>赴北京多次。<br>Travels to Beijing frequently. |
| **2014** | **51 歲 ｜ 51 years old** |
| 個展<br>Solo Exhibition | 「天行・荷・西藏——林天行彩墨作品展」，深圳畫院，中國深圳<br>"Tian Xing・Lotus・Tibet", Shenzhen Fine Art Institute, Shenzhen, China |

| | |
|---|---|
| 參展<br>Exhibition | 「第 28 屆亞洲國際美術展——金門邀請展」，金門，中國台灣<br>"The 28th Asian International Art Exhibition of the Federation of Asian Artists — Kinmen Invitational Exhibition",<br>Kinmen, Taiwan, China<br>「香港當代水墨藝術展」，北京畫院、雲峰畫院，中國北京<br>"Hong Kong Contemporary Ink Painting Exhibition", Beijing Fine Art Academy and Beijing Wang Fung Art Gallery,<br>Beijing, China<br>「港水港墨——中國畫學會香港首屆會員作品展」，關山月美術館，中國深圳<br>"Shui Mo Hong Kong · The 1st Exhibition of Chinese Painting Institute Hong Kong", Guan Shanyue Art Museum,<br>Shenzhen, China<br>「美麗中國幸福香港 香港美協首屆會員作品展」，榮寶齋（香港），中國香港<br>"The 1st Exhibition of the Hong Kong Artists Association", Rong Bao Zhai (Hong Kong), Hong Kong, China |
| 收藏<br>Works<br>Collected | 關山月美術館，中國深圳<br>Guan Shanyue Art Museum, Shenzhen, China<br>深圳畫院，中國深圳<br>Shenzhen Fine Art Institute, Shenzhen, China |
| 講座<br>Presentation | 「林天行藝術歷程」，香港城市大學中華文化中心，中國香港<br>Lecture on "My Painting Pilgrimage: The Journey of a Painter", City University of Hong Kong, Hong Kong, China |
| 寫生<br>Sketch<br>Trips | 與學生到法國巴黎、普羅旺斯、尼斯，西班牙巴塞隆拿寫生考察<br>Study Tour with students to Paris, Provence, Nice and Barcelona |
| 遊歷<br>Travels | 丹霞山、南華寺、韶關、梅嶺古道、珠璣古巷<br>Danxia Mountain, Nanhua Temple, Shaoguan, Meiling Ancient Road and Zhuji Ancient Alley<br>到廈門、漳州、雲霄、泉州、寧德、福州訪友。<br>Visits friends in Xiamen, Zhangzhou, Yunxiao, Quanzhou, Ningde and Fuzhou.<br>赴北京多次。<br>Travels to Beijing frequently. |
| **2015** | **52 歲 \| 52 years old**<br><br>父親林鴻昌於香港仁濟醫院去世，享年 75 歲。<br>Father Lam Hung Cheong passes away at the age of 75 at Yan Chai Hospital, Hong Kong. |
| 個展<br>Solo Exhibition | 「林天行 惜食堂慈善畫展」，交易廣場中央大廳，中國香港（惜食堂主辦）<br>"Lam Tian Xing Charity Art Exhibition — In Benefit of Food Angel", Exchange Square, Hong Kong, China (organised<br>by Food Angel)<br>「林天行彩墨荷花展」，Ausmeyer & Gerling 畫廊，德國不來梅<br>"Lotus — The Ink Colour Paintings of Lam Tian Xing", Ausmeyer & Gerling, Bremen, Germany |
| 策展<br>Curation | 「水墨彩——四維彩墨會員作品展」師生展，香港大會堂，中國香港<br>"Fusion Extravaganza: Brush Painting and Calligraphy by The 4-D Art Club" by Lam Tian Xing and Students, Hong<br>Kong City Hall, Hong Kong, China |

| | |
|---|---|
| 參展<br>Exhibition | 「中國畫學會展」，中國美術館，中國北京<br>"Exhibition of Chinese Painting Institute", National Art Museum of China, Beijing, China<br>「中國風」，聖彼得堡國立大學，俄羅斯聖彼得堡<br>"Chinese Flair", St. Petersburg State University, St. Petersburg, Russia<br>「筆相墨境——李可染畫院名家十三人學術徐州邀請展」，徐州美術館，中國徐州<br>"Engrain of the Brushes and Ink · Famous Expert Painters Scholarly Exhibition of Li Keran Academy of Painting", Xuzhou Art Museum, Xuzhou, China<br>「中國畫學會香港—上海·香港巡迴展」，中國香港、上海<br>"Chinese Ink Painting Institute HK — Shanghai · Hong Kong Touring Exhibition", Hong Kong and Shanghai, China<br>「2015 港滬澳當代水墨交流展」，香港中央圖書館，中國香港<br>"Hong Kong, Shanghai & Macao Joint Exhibition of Modern Ink Painting", Hong Kong Central Library, Hong Kong, China |
| 出版<br>Publication | 《林天行》，惜食堂，中國香港<br>*Lam Tian Xing Charity Art Exhibition — In Benefit of Food Angel*, Food Angel, Hong Kong, China |
| 講座<br>Presentation | 講座示範，聖彼得堡國立大學，俄羅斯聖彼得堡<br>Lecture and demonstration at St. Petersburg State University, St. Petersburg, Russia |
| 遊歷<br>Travels | 西安、寶雞<br>Xi'an and Baoji<br>俄羅斯聖彼得堡<br>St. Petersburg, Russia |
| **2016** | **53 歲 ｜ 53 years old** |
| 個展<br>Solo Exhibition | 「天行造境——林天行彩墨畫展」，榮寶齋（香港），中國香港<br>"Tian Xing Fantasia · The Ink Colour Paintings of Lam Tian Xing", Rong Bao Zhai (Hong Kong), Hong Kong, China |
| 參展<br>Exhibition | 「東方墨韻·2016 滬港水墨藝術交流展」，香港中央圖書館，中國香港<br>"Oriental Charm · Ink Art in Hong Kong & Shanghai 2016", Hong Kong Central Library, Hong Kong, China<br>「傳承寫生」第二回，西山逸林畫院美術館，中國北京<br>"Drawing from Nature: Three Generations of Artists", Gallery of Yilin Academy of Fine Arts, Xishan, Beijing, China<br>「澳門美術協會成立六十週年美術作品邀請展」，澳門教科文中心，中國澳門<br>"Invitational Exhibition of Fine Arts Works for the 60th Anniversary of the Establishment of the Macao Fine Arts Association", The UNESCO Centre of Macao, Macao, China |
| 出版<br>Publication | 《天行造境》，榮寶齋（香港），中國香港<br>*Tian Xing Fantasia*, Rong Bao Zhai (Hong Kong), Hong Kong, China |
| 講座<br>Presentation | 水墨講座示範，香港會議展覽中心（香港貿易發展局邀請）<br>Lecture and Demonstration on ink and brush, Hong Kong Convention and Exhibition Centre (invited by Hong Kong Trade Development Council) |
| 當選<br>Positions<br>Elected | 香港選舉委員會委員（文化界代表）<br>Member of the Hong Kong Election Committee (representative of the cultural sector) |
| 寫生<br>Sketch<br>Trips | 和學生到不丹寫生。<br>Travels to Bhutan to sketch with students. |

| | |
|---|---|
| 遊歷<br>Travels | 往青海西寧考察。<br>Travels to Xining, Qinghai.<br>和學生到德國不來梅訪友。<br>Visits friends with students in Bremen, Germany.<br>赴北京多次。<br>Travels to Beijing frequently. |

**2017**      **54 歲 ｜ 54 years old**

| | |
|---|---|
| 個展<br>Solo Exhibition | 「荷花天行——林天行彩墨藝術展」，香港天趣當代藝術館，中國香港<br>"Tian Xing Lotus · Lam Tian Xing Ink Art Exhibition", Art of Nature Contemporary Gallery, Hong Kong, China |
| 策展<br>Curation | 「心彩墨——四維彩墨畫會成立十五周年會員作品展」師生展，香港大會堂，中國香港<br>"Splashing Colours from Our Hearts — The 15th Anniversary of The 4-D Art Club" by Lam Tian Xing and Students, Hong Kong City Hall, Hong Kong, China |
| 參展<br>Exhibition | 「六零六零——當代中國畫 60 後藝術家提名展」，中國政協文史館，中國北京<br>"Sixty sixty · Nomination Exhibition of Contemporary Chinese Painting by Post-60s Chinese Artists", CPPCC Literature and History Museum, Beijing, China<br>「西雙版納國際美術展」，西雙版納美術館，中國西雙版納<br>"Xishuangbanna International Art Exhibition", Xishuangbanna Art Museum, Xishuangbanna, China<br>「第五屆全國畫院美術作品展」，江蘇省美術館，中國南京<br>"The 5th Fine Arts Exhibition of All Painting Academies of China", Jiangsu Art Museum, Nanjing, China<br>「第七屆中國畫節——全國 19 省市中國畫學會作品展」，濰坊市美術館，中國濰坊<br>"The 7th Chinese Painting Festival · Exhibition of Artworks from Chinese Ink Painting Institute", Weifang Art Museum, Weifang, China<br>「全球水墨畫大展 2017」，香港會議展覽中心，中國香港<br>"Ink Global 2017", Hong Kong Convention and Exhibition Centre, Hong Kong, China<br>「十分春色——當代名家牡丹精品展」，榮寶齋（洛陽），中國洛陽<br>"Colours of Spring · Exhibition of Contemporary Masters of Peony Paintings", Rong Bao Zhai (Luoyang), Luoyang, China |
| 當選<br>Positions<br>Elected | 廣東省美術家協會藝術委員會中國山水畫藝委會委員<br>Member of the Chinese Landscape Painting Art Committee of the Art Committee of the Guangdong Artists Association |
| 會議<br>Meetings | 中國文聯委員會會議，中國北京<br>China Federation of Literary and Art Circles Committee Meeting, Beijing, China |
| 寫生<br>訪友<br>Sketch Trips | 青海訪友寫生，到訪西寧、瞿塘、貴德、蘭州、武威、張掖、馬蹄寺、天梯山等地。<br>visits friends in Qinghai and sketches at Xining, Qutang, Guide, Lanzhou, Wuwei, Zhangye, Horseshoe Temple, Tianti Mountain, etc. |
| 遊歷<br>Travels | 隨詩人秦嶺雪訪福建安海、龍山寺、安平橋、靈源寺、草庵（明教聖地）。<br>With the poet Qin Lingxue, travels to Anhai, Longshan Temple, Anping Bridge, Lingyuan Temple and Cao Nunnery (the shrine of Religion of Light) in Fujian. |
| 傳媒<br>Media Coverage | 《香港經濟日報》專訪<br>*Hong Kong Economic Daily* Interview<br>台灣傳媒專訪<br>Taiwan Media Interview |

| | |
|---|---|
| **2018** | **55 歲 ｜ 55 years old** |
| | 兒子沙洲結婚，並創辦「明畫廊」。 |
| | Son, Sha Chau, marries and establishes "Illuminati Fine Art". |
| 個展<br>Solo Exhibition | 「蓮說」，明畫廊，中國香港<br>"Love of Lotus", Illuminati Fine Art, Hong Kong, China |
| 參展<br>Exhibition | 「水墨之上──2018 第四屆昆明美術雙年展」，雲南美術館，中國昆明<br>"On Ink Painting — The 4th Kunming Art Biennial 2018", Yunnan Art Museum, Kunming, China<br>「香港牽動我的心──慶祝改革開放四十周年美術創作展」，香港會議展覽中心，中國香港<br>"Hong Kong Tugs at my Heartstrings·Art Exhibition to Mark 40 Years of Reform And Opening Up Policy", Hong Kong Convention and Exhibition Centre, Hong Kong, China<br>「水墨藝博」，香港會議展覽中心，中國香港。現場為大會畫兩幅 4 米 x4 米水墨壁畫。<br>"Ink Asia", Hong Kong Convention and Exhibition Centre, Hong Kong, China (painting two ink murals of 4m x 4m for the Exhibition)<br>「三人行──京港澳中國畫先鋒交流展」，澳門教科文中心，中國澳門<br>"Three — Beijing, Hong Kong and Macao Chinese Painting Pioneer Exchange Exhibition", The UNESCO Centre of Macao, Macao, China<br>「嶺海虹輝──粵港澳大灣區書畫名家作品邀請展」，澳門回歸賀禮陳列館，中國澳門<br>"Linghai Honghui — Invitational Exhibition of Calligraphy and Painting Works by Famous Artists in Guangdong-Hong Kong-Macao Greater Bay Area", Handover Gifts Museum of Macao, Macao, China<br>「凝──兩岸三地藝術家聯展」，明畫廊，中國香港<br>"Cohesion·Joint Exhibition", Illuminati Fine Art, Hong Kong, China<br>「三十芳華──香港福建書畫研究會成立三十周年大展」，香港中央圖書館，中國香港<br>"Thirty Years·The 30th Anniversary Exhibition of Calligraphy and Painting Study Association of Hong Kong Fukienese", Hong Kong Central Library, Hong Kong, China<br>「百犬獻瑞」，金陵美術館，中國南京<br>"Bai Quan Xian Rui", Jinling Art Museum, Nanjing, China<br>「第二屆中國畫學會展·時代華章 2018」，北京中國美術館、山東濰坊、江陰海瀾美術館<br>"Grand Page of Age — The 2nd Exhibition of Chinese Painting Institute", National Art Museum of China, Beijing; Weifang, Shandon; Hailan Art Museum, Jiangyin, China |
| 出版<br>Publication | 《蓮說──林天行》，明畫廊，中國香港<br>*Love of Lotus*, Illuminati Fine Art, Hong Kong, China |
| 教學<br>Teaching | 北京辛莊學堂水墨畫課程兩周，中國北京<br>Two-week ink painting course, Beijing Xinzhuang Academy, Beijing, China |
| 會議<br>Meetings | 中國文聯委員會會議，中國北京<br>China Federation of Literary and Art Circles Committee Meeting, Beijing, China<br>福建省美協理事會會議，中國福州<br>Fujian Artists Association Committee Meeting, Fuzhou, China |
| 遊歷<br>Travels | 往台灣台北、台中訪友。<br>Visits friends in Taipei and Taichung in Taiwan. |
| **2019** | **56 歲 ｜ 56 years old** |
| | 孫子林行之出生。 |
| | Grandson, Quentin Lam Hang Chi, is born. |

| | |
|---|---|
| 策展<br>Curation | 「香港藝術家邀請展」，香港大會堂，中國香港（香港各界文化促進會、香港美協合辦）<br>"Hong Kong Artists Invitational Exhibition", Hong Kong City Hall, Hong Kong, China (jointly organised by Hong Kong Culture Association and Hong Kong Artists Association)<br>「藝術共融——香港美協會員作品展」，古元美術館，中國珠海<br>"Artistic Integration — Exhibition of Works by Members of The Hong Kong Artists Association", Guyuan Art Museum, Zhuhai, China<br>「彩墨印象——四維彩墨會員作品展」師生展，香港大會堂，中國香港<br>"Evocation — Creating an Image by The 4-D Art Club" by Lam Tian Xing and Students, Hong Kong City Hall, Hong Kong, China |
| 應邀<br>Activities by<br>Invitation | 「第十二屆中國藝術節全國優秀美術作品展覽」，中華藝術宮（上海美術館），中國上海<br>"The 12th China Art Festival National Excellent Art Works Exhibition", China Art Museum (Shanghai Art Museum), Shanghai, China |
| 參展<br>Exhibition | 「藏・緣——西藏當代美術作品邀請展」，李可染藝術基金美術館，中國北京<br>"Tibet・Fate — Invitational Exhibition of Tibetan Contemporary Art Works", Li Keran Art Foundation Gallery, Beijing, China<br>「第六屆全國畫院美術作品展覽」，湖南美術館，中國長沙<br>"The 6th Fine Arts Exhibition of All Painting Academies of China", Hunan Art Museum, Changsha, China<br>「中國畫學會理事作品展」，中國美術館，中國北京<br>"Exhibition of Works by Committee Members of the Chinese Painting Institute", National Art Museum of China, Beijing, China<br>「粵港澳大灣區美術作品展」，廣州美術學院大學城美術館，中國廣州<br>"Guangdong-Hong Kong-Macao Greater Bay Area Art Works Exhibition", University City Art Museum, Guangzhou Academy of Fine Arts, Guangzhou, China<br>「水墨藝博 2019」，香港會議展覽中心，中國香港<br>"Ink Asia 2019", Hong Kong Convention and Exhibition Centre, Hong Kong, China<br>「港水港墨——當代中國水墨名家邀請展」（八人聯展），香港中央圖書館，中國香港<br>"Shui Mo Hong Kong・Exhibition of Hong Kong Ink Paintings", Hong Kong Central Library, Hong Kong, China |
| 收藏<br>Works<br>Collected | 《潔淨的地方》，西藏美術館，中國拉薩<br>"Place of Purity" (364x146cm, ink and colour on paper, 2006), Tibet Art Museum, Lhasa, China |
| 當選<br>Positions<br>Elected | 香港美協主席<br>Chairman of The Hong Kong Artists Association<br>中國美術家協會香港會員分會主席<br>Chairman of China Artists Association Hong Kong Chapter<br>中國美術家協會理事<br>Committee member of China Artists Association |
| 評委<br>Jury Member | 「第十三屆全國美術作品展港澳台・海外作品」<br>"The 13th National Exhibition of Fine Arts, China — Hong Kong, Macao and Taiwan・Overseas Works"<br>「全球水墨畫大展」<br>"Ink Global" |
| 會議<br>Meetings | 中國文聯第十屆全國委員會第四次會議，中國北京<br>The 4th Meeting of the 10th National Committee of the China Federation of Literary and Art Circles, Beijing, China |

| | |
|---|---|
| 寫生<br>Sketch<br>Trips | 帶學生往陽朔及雲南昆明、元陽寫生。<br>Takes students to sketch in Yangshuo of Guangxi, and Kunming and Yuanyang of Yunnan. |
| 遊歷<br>Travels | 往貴州茅台鎮、遵義等地參觀及寫生。<br>Visits and sketches in Maotai Town, Zunyi and other places in Guizhou.<br>杭州、安吉、寧波<br>Hangzhou, Anji and Ningbo |

## 2020 　　57 歲 ｜ 57 years old

| | |
|---|---|
| 個展<br>Solo Exhibition | 「楚頌新聲・菖蒲集」林天行菖蒲展，明畫廊，中國香港<br>"Anthem of Calamus", Illuminati Fine Art, Hong Kong, China |
| 參展<br>Exhibition | 「一新時光：香港速寫」展，一新美術館，中國香港（一新美術館與香港美協合辦）<br>"Instant Reflection — Hong Kong Artists and Sketches", Sum Museum, Hong Kong, China (jointly organised by Sum Museum and The Hong Kong Artists Association)<br>「同心和韻——廣東省政協書畫院理事作品展」，廣東省政協書畫院，中國廣東<br>"Harmony of Hearts — Exhibition of Works by Directors of Guangdong Provincial Committee of Chinese People's Political Consultative Conference Painting and Calligraphy Academy", Guangdong Provincial Committee of CPPCC Painting and Calligraphy Academy, Guangzhou, China<br>「9+2 粵港澳美術作品交流展」，廣州藝術博物院，中國廣州<br>"9+2 Guangdong-Hong Kong-Macao Art Works Exchange Exhibition", Guangzhou Museum of Art, Guangzhou, China<br>「中國美術世界暨海外研修工程成果匯報展」，炎黃藝術館，中國北京（中國美協主辦）<br>"China Art World and Overseas Training Project Achievement Report Exhibition", Yan Huang Art Museum, Beijing, China (organised by China Artists Association) |
| 出版<br>Publication | 《楚頌新聲・菖蒲集》林天行作品集，明畫廊，中國香港<br>*Anthem of Calamus*, Illuminati Fine Art, Hong Kong, China |
| 講座<br>Presentation | 「校長論壇——藝術與成長」，中華教育文化交流基金會，中國香港<br>"Principals Forum — Art and Growth", China Education Culture Exchange Foundation, Hong Kong, China |
| 當選<br>Positions<br>Elected | 中國文聯香港會員總會常務副會長<br>Executive Vice Chairman of the China Federation of Literary and Art Circles Hong Kong Member Association<br>粵港澳大灣區藝術家聯盟副主席<br>Vice Chairman of Guangdong-Hong Kong-Macao Greater Bay Area Artists Union |
| 會議<br>Meetings | 中國文聯第十屆全國委員會第五次會議，中國北京<br>The 5th Meeting of the 10th National Committee of the China Federation of Literary and Art Circles, Beijing, China |
| 應邀<br>Activities by<br>Invitation | 任香港書畫文玩協會顧問<br>Consultant of Hong Kong Fine Art and Antiques Society<br>任中國書法家協會（香港）顧問<br>Consultant of Chinese Calligraphers Association (Hong Kong) |

## 2021 　　58 歲 ｜ 58 years old

將身份證姓名改為「林天行」，原名「林仚」。
Changes the name on the identity card from "Lam Sin" to "Lam Tian Xing".

| | |
|---|---|
| 雙個展<br>Joint Solo<br>Exhibition | 「金耀基・林天行 書畫展」，集古齋，中國香港<br>"King Yeo Chi・Lam Tian Xing Calligraphy and Painting Exhibition", Tsi Ku Chai, Hong Kong, China<br>「靳埭強・林天行 雙個展」，香港經藝聯，中國香港<br>"Kan Tai Keung — Lam Tian Xing Joint Solo Exhibition", Kings Arts, Hong Kong, China |
| 策展<br>Curation | 「同源異彩——香港美協會員作品展」綫上展<br>"Homology — Art Creations by The Hong Kong Artists Association 2021" Online Exhibition |
| 參展<br>Exhibition | 「正值風華——中國畫學會精品展」，中國美術館，中國北京<br>"The time of Splendor — Excellent Exhibition of the Chinese Painting Society", National Art Museum of China, Beijing, China<br>「中國國家畫院慶祝中國共產黨成立 100 周年邀請展：百年風華——花鳥畫名家作品展」，中國國家畫院美術館、西安美術館、廣州畫院美術館，中國北京、西安、廣州（中國國家畫院花鳥畫所主辦）<br>"China National Academy of Painting Celebrating the 100th Anniversary of the Founding of the Communist Party of China Invitational Exhibition: A Century of Grace — Exhibition of Famous Flower and Bird Painting Works", the National Academy of Painting Art Museum, Beijing; Xi'an Art Museum, Xi'an; Guangzhou Art Academy Art Museum of China, Guangzhou, China (organised by the National Academy of Painting Flower and Bird Painting Institute)<br>「亞洲藝術家聯盟：意識聚集——第 29 屆亞洲國際美術展」，福岡九州藝文館，日本九州<br>"The 29th Asian International Art Exhibition of the Federation of Asian Artists", Fukuoka Kyushu Art Museum, Kyushu, Japan<br>「河山有君——李可染畫院院展」，中國美術館，中國北京<br>"The River and the Mountains — Li Keran Academy of Painting Exhibition", National Art Museum of China, Beijing, China<br>「全球水墨畫大展 2021」，香港中央圖書館，中國香港<br>"Ink Global 2021", Hong Kong Central Library, Hong Kong, China<br>「水墨藝博 2021」展出漢字起源系列，香港會議展覽中心，中國香港<br>"Ink Asia 2021", exhibiting Chinese Character Origin Series, Hong Kong Convention and Exhibition Centre, Hong Kong, China |
| 收藏<br>Works<br>Collected | 紫荊文化集團，中國香港<br>Bauhinia Culture Holdings Limited, Hong Kong, China<br>廈門大學，中國廈門<br>Xiamen University, Xiamen, China<br>集古齋，中國香港<br>Tsi Ku Chai, Hong Kong, China |
| 入編<br>Works in<br>Compilation | 《中國水墨年鑑 2021》，文化藝術出版社，中國北京<br>*Chinese Ink Yearbook 2021*, Wenhua Yishu Chubanshe, Beijing, China |
| 講座<br>Presentation | 「我的路——林天行藝術創作歷程」，香港中央圖書館，中國香港（香港星河畫藝會主辦）<br>"My Way: Lam Tian Xing's Ordeal of Artistic Creation", Hong Kong Central Library, Hong Kong, China (organised by Galaxy Art Association of Hong Kong) |
| 當選<br>Positions<br>Elected | 香港選舉委員會委員（體育演藝文化及出版界）<br>Member of the Hong Kong Election Committee (subsector of Sports, Performing Arts, Culture and Publication)<br>中國文聯第十一屆全委會委員（連任）<br>Member of the 11th National Committee of the China Federation of Literary and Art Circles (re-elected) |

| | |
|---|---|
| 評委<br>Jury Member | 中國國家藝術基金港澳美術評委<br>China National Arts Fund Hong Kong and Macao Art Jury<br>「全球水墨畫大展」<br>"Ink Global"<br>「2021 奧運日——填色及繪畫比賽」，中國香港體育協會暨奧林匹克委員會<br>"Olympic Day 2021 — Colouring and Drawing Competition", The Sports Federation and Olympic Committee of Hong Kong, China |
| 傳媒<br>Media Coverage | 「藝術中國——著名畫家林天行」，藝術中國網上專頁<br>"Art China — Eminent Painter Lam Tian Xing", Art China Online Page<br>「紫荊專訪——林天行：畫壇天馬行空的探索者」，《紫荊雜誌》<br>"Interview with Bauhinia Magazine — Lam Tian Xing: The Explorer of the Artistic World", *Bauhinia Magazine* |

## 2022　59 歲　｜　59 years old

| | |
|---|---|
| 個展<br>Solo Exhibition | 「多彩的地方——林天行景象香港彩墨畫展」，明畫廊，中國香港<br>"Splendid Place, Hong Kong Scenery by Lam Tian Xing", Illuminati Fine Art, Hong Kong, China |
| 策展<br>Curation | 「繼往開來——香港美術家慶祝香港回歸祖國 25 週年作品展」，香港中央圖書館，中國香港<br>"Continuing the Past and Forging the Future — Exhibition of Works by Hong Kong Artists to Celebrate the 25th Anniversary of Hong Kong's Return", Hong Kong Central Library, Hong Kong, China<br>「春華秋實——香港四維彩墨畫會成立 20 周年作品展」師生展，香港大會堂，中國香港<br>"Attainments — Artwork Exhibition for 20th Anniversary of The 4-D Art Club" by Lam Tian Xing and Students, Hong Kong City Hall, Hong Kong, China<br>「國際藝術交流展 2022」，香港大會堂低座，中國香港（香港國際藝術交流協會、香港張仃藝術基金會聯合主辦）<br>"International Art Exchange Exhibition 2022", Hong Kong City Hall, Hong Kong, China (jointly organised by Hong Kong International Art Association and Hong Kong Zhang Ding Art Foundation) |
| 參展<br>Exhibition | 「筆墨丹青繪灣區——慶祝香港回歸祖國 25 周年美術作品巡迴展」，中國國家博物館、香港中央圖書館、澳門舊法院大樓、深圳美術館，中國北京、香港、澳門、深圳<br>"Greater Bay Area in the Eyes of Artists — An Exhibition Celebrating the 25th Anniversary of Hong Kong's Return to the Motherland Touring Exhibition", National Museum of China, Hong Kong Central Library, Macao Old Court Building and Shenzhen Art Museum, Beijing, Hong Kong, Macao and Shenzhen, China<br>「三地藝海情濃　抗疫大愛無疆主題展」，香港美協、香港書畫文玩協會、集古齋畫廊巡迴展<br>"Artists express feelings in Calligraphy about Hong Kong, an Anti-epidemic Great Love Theme Exhibition" Touring Exhibition (jointly organised by The Hong Kong Artists Association, Hong Kong Fine Art and Antiques Society, and Tsi Ku Chai Gallery)<br>「傳承寫生展」，中間美術館，中國北京<br>"Drawing from Nature: Three Generations of Artists", Inside-out Art Museum, Beijing, China<br>「香港藝文」，香港會議展覽中心，中國香港（紫荊文化集團、新世界集團、香港故宮博物館主辦）<br>"Hong Kong Arts and Culture", Hong Kong Convention and Exhibition Centre, Hong Kong, China (jointly organised by Bauhinia Culture Holdings, New World Group and Hong Kong Palace Museum)<br>「今朝更好看——慶祝香港回歸祖國 25 周年藝術名家作品展」，天際 100，香港觀景台，中國香港<br>"Better Than Ever — Art Exhibition by Renowned Artists in Celebration of the 25th Anniversary of Hong Kong's Return to the Motherland", Sky 100, Hong Kong Observation Deck, Hong Kong, China |

| | |
|---|---|
| 參展<br>Exhibition | 「香港美術家書畫專題作品展」，香港大會堂，中國香港（香港書畫文玩協會、香港美協主辦）<br>"Hong Kong Artists' Calligraphy and Painting Thematic Exhibition", Hong Kong City Hall, Hong Kong, China (jointly organised by Hong Kong Fine Art and Antiques Society, and The Hong Kong Artists Association)<br><br>「第十三屆中國藝術節全國優秀美術作品展」，中國美術館，中國北京（中國文化和旅遊部等主辦）<br>"The 13th China Art Festival National Excellent Art Works Exhibition", National Art Museum of China, Beijing, China (organised by Ministry of Culture and Tourism of The People's Republic of China, etc.)<br><br>「奮進新征程，共譜新篇章——慶祝香港回歸祖國 25 周年暨迎接黨的二十大美術作品展」，香港大會堂，中國香港（香港各界文化促進會主辦、香港美協協辦）<br>"Forging a New Journey and Writing a New Chapter Together — Celebrating the 25th Anniversary of Hong Kong's Return to the Motherland and Welcoming the Party's 20th National Art Exhibition", Hong Kong City Hall, Hong Kong, China (organised by Hong Kong Culture Association, co-organised by The Hong Kong Artists Association)<br><br>「水墨壹佰·後海派 2022 藝術大展」，江蘇美術館、揚州美術館、南通美術館巡迴展（南通大學主辦）<br>"One Hundred Ink Paintings · The 2022 Art Exhibition of Post-Shanghai Painting School", Touring Exhibition of Jiangsu Art Museum, Yangzhou Art Museum and Nantong Art Museum (organised by Nantong University)<br><br>「從可園出發——中國花鳥畫展」（嶺南美術館、廣東省美協、關山月美術館、廣州美術學院主辦）<br>"Originated From Keyuan: The Artworks Collection of Chinese Bird-and-flower Painting Exhibition" (jointly organised by Lingnan Art Gallery, Guangdong Artists Association, Guan Shanyue Art Museum and Guangzhou Academy of Fine Arts) |
| 出版<br>Publication | 《天行之路》，中華書局（香港）有限公司，中國香港<br>*My Art Journey*, Chung Hwa Book Co. (H.K.) Ltd., Hong Kong, China |
| 合作<br>Collaboration | 《長期戰略合作協議》，香港美協、香港書畫文玩協會（簽約人：林天行、趙東曉）<br>Long-term Strategic Cooperation Agreement Between The Hong Kong Artists Association and Hong Kong Fine Art and Antiques Society (signatories: Lam Tian Xing, Zhao Dongxiao) |
| 傳媒<br>Media Coverage | 鳳凰衛視、無綫電視專訪<br>Interviewed by Phoenix TV and TVB |

❶ ❷ │ 1963 年 10 月 17 日，林天行在祖屋出生。 │ On 17 October 1963, Lam Tian Xing is born in the ancient ancestral house.

❹ │ 12 歲的林天行 (1975) │ 12-year-old Tian Xing

❸ │ 祖屋後面是蓮花峰 │ The Lotus Peak behind the house

❺ │ 16 歲的林天行與父母之合影 (1979) │ 16-year-old Tian Xing with his parents

❻ │ 與恩師吳國光在家鄉 (1979) │ With Mr. Wu Guoguang in the hometown

**7** | 與恩師林光及師母在杭州（1979）| Tian Xing and Mr. Lin Guang and Mrs. Lin in Hangzhou

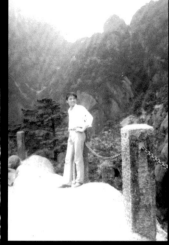

**8** | 在黃山（1979）|
At Mount Huangshan

**9** | 17 歲的林天行，守志留鬚（1980）|
17-year-old Tian Xing with a beard

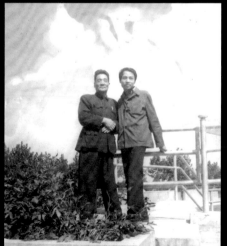

**10** | 與恩師陳挺在西安（1980）|
With Mr. Chen Ting in Xi'an

**11** | 香港美術會會員合影（第三排左五為林天行）（1985）|
Group photo of members of the Hong Kong Art Club (third row, fifth left is Tian Xing)

⑫ ｜ 作品參加華人現代藝術研究會年展，香港大會堂（1986）｜ Works selected into "The Chinese Contemporary Artists' Guild Annual Exhibition", Hong Kong City Hall

**⑮** ｜ 北京畫院，左起：王明明、張步、林天行（1987）｜ From left to right: Wang Mingming, Zhang Bu, Lam Tian Xing, at the Beijing Fine Art Academy

**⑭** ｜ 武夷山寫生（1987）｜ Sketching in Mount Wuyi

**⑰** ｜ 黃山寫生（1987）｜ Sketching in Mount Huangshan

**⑱** ｜ 在中央美院學生宿舍作畫（1989）｜ Painting in the dormitory of CAFA

**⑯** ｜ 與夫人吳明芬在北京長城（1987）｜ Tian Xing and his wife Ng Ming Fan at the Great Wall in Beijing

**⑲** ｜ 在中央美院求學期間（1990）｜ Study at CAFA

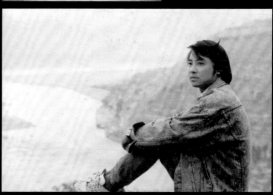

**⑳** ｜ 在陝北俯瞰黃河（1990）｜ Overlooking the Yellow River in Northern Shannxi

㉑ ｜ 在中國畫研究院舉行首次個展「陝北系列」（1990）｜ Tian Xing's first solo exhibition "Northern Shannxi Series" at Research Institute of Traditional Chinese Painting

㉒ ｜ 與恩師劉牧 ｜ With Mr. Liu Mu

㉓ ｜ 劉勃舒（左二）｜ Liu Boshu (second left)

㉔ ｜ 張仃（右）｜ Zhang Ding (right)

㉕ ｜ 李可染夫人鄒佩珠（右二）、黃潤華（左一）、張憑（左二）｜ Ms. Zou Peizhu, the wife of Li Keran (second right), Huang Runhua (first left), Zhang Ping (second left)

㉖ ｜ 盧沉（左一）、周思聰（左二）｜ Lu Chen (first left), Zhou Sicong (second left)

❷⓻ ｜ 賈又福（右）｜ Jia Youfu (right)

❸⓪ ｜ 與杜大愷（右）｜ With Du Dakai (right)

❷⓽ ｜ 與郎紹君（中）｜ With Lang Shaojun (centre)

❸⓵ ｜ 與朋友們在陝北系列展（右七為林天行）｜ Tian Xing (seventh right) and his friends

❸⓶ ｜ 與朋友們在陝北系列展（右七為林天行）｜ Tian Xing (seventh right) and his friends

**㉝** | 在香港藝術中心舉辦「林天行畫展」，左為劉勃舒為畫展的題詞（1991） | With Professor Liu Boshu's calligraphy for "Lam Tian Xing Painting Exhibition" at the Hong Kong Arts Centre

**㉟** │ 大一藝術設計學院教師合影，前排左起：鄧國雄、吳麗明、樓寶善、黃配江、鄭家奇；後排左起：陳小顏、盧兆熹、梁德祥、劉中行、余錦漢、林天行、王創華（1992）│ Group photo of teachers from the First Institute of Art and Design, front row from left to right: Tang Kwok Hung, Ng Lai Ming, Lau Po Shin, Wong Pui Kong, Cheng Ka Kay; back row from left to right: Chan Siu Ngan, Lo Siu Hei, Leung Tak Cheung, Lau Chung Hang, Yu Kam Hon, Lam Tian Xing, Wong Chong Wah

**㊱** │ 在北京（1993）│ In Beijing

**㊲** │ 與夫人吳明芬、長子林沙洲在林天行畫展（1994）│ With wife Ng Ming Fan and the eldest son Sha Chau at Tian Xing's solo exhibition

**㊳** │ 左起：劉欽棟夫人、林天行、熊海、梁巨廷、文樓、靳埭強、劉欽棟、黎日晃、文鳳儀，前：夏碧泉（1995）│ From left to right: Mrs. Liew, Lam Tian Xing, Hung Hoi, Leung Kui Ting, Van Lau, Kan Tai Keung, Liew Come Tong, Li Rihuang, Man Fung Yi; front row: Ha Bik Chuen

**㊴** │ 在北京楊沂京家中聚會，左起：石晶、楊沂京、于躍、白國良、林天行、杜杰（1997）│ Gathering at Yang Yijing's home in Beijing, from left to right: Shi Jing, Yang Yijing, Yu Yue, Bai Guoliang, Lam Tian Xing, Du Jie

**㊵** │ 香港藝術中心個展，一家四口合影（1997）│ Group photo of family members at the solo exhibition at the Hong Kong Arts Centre

**㊻** ｜ 前排左起：林天行、林海鐘、紀京寧、吳慶林、記者、紀連彬、蔡超、楊明義、劉二剛、林容生，後排左起：梁佔岩、記者、王孟奇、高卉民、李乃宙（1997）｜ Zhuhai Invitational Exhibition of Chinese Contemporary Famous Artists, front row from left to right: Lam Tian Xing, Lin Haizhong, Ji Jingning, Wu Qinglin, the journalist, Ji Lianbin, Cai Chao, Yang Mingyi, Liu Ergang, Lin Rongsheng; back row from left to right: Liang Zhanyan, the journalist, Wang Mengqi, Gao Huimin, Li Naizhou

**㊼** ｜ 左起：安林、姚鳴京、梁佔岩、申少君、王孟奇、劉二剛、林天行（1997）｜ From left to right: An Lin, Yao Mingjing, Liang Zhanyan, Shen Shaojun, Wang Mengqi, Liu Ergang, Lam Tian Xing

**㊽** ｜ 左起：李洋、崔曉東、王書傑、唐勇力、吳慶林、李乃宙、林天行、胡應康（1997）｜ From left to right: Li Yang, Cui Xiaodong, Wang Shujie, Tang Yongli, Wu Qinglin, Li Naizhou, Lam Tian Xing, Hu Yingkang

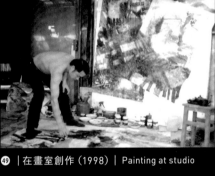

**㊾** ｜在畫室創作（1998）｜ Painting at studio

**�51** ｜女兒莎娜在畫桌上作畫（1998）｜ Tian Xing's daughter Sha Na is drawing on the table.

**㊿** ｜西班牙畢爾包古根海姆博物館（1998）｜ In Bilbao Guggenheim Museum, Spain

**52** | 在西藏（1999）| In Tibet

**53** | 舉辦「景象・香港」畫展，一家四口合影
（1999）| Group photo of family members at
"Scenes・Hong Kong" Painting Exhibition

**54** | 與學生談雅文
在香港藝術中心個展
（1999）| With student
Tam Nga Man at solo
exhibition at Hong Kong
Arts Centre

**55** | 「第六屆中國藝術節——國際中國畫大展」，劉海
粟美術館，常州，左起：王瓚、王健爾、何加林、茹峰、林
天行、林容生、張捷、劉西潔（2000）| "The 6th session
of the Chinese Art Festival — International Chinese Painting
Exhibition", Liu Haisu Art Museum, Changzhou, from left to
right: Wang Zan, Wang Jianer, He Jialin, Ru Feng, Lam Tian
Xing, Lin Rongsheng, Zhang Jie, Liu Xijie

**56** | 「第二屆深圳國際水墨畫雙年展：水墨與都市」，深
圳關山月美術館，左起：向土、林天行、白豐中、周京新、閻
秉會、朱振庚、陳心懋（2000）| "The 2nd International Ink
Painting Biennial of Shenzhen: Ink Painting and Metropolis",
Guan Shanyue Art Museum, Shenzhen, from left to right: Xiang
Tu, Lam Tian Xing, Bai Fengzhong, Zhou Jingxin, Yan Binghui,
Zhu Zhengeng, Chen Xinmao

**57** | 左起：武藝、林天行、張浩、
劉慶和（2000）| From left to right:
Wu Yi, Lam Tian Xing, Zhang Hao, Liu
Qinghe

**58** | 台灣藝術家顧重光、李錫奇、古月、潘鈺、盧根一行到訪大也堂（2000）| Taiwanese artists visit The Hall of Boundlessness.

**61** | 在北京可創銘佳藝苑舉辦林天行西藏畫展，左起：李曉林（左二）、劉牧、林天行、吳慶林、鄧林、聶鷗、劉彥萍、杜大愷、劉慶利（2002）| "Shining Tibet" exhibition at Creation Art Gallery, Beijing, from left to right: Li Xiaolin (second left), Liu Mu, Lam Tian Xing, Wu Qinglin, Deng Lin, Nie Ou, Liu Yanping, Du Dakai, Liu Qingli

**60** | 煙台聯展，左起：崔海、姚鳴京、胡應康、林天行、林容生、朱雅梅（2002）| "Contemporary Ink Paintings of Six Painters' Exhibition", Yantai, from left to right: Cui Hai, Yao Mingjing, Hu Yingkang, Lam Tian Xing, Lin Rongsheng, Zhu Yamei

65 | 首屆四維彩墨畫會師生展與學生合影（2003）| Group photo of Lam Tian Xing and students at the first exhibition of "The Ink Dimensions"

67 | 「第一選擇」，左起：黃魯、林天行、呂振光、金馬倫（策展人）、司徒元傑、朱興華、白景熙、黎明海、潘振華、夏碧泉（2004）| "First Choice", from left to right: Wong Lo, Lam Tian Xing, Lui Chun Kwong, Nigel Cameron (curator), Szeto Yuen Kit, Chu Hing Wah, Norman de Brackinghe, Lai Ming Hoi, Poon Chun Wah, Ha Bik Chuen

68 | 香港視覺藝術中心水墨畫課程謝師宴，左起：鄭明、莫家良、梁巨廷、歐陽乃霑、潘振華、王無邪、林天行、曾廣才（2005）| Graduation dinner for Chinese Brush Paintings course of Hong Kong Visual Arts Centre, from left to right: Cheng Ming, Mok Kar Leung, Leung Kui Ting, Auyeung Nai Chim, Poon Chun Wah, Wucius Wong, Lam Tian Xing, Tsang Kwong Choi

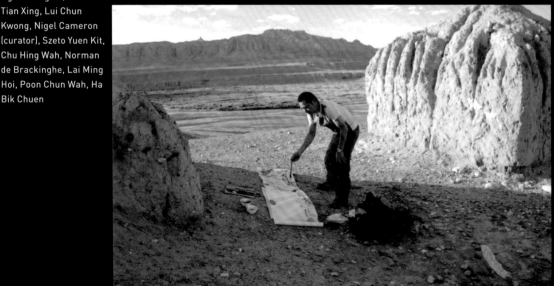

69 | 在西藏阿里土林寫生（2005）| Sketching in soil forests of Ali, Tibet

**⑳** | 在可創銘佳藝苑辦個展，左起：劉瑩、華天雪、齊艷卿、林天行、李小可、洪浩（2005）| Holding solo exhibition at Creation Art Gallery, from left to right: Liu Ying, Hua Tianxue, Qi Yanqing, Lam Tian Xing, Li Xiaoke, Hong Hao

**㉑** | 左起：陳君、林天行、梁銓、王孟奇、鄧肇雄、王守清、古秀玲，大也堂（2005）| At The Hall of Boundlessness, from left to right: Chen Jun, Lam Tian Xing, Liang Quan, Wang Mengqi, Deng Zhaoxiong, Wong Sau Ching, Gu Xiuling

**㉒** | 在師生展與學生合影（2005）| Group photo with students

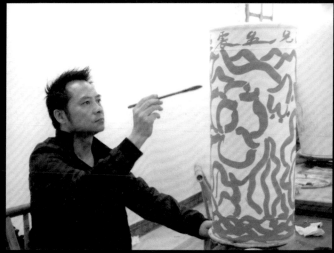

**㉓** | 在景德鎮畫瓷（2009）| Painting porcelain in Jingdezhen

**74** | 與秦嶺雪(李大洲)在泉州(2009)| With Qin Lingxue (Li Dazhou), in Quanzhou

**76** | 米蘭個展記者招待會（2011）| Press conference for solo exhibition in Milan

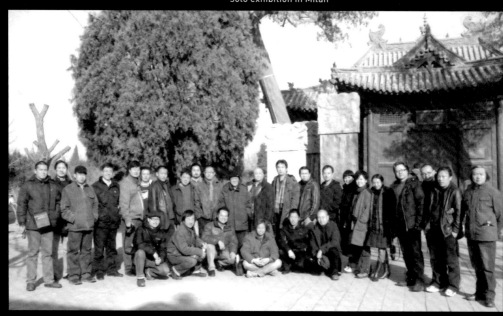

**75** | 在石家莊美術館與參展藝術家合影（前排左三為林天行）（2009）| Group photo with artists at Shijiazhuang Art Gallery (front row third left is Lam Tian Xing)

**78** | 家鄉福建畫家到訪，前排左起：陳方遠、陳初良、翁振新、王和平、林容生，後排左起：林天行、楊煌、賴東平、何瑋明、林任菁、張永海、林濤（2013）| Artists from Fujian visit, front row from left to right: Chen Fangyuan, Chen Chuliang, Weng Zhenxin, Wang Heping, Lin Rongsheng; Back row from left to right: Lam Tian Xing, Yang Huang, Lai Dongping, He Weiming, Lin Renjing, Zhang Yonghai, Lin Tao

**77** | 刻紫砂壺（2011）| Carving on Purple Clay Teapot

**79** | 香港寫生（2012）| Sketching in Hong Kong

**80** | 左起：李小偉、陳北辰、李豫閩、宋建明、林容生、范迪安、朱進、陳子、呂山川、唐承華、林天行、湯志義（2014）| From left to right: Li Xiaowei, Chen Beichen, Li Yumin, Song Jianming, Lin Rongsheng, Fan Di'an, Zhu Jin, Chen Zi, Lu Shanchuan, Tang Chenghua, Lam Tian Xing, Tang Zhiyi

**81** | 「天行・荷・西藏——林天行彩墨作品展」，全家在深圳畫院合影（2014）| Group photo of family members at "Tian Xing · Lotus · Tibet" exhibition at Shenzhen Fine Art Institute

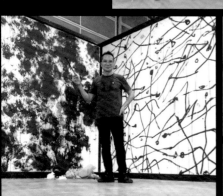

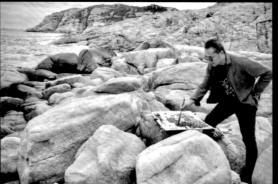

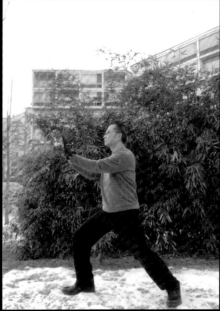

**89** | 打太極（2020）| Playing Tai Chi

**88** | 「藝術共融──香港美協會員作品珠海展」，珠海古元美術館（2019）| "Artistic Integration — Exhibition of Works by Members of The Hong Kong Artists Association", Guyuan Art Museum, Zhuhai

**90** | 打太極刀（2020）| Playing Tai Chi Sabre

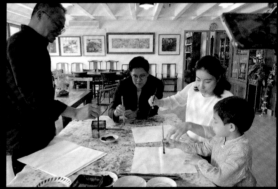

**93** | 霍啟剛、郭晶晶和公子在大也堂畫畫（2020）| Fok Kai Kong, Guo Jingjing and their son are drawing at The Hall of Boundlessness.

**91** | 香港大嶼山寫生（2020）| Sketching in Lantau Island, Hong Kong

**92** | 左起：趙東曉、金耀基、林天行、傅偉中、曲桂福，大也堂（2020）| At The Hall of Boundlessness, from left to right: Zhao Dongxiao, King Yeo Chi, Lam Tian Xing, Fu Weizhong, Qu Guifu

94 | 擔任「校長論壇」主講嘉賓（2020）| Giving keynote speech for Principals Forum

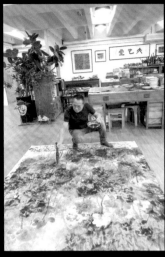

95 | 創作中（2021）| Creating

96 | 練瑜伽（2021）| Yoga practice

98 | 與夫人吳明芬到西貢寫生（2020）| Sketching in Sai Kung with wife Ming Fan

97 | 維港寫生（2020）| Sketching in the Victoria Harbour

**99** | 與親友、學生在大也堂慶祝生日（2021）| Celebrating Tian Xing's 58th birthday with family, friends and students at The Hall of Boundlessness

**100** | 祖孫三代合影（2021）| Group photo of three generations

**101** | 香港中央圖書館講座——《我的路》（2021）| Giving presentation "My Way" at Hong Kong Central Library

**102** | 林天行畫竹、鄭培凱題字，贈送作品予汪明荃，大也堂（2021）| Presenting Liza Wang with a piece of artwork with bamboo painting by Tian Xing and calligraphy by Cheng Pei Kai at The Hall of Boundlessness

**103** ｜ 「金耀基 · 林天行書畫展」，左起：趙東曉（策展人）、金耀基、林天行（2021）｜ "King Yeo Chi · Lam Tian Xing Calligraphy and Painting Exhibition", from left to right: Zhao Dongxiao (curator), King Yeo Chi, Lam Tian Xin

**104** ｜ 左起：李濟平、姜在忠、科維、王凱波、蔣建湘、林天行、金耀基、梁愛詩、劉遵義、鄭李錦芬、吳保安、傅偉中 ｜ From left to right: Li Jiping, Jiang Zaizhong, Ke Wei, Wang Kaibo, Jiang Jianxiang, Lam Tian Xing, King Yeo Chi, Leung Oi Sie, Lawrence Lau, Eva Cheng, Wu Baoan, Fu Weizhong

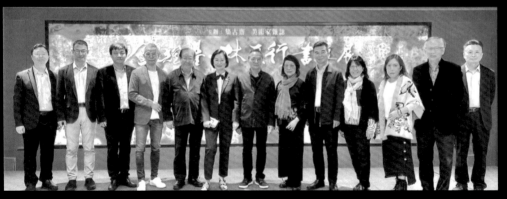

**105** ｜ 丁凱（左二）、趙東曉、李志清、金耀基、林青霞、林天行、金聖華、傅偉中、伍汝（左十一）、施養耀（左十三）｜ Ding Kai (second left), Zhao Dongxiao, Lee Chi Ching, King Yeo Chi, Brigitte Lin, Lam Tian Xing, Serena Jin, Fu Weizhong, Wu Ru (eleventh left), Sze Yeung Yiu (thirteenth left)

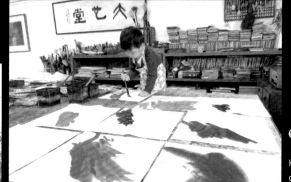

**106** | 孫子行之在作畫（2021）| Quentin Lam Hang Chi, Tian Xing's grandson, is painting.

**107** | 祖孫三代合影（2022）| Group photo of three generations

**108** | 與親友、學生在大也堂慶祝生日（2022）| Celebrating Tian Xing's 59th birthday with family, friends and students at The Hall of Boundlessness

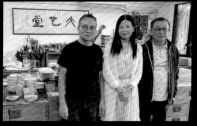

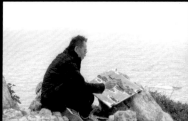

**109** | 萍兒（羅光萍）和潘耀明先生來訪大也堂（2022）| Ping'er (Luo Guangping) and Poon Yiu Ming visit The Hall of Boundlessness.

**110** | 香港西貢寫生（2022）| Sketching in Sai Kung, Hong Kong

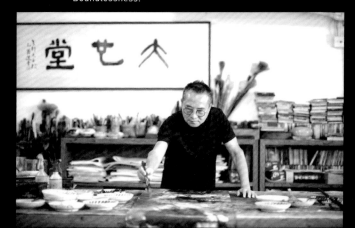

# 附錄三　林天行作品索引
## Annex III Index of Works

責任編輯——顧瑜

裝幀設計——曦成製本

排　版——曦成製本

印　務——劉漢舉

Duty Editor: Gu Yu

Design: Hei Shing Book Design

Typesetting: Hei Shing Book Design

Production: Eric Lau

天行

MY

ART

之路

JOURNEY

作者——
林天行

Author:

Lam Tian Xing

出版——
中華書局（香港）有限公司
香港北角英皇道499號北角工業大廈一樓B
電話｜（852）2137 2338　傳真｜（852）2713 8202
電子郵件｜info@chunghwabook.com.hk
網址｜http://www.chunghwabook.com.hk

Published by:

Chung Hwa Book Co., (H.K.) Ltd.

Flat B, 1/F, North Point Industrial Building,

499 King's Road, North Point, H.K.

E-mail: info@chunghwabook.com.hk

Website: www.chunghwabook.com.hk

發行——
香港聯合書刊物流有限公司
香港新界荃灣德士古道220-248號
荃灣工業中心16樓
電話｜（852）2150 2100　傳真｜（852）2407 3062
電子郵件｜info@suplogistics.com.hk

Distributed by:

SUP Publishing Logistics (H.K.) Ltd.

16/F, Tsuen Wan Industrial Centre,

220-248 Texaco Road, Tsuen Wan, N.T., H.K.

Tel: 852 2150 2100  Fax: 852 2407 3062

E-mail: info@suplogistics.com.hk

印刷——
中華商務彩色印刷有限公司
香港大埔汀麗路36號中華商務印刷大廈

Printed by:

C & C Offset Printing Co., Ltd.

C & C Building, 36 Ting Lai Road, Tai Po, H. K.

版次——
2022年11月第一版第一次印刷
©2022 中華書局（香港）有限公司

First Edition November 2022

©2022 Chung Hwa Book Co., (H.K.) Ltd.

規格——
16開（180mm ×260mm）

Specifications:

180mm ×260mm

ISBN——
9789888808984

ISBN: 9789888808984